Performing Institutions

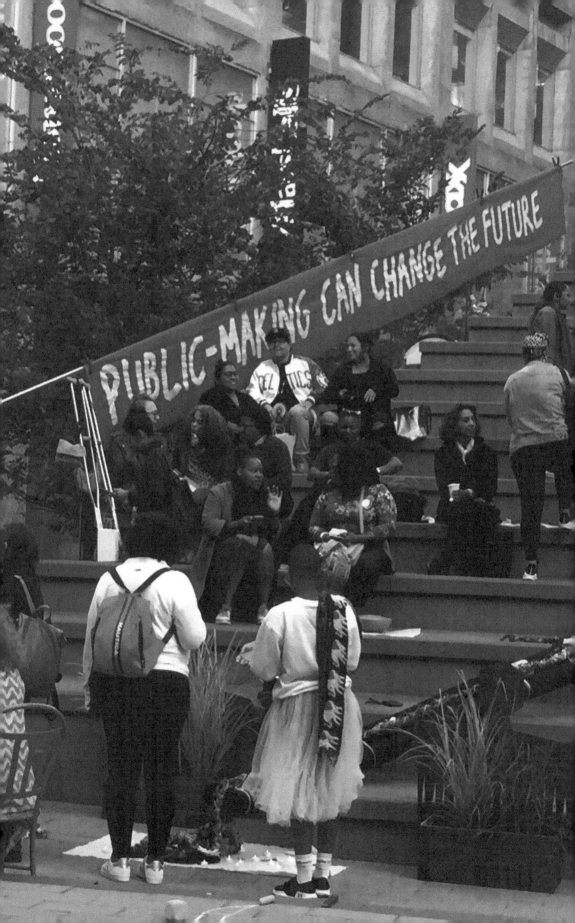

Performing Institutions

Contested Sites and Structures of Care

EDITED BY

Anja Mølle Lindelof and Shauna Janssen

Bristol, UK / Chicago, USA

First published in the UK in 2023 by
Intellect, The Mill, Parnall Road, Fishponds, Bristol, BS16 3JG, UK

First published in the USA in 2023 by
Intellect, The University of Chicago Press, 1427 E. 60th Street,
Chicago, IL 60637, USA

Copyright © 2023 Intellect Ltd

Paperback Copyright © 2024 Intellect Ltd

All rights reserved. No part of this publication may be reproduced,
stored in a retrieval system, or transmitted, in any form or by
any means, electronic, mechanical, photocopying, recording, or
otherwise, without written permission.
A catalogue record for this book is available from
the British Library.

Copy editor: MPS Limited
Cover designer: Aleksandra Szumlas
Frontispiece image: Participants at DS4SI's in PUBLIC Festival, 2019.
Courtesy of Lori Lobenstine.
Production manager: Sophia Munyengeterwa
Typesetter: MPS Limited

Print (Hardback) ISBN 978-1-78938-665-3
Print (Paperback) ISBN 978-1-78938-955-5
ePDF ISBN 978-1-78938-666-0
ePUB ISBN 978-1-78938-667-7

Printed and bound by CMP

To find out about all our publications, please visit our website.
There you can subscribe to our e-newsletter, browse or download our current
catalogue and buy any titles that are in print.

www.intellectbooks.com

This is a peer-reviewed publication.

Table of Contents

List of Figures	ix
Acknowledgements	xiii
Introduction: Contested Sites and Structures of Care	xv
Shauna Janssen and Anja Mølle Lindelof	

ACT ONE 1

1. *Silver*: Self/Site-Writing *A Courthouse Drama* 3
 Jane Rendell
2. Act 01: Love. On Political Love vs. Institutional Loyalty 32
 Sepideh Karami
3. The Thinkers: Thought–Action Figures #7 46
 Jon McKenzie and Aneta Stojnić

ACT TWO 59

4. Performing Indigenization: New Institutional Imperatives Post Truth and Reconciliation 61
 Kathleen Irwin
5. Foolish White Men: Tree-Felling and Wrestling: Performing the Institution of the White Man from an Aotearoa Perspective 81
 Mark Harvey

ACT THREE 95

6. Performing Aural and Temporal Architecture: Re-framing the University through The Verbatim Formula 97
 Maggie Inchley, Paula Siqueira, Sadhvi Dar, Sylvan Baker and Mita Pujara

7. Performance Design as Education of Desire 106
 Franziska Bork Petersen and Michael Haldrup
8. Mode D: Evental Forms of Exchange in Art Education 120
 Glenn Loughran
9. Performative Urbanism: Mapping Embodied Vision 135
 Christina Juhlin and Kristine Samson
10. Performance Design: Performative Gestures within 156
 Academic Institutions
 Rodrigo Tisi

ACT FOUR 167

11. Caring Buildings 169
 Liisa Ikonen
12. *Alieni nati*: Journey-Performance at S. Maria della Pietà 185
 Former Psychiatric Hospital in Rome
 Fabrizio Crisafulli

ACT FIVE 201

13. From Garage to Campus: Exploring the Limits of the 203
 Museum in Contemporary Russia
 Anton Belov and Katya Inozemtseva
14. Not Not Research 214
 Henk Slager
15. LGB's Manifest 226
 LGB Society of Mind

ACT SIX 237

16. Dis-establishment 239
 Sam Trubridge
17. Reclaiming Subjectivity through Urban Space 256
 Intervention: The People's Architecture Helsinki
 Maiju Loukola

18. Public-Making as a Strategy for Spatial Justice 266
 Kenneth Bailey and Lori Lobenstine, Design Studio for Social Intervention

Notes on Contributors 275

Figures

Figure 3.1:	TAF Comic, 2017. By Aneta Stojnić and Jon McKenzie.	46
Figure 3.2:	Still from performance TAF EPISODE 7: The Thinkers / Jon McKenzie and Aneta Stojnić, Spring Festival in Utrecht, 2018.	56
Figure 3.3:	Still from performance TAF EPISODE 7: The Thinkers / Jon McKenzie and Aneta Stojnić, Spring Festival in Utrecht, 2018.	56
Figure 4.1:	Grad Students at Grasslands National Park. Courtesy of Dianne Ouellette.	70
Figure 4.2:	Joely Bigeagle Kequahtooway tanning buffalo hide in art class. Courtesy of Jan Bell.	70
Figure 4.3:	Micheal Langen discussing a collaborative skateboard project he developed with artist Kent Monkman. Courtesy of Noel Wendt.	73
Figure 4.4:	Micheal Langen performs. Courtesy of Noel Wendt.	73
Figure 5.1:	Mark Harvey, 2016–17, *Weed Wrestle*. Video still by Daniel Strang. Courtesy of Harvey/Strang.	83
Figure 5.2:	Mark Harvey, 2016–17, *Group Weed Wrestle*. Video Still. Camera by Daniel Strang. Courtesy of Harvey/Strang.	83
Figure 5.3:	Mark Harvey, 2019, *Climate Recycle Privilege*. Video still by Daniel Strang. Courtesy of Harvey/Strang.	87
Figure 5.4:	Mark Harvey, 2013, *Political Climate Wrestle*. Photograph by Paolo Rosso. Courtesy of Harvey/Rosso.	87
Figure 6.1:	Shona and the painted white woman. Photograph by Paula Siqueira.	101
Figure 6.2:	Hannah rehearses. Photograph by Paula Siqueira.	101
Figure 6.3:	Julie and Matt. Photograph by Paula Siqueira.	103
Figure 6.4:	Anthony and the screen. Photograph by Paula Siqueira.	104
Figure 8.1:	Hedgeschoolproject 08: Literacy House, 2008. Image Credit: Glenn Loughran.	129
Figure 8.2:	How to teach what you don't know, 2008. Image Credit: Glenn Loughran.	129
Figure 8.3:	Hedgeschoolproject 08: Literacy house, 2008. Image Credit: Glenn Loughran. 2008.	131

Figure 9.1:	Peter Kirk, the director of the Theatre Island, introduces students to the space like they were old friends. Photo by Kristine Samson.	140
Figure 9.2:	Superkilen Park, the Red Square in Nørrebro. Visual design and urban furniture are collected from all over the world to illustrate the cultural diversity of the neighbourhood. Photo by Kristine Samson.	143
Figure 9.3:	*The Emergence of a Collective Body*. The performance was made by a group of students to map and explore the potentials for collective agency at Nørrebro train station. Photo by Kristine Samson.	143
Figure 9.4:	*Mirror Walk* was an exploratory walk in which students played with the participants gaze and conception of what is urban nature. Photo by Kristine Samson.	149
Figure 9.5:	*Twin Harbours* was a video installation on canvas mapping two harbour areas in Copenhagen Harbour, exploring differences and similarities – and possible futures. Photo by Kristine Samson.	149
Figure 9.6:	Video excerpt from the audiovisual mapping *Barriers* at Refshaleøen.	150
Figure 10.1:	Performance Design within academic institutions. This diagram depicts a possible situation of the field. Performance Design can be situated in educational models that are integrative and that promote interdisciplinary methodologies for creative work and research, from disciplines to transdisciplines.	158
Figure 12.1:	Marcello Sambati in *Alieni nati*. Courtesy of Stefania Macori.	193
Figure 12.2:	Naoya Takahara, *Acchiappaspiriti* ('Gost catcher'), performing sculpture for *Alieni Nati,* 2018. Courtesy of Naoya Takahara.	193
Figure 12.3:	Simona Lisi in *Alieni nati*. Courtesy of Gatd.	194
Figure 12.4:	Federica Luzzi, costume for Simona Lisi in *Alieni nati*, 2018. Courtesy of Federica Luzzi.	194
Figure 12.5:	Alberto Paolini in *Alieni nati*. Courtesy of Federica Luzzi.	195
Figure 12.6:	Alessandra Cristiani in *Alieni nati*. Courtesy of Gatd.	196
Figure 13.1:	Garage Center for Contemporary Culture at the Bakhmetevsky Bus Garage, Moscow, 2008. Courtesy of Garage Museum of Contemporary Art.	204
Figure 13.2:	Vremena Goda Café in Gorky Park, Moscow, 1968. Courtesy of Igor Vinogradsky Archive, Moscow.	205
Figures 13.3 and 13.4:	Vremena Goda café ruins, facade and interior, 2011. Courtesy of Garage Museum of Contemporary Art.	206
Figure 13.5:	The Shigeru Ban pavilion in Gorky Park. Courtesy of Garage Museum of Contemporary Art.	207

FIGURES

Figure 13.6:	Garage Museum of Contemporary Art in Gorky Park. Courtesy of Garage Museum of Contemporary Art.	207
Figure 13.7:	Garage Screen summer cinema, designed by SYNDICATE (Moscow), 2019. Courtesy of Garage Museum of Contemporary Art.	209
Figure 13.8:	Garage Studios, VDNKh, Moscow, 2019. Courtesy of Garage Museum of Contemporary Art.	209
Figure 13.9:	Interior of Garage Studios, VDNKh, 2019. Courtesy of Garage Museum of Contemporary Art.	210
Figure 14.1:	Installation view *Exhausted Academies: Fatigue Society*, Byung-Chul Han, Seoul Media City, 2016. Courtesy of Seoul Museum of Art.	216
Figure 14.2:	Installation view *To Seminar* (Sarah Pierce, Falke Pisano, Tiong Ang), BAK Utrecht, 2017. Courtesy of BAK, basis voor actuele kunst, Utrecht.	216
Figure 14.3:	Installation view *Aesthetic Jam: Zero Degree Situation* (Kai Huang Chen, Lonnie van Brummelen and Siebren de Haan), Taipei Biennial 2014. Courtesy of Taipei Fine Arts Museum, Taipei.	220
Figure 14.4:	Installation view *Research Ecologies* (3rd Research Pavilion, Venice Biennale 2019). Courtesy of Research Pavilion Venice/Uniarts Helsinki.	220
Figure 15.1:	LGB's Manifest on screen. *I am LGB*, 2016. Photo credit: Kong Chong Yew.	227
Figure 15.2:	LGB's Manifest live broadcast, *I am LGB*, 2016. Photo credit: Wan Zhong Hao.	228
Figures 15.3 and 15.4:	Mapping the visual domain, *I am LGB*, 2016. Photo credit: Kong Chong Yew.	233
Figure 15.5:	Participant photos, *I am LGB*, 2016. Photo credit: Wan Zhong Hao.	235
Figure 16.1:	The Performance Archade 2017. Photo by Sam Trubridge.	240
Figure 16.2:	*EurekaII*, by Amy Miller and Daniel Cruden. Photo by Sam Trubridge.	240
Figure 16.3:	*Cargo*, by Kasia Pol and Mat Hunkin. Photo by Sam Trubridge.	246
Figure 16.4:	*A Machine*, by Meg Rollandi, Nick Zwart and Andrew Simpson. Photo by Sam Trubridge.	252
Figure 16.5:	*Salt Walk*, by Mick Douglas. Photo by Sam Trubridge.	252
Figures 17.1 and 17.2:	*People's Architecture* Helsinki in-process. Courtesy of People's Architecture HDW 2017 / Architecture for People.	259

Figure 18.1: Participants at DS4SI's in PUBLIC Festival, 2019. 269
Courtesy of Lori Lobenstine.

Figure 18.2: Cape Verdean gypsy cab drivers playing ouril while awaiting 271
customers. Courtesy of Max MacCarthy.

Figure 18.3: (a) Participants deep in conversation at DS4SI's Street Lab: 272
Upham's event. Courtesy of Rafael Feliciano-Cumbas.
(b) Street Lab: Upham's knitter working on the knit handrailing.
Courtesy of Rafael Feliciano-Cumbas. (c) Residents check out
Street Lab: Upham's temporary art gallery. Courtesy of
Rafael Feliciano-Cumbas. (d) Magnet boards helped community
members imagine what they'd like to see in the alley.
Courtesy of Lori Lobenstine.

Acknowledgements

A great many people and colleagues around the world have contributed to the idea of making this book, and, of course, to those who have contributed their ideas, stories and reflections to this anthology, we are especially grateful. We are also thankful to all those who have participated in the *International Performance Design* symposiums – your participation is what has helped to grow and nurture an international network of artists and researchers. We wish to thank the managing editors at Intellect, and especially Jessica Lovett, for taking this book project on, and Sophia Munyengeterwa, production editor at Intellect, for guiding us with such care in bringing this project to the public realm. Thank you to our anonymous peer-reviewer for your overwhelmingly positive and useful feedback. We wish to thank the Concordia University Research Chair in Performative Urbanism, Montreal, and Department of Communication and Arts, Roskilde University for financial support towards the publication of colour images. And last but not least, we wish to extend a very special and heartfelt thank you to Dorita Hannah and Olav Harsløf for inspiring and creating a global sense of community on this theme of *Performing Institutions*. Making this book would not have been possible without you.

Shauna Janssen and Anja Mølle Lindelof,
November 2021

Introduction

Shauna Janssen and Anja Mølle Lindelof

By evoking the idea of *Performing Institutions*, we seek to foreground all kinds of 'actors' that engage with (re)imagining creative practices – social, design, artistic and pedagogical – that critically interact with institutional frameworks and the broader local and global society of which these institutions are a part. How do current institutions perform – academically, spatially, custodially and structurally? How might we stay critically engaged with the ways that institutions are inherently contested sites, and what role do care and counter-hegemonic practices play in rearticulating other ways of performing institutions, and how they perform on us? These are the questions that are central to this project. As such, the aim of this anthology is to stage a productive tension between two main themes: structures of care (instituting otherwise) and sites of contestations (desiring change).

The making of this anthology takes its inspiration from the third *International Performance Design Symposium* (2018) and engages with the thinking and practices of that interdisciplinary and global community of scholars, performance theorists, artists, performance designers, architects, researchers and educators. Dorita Hannah and Olav Harsløf were central to this symposium, not only in their roles as instigators, community builders, planners and organizers of three performance design symposiums, but as scholars and performance designers who have been shaping the field since 2004. At this time, performance design became a relatively new way of thinking about design for performance as a transdisciplinary field of practice. Hannah and Harsløf instituted Performance Design academic programs at Massey University in New Zealand, and Roskilde, Denmark, respectively. The discourse on performance design was further articulated in their oft-cited published anthology by the same name, where they describe performance design as a

> loose and inclusive term [that] asserts the role of artists/designers in the conception and realization of events, as well as their awareness of how design elements

not only actively extend the performing body, but also perform without and in spite of the human body. Acknowledging that places and things precede action – as action – is critical to performance design as an aesthetic practice and an event-based phenomenon. In harnessing the dynamic forces inherent to environments and objects, and insisting on a co-creative audience as participatory players, it provides a critical tool to reflect, confront and realign worldviews.

(Hannah and Harsløf 2008: 18)

Since its inception in 2004, the discourse and practice of Performance Design has become an institutionalized paradigm. The third Performance Design symposium revealed to its participants that perhaps the field – as practice and pedagogy – was at a crossroads. Is it still a transdisciplinary creative arts paradigm or has the time come for Performance Design to (de/re) institutionalize as an independent post-disciplinary research field and artistic paradigm that resists institutionalization? The third symposium was hosted by Teatro Potlach, located in the bucolic Italian village of Fara Sabina. Over the course of four days participants shared ideas and provocations to consider how academic and cultural institutional frameworks might be re-imagined, and what a performance design paradigm might have to offer such a re-imagining. The making of this book project is thus inspired by the many acts of communing and connecting that occurred among those participating in the symposium.

Performing Institutions: Contested Sites and Structures of Care builds upon scholarly work and critical reflection rooted in the social and cultural histories of education, self-organization, activist practices, performance, design and artistic research, (at)tending to the ways that institutions are necessarily political and performed. Contemporary thinkers and writers that have, in part, informed our thinking on institutional frameworks include, among others, the artist Ahmet Öğüt's project on *The Silent University: Towards a Transversal Pedagogy* (2016), cultural critic Gerald Raunig's 'instituent practices' (2016), Fred Moten and Stefano Harney's *The Undercommons: Fugitive Planning & Black Study* (2013), Irit Rogoff's oft-cited critical writings on pedagogical aesthetics and knowledge production (2010), Gerd Biesta's *The Beautiful Risk of Education* (2015) and Markus Miessen's 'Crossbenching as a form of institutional polity' (2016). What these critical thinkers all draw attention to, from their own disciplinary fields and practices, is that in order to contest or disrupt the neoliberal processes and colonial legacies by which knowledge, artistic and cultural production are institutionalized, one must operate on the margins, become the figure of the 'uninvited outsider' (Miessen 2016). As it pertains to academic institutions, Moten and Harney invoke the figure of the 'subversive intellectual' and write,

it cannot be denied that the university is a place of refuge, and it cannot be accepted that the university is a place of enlightenment. In the face of these conditions one can only sneak into the university and steal what one can. To abuse its hospitality, to spite its mission, to join its refugee colony, its gypsy encampment, to be in but not of – this is the path of the subversive intellectual in the modern university.

(2013: 26)

Furthermore, institutional polity, as Miessen observes,

seems increasingly difficult to produce meaningful content within the institutionalized structures of major universities and academies, an ethical and content-driven approach to producing new knowledge can only be achieved from the outside – through the setting up of small-scale frameworks that are nestled on the margins or borders.

(2016: 3)

What the above perspectives do in various ways is signal how performing institutional frameworks *otherwise*, whether through contested acts or *careful* engagements, are actualized by the agency of the actors who perform them. Scenographer Elke Van Campenhout's proposal for a 'Tender Institute' is most provocative and generative in terms of acknowledging this agency. 'The Tender Institute', writes Van Campenhout,

is the institute that has become tender to the touch of its participants. It has shed off its monumental phantasies and now only lives and breathes through and with the interests invested in it by its stakeholders. The Tender Institute is created through the grace of the labour of devotion; the labour invested in the practice of desire and love.

(2016: 144)

Keeping neoliberal institutional practices in mind, Van Campenhout's notion of a tender institute raises pertinent questions about the value given to (hidden) institutional labour, and to considering what it might mean to break with institutional power dynamics, with quantifiable and measurable results, and instead embrace the labour of making space for engaging with yet unknown social relations.

Our thinking through performing institutions as contested sites has been informed by political theorist Chantal Mouffe, whose work on agonism is central to considering the role that criticality and a sustained engagement with institutions (writ large) might play in enacting their transformation(s). Mouffe argues, in order for transformation to occur, there needs to be an embrace of critical artistic and

counter-hegemonic practices of (re)engagements that produce agonistic spaces. She writes,

> I think one of the main disagreements that we will face, concerns the space in which resistances should be deployed and the type of relation to be established with the institutions. Should critical artistic practices engage with current institutions with the aim of transforming them or should they desert them altogether? Critical artistic practices do not contribute to the counter-hegemonic struggle by deserting the institutional terrain but by engaging with it, with the aim of fostering dissent and creating a multiplicity of agonistic spaces where the dominant consensus is challenged and where new modes of identification are made available.
>
> (Mouffe 2012)

Following Mouffe, the labour of critically engaging with the institution from within, and acknowledging that institutions are contested sites, is a necessary part of performing institutional logic; how performing institutions (de)emphasize social values and ethical practices that a majority of its 'loyal actors' agree upon and, by doing so, directly or indirectly enact inclusionary and exclusionary mechanisms. If institutions were not contested, they would render themselves obsolete. The challenges, however, are that it requires a great deal of collectivity to contest the neoliberal tendencies that institutions enact, and an equal amount of care to transform the systemic racism, class and gender inequities that institutions perpetuate (intentionally or not). To put forward a constructive critique of performing institutions then, is to recognize that a multiplicity of actors contribute to institutional meaning making through their continuous negotiation with sites of structural, social, spatial, material and human agencies. To contest neoliberal institutional practices and to care for such contestations require a sustained and critical engagement with current frameworks and policies of any specific institution, how and by whom it is governed, and the performances that it portends to nurture and care for.

What, then, is a caring institution? How might a *careful* engagement with institutional practices transform their neoliberal underpinnings? In order to explore this, we turn to the idea of care as a disruptive force, as suggested by Maria Puig de la Bellacasa (2017) in her elaboration on labour, affect and ethics as central dimensions of giving and taking care. For Bellacasa, building upon critical, feminist and speculative lines, care is a reciprocal process of care-giving and care-taking that relies simultaneously on interdependency and the (hidden) labour of maintenance that presupposes a critical approach to the present. Bellacasa draws on Joan Tronto's definition of care as 'everything that we do to maintain, continue and repair "our world" so that we can live in it as well as possible' (1993: 3).

Tronto's idea of 'our world' includes not only our bodies, ourselves, but also the materiality of our environment and the methods of these everyday practices – it includes 'all of which we seek to interweave in a complex, life-sustaining web' (1993: 3) and calls for a multivocal and material understanding of care. In other words, care is much more than a moral stance – it is a practice. 'Good care' is not an ideal that can be discussed or defended in general terms, but something that is located and constantly shaped and reshaped in specific every-day practices. So, in what language to speak of performing care and its specificities? Studies of caring practices have grown out of the healthcare field (Moll 2008) and, more recently, have been applied to cultural institutions and the structures of live events (Scannell 2017), to communities of care in the creative industries (Campbell 2020), as well as cultural policies and concepts of hope (Gross 2021).

Contemporary studies of care are concerned with redressing the normative wish for a better world and with ideas of hope or what Paddy Scannell refers to as 'hermeneutics of trust' that elicit the wonders of ordinary, everyday life. The labour of reclaiming care as a critical concept has been grounded in disentangling normative meanings of care, for example, associated with kindness, motherhood and generosity. As Bellacasa explains, 'certainly any notion that care is a warm pleasant affection or a moralistic feel-good attitude is complicated by feminist research and theories about care' (2017: 2). In a similar vein, for Anne Marie Moll, the logic of care is best understood in opposition to what she terms the logic of choice, and neo-liberal attitudes that often underpin health care systems. In Moll's view, individualism and privatization are not progressive approaches to healthcare. As such, she advocates a language of care that contests neo-liberal and colonial ideals embedded in society and its institutions (Moll 2008: 3).

The language of care, in other words, cannot be conflated with what we desire or choose or hope to happen. Rather, to perform care means it needs to be enacted – to be given and received, experienced and witnessed. As Scannell argues,

> the care structure is everything that contributes to the realization of the event: it is the sum of all the advance work of preparation and its enactment, live and in real time on the day. But it is not just a question of the invisible labour of its producers and actors; it is also the care and concern for the event as such. Any event aspires to be a meaningful, significant experience for all concerned.
>
> (2017: 75)

When it comes to 'good care', one of the main difficulties lies in how to define notions of good. As Moll posits, in the logic of choice, normative judgements are the moral activity par excellence, whereas in the logic of care, defining 'good', 'worse' and 'better' does not precede practice, but forms part of it. A difficult

part, too. One that gives ample occasion for ambivalences, disagreements, insecurities, misunderstandings and conflicts. Nobody ever said that care would be easy (Moll 2008: 76).

Read this way, there is perhaps something generative in pursuing and (re)enacting caring contestations, or the logics of care as a contested site. And this, we propose, might be a transformative engagement with performing institutions.

Performing Institutions *in six acts*

This book is a collection of ideas, stories, short reflections and manifestos that, indirectly, stage and build upon the well-established discourse of institutional critique. We have placed these works in discussion with themes of care and contest, with the aim of critically engaging with institutional practices and structures, and why that matters. The institutional structures hosting pedagogical, cultural, caring, social activist and artistic practices that are explored in this book redress, from different disciplinary and practice positions, experimental approaches for participating in the construction and reconfiguration of institutions and their meaning making. The following Six Acts consist of full-length chapters and shorter manifesto-like works from a host of critical scholars and educators, performance designers, activists and artist-researchers from around the globe, working across the disciplines and fields of architecture and performance design, urbanism and public art, cultural production and social practice, curation and education. With case studies and critical reflections from Denmark, Ireland, Finland, the UK, Canada, the US, Chile, Asia and Australasia, contributors provide a counterpoint for considering institutions *otherwise* and the ways they envision or pursue performing artistic, cultural, social and educational practices as caring engagements with contested sites.

Act One: *Performing* parrhesia, *political love and post-colonial matters*

It matters what matters we use to think other matters with; it matters what stories we tell to tell other stories with; it matters what knots knot knots, what thoughts think thoughts, what descriptions describe descriptions, what ties tie ties.
It matters what stories make worlds, what worlds make stories.

(Haraway 2016: 12)

INTRODUCTION

Our theme of contested sites within the purview of educational institutions begins in Act One with architectural and critical spatial practice theorist Jane Rendell, and her part playscript-institutional critique, '*Silver*: Self/Site-Writing A *Courthouse Drama*'. Rendell takes a performative site-writing approach to exploring 'instituent practices' (Raunig 2009) by situating us in a courthouse drama – as well as herself as 'Author' in this drama. Interpolating Michel Foucault's concept of *parrhesia*, Rendell problematizes the ethics and risks associated with neoliberal academic research expansion that is sponsored by corporate financing. In the case of *Silver*, Rendell dramatizes a court hearing about a multinational fossil fuel mining corporation that finances the creation of a higher education 'Institute for Sustainable Resources'. In one scene, the character of the 'Author' describes being awakened in the middle of the night with questions regarding her institutional loyalty and the potential consequences of contesting her own academic institution's governing structures: 'Will fighting this battle, pitting myself against my institution, lose me my job? Will the right governance structures and due diligence procedures really protect the independence of academic research?'

Rendell's dramatic characterization and questioning of institutional values and loyalty as they are performed through a disciplinary society (à la Foucault) are further explored in Sepidah Karami's 'Act 01: Love. On political love vs. institutional loyalty'. Building on Byung-Chul Han's idea of an 'achievement society' (*The Burnout Society*, 2010), Karami proposes the amateur (vs. the professional) as a subversive and contested institutional actor. The author puts forth two main protagonists – the lover vs. the loyalist, otherwise known as the amateur vs. the professional, or the kite vs. the flag – to speculate upon love as a political and dissenting force with the potential to overcome or mitigate uneven power relations and the normative structures of governance that have become so inherent to 'professionalizing' institutional behaviour. Karami invites us to engage with her poetic reflection on the potential for the figure of love to move beyond acts of care in worlding and transforming institutional experiences (writ large); sharing affinities with Van Campenhout's notion of a tender institution, and situating love as a revolutionary force and agonistic figure of institutional transformation.

Act One concludes with 'The thinkers: Thought–Action Figures #7', a performance lecture created by performance studies and media scholars Jon McKenzie and Aneta Stojnić, who cast themselves as Thought–Action Figures or 'TAFS', among others, ranging from world historical TAFS such as Plato to Pussy Hats and Apple desktops. Part theatre forum part manifesto McKenzie and Stojnić query how western cultural thoughts, à la Plato, have colonized and institutionalized our ideas about knowledge production, asking: 'What about other knowledges and other epistemologies that have been subjugated to the western colonial epistemic violence, all the embodied knowledges pushed aside by the logocentrism of

power?' Like Rendell, the authors invoke the meaning of *logos* as it was used by Plato, albeit in a different context, to contest the institutional power inherent in western cultural thought and practices.

Act Two: A 'wild studio' pedagogy and pākehā practices for unsettling colonial power

> When metaphor invades decolonization, it kills the very possibility of decolonization; it recentres whiteness, it resettles theory, it extends innocence to the settler, it entertains a settler future. Decolonize (a verb) and decolonization (a noun) cannot easily be grafted onto pre-existing discourses/frameworks, even if they are critical, even if they are anti-racist, even if they are justice frameworks.
>
> (Tuck and Yang 2012: 3)

Act Two further underscores themes of western colonial ontologies and systemic institutional violence. In 'Performing indigenization: New institutional imperatives post truth and reconciliation', theatre artist/scenographer and educator Kathleen Irwin problematizes strategies for indigenizing and practices of decolonizing academic institutions from a Canadian perspective. The author illustrates the difficulties of enacting restorative justice while providing critical insights on decolonizing and indigenizing practices within postsecondary education, specifically in the context of the Faculty of Media, Art and Performance at the University of Regina, her home institute. As Irwin points out, in Saskatchewan, 'the material markers of colonial power and its absence are readily apparent in the disparities between Indigenous and non-Indigenous' populations (60); simultaneously a place of on-going colonial oppression, and place of possibilities for meaningful indigenizing practices in the academy post Canada's Truth and Reconciliation Commission. She draws from transcultural approaches to art making to consider how the pedagogical paradigm of a 'wild studio' might unsettle and 'unhouse' institutional colonial structures and educational practices.

In 'Foolish White men', artist Mark Harvey's performances of 'tree felling' and 'weed wrestling' become contested actions through which Harvey confronts his own identity as a Pākehā (mainly British) and Māori male artist, as he performs the power and privilege of white settler male institutionality in Aotearoa/ New Zealand. In his performances, Harvey casts himself as the fool, inspired by Friederich Nietzche's meaning of the figure (*Gay Science*, [1882] 2001), to playfully contest the cultural and political norms that have shaped his own sense of embodying white male privilege. Through his performances, many of which focus on themes of climate change, Harvey seeks to question 'what might occur if

someone (me) who holds institutional power (as a White man) attempts to test out promises of subservience in contrast to institutional stereotypes?' (86). Just below the surface of Harvey's highly physical, and perhaps even buffoon like, performances and his intention to subvert the norms instituted by white (predominantly male) colonial power, also lies the artist's desire to care for and repair 'acts of [our] colonisation' (89).

Act Three: Desiring and mapping eventual educational and instituent practices

When I talk about an 'instituent practice', this is not the opposite of institution in the same way that a utopia, for example, is the opposite of bad reality. Nor is it necessarily to be understood in its relation of institutedness. Instituent practice as a process and concatenation of instituent events is instead an absolute concept that goes beyond the institution: it does not oppose the institution, but it does flee institutionalisation.

(Raunig 2016: 15)

In Act Three, contributors provide case studies that explore (both historical and more recent) experimental turns in how careful engagements have been enacted in educational, learning and teaching practices that operate both within and on the periphery of established educational systems. In the 'Hedgeschoolproject', Glenn Loughran provides a historical case study and recounts a genealogy of teaching and learning that falls outside of commodity exchanges and highlights pedagogical practices that are driven by necessity and experimentation. In his accounting of the Irish hedge schools, Loughran explores the principles and values of 'eventual education'. Drawing upon emancipatory theory from Alain Badiou and Gerd Biesta, the author foregrounds a socially engaged art 'turn' in pedagogical practices through the conceptual and experimental hedge schools which were constructed around the dictum 'how to teach what you don't know' (128).

In a similar vein, the authors of 'Performing aural and temporal architecture: Re-framing the university through The Verbatim Formula', describe an applied theatre method they call the The Verbatim Formula (VFL) which highlights, traditionally, how students, and specifically marginalized ones, have had very little agency in formulating the way they experience places of learning. Specialized spaces, such as classrooms, typically demarcate and codify educational hierarchies. As such, the authors propose VFL as a teaching and learning approach to transcending uneven power dynamics, norms, rules, patterns and relationships embedded within institutional spaces of learning.

Franziska Bork Petersen and Michael Haldrup's 'Performance design as education of desire' draws from the concept of the *not yet* to examine Roskilde University's Performance Design programme and its approach to curricular expansion in the School of Communications (between 2008 and 2019). Drawing from utopian thinkers Ernest Bloch and David Bell, they suggest 'education of desire' as a pedagogical strategy for transformational learning through design. Within the context of teaching design theory and eventing practices for the experience economy, the authors propose the idea of 'affective estrangements' as a pedagogy for moving beyond cognitive learning and pursuing more embodied experiences of learning.

This theme of eventing pedagogical practices is further explored by urbanists and educators Kristine Samson and Christina Juhlin in their pedagogical experiments with 'Performative urbanism: Mapping-embodied vision'. The authors provide examples of their pedagogy and work with students also undertaking a degree in the Performance Design programme at Roskilde, with a focus on making urban research through mapping performative actions. Their driving research question asks: 'within the context of neoliberal urban development how can a performative urbanism approach to planning and design shift our experience of cities, and the learning and teaching of cities?' (135).

Rodrigo Tisi, performance designer and educator based at the Universidad Adolfo Ibáñez, Santiago de Chile, explores how performative gestures within the context of an architectural and design studio hold the potential to contribute to disciplinary field expansions. From the perspective of teaching architecture and design in the global south, Tisi reflects on his own experiences of navigating institutional neoliberal academic structures while teaching and researching across disciplinary boundaries.

Act Four: Designing for acts of care and performing institutional memory

[A] renewed focus on how scenography happens stresses that it occurs, in time, as an assemblage of place orientation [...] that scenography happens stresses the interventional quality of the practice at a particular moment in time.

(Hann 2019: 69)

In 'Caring buildings', Finnish scenographer and artist-researcher Liisa Ikonen brings our attention to institutional designs for healthcare facilities. Drawing from scholarship on practices of *'expanded' scenography* (McKinney and Palmer 2017), the author considers how an expanded notion of scenography, as a design and research method that moves beyond theatrical representation, can play a role

in producing more caring atmospheres and spaces for users and residents of health care institutions. In this context, and informed by Heidegger's concepts of dwelling and being, Ikonen argues for a 'scenography that happens' and proposes: if an environment of care enables 'us to identify familiar phenomena within one's own life-world, the bodily way of *being* can also be realized accordingly' (172, original emphasis).

The notion of expanded scenography as a 'caring act' is further explored in Italian theatre director Fabrizio Crisafulli's '*Alieni nati*', a performance event that took place in Rome's abandoned psychiatric hospital, S. Maria delle Pientà. In this chapter, Crisafulli poetically reflects upon the process by which he collaborated with the artist collective, *Alieni nati* ('aliens born'), to performatively engage with the social history of Rome's built environment and the institutionalization of its mentally ill. Crisafulli's recounting of the performance event is an homage of sorts to those forgotten residents of S. Maria delle Pientà and suggests the powerful capacity that site-specific performance events have to bring public awareness to often overlooked and harmful institutional legacies.

Act Five: Performing queer, transversal, curatorial and artistic research practices

> A Transversal methodology ensures a trans-local form of knowledge production that rhizomatically reaches beyond topics of architecture and design such as citizenship, militant pedagogy, institutionalism, borders, war, displacement, documents/ documenting, urban segregation, commons and others.
>
> (Tan 2016: 31)

Act Five focuses on transversal approaches to artistic curatorial and design research practices both within and peripherally to educational institutions. 'From Garage to campus: Exploring the limits of the museum in contemporary Russia', curators Anton Belov and Katya Inozemtseva describe their concept and project to design a space for engaging with contemporary art in Moscow. Rather than an exhibition room, Garage is envisioned as a provisional space for connecting various buildings and activities. The authors foreground curatorial praxis as a mode of design research to consider working beyond, or transversing, the limits of the museum space (or the ubiquitous white cube) and the key role their project plays in the larger re-development and transformation of Gorky Park's surrounding cultural landscape.

In 'Not not research', artist researcher and curator Henk Slager reconsiders the production of artistic research practices in the circulation and curation of

contemporary art in a neo-liberal context – emphasizing the import and meaning making of artistic research practices in the academy. Like Karami (Act One) Slager also draws upon Byung-Chul Han's *The Burnout Society*, in relation to four art projects to propose a 'verticalist' approach to artistic research, and he argues for this work as one of oscillations, relational fields and perhaps how 'thinking with art' might help to resignify the value of artistic research differently. Taking a critical stance towards what he calls a 'disproportional interest in knowledge production' in 'the first decade of the twenty-first century' (219), the author advocates for the importance of artistic thinking as a way to 'redraw attention to not-knowing, the singular, the affective, the transgressive and the unforeseen' (this volume).

The themes of performing contested artistic research methodologies, as well as their potential for producing 'uncommon knowledge' – as put forth by artist-activists such as Pelin Tan and Amhet Ögüt of The Silent University – are central to *LGB's Manifest*, a four-hour performance experiment created by the queer collective LGB Society of Mind (Chan Silei, Kelvin Chew, Shawn Chua, Bani Haykal, Ray Langenbach, Lee Mun Wai, Bjorn Yeo and Zihan Loo). The collective interpolates a fictional Chinese immigrant artist, LGB – Lan Gen Bah, a Southeast Asian cognitive scientist, artist and academic, described by one of the characters in the performance as a 'diasporic vagrant', banned for her artistic and political activities. Using the aesthetics of camp and drag, the experimental performance is designed for audience participation, whereby the participants themselves are put under scientific observation as they are immersed in a series of playful, careful engagements and archival rituals that expose the political stakes and personal risks that come with contesting and performing institutional non-conformity.

Act Six: Performing publics and spatial justice

One that acts as an experimental space in which ideas need not - by necessity, policy, or protocol - be fully formed [...] should offer and enable the public to have agency, or something at stake, in terms of the institution's reciprocal behaviour[.] Understood as both an intellectual practice and a social activity, the resulting institution acts, therefore, as a producer of social and physical form(s) and formats.

(Miessen 2016: 1)

The authors of the texts in our final act stage cities as civic institutions and contested sites with affordances to publicly perform instituent cultural exchanges, to design space for caring acts of citizenship and for rehearsing yet unknown social

relations. In 'Dis-establishment', performance designer Sam Trubridge recounts his experience of instituting *The Performance Arcade*, a site-specific, temporary, and recurring exhibition and performance series taking place on Wellington's waterfront in Aotearoa/New Zealand. A modular arrangement of stacked shipping containers housing the festival's performance and exhibition spaces is its defining characteristic and situates the public within the everyday spatial materiality used to repair, resist, shelter and protect Wellingtonians from the precarity of their built environment, impacted by seismic earthquake activity.

Maiju Loukola, artist–researcher based in Helsinki, presents a case study of the 'Peoples Architecture', a design project initiated by the Taiwanese architect HSIEH Ying-Chun. In the context of Finland's poor handling of asylum seekers and drawing from Jacques Ranciere's ideas on emancipatory politics and equality at work, Loukola provides an analysis of the project and the capacity for co-performed architectural interventions to reorient or temporarily transform experiences of citizenship that facilitate democratic processes.

Themes of the right to the city and overcoming spatial experiences of systemic injustice are further explored in the context of caring for civic public culture and a timely manifesto by social activists Kenneth Bailey and Lori Lobenstine on 'Public-making as a strategy for spatial justice'. Through their Boston-based Design Studio for Social Intervention (DS4SI), the authors approach public-making as a relational performance practice that has the capacity to harness meaningful creative and inclusive civic engagement that mobilizes publics in the 'collective creation and activation of public spaces for interaction and belonging – as a way to organize and take on new forms of sociability' (268).

As this brief overview of chapters suggests, *Performing Institutions* seeks to foreground the multiple and diverse ways that institutional structures, and our engagements within them, resonate across and between various disciplines, practices, academic and cultural spaces, and societal settings. For us, all of the authors' contributions, in divergent ways, conjure meanings and performances associated with care and contestation within institutional settings, structures and sites. Some of the texts in this anthology stage a productive tension between ideas about caring contestations and contestation as a caring engagement in practice, with a view towards institutional transformation. Other contributors investigate the idea of caring contestations as a critical concept that draws attention to questions of power and to the exclusions produced and reproduced in and through specific institutional practices. As such, this collection of writing puts forward *caring contestations* as a critical mode for (re)enacting institutional engagements. This also brings forward questions of agency and how, for those of us who perform within institutional structures, we care to engage and/or contest those institutional engagements.

REFERENCES

Bellacasa, Maria Puig de la (2017), *Matters of Care: Speculative Ethics in More Than Human Worlds*, Minneapolis and London: University of Minnesota Press.

Biesta, Gert (2015), *The Beautiful Risk of Education*, Boulder: Paradigm Publishers.

Campbell, Miranda (2020), '"Shit is hard, yo": Young people making a living in the creative industries', *International Journal of Cultural Policy*, 26:4, pp. 524–43, https://doi.org/10.1080/10286632.2018.1547380. Accessed 22 February 2022.

Gross, Jonathan (2021), 'Practices of hope: Care, narrative and cultural democracy', *International Journal of Cultural Policy*, 27:1, pp. 1–15.

Hann, Rachel (2019), *Beyond Scenography*, London and New York: Routledge.

Hannah, Dorita and Harsløf, Olav (eds) (2008), *Performance Design*, Copenhagen: Museum Tusculanum Press.

Haraway, Donna (2016), *Staying with the Trouble: Making Kin in the Chthulucene*, London: Duke University Press.

Harney, Stefano and Fred, Moten (2013), *The Undercommons: Fugitive Planning and Black Study*, New York: Minor Compositions.

Miessen, Markus (2016), 'Crossbenching as a form of institutional polity', MaHKU script, *Journal of Fine Art Research*, 1:2: pp. 19, http://dx.doi.org/10.5334/mjfar.20. Accessed 22 February 2022.

Moll, Anne Marie (2008), *The Logic of Care: Health and the Problem of Patient Choice*, England: Taylor & Francis.

Mouffe, Chantal (2012), 'Strategies of radical politics and aesthetic resistance', *Truth is Concrete*, 24/7 Marathon Camp on Artistic Strategies in Politics & Political Strategies in Art. Accessed 21 October 2017 [URL no longer available].

Raunig, Gerald (2016), 'Instituent theatre: From Volxtheatre to Teatro Valle Occupato', in E. Van Campenhout and L. Mestre (eds), *Turn, Turtle! Reenacting the Institute*, Berlin: Alexander Verlag, pp. 14–23.

Rogoff, Irit (2010), 'Turning', in Paul O'Neill and Mick Wilson (eds), *Curating and the Educational Turn*, London: Open Editions, pp. 32–46.

Scannell, Paddy (2017), 'The meaning of lived experience', in Reason and Lindelof (eds), *Experiencing Liveness in Contemporary Performance: Interdisciplinary Perspectives*, New York: Routledge, pp. 73–82.

Tan, Pelin (2016), 'The silent university as an instituent practice', in F. Malzacher, A. Ögüt' and P. Tan (eds), *The Silent University: Towards a Transversal Pedagogy*, Berlin: Sternberg Press, pp. 24–33.

Tuck, Eve and Wayne, Yang (2012), 'Decolonization is not a metaphor', *Decolonization: Indigeneity, Education & Society*, 1:1, pp. 1–40.

Van Campenhout, Elke (2016), 'Strange love: How I learned to stop worrying and love the institute', in E. Van Campenhout and L. Mestre (eds), *Turn, Turtle! Reenacting the Institute*, Berlin: Alexander Verlag, pp. 140–50.

ACT ONE

ACT ONE

1

Silver:
Self/Site-Writing *A Courthouse Drama*[1]

Jane Rendell

CHARACTERS

THE AUSTRALIAN MINING MAGNATE: An Irish man of 47, the model of a colonial pioneer, tall, broadly built, strongly knit and fair.

THE AUTHOR: A woman of around 50, with mid-length brown hair and a fringe resting on her glasses. Tense and slightly distracted, she wears a grey polo-neck, a tan skirt and boots, with a vertical frown-line between her eyebrows.

THE BOUNDARY RIDER AND PROSPECTOR: A German man in his 50s, with delicate health.

THE CEO: A Scottish man in his early 50s, dressed in a well-cut dark-grey suit, with a well-ironed pale grey shirt and a dove-grey silk tie. His left hand, with short-cut nails, displays a wedding band.

THE PHILOSOPHER: A French man in his early 50s, bald, dressed in a blue-grey polo-neck, with lightly-tanned skin and heavy-framed glasses. He is confident in front of an audience, relaxed and capable of inspiring respect, but not without his critics.

THE REP RISK ANALYST: A Swiss woman in her late 30s, with an expensive haircut, dressed in a formal Swiss business suit, with low-heeled patent shoes. She carries a leather briefcase, and in it a copy of a *Rep Risk* report.

THE YOUNG MAN FROM BENTO RODRIGUES: A Brazilian man in his early 20s, terrified, escaping from the fast-rising toxic flood-waters of a collapsing tailing dam.

THE YOUNG WOMAN OUTSIDE THE CORPORATE HEADQUARTERS: A Brazilian woman in her early 20s angry, in a black T-shirt, with long curly dark hair pulled back from her face.

POSITIONS

THE AUDIENCE'S TWO BENCHES: Located with THE WITNESS ahead and to the right, THE DEFENDANT'S BOX ahead and to the left, facing the back of THE POLICE PROSECUTATION AND LAWYER'S CHAIR, and beyond THE CLERK OF COURT'S WOODEN CHAIR and THE MAGISTRATE'S BLACK LEATHER SWIVEL CHAIR.

THE CLERK OF COURT'S WOODEN CHAIR: Located on one side of the table in the centre of the Courthouse, with THE DEFENDANT'S BOX to the right, THE WITNESS to the left, facing THE POLICE PROSECUTION AND LAWYER'S CHAIR directly, with THE AUDIENCE'S TWO BENCHES and the door to the Police Office straight ahead, back to THE MAGISTRATE'S BLACK LEATHER SWIVEL CHAIR.

THE DEFENDANT'S BOX: Located with THE AUDIENCE'S TWO BENCHES to the right, THE MAGISTRATE'S BLACK LEATHER SWIVEL CHAIR to the left, facing THE WITNESS directly and, from the side, facing THE CLERK OF COURT'S WOODEN CHAIR and THE POLICE PROSECUTION & LAWYER.

THE MAGISTRATE'S BLACK LEATHER SWIVEL CHAIR: Located behind a wooden bench, at the back of the Courthouse, with THE DEFENDANT'S BOX to the right, THE WITNESS to the left, facing the back of THE CLERK OF COURT'S WOODEN CHAIR, and, directly, THE POLICE PROSECUTION AND LAWYER'S CHAIR, with THE AUDIENCE'S TWO BENCHES and the door to the Police Office straight ahead.

THE POLICE PROSECUTION AND LAWYER'S WOODEN CHAIR: Located on one side of the table in the centre of the Courthouse, with THE WITNESS'S BOX to the right, THE DEFENDANT'S BOX to the left, facing THE CLERK OF COURT'S WOODEN CHAIR directly and THE

MAGISTRATE'S BLACK LEATHER SWIVEL CHAIR straight ahead, back to THE AUDIENCE'S TWO BENCHES.

THE WITNESS'S BOX: Located with THE MAGISTRATE'S BLACK LEATHER SWIVEL CHAIR to the right, THE AUDIENCE'S TWO BENCHES to the left, facing THE DEFENDANT'S BOX directly and THE CLERK OF COURT'S WOODEN CHAIR and THE POLICE PROSECUTION AND LAWYER'S CHAIR from the side.

SCENE 1: '"Pegging Out" Wilyu-wilyu-yong'

SETTING: Wilyu-wilyu-yong and the Peaks of the Barrier, Broken Hill, Australia, September 1883.

AT RISE: All characters are seated on THE AUDIENCE'S TWO BENCHES.

(THE AUTHOR *standing up and announcing*)

THE AUTHOR: Scene 1, '"Pegging Out" Wilyu-wilyu-yong', the Peaks of the Barrier, Broken Hill, September 1883.

(THE AUTHOR *walks to sit on* THE CLERK OF COURT'S WOODEN CHAIR, *and, standing up, says*)

THE AUTHOR: A BOUNDARY RIDER & PROSPECTOR is at the Mount Gipps station, mustering sheep near Broken Hill, on the peaks of the Barrier. The southern portion of the hill, which runs north-east and south-west for one to two miles, presents the appearance of a very jagged razor, so fine seems the edge and so peculiar the indications. *(sits)*

(THE BOUNDARY RIDER & PROSPECTOR *rises and walks to stand at the* DEFENDANT'S BOX, *facing* THE AUDIENCE'S TWO BENCHES, *says*)

THE BOUNDARY RIDER & PROSPECTOR: I have discussed with Mr George McCulloch, the manager and part owner of the station, the promising look of the hill for prospecting, and it has been decided to peg it out in the possibility of discovering a tin lode. 'Wilyu-wilyu-yong', the Aboriginal name for Broken Hill, has been applied for in the names of Messrs. George McCulloch, G. A. Lind and George Urquhart. Seven blocks, or a total of two miles, secured along the line of the lode.

(THE AUTHOR *stands*)

THE AUTHOR: Now is the time of silver and the opportunity of the Barrier. It has passed into a proverb amongst dealers that every stock has its turn. Today there will be a run on this, and to-morrow on that scrip. How it is, nobody knows. 'It is the fashion'. *(sits)*

(BLACKOUT)

(END OF SCENE)

THE AUTHOR and THE BOUNDARY RIDER & PROSPECTOR return to sit down on THE AUDIENCE'S TWO BENCHES.

SCENE 2: 'The "Shows" and the "Deal"'

SETTING: A Hotel in Northumberland Avenue, London, Saturday, 26 August 1899.

AT RISE: All characters are seated on THE AUDIENCE'S TWO BENCHES.

(THE AUTHOR *stands up and announces*)

THE AUTHOR: Scene 2, 'The "Shows" and the "Deal"', A Hotel in Northumberland Avenue, London, Saturday, 26 August 1899.

(THE AUTHOR *walks to sit on* THE CLERK OF COURT'S WOODEN CHAIR, *and, standing up, says*)

THE AUTHOR: THE AUSTRALIAN MINING MAGNATE is being interviewed for the *Freeman's Journal*, A Hotel in Northumberland Avenue, London, on Saturday, 26 August 1899. *(sits)*

(THE AUSTRALIAN MINING MAGNATE *rises and walks to stand at the* DEFENDANT'S BOX, *facing* THE AUDIENCE'S TWO BENCHES, *says*)

THE AUSTRALIAN MINING MAGNATE: My good fortune came about in this way. In 1889 very encouraging reports came from the Zeehan

district of Tasmania of the discovery of high grade galena carrying very rich silver. A friend of mine, Mr William Orr, induced me to visit the north-west coast, and we became interested together in various prospecting 'shows' in the locality, which has since been the scene of so much speculation. We subsequently visited it twice a year until about the middle of 1891, when we were offered an interest in what was then known as the Mount Lyell Gold Mining Company, for it is a strange fact that what was to become one of the greatest copper mines in the world has been worked as a gold proposition by a company registered locally and managed from Launceston. Mr Orr and I decided to look carefully into the business; and in September 1891, we thoroughly inspected the property, and had samples of the various classes of ore, which had been exposed taken. These samples we submitted to Mr Schlapp, the eminent metallurgist, who was then officially connected with the Broken Hill Proprietary Company, who at once perceived their value and encouraged us to go on with the 'deal', in which, as a matter of fact, he participated. To make a long story short, Mr Orr, Mr Schlapp and I purchased the interest under offer to us on our own terms.

(BLACKOUT)

(END OF SCENE 2)

THE AUTHOR and THE AUSTRALIAN MINING MAGNATE return to sit on THE AUDIENCE'S TWO BENCHES

SCENE 3: 'At her Desk'

SETTING: An Academic's Office, A London University, July 2013.

AT RISE: All characters are seated on THE AUDIENCE'S TWO BENCHES.

(THE AUTHOR *stands up and announces*)

THE AUTHOR: Scene 3, 'The Author at her Desk', an Academic's Office, a London University, July 2013.

(THE AUTHOR *walks to sit on* THE CLERK OF COURT's *chair; remaining seated and looking down, she whispers anxiously*)

THE AUTHOR: Before dawn, almost every night, I am jolted awake, surprised and disorientated for a second or two; and then I remember, and the panic rears up through me. Will fighting this battle, pitting myself against my institution, lose me my job? Will the right governance structures and due diligence procedures really protect the independence of academic research? Will engaging with businesses really change them? I still don't grasp the logic that, on the one hand, when the funding is at arm's length, the giver of the gift, in this case a mining company, should not influence the activities of the receiver of the gift or be influenced by the activities that the receiver conducts with the funds given, but that, on the other hand, the receiver of the gift, in this case my university, wishes to influence the activities of the giver.

(THE REP RISK ANALYST *walks across to* THE POLICE PROSECUTION's chair. *She sits down, briskly snaps open her briefcase, takes from it a copy of this script, containing quotes from a Rep Risk report, and, after clearing her throat for effect, starts reading it aloud*)

THE REP RISK ANALYST: The report, *Point of No Return*, published by Greenpeace with research from the environmental consultancy Ecofys, has expressed serious concerns about a boost in mining, oil and gas extraction by major multinational companies, including Adaro Energy, BHP Billiton, Gazprom, Peabody Energy, Vale and others.

(THE CEO *makes his way in firm swinging strides to* THE DEFENDANT'S BOX, *and speaks confidently and with feeling*)

THE CEO: We accept the Intergovernmental Panel on Climate Change's (IPCC) assessment of climate change science, which has found that climate warming is unequivocal, the human influence is clear and the physical impacts are unavoidable.

(THE REP RISK ANALYST *stands up to continue*)

THE REP RISK ANALYST: The report claims that the projected activities of these companies could lead to a 20 per cent increase in CO_2 levels, as well as an increase of five to six degrees in global temperature by 2020.

(THE CEO *confidently and with purpose*)

THE CEO: We believe that the world must pursue the twin objectives of limiting climate change to the lower end of the IPCC emission scenarios in line with current international agreements; while providing access to the affordable energy required to continue the economic growth essential for maintaining living standards and alleviating poverty. Under all current plausible scenarios, fossil fuels will continue to be a significant part of the energy mix for decades. There needs to be an acceleration of effort to drive energy efficiency, develop and deploy low emissions technology and adapt to the impacts of climate change. There should be a price on carbon, implemented in a way that addresses competitiveness concerns and achieves lowest cost emissions reductions.

(THE AUTHOR *looks up, facing* THE REP RISK ANALYST)

THE AUTHOR: When the fear that woke my stomach reached my head, I found myself wide-awake in a still-dark bedroom. I realized that, when the morning came, I would have to outline the research I had conducted for the risk register. I'd been asked to 'own' the risk of research expansion, whatever that means *(a slight chuckle)*. I have decided to focus on my university's position as a global research leader and remind my colleagues that our academic reputation is based on independence and integrity.

(*facing* THE AUDIENCE'S TWO BENCHES)

I am going to suggest that one of the risks associated with research expansion comes from accepting financial gifts from corporations, particularly where there are disparities between the practices of those corporations and our institution's values published as its core principles and procedures.

(*gaining confidence now*)

If we follow the Brundtland Report of 1987, which states that sustainable development must be 'development that meets the needs of the present without compromising the ability of future generations to meet their own needs', then fossil fuel mining is unsustainable on two grounds: first, fossil fuels are a finite resource, and second, as the published climate science evidence demonstrates the limit of the ecosystem to absorb CO_2 has already been dangerously surpassed.

(*leaning forward to emphasize her question*)

How then can a university accept funding from the charitable arm of one of the world's largest mining corporations to set up an Institute of Sustainable Resources?

(THE CEO *acting as if he has not heard either* THE AUTHOR *or* THE REP RISK ANALYST)

THE CEO: We will continue to take action to reduce our emissions. Build the resilience of our operations, investments, communities and ecosystems to the impacts of climate change. Recognize our role as policymakers, seek to enhance the global response by engaging with governments. Work in partnership with resource sector peers to improve sectoral performance and increase industry's influence in policy development to deliver effective long-term regulatory responses. And through material investments in low emissions technology, contribute to reducing emissions from the use of fossil fuels.

(followed by a deep breath)

(THE REP RISK ANALYST *taking advantage of the pause to intervene*)

THE REP RISK ANALYST: The report also argues that the environmental impacts of such changes could lead to impacts on food supplies and a series of social upheavals. Areas of particular concern include coal mining in northwestern USA, Indonesia, China and Australia's Gunnedah, Surat and Galilee basins; tar sand exploration and oil pipelines by Enbridge and others in Canada; Arctic drilling by Gazprom and others in Russia; and deep-sea drilling off the Brazilian coast by Petrobras, BP, Shell, Total and Statoil.

(THE AUTHOR *stands up and walks past* THE CEO, *towards* THE AUDIENCE'S TWO BENCHES, *to address them more directly, speaks rather loudly and with authority now*)

THE AUTHOR: In the autumn of 1983, Foucault gave six lectures at the University of California, Berkeley, exploring the practice of *parrhesia* in the Greek culture of the fourth and fifth centuries BC. He examined the evolution of the term with respect to rhetorics, politics and philosophy, investigating the link between *parrhesia* and the concepts of frankness, truth, danger, criticism and duty.

(THE PHILOSOPHER *slowly rises and walks across the Courthouse, and up the steps behind* THE MAGISTRATE'S BLACK LEATHER SWIVEL CHAIR, *and, standing, addresses the Courthouse*)

THE PHILOSOPHER: *Parrhesia* is a kind of verbal activity where the speaker has a specific relation to truth through frankness, a certain relationship to his own life through danger, a certain type of relation to himself or other people through criticism (self-criticism or criticism of other people), and a specific relation to moral law through freedom and duty. More precisely, with *parrhesia* a speaker expresses his personal relationship to truth and risks his life because he recognizes truth-telling as a duty to improve or help other people (as well as himself).

(BLACKOUT)

(END OF SCENE)

THE AUTHOR, THE REP RISK ANALYST, THE CEO and THE PHILOSOPHER return to sit on THE AUDIENCE'S TWO BENCHES.

SCENE 4: 'Between a Rock and a Hard Place'

SETTING: The Mining Memorial, Broken Hill, November 2015.

AT RISE: All characters are seated on THE AUDIENCE'S TWO BENCHES.

(THE AUTHOR *stands up and announces*)

THE AUTHOR: Scene 4, 'Between a Rock and a Hard Place', The Mining Memorial, Broken Hill, November 2015.

(THE AUTHOR *walks towards* THE CLERK OF COURT'S WOODEN CHAIR, *and, as she does so, she circles and turns, looks at the ground and mutters to herself*)

THE AUTHOR: And so here she is – finally – her left cheek still hot from the setting sun, squinting to match the hulks of the abandoned mining machinery to the healing tears in the ground, to the lines of the urban grid stretching away into the horizon – Oxide, Chloride, Sulphide, Bromide... She is trying to find the exact spot where it was born. Coming into its orbit has

meant drawing a different line, one that has involved a certain refusal and a decision not to comply. The heat, the rough ground underfoot, the scuttle of tails and the shimmering dust: they all remind her of something way back.

(THE AUTHOR *continues towards* THE CLERK OF COURT'S WOODEN CHAIR *at the table, pauses and looks up, still talking to herself*)

THE AUTHOR: When she finally gets there, the sun is low in the sky, so low that the rays are almost horizontal.

(*she pauses again*)

I can still feel them now and remember the transforming effect this kind of light, this kind of reflections, could have on me. This is a road of a kind, a surface of hot dry rocks that takes a sharp turn at the bend, in its rise away from one side of the town and towards the other. It is hard to be sure if it was here or there – how does one choose between one rock and another? What can the profile of a rock or a glimmer in the dust tell me of how it all began, and, more importantly, why do I feel the need to look back for the beginnings? Why judge the efforts of these men – according to those men – back then?

(THE AUTHOR *finally reaches* THE CLERK OF COURT'S WOODEN CHAIR *and sits down. She stares into the space in front of her. Her eyes look from left to right as if she is reading a line of words right in front of her, words that no one else can see*)

THE AUTHOR: Before me, I can see the names of hundreds of dead miners, carefully etched into the thick glass, garlanded with white roses. I can see my own eyes in the reflection, layered over the words: 'Vaughn, Master John, 29.07.1886. 14. B.H.P. Mine. Fell Down Ore Heap'.

(THE PHILOSOPHER *rises and walks across the Courthouse as he approaches* THE AUTHOR, *pauses at her side, and gently taps her on the shoulder. She rises.*)

(THE AUTHOR *facing* THE AUDIENCE'S TWO BENCHES *directly*)

THE AUTHOR: According to Foucault, the 'signature mark' of the critical attitude and its particular virtue is governance: 'how not to be governed *like that*, by that, in the name of those principles, with such and such an

objective in mind and by means of such procedures, not like that, not for that, not by them'.

(THE PHILOSOPHER *continues to walk to the steps leading up to* THE MAGISTRATE'S BLACK LEATHER SWIVEL CHAIR. *He climbs them slowly and lowers himself into the black leather chair, faces the Courthouse, and nods.*)

THE PHILOSOPHER: Just so. Just so.

(*and then very gravely*)

I would therefore propose as a very first definition of critique, this general characterization: the art of not being governed quite so much.

(BLACKOUT)

(END OF SCENE)

THE AUTHOR and THE PHILOSOPHER return to sit on THE AUDIENCE'S TWO BENCHES.

SCENE 5: 'The Countryside Laid Waste'

SETTING: Bento Rodrigues, Brazil, November 2015.

AT RISE: All characters are seated on THE AUDIENCE'S TWO BENCHES.

(THE AUTHOR *stands up and announces*)

THE AUTHOR: Scene 5, 'The Countryside Laid Waste', Bento Rodrigues, Brazil, November 2015. Surrounded by three or four trees, whose bright green foliage stands out, is a rectangular one-storey dwelling, positioned centrally, but at a diagonal, with a square window (glass missing) in each of the two visible facades. It is covered in a red-brown thick and glossy liquid that spreads out around the house as far as the eye can see. Two cars – one grey, one white – seem to float in it. Another building, located behind, has its roof missing. It has collapsed inwards, bringing down a wall. One of the cars appears to be stranded at the corner of an adjacent, also roof-less, building.

(*sits down again among* THE AUDIENCE'S TWO BENCHES)

(THE YOUNG MAN FROM BENTO RODRIGUES *stands up and walks across the Courthouse to take up position in* THE WITNESS'S BOX. *At the same time,* THE CEO *stands up and walks across the Courthouse to take up position in the* DEFENDANT'S BOX.)

THE YOUNG MAN FROM BENTO RODRIGUES: (*shouting*) Come back Tiago!

THE CEO: (*calmly lifting his left hand to display a wedding band; he holds his hand across his chest so that it rests just above his liver*) I travelled to the region last week, and what I witnessed on site and around the community was truly heart-breaking.

THE YOUNG MAN FROM BENTO RODRIGUES: (*shouting*) The dam is breakin' down, man!

THE CEO: (*calmly*) We are deeply sorry to everyone who has and will suffer from this terrible tragedy.

THE YOUNG MAN FROM BENTO RODRIGUES: (*shouting*) Go, Tiago, go faster!

THE CEO: (*calmly*) We want this fund to assist the affected families and communities as quickly as possible.

THE YOUNG MAN FROM BENTO RODRIGUES: (*shouting*) Look at the truck ...

THE CEO: (*calmly*) We are determined to bring together all of the necessary skill, experience and expertise this ongoing effort will require, and we will learn the lessons to improve all our operations.

THE YOUNG MAN FROM BENTO RODRIGUES: (*shouting*) Go back, go back, go back, go back!

THE CEO: (*calmly*) I would also like to thank people here in Australia and in the UK for their messages of support. My family and I are enormously grateful.

THE YOUNG MAN FROM BENTO RODRIGUES: (*shouting*) Oh man, turn back the truck, and let's get away from here!

THE CEO: (*calmly*) Thank you from the bottom of my heart.

THE YOUNG MAN FROM BENTO RODRIGUES: (*shouting*) Come back André! Let's get out of here!

THE CEO: (*calmly*) At every stage, we will continue to be guided by our Charter Values. Our Charter enshrines the values of Sustainability, Integrity, Respect, Performance, Simplicity and Accountability. It defines who we are and what we stand for as an organization.

THE YOUNG MAN FROM BENTO RODRIGUES: (*shouting*) It killed the guys, man!

THE CEO: (*calmly*) Our first Charter Value of Sustainability is our commitment to Health and Safety. So the tragedy in Brazil goes to the very heart of who we are as a company.

THE YOUNG MAN FROM BENTO RODRIGUES: (*screaming now*) It killed everyone, man! Holy Mother…

(BLACKOUT)

(END OF SCENE)

THE CEO and THE YOUNG MAN FROM BENTO RODRIGUES return to sit on THE AUDIENCE'S TWO BENCHES.

SCENE 6: 'The Entrance to the Corporate Headquarters'

SETTING: Brazil, November 2015.

AT RISE: All characters are seated on THE AUDIENCE'S TWO BENCHES.

(THE AUTHOR *stands up and announces*)

THE AUTHOR: Scene 6, 'The Entrance to the Corporate Headquarters', Brazil, November 2015. A marble-clad column is located at the front of

the corporate headquarters. A woman in a black T-shirt steps forward, her black curly hair pulled back from her face. She raises one arm, her hand covered in mud and starts smearing it across the marble, working it back and forth across the shiny surface. Then she lifts up a plastic tub and throws the remainder hard so that it splatters right across the company's logo and letters, raised in profile.

(*sits down again among* THE AUDIENCE'S TWO BENCHES)

(THE YOUNG WOMAN OUTSIDE THE CORPORATE HEADQUARTERS *stands up and walks across the Courthouse to take up position in* THE WITNESS'S BOX. *At the same time,* THE REP RISK ANALYST *stands up and walks across the Courthouse to take up position in* THE POLICE PROSECUTION & LAWYER's CHAIR.)

THE YOUNG WOMAN OUTSIDE THE CORPORATE HEADQUARTERS: (*chanting*) No! It was no accident! No!

THE REP RISK ANALYST: (*reading from the script on the desk in front of her*) Brazilian police have requested for the arrest of Samarco's chief executive and six others after having been charged with homicide linked to the collapse of the miner's dam in November 2015. They have also been accused of endangering public health after the collapse of the dam [Note of RepRisk Analyst: refers to the Fundao Tailings dam, which is part of the Germano mine], which spewed mining waste and polluted drinking water. Reports claim that the incident, which was considered by the government to be Brazil's worst environmental disaster, led to the death of seventeen people, buried communities and displaced a total of 725 people. The incident has also resulted in several legal cases including a USD 5.1 billion lawsuit by Brazil's attorney general, state and federal prosecutor lawsuits demanding compensation to damages, as well as plea to freeze BRL 500 million of Samarco's assets to guarantee town repairs. Samarco is a joint venture between Vale and BHP Billiton.

THE YOUNG WOMAN OUTSIDE THE CORPORATE HEADQUARTERS: (*chanting*) No! It was no accident! No!

THE REP RISK ANALYST: (*continuing to read from the script on the desk in front of her*) A court in the Brazilian state of Minas Gerais has ordered the freezing of BRL 500 million owned by Samarco, Vale and BHP Billiton for the environmental damage caused by the collapse of the Fundao dam in

Mariana, Brazil. The order follows a request from the State Public Ministry. The funds will be used to compensate for damaged or destroyed infrastructure, buildings, sewage systems and water supply systems for schools, public spaces and football fields. The mining companies have been asked to carry out containment works on the Carmo river, in order to avoid landslides, and to guarantee the stability of the river banks. The judge also ordered the companies to establish evacuation and alert plans, in the case of further disasters. The companies have also been asked to provide a six-month recovery plan within the next 30 days, and risk facing daily fines of BRL 500,000 if they do not submit the plan on time.

THE YOUNG WOMAN OUTSIDE THE CORPORATE HEADQUARTERS: (*chanting*) No! It was no accident! No!

(BLACKOUT)

(END OF SCENE)

THE REP RISK ANALYST and THE YOUNG WOMAN OUTSIDE THE CORPORATE HEADQUARTERS return to sit on THE AUDIENCE'S TWO BENCHES.

SCENE 7: 'Ethics Sub-Contracted'

SETTING: The Provost's Dining Room, A London University, March 2016.

AT RISE: All characters are seated on THE AUDIENCE'S TWO BENCHES.

(THE AUTHOR *stands up and announces*)

THE AUTHOR: Scene 7, 'Ethics Sub-contracted', The Provost's Dining Room, A London University, March 2016. Tucked away at the top of a strange dog-legged staircase, the Provost's Dining Room is just large enough to hold a table for an intimate dinner for six. She has to call the Security Guard to find it.

(THE AUTHOR *walks to sit in* THE CLERK OF COURT's *chair.* THE PHILOSOPHER *slowly rises and walks across the Courthouse, and up the steps behind* THE MAGISTRATE'S BLACK LEATHER SWIVEL CHAIR, *and, standing, addresses the Courthouse.*)

THE PHILOSOPHER: Here, giving an account of your life, your bios, is also not to give a narrative of the historical events that have taken place in your life...

THE AUTHOR: (*seated, with her back to* THE MAGISTRATE'S BLACK LEATHER SWIVEL CHAIR) I had to call a security guard to find the room. It was empty of the committee when I arrived. But the secretary was already there pouring coffee and adding finishing touches to the paper work.

THE PHILOSOPHER: (*continuing*) ...but rather to demonstrate whether you are able to show that there is a relation between the rational discourse, the logos you are able to use and the way that you live.

THE AUTHOR: (*rising now, but still with her back to* THE MAGISTRATE'S BLACK LEATHER SWIVEL CHAIR) In the future, it seems as if it has been decided that it will no longer be necessary for academics to be involved in making decisions that concern ethical investments. Instead, the work is to be sub-contracted.

THE PHILOSOPHER: (*continuing*) Socrates is inquiring into the way that logos gives form to a person's style of life...

THE AUTHOR: (*turning to face* THE MAGISTRATE'S BLACK LEATHER SWIVEL CHAIR) It strikes me that this is a convenient way to avoid the potential and actual offense to investors that might be caused by divesting from specific fossil fuel companies.

All characters sitting among THE AUDIENCE: (*eyebrows raised, with quizzical expressions*) And what of you, who chose, and still chooses, to fly?

THE PHILOSOPHER: (*frowning a little at the unexpected interruption, and then continuing*) For he (*and then adding, with a dazzling smile*) or, of course, she (*and concluding*) is interested in discovering whether there is a harmonic relation between the two.

(BLACKOUT)

(END OF SCENE)

THE AUTHOR and THE PHILOSOPHER return to sit on THE AUDIENCE'S TWO BENCHES.

(THE END)

*

Silver: A Courthouse Drama reconfigures the sites of a journey that began on 11 June 2011, when unbeknownst to me, a handshake occurred between Malcolm Grant, Provost of UCL and Andrew McKenzie, CEO of BHP Billiton. The handshake sealed the deal for UCL's decision to accept $10 million of funding from the Anglo-Australian multinational mining and petroleum company, BHP Billiton, to create an International Energy Policy Institute in Adelaide, and the Institute for Sustainable Resources in London at the Bartlett Faculty of the Built Environment. I was Vice Dean of Research for the Bartlett at the time, and not consulted on the decision, which I disagreed with; and I stood down from my institutional role as a result.

Developing my own critical spatial practice of site-writing (see Rendell 2010), in relation to Michael Foucault's work on *parrhesia*, and 'self writing' (see Foucault 1983) as an ethopoietic practice, I decided to make my own acts of questioning the corporate funding of university research part of my own writing, both personal and institutional. So in November 2015 when I was invited to be 'thinker in residence' for a month at the Tasmanian College of the Arts in Hobart, I combined my visit to Australia (and all the air miles this entailed) with research visits to a number of sites connected to BHP Billiton, including Broken Hill, the 'birth place' of BHP Billiton, a town in the Barrier Ranges of south Australia which started with the discovery of a mineral lode rich in silver, hence its other name – Silver City.

It was while I was in Tasmania, that I met artists Justy Phillips and Margaret Woodward, who were just embarking on a new initiative called *The Published Event*, in which they explore the spatial, temporal and aesthetic processes of publishing. They invited me to join a specific project called Lost Rocks, which had started life due to a 'find' in a second-hand junk shop – a board of Tasmanian rocks of which 40 of the 56 had been lost. Over the next five-year period, Justy and Mags invited 40 artists and writers to respond to a chosen lost rock, in the form of what Justy calls a 'fictionella' – a version of a novella, not made *up* like a fiction, but made *with*, lived experience (see Various 2017–21).

My own fictionella, *Silver*, starts with the story presented in Silver City's Albert Kersten Mining and Minerals Museum (Geocentre) explaining how the rock formation specific to the aboriginal land of Wilyu-wilyu-yong came into being, according to indigenous myth, and on which the finds of Broken Hill were pegged

out: 'At each stop, the blood that dripped from the Marupi's (Bronzewing Pigeon) wounds soaked into the ground, forming the unusual geological landforms we see today' (Rendell 2015).

As with many of my site-writings, which aim to reproduce the spatial form of the subject they investigate, *Silver* is composed around the structure of the metallic element itself, whose atomic number is 47, with its 47 electrons arranged on five shells. *Silver* corresponds with its 47 electrons arranged on five 8 shells: 2, 8, 18, 18, 1. Silver corresponds with a five-part structure: Star-Crossed Beginnings (twice); The Silver Age (in eight takes); A Two-Sided Tale (eighteen times); (eighteen scenes) In Silver City; *Une Crise de Foie* (just the once) (see Rendell 2016a).

The first four fictionellas were launched in March 2017 at a curated event called *Sites of Love and Neglect*, located in a number of sites, including the Zeehan West Coast Heritage Centre, as part of a larger arts festival called *10 Days on the Island*. Zeehan is an old mining town, in the west of Tasmania, founded on silver, by a mining magnate also involved in the establishment of Broken Hill and BHP. For *Silver: A Courthouse Drama*, I extracted texts from my fictionella and reconfigured them into a script that was performed in the Courthouse of the West Coast Heritage Centre, where in the past legal proceedings related to Zeehan took place.

The Courthouse museum has five clearly labelled positions – Witness, Clerk of Court, Police Prosecutor and Lawyer, Defendant, Magistrate and benches where the Audience sits – and my script contained a list of characters, instructions for action and words to be spoken, at these specific institutional positions. *Silver: A Courthouse Drama* deals with ethical and governance issues that arise when fossil fuel companies fund university research on sustainability and relates these issues to a set of specific sites and moments in time, in particular, to the environmental disaster that occurred in Brazil on the 5 November 2015 (Pearson and Smyth 2016)[2].

Several days later while making my way to Broken Hill from Tasmania, I purchased a copy of the *Australian Financial Review*. On the front page was a photograph of Andrew McKenzie, BHP Billiton's CEO, holding his hand over his heart. On seeing the image a colleague noticed that McKenzie's hand was resting on the right-hand side of his torso, covering not his heart, but his liver, the organ in the body that processes toxicity. Refiguring words from the *Silver* book, as a script to be performed in speech in the courthouse, reconnected sites in Brazil, Colombia, London, Broken Hill and Tasmania, but also repositioned spaces related to the institute of the university, a site of learning, to those of the courthouse, a site of justice. This practice of figuration[3] was both ethical and poetic and allowed me to reflect on the differing ways in which the toxicity of the financial transaction had entered my life, and how I might reprocess it through social but also self-critique.

> [...] ethical deliberation is bound up with the operation of critique. And critique finds that it cannot go forward without a consideration of how the deliberating subject comes into being and how a deliberating subject might actually live or appropriate a set of norms. Not only does ethics find itself embroiled in the task of social theory, but social theory, if it is to yield nonviolent results, must find a place for this 'I'.
>
> (Butler 2005: 8)

In *Giving an Account of Oneself*, Judith Butler argues that 'the "I" has no story of its own that is not also the story of a relation – or set of relations – to a set of norms' (2005: 8). She goes on to note that: 'If the "I" is not at one with moral norms', this means that 'the subject must deliberate upon these norms' and that part of such a deliberation will 'entail a critical understanding' of the social genesis and meaning of those norms (Butler 2005: PP). In her close analysis of Foucault's 1978 lecture 'What is critique' from *The Politics of Truth*, she notes how 'critique is always a critique of some instituted practice, discourse, episteme, institution and it loses its character the moment in which it is abstracted from its operation and made to stand alone as a purely generalizable practice' (Butler 2002: 212). Butler talks of how, for Foucault, '"critique" is precisely a practice that not only suspends judgment for him, but offers a new practice of values based on that very suspension' (2002: 212). Pointing to the way in which the practice of critique emerges from 'the tear in the fabric of our epistemological web', Butler outlines that, for Foucault, 'this exposure of the limit of the epistemological field is linked with the practice of virtue, as if virtue is counter to regulation and order, as if virtue itself is to be found in the risking of established order' (2002: 215). For Butler, according to Foucault, the signature mark of 'the critical attitude' and its particular virtue is governance, and she quotes 'how not to be governed *like that*, by that, in the name of those principles, with such and such an objective in mind and by means of such procedures, not like that, not for that, not by them' (2002: 218). 'I would therefore propose', says Foucault, 'as a very first definition of critique, this general characterization: the art of not being governed quite so much' ([1997] 2007: 45).

Understanding that ethics could be considered a practice of critique and that such a practice held a close relation to governance was of great relevance to me, having inadvertently entered into processes that questioned the position and role of ethics in institutional governance structures as a result of my critique of UCL's acceptance of BHP Billiton's charitable donation. In particular, I became fascinated by the work Foucault was doing at the end of his life, in his specific lectures on *parrhesia* in 1982 and 1983, and at the College de France from 1981 to 1984, and how the thinking he developed around practices of the self could be related to his own speech activities.[4]

I initially came across the concept of parrhesia as I was composing a public talk on my response to the BHP Billiton funding, and on my decision to stand down from my role as Vice Dean of Research, as a result. I had drafted a lecture to be delivered under Chatham House rules, which moved back and forth between extracts from diary accounts and more theoretical reflections, and Foucault's writing pushed me to consider much more carefully how I could balance aspects of bios and logos in the practice of parrhesia, but also to think about and reflect on how actions of self and social critique were related. It was through my reading of Foucault that I found the writings of cultural critic, Gerald Raunig, on 'instituent critique', in which he refers closely to Foucault's lectures on *parrhesia* and draws out the possibilities of what he calls 'a double strategy': 'what is needed here and now, is *parrhesia* as a double strategy: as an attempt of involvement and engagement in a process of hazardous refutation, and as self-questioning' (Raunig 2006: n.pag.).

> Recomposing social criticism and institutional criticism means merging political and personal *parrhesia*. It is only by linking the two *parrhesia* techniques that a one-sided instrumentalization can be avoided, that the institutional machine is saved from closing itself off, that the flow between movement and institution can be maintained.
> (Raunig 2004: n.pag.)

The double strategy that Raunig describes involves the performance of both political *and* personal *parrhesia* to achieve institutional and social critique and requires continuously balancing actions of involvement and distancing. He writes:

> What is needed, therefore, are practices that conduct radical social criticism, yet which do not fancy themselves in an imagined distance to institutions; at the same time practices that are self-critical and yet do not cling to their own involvement, their complicity, their imprisoned existence in the art field, their fixation on institutions, and the institution, their own-being institution.
> (Raunig 2006: n.pag.)

It is clear that Foucault understands ethics as an active experience, intellectual and practical, related, according to Paul Rabinow, to how 'who one is [...] emerges acutely out of the problems with which one struggles' ([1997] 2007: xi–xlii, xix). Foucault distinguishes between the rule of conduct, the conduct measured by the rule and 'the manner in which one ought to "conduct oneself" – that is, the manner in which one ought to form oneself as an ethical subject acting in reference to the prescriptive elements that make up the code' ([1997] 2007: 26).

These are concerned with what he calls the '*determination of the ethical substance*; that is, the way in which the individual has to constitute this or that part of himself as the prime material of his moral conduct' and 'the *mode of subjection* (mode d'assujettissement); that is, with the way in which the individual establishes his relation to the rule and recognizes himself as obliged to put it into practice'(Foucault [1985] 1990: 26, original emphasis).

It is important to distinguish subjectivation from subjection in Foucault's work. Frédéric Gros, for example, argues that

> [t]he history of the subject, from the perspective of the practices of the self and the procedures of subjectivation, is completely separate from the project, formulated in the 1970s, of the history of the production of subjectivities, of the procedures of subjection by the machines of power.
>
> (Gros 2005: 697–708, 698)

Clive Barnett also argues that in Foucault's later work, subjectivity is not subjection, but rather a mode of subjectivation; he writes, 'Foucault formally articulated the notion of problematization as the object of a programme of research on practices through which people willfully take aspects of their own selves to be the material of ethical concern' (2015: n.pag.). Barnett discusses how in *The Use of Pleasure*, the second volume of *The History of Sexuality*, Foucault outlined a framework for analyzing the 'history of ethical problematizations based on practices of the self' (2015: 16).[5]

It has been argued by scholars, such as Gros, that Foucault's central intervention in *The Hermeneutics of the Subject* (his College de France lectures from 1982) is to shift focus from 'care of the self' (*epimeleia heautou*) to self-knowledge (*gnothi seauton*; 'know thyself') (2005: 698). And Edward McGushin describes how, when in the introduction to *The Use of Pleasure*, Foucault analyzes subjectivity and subjectivization within a framework he calls 'care of the self', he juxtaposes care of the self with confessional and hermeneutic modes of self-examination more concerned with self-knowledge (2011: 139). These techniques and practices of self-care are examined in extraordinary detail in Foucault's late work, and as Matthew Sharpe outlines, the schema Foucault uses to analyze the 'different ethical modes of *rapport a soi*' consists of four aspects:

> Each historical form of ethical self-relationship is analysed as to its 'substance' ('the material that is going to be worked over by ethics'); a mode of subjectivation ('the way in which people are invited or incited to recognize their moral obligations'); the means by which ethical self-transformation is undertaken, and the telos that orients the entire rapport.
>
> (2005: 106)

Sharpe discusses the textual practices involved in the ethical process of self-formation, or *askesis*, and draws our attention to how Foucault considers 'meditation' to be a form of 'self-writing' or 'written techniques through which individuals in Stoicism and Christianity monitored and transformed his *rapport a soi* (relationship to her/himself)' (2005: 100). In examining Foucault's genealogy of ethics from the Stoics to the Greeks, Sharpe notes how Foucault pays close scrutiny to the ways in which the truth that subjects have to relate to in Stoic *askesis* comes from the outside, from the logos of teachers. Sharpe explores how the '"ethico-poetic" ways in which this external truth is made personal or "subjectivised"', for the Stoics, defined a particular mode of *techne* (or know how) (see Flyvbjerg 2001)[6] that related specific forms of written, bodily and meditative practices (Sharpe 2005: 105).

I've found it interesting to consider the aspects of techne I've engaged with here, with respect to the processes of *parrhesia* used in *Silver*, in relation to what Foucault has to say about the ethical and poetic aspects of writing practices from the Stoic period. For example, in his 'Self writing' essay from 1983, he writes:

> No technique, no professional skill can be acquired without exercise; nor can the art of living, the *technê tou biou*, be learned without *askesis* that should be understood as a training of the self by oneself. This was one of the traditional principles to which the Pythagoreans, the Socratics, the Cynics had long attached a great importance. It seems that, among all the forms taken by this training (which included abstinences, memorizations, self-examinations, meditations, silence and listening to others), writing – the act of writing for oneself and for others – came, rather late, to play a considerable role.
>
> (Foucault 1983: n.pag.)

And he explains in great detail how the Stoics understood the relation between the practices of writing and thinking:

> [...] writing is associated with the exercise of thought in two different ways. One takes the form of a linear 'series': it goes from meditation to the activity of writing and from there to *gumnazein*, that is, to training and trial in a real situation – a labor of thought, a labor through writing, a labor in reality. The other is circular: the meditation precedes the notes which enable the rereading which in turn reinitiates the meditation. In any case, whatever the cycle of exercise in which it takes place, writing constitutes an essential stage in the process to which the whole *askesis* leads: namely, the fashioning of accepted discourses, recognized as true, into rational principles of action. As an element of self-training, writing has, to use an expression that

one finds in Plutarch, an *ethopoietic* function: it is an agent of the transformation of truth into *ethos*.

(Foucault 1983: n.pag.)

In *Giving an Account of Oneself*, Butler stresses how intrinsically linked processes of self-making and subjectivation are in the formation of the ethical subject. On the one hand, she writes: 'There is [...] no forming of the ethical subject without "modes of subjectivation" and an "ascetics" or "practices of the self" that support them' (Foucault 1985: 28 cited in Butler 2005: 21), and on the other, that: 'There is no making of oneself (*poiesis*) outside of a mode of subjectivation (*assujettisement*)' (2005: 21).

As Butler stresses, these processes take place through dyadic encounters with others, and in *Giving an Account of Oneself*, she faults Foucault for 'not making more room explicitly for the other in his consideration of ethics' (2005: 26). Yet we do find mention of the other in Foucault, for example, he stresses the role of the other person as 'indispensable for telling the truth about oneself', even though this other person may 'appear[s] with a number of different aspects and profiles – medical, political and pedagogical – which mean that it is not always easy to grasp exactly what his role is' (1984: 6). And in his discussion of Stoic writing practices, he distinguishes between *hupomnemata* and the *correspondence* as two modes of writing which figure different kinds of reading and writing, in relation to the ways in which they address not only the self but also the other:

> To write is thus to 'show oneself', to project oneself into view, to make one's own face appear in the other's presence. And by this it should be understood that the letter [*correspondence*] is both a gaze that one focuses on the addressee (through the missive he receives, he feels looked at) and a way of offering oneself to his gaze by what one tells him about oneself.
>
> [...] The work the letter carries out on the recipient, but is also brought to bear on the writer by the very letter he sends, thus involves an 'introspection'; but the latter is to be understood not so much as a decipherment of the self by the self as an opening one gives the other onto oneself.

(Foucault 1983: n.pag.)

The close attention Foucault pays to the relation of self and other in the practice of *parrhesia* has been vital for me in understanding the need to balance these aspects, as well as self and social, in the performance of instituent critique. The tension between these elements – self and other, on the one hand, and individual

and social, on the other – has been shaped here by moving context from the institutional structure of the university to that of the courthouse. In the act of refiguring a set of texts – consisting of philosophical essays, media reports and transcriptions of the terrified and angry speech of those escaping the toxic mud of the dam bursts and protesting outside corporate offices – I have worked poetically, as well as ethically, with the literary and performative genre of the diary, as a more private *hupomnemata* mode, and the theatre script, as a more public address in the *correspondence* mode.

It was in response to the invitation of another – to write a fictionella for *Lost Rocks* – that brought *Silver: A Courthouse Drama* to life through self and site-writing. Over the past five years, I have collaborated with a diverse range of people – including academics, activists, artists and practitioners – to host events and encourage debates on university governance and fossil fuels (UCL n.d.), while other colleagues have commissioned and published essays of mine on the topic (see Rendell 2016b; Rendell 2018; Rendell 2019a). I have worked with the student activist group Fossil Free, and many other colleagues at UCL to try – via debates and votes at UCL's Academic Board – to encourage our university to divest from fossil fuel (UCL 2015; UCL 2014); something that finally happened on 16 October 2019, after years of activist pressure (UCL 2019). With Diana Salazar, and her colleagues from The Colombian Solidarity Campaign and London Mining Network, we convened *Speech ExtrActions*, where some of those directly affected by activities related to mines co-owned by BHP Billiton, were – as part of a visit to BHP Billiton's AGM – invited to UCL to discuss their experiences (UCL 2016). So although *Silver*, as a self or site-writing, operates as a kind of autopoiesis or self-making, it could also be described as produced through what Donna Haraway calls sympoiesis, a collaborative form of etho-poiesis – a 'making-with'.[7]

Notes for Silver: A Courthouse Drama

This script has been composed using found sources to create speech for a number of invented characters, given in CAPS, extracted from the following references:

The Barrier Silver Field and Tin Fields, in 1888: Being a Series of Letters Written by a Special Correspondent of 'The South Australian Register', 'Adelaide Observer' and 'Evening Journal', and Reprinted from Those Papers (Adelaide: W. K. Thomas & Co., 1888).
[See the words of THE BOUNDARY RIDER AND PROSPECTOR]
 'Mr Bowes Kelly: An australian mining king: His big interest in Broken Hill and Mount Lyell', *Freeman's Journal*, Sydney (Saturday, 26 August 1899): 24.

[See the words of THE AUSTRALIAN MINING MAGNATE]
 'Point of no return: The massive climate threats we must avoid', *Greenpeace International*, 22 January 2013, http://www.greenpeace.org/international/en/publications/Campaign-reports/Climate-Reports/Point-of-No-Return/?accept=6ea9feed3a8bff7ea151e35224a360f4. Accessed 16 February 2017.
[See the words of THE REP RISK ANALYST]

Michel Foucault, *Discourse and Truth: The Problematization of Parrhesia*, Six lectures given by Foucault at the University of California in Berkeley from October to November 1983, https://foucault.info/parrhesia/ Accessed 9 March 2022.
[See the words of THE PHILOSOPHER]
 Michel Foucault, 'What is critique?', in *The Politics of Truth* (New York: Semiotext(e), 2007), 41–82.
[See the words of THE PHILOSOPHER]
 Rep Risk Company Report, *BHP Billiton PLC* (also listed as *BHP Billiton Ltd*), Tuesday, 28 May 2013.
[See the words of THE REP RISK ANALYST]
 Rep Risk Company Report, *BHP Billiton Group* (*BHP Billiton*), Thursday, 21 April 2016.
[See the words of THE REP RISK ANALYST]
 Speech by BHP Billiton's CEO Andrew McKenzie, at The Annual General Meeting of BHP Billiton Limited, 10:00 a.m. (Perth time), Thursday, 19 November 2015 at the Perth Convention and Exhibition Centre, Perth, Western Australia, https://www.youtube.com/watch?v=JxFq1w2X7VE. Accessed 16 February 2017.
[See the words of THE CEO]
 Matthew Stevens, 'BHP Billiton's Andrew Mackenzie weeps as dam disaster toll mounts', *Financial Review*, 20 November 2015, http://www.afr.com/business/mining/bhp-billitons-andrew-mackenzie-weeps-as-dam-disaster-toll-mounts-20151119-gl32sm#ixzz4BYRxZ1PM. Accessed 16 February 2017.
[See the words of THE CEO]
 Marcelo Bicharo, *The Valley of the Dead River* (2016), https://www.youtube.com/watch?v=mAPn5zVN56Q. Accessed 16 February 2017.
[See the words of THE YOUNG MAN FROM BENTO RODRIGUES and THE YOUNG WOMAN OUTSIDE THE CORPORATE HEADQUARTERS]
 Jane Rendell, 'Giving an account of oneself, architecturally', *Architecture!* edited by Jae Emerling and Ronna Gardner, Special Issue of the *Journal of Visual Culture* v15:3 (2016b), pp. 3 34–48.
[See the words of THE AUTHOR]

NOTES

1. *Silver: A Courthouse Drama* was first staged 4–6 p.m., Saturday 18 March 2017, as one element of CROCOITE. CROCOITE. SILVER. SILVER/LEAD, West Coast Heritage Centre, Zeehan, curated by Justy Phillips and Margaret Woodward, for *Sites of Love and Neglect*, curated by Jane Deeth. See also Rendell 2019b.
2. Taken from the RepRisk Company Report, *BHP Billiton Group (BHP Billiton)*, Thursday, 21 April 2016.
3. The process of figuration has been described in feminist terms by Donna Haraway and Rosi Braidotti. See, for example, Haraway 1997: 11; Haraway (2000) 2004: 338; Braidotti 1994: 4; Braidotti 2006: 90. Figuration also features in the philosophical work of Gilles Deleuze, Jean Francois Lyotard and Paul Riceour, and in the psychoanalytic theory and practice of César Botella and Såra Botella. For an overview, see Rendell 2017.
4. This thinking took the form of Foucault's lectures at the College de France from 'Truth and Subjectivity' (1981), 'The Hermeneutics of the Subject' (1982), 'The Government of the Self' (1983), to 'The Courage of Truth' (1984). In this same time period, Foucault also spoke on his study of self-care in ancient Greece and Rome at the universities of Toronto (May–June 1982) – 'Care of the Self'; Vermont (Autumn 1982) – 'Technologies of the Self'; and Berkeley (12 April 1983) – 'Culture of the Self'. He focused specifically on the topic of *parrhesia* at the universities of Grenoble (18 May 1982) and Berkeley (10 October–30 November 1983) – 'Discourse and Truth'. It is fascinating that the work on *parrhesia*, itself an oral practice, only exists in the form of transcripts of Foucault's spoken words. In this chapter, I refer to Michel Foucault, *Discourse and Truth: the Problematization of Parrhesia*. Transcripts of the Grenoble lecture were published in *Anabases* (16) 2012, and the California lectures by Semio(texte) in 2002 by Joseph Pearson as *Fearless Speech*. A more recent publication combines the two: Michael Foucault (2019), *Discourse & Truth and Parrhesia*, edited by Henri-Paul Fruchaud and Daniele Lorenzini, Chicago and London: University of Chicago Press. The thinking from the lectures at the College de France also strongly informs the three volumes of the *History of Sexuality*, but in particular 'Morality and practices of the self', the third part of the introduction to *Use of Pleasure*, Vol. 2. See Foucault (1985) 1990. See also Michael Foucault, ([2007] 2011).
5. Barnett examines two strands of work concerning problemmatization in social theory, one in which problematization is an object of study, where the 'process by which modes of living or modes of self-care become problems', and the other in which problematization is located in the mode of interpretation itself, 'in which the task of analysis is primarily to call into question taken-for granted assumptions and identities and settlements' (2015: 16). For Barnett, in the work of Foucault problematization exists as both noun and verb, in the ethical framing of the theme of problematization, and in how problems relate to the practical conduct of people's lives. He notes that '[t]he most interesting thing about Foucault's thinking about problems is his particular understanding of the situational emergence of problems and of their manifestation in "thought,"' (2015: 14); and 'how experience and

thought, understood as functions of practices of reflection, are historically variable, and in turn how thought in this sense is occasioned by uncertain situations' (2015: 15).
6. In comparing Aristotle's definition of ethics as the relationship you have to society and politics when you act, to Foucault's definition 'as the relationship you have to *yourself* when you act', B. Flyvbjerg draws out a definition of ethics as episteme (know why), techne (know how), and phronesis (practical ethics) (2001: 55–57).
7. In Donna Haraway's most recent book, *Staying with the Trouble*, where she reconceptualizes the Anthropocene as the Chthulucene, an epoch in which the human and nonhuman are inextricably linked, she makes a strong claim for what she calls sympoiesis or making-with to replace processes of autopoiesis or self-making (see Haraway 2016: 61). Haraway credits the introduction of the term sympoiesis to M. Beth Dempster.

REFERENCES

Barnett, Clive (2015), 'On problematization: Elaborations on a theme in "Late Foucault"', nonsite.org, 16, https://nonsite.org/on-problematization/. Accessed 9 March 2022.

Braidotti, Rosi (1994), *Nomadic Subjects: Embodiment and Sexual Difference in Contemporary Feminist Theory*, New York: Colombia University Press.

Braidotti, Rosi (2006), *Transpositions: On Nomadic Ethics*, Cambridge: Polity Press.

Butler, Judith (2002), 'What is critique? An essay on Foucault's virtue', in David Ingram (ed.), *The Political: Readings in Continental Philosophy*, London: Basil Blackwell, pp. 212–26.

Butler, Judith (2005), *Giving An Account of Oneself*, New York: Fordham University Press.

Flyvbjerg, B. (2001), *Making Social Science Matter*, Cambridge: Cambridge University Press.

Foucault, Michel (1983), 'Self writing', *Corps écrit*, 5 (February), pp. 3–23, https://foucault.info/documents/foucault.hypomnemata.en/. Accessed 1 November 2021.

Foucault, Michel ([1985] 1990), *The History of Sexuality, Vol. 2, The Use of Pleasure* (trans. Robert Hurley), New York: Vintage Books.

Foucault, Michel ([1997] 2007), 'What is critique?' (trans. Lysa Hochroth and Catherine Porter), in *The Politics of Truth*, Los Angeles: Semiotext(e).

Foucault, Michel (1999), *Discourse and Truth: The Problematization of Parrhesia*, J. Pearson (ed.), Six lectures given by Michel Foucault at the University of California in Berkeley, October–November 1983, https://foucault.info/parrhesia/. Accessed 1 November 2021.

Foucault, Michel ([2007] 2011), *The Courage of Truth, Lectures at the College de France, 1983–4* (ed. Frédéric Gros; trans. Graham Burchell), 1 February 1984, 1 Hour, London: Palgrave Macmillan.

Gros, Frédéric (2005), 'Le souci de soi chez Michel Foucault: A review of The hermeneutics of the subject: Lectures at the Collège de France, 1981–1982', *Philosophy and Social Criticism*, 31:5&6, pp. 697–708.

Haraway, Donna (1997), 'Syntactics: The grammar of feminism and technoscience', in *Modest-_Witness@Second_Millenium. FemaleMan_Meets_OncoMouse: Feminism and Technoscience*, London: Routledge, pp. 1–22.

Haraway, Donna (2000 [2004]), 'Cyborgs, coyotes and dogs: A kinship of feminist figurations and there are always more things going on than you thought! Methodologies as thinking technologies: An interview with Donna Haraway conducted in two parts by Nina Lykke, Randi Markussen, and Finn Olesen', in D. Haraway (ed.), *The Donna Haraway Reader*, London: Routledge, pp. 321–42.

Haraway, Donna (2016), *Staying with the Trouble: Making Kin in the Chthulucene*, Durham and London: Duke University Press.

McGushin, Edward (2011), 'Foucault's theory and practice of subjectivity', in Dianna Taylor (ed.), *Foucault: Key Concepts*, London: Routledge, pp. 131–46.

Pearson, Samantha and Smyth, Jamie (2016), 'Samarco chief charged with homicide by Brazilian police', *Financial Times*, 24 February, https://next.ft.com/content/502c4af2-da89-11e5-9ba8-3abc1e7247e4. Accessed 1 November 2021.

Rabinow, Paul (1997), 'Introduction: The history of systems of thought', in Paul Rabinow (ed.), *Michel Foucault, Ethics: Subjectivity and Truth* (trans. Robert Hurley et al.), *The Essential Works of Michel Foucault 1954–1984*, vol. 1, London: Allen Lane and The Penguin Press, pp. xi–xlii.

Raunig, Gerald (2004), 'The double criticism of parrhesia: Answering the question "what is a progressive (art) institution?"' (trans. Aileen Derieg), April, http://eipcp.net/transversal/0106/raunig/en. Accessed 1 November 2021.

Raunig, Gerald (2006), 'Instituent practices: Fleeing, instituting, transforming' (trans. Aileen Derieg), January, http://eipcp.net/transversal/0106/raunig/en. Accessed 1 November 2021.

Rendell, Jane (2010), *Site-Writing: The Architecture of Psychoanalysis*, London: I. B. Tauris.

Rendell, Jane (2015), exhibition panel, Geocentre, Albert Kersten Mining & Minerals Museum, Broken Hill, Australia, November.

Rendell, Jane (2016a), *Silver*, Hobart: n.p.

Rendell, Jane (2016b), 'Giving an account of oneself, architecturally', Special Issue, *Journal of Visual Culture*, 10:3 (June), pp. 255–64.

Rendell, Jane (2017), 'Figurations', *The Architecture of Psychoanalysis*, London: I. B. Tauris.

Rendell, Jane (2018), 'Configuring critique', in C. Brisbin and M. Thiessen (eds.), *The Routledge Companion to Criticality in Art, Architecture, and Design*, London: Routledge.

Rendell, Jane (2019a), 'Activating home and work', in Sandra Loschke (ed.), *Rethinking Architectural Production: Between Experience, Action and Critique*, London: Routledge.

Rendell, Jane (2019b), *Silver: A Courthouse Drama*, in G. Heindl, M. Klein and C. Linortner (eds), *Building Critique*, Leipzig: Spector Books.

Sharpe, Matthew (2005), '"Critique" as technology of the self', *Foucault Studies*, 2, pp. 97–116.

UCL (n.d.), 'Ethics in the built enviorment', https://www.ucl.ac.uk/bartlett/about-us/our-values/ethics-built-environment. Accessed 1 November 2021.

UCL (2014), 'Rich seams or dark pools? Fossil fuel funding and research', 16 January, https://www.ucl.ac.uk/urban-lab/events/2014/jan/rich-seams-or-dark-pools-fossil-fuel-funding-and-research. Accessed 1 November 2021.

UCL (2015), 'Debate: This house would divest from fossil fuels', 24 March, https://www.ucl.ac.uk/bartlett/events/2015/mar/debate-house-would-divest-fossil-fuels. Accessed 1 November 2021.

UCL (2016), 'Speech extractions witness, testimony, evidence in response to the mining industry', 21 October, https://www.ucl.ac.uk/bartlett/development/events/2016/oct/speech-extractions-witness-testimony-evidence-response-mining-industry. Accessed 1 November 2021.

UCL (2019), 'UCL divests from fossil fuels as it launches bold new sustainability strategy', 16 October, https://www.ucl.ac.uk/news/2019/oct/ucl-divests-fossil-fuels-it-launches-bold-new-sustainability-strategy. Accessed 1 November 2021.

Various (2017–21), *Lost Rocks*, https://www.lostrocks.net/. Accessed 1 November 2021.

2

Act 01: Love. On Political Love vs. Institutional Loyalty

Sepideh Karami

Love requires something active. It is not just about having regard to or taking notice of someone.

(Harris 2016: n.pag.)

Prologue: To thole

The ambiguity and disruptive force of love, combined with the fragility and vulnerability it lends to the elements involved in the act of love, is what makes it a powerful but difficult concept to work with and to think through. The landscape of love is immense, broad and growing, de-territorializing the world through which it grows and questioning the borders, boundaries and categories it encounters. The vanishing edges of this landscape expand beyond sight, beyond the reaches of perception, into a darkness that requires other ways of relating to one's surroundings. It's why defining love and categorizing it in various forms of romantic – Platonian, etc. – destroys it and threatens to lay waste to its radicality, its disruptive and revolutionary potential. To define love is to try to regulate something unregulatable and to pollute it with control.

To grasp love, however, one must inhabit it, act it and take the risk of facing its pain of falling. Its complexity, and being lost in the impossibility of understanding it, should be preserved and cherished by avoiding attempts to define what it is, and instead listening to it, enjoying it, probing about in its darkness, *'tholing'*

its unknowingness, sniffing its pungency and thereby constructing a universe out of the agglomeration of all these fragments, out of the feeling of being lost (@RobGMacfarlane 2018, emphasis added). Whatever this complex agglomeration of incompatible things is, one thing is clear: when one is there, off the edge, leaning slightly over the threshold, nothing is the same; one's experience of life, and of the world, becomes different from the moment of falling in love. That moment and the inhabitation of what follows as the duration of being in love can be expanded to various arenas of life. In this text, this understanding of love and its ambiguity is situated in the context of institution. The disruptive force of love is investigated through two characters: the *lover* and the *loyal*. These two characters represent the amateur and the professional. I insist on putting loyalty and love at odds with one another in this text, to arrive at a slippery, unstable and ambiguous ground where love could work as a political and dissenting force instead of conforming to the existing power relations; where it could construct other ways of acting within institutions and dealing with issues such as disciplines and professionalism. As is apparent in its etymology,[1] the *amateur*, as a lover in the professional world, examines love as a critical force that challenges that world. To replace loyalty with love then is to valorize criticality over conformism. It is to 'de-professionalize' the professional world (Merrifield 2017: xv).

To write through love, one needs to find a language that keeps its complexity intact without simplifying it. This is what this text is trying to achieve: it aims to expand and dwell in the moments when love is experienced as a force that moves one out of habit. To avoid limiting the concept of love and as an experiment of constructing a transversal ground of love, where love can be exposed and grasped momentarily, I have applied forms of experimental writing that evolve through things, acts, and places that come in between discussions of amateurism and professionalism. In each of these parts, the effort is to put love and loyalty into an encounter and *let love perform*. These acts, things and places also challenge and problematize the established understanding of love and try to find potential in what is condemned in love, to arrive at a *political concept of love*.

Things: A kite and a flag

A connection is like a kite in the wind, unmoored, high up in the sky. No matter how high or far, it's there, drifting in the heavens. No matter how free or wild, it is here, generated from inside in the warmth of a thought, in a hint of a clasp, in a sigh, as subtle as the sound of a hair moving on a shoulder.

In contrast, control is the sound of punching poetry over sheets of paper; categorization, filing, naming, drawing lines between categories of love. While the kite

flies freely in the sky, control is like a flag, the flag of a nation fantasising about territory, ownership, borders, dancing in the backyard of a nationalist's holiday house or a state institution. A flag is the opposite of a kite. Its strong foot is firmly on the ground, marking ownership. It's the *symbol* of control. Control doesn't recognize the drifting of the kite across the borders, flowing between things of love.

The kite is the thing of love. It is turbulent, taken, lost, torn down, broken, yet free to move aloft, even if broken, even if detached. A lost kite lands on a mountain, or in the ocean. It ultimately becomes a fragment of an immense landscape.

The flag is stable. It enjoys a safe dance, protected by a pole. The flag pretends freedom, wildness, but the dance is staged, applauded by its supporters. Control grows over clamour, over being a hero, over fame, a name, a celebrity. Control is the institutions that construct those heroes, names, celebrities, grading, inside and outside, prizes, best and worst. It defines the idea of success.

The kite is dreaming of a forbidden love. It disappears from sight. In silence, or in the roar of a tornado. The thread disappears into infinity. It dreams of holding on to the kite, stretched, taut, intense. The thread is just a reminder of a kite that passes out of sight. It lets it go.

Love vs. loyalty

In the labyrinthine corridors of the modern institutions, the lover and the loyal probe about, to find their ways and to find a ground to act on. They oscillate between following the institutional instructions and transforming them. They give meaning to these institutions by inhabiting them, either by reconstructing them critically through the force of love or by conforming to their established structure by remaining loyal to it. While the lovers construct their ground of action through critical engagement[2] and contributing to the project of change, the loyals hold onto a given ground and conform to the structures that make the very identity of those specific institutions. The lover as the constructor and composer expands this ground beyond the unpermeable walls of institutions to encounter and include the other, 'the stranger', 'the farthest' and 'the alterity' (Hardt and Nagri 2009: 183). The lover uses the radical force of love to move towards the other(s), as a way of engaging with institutions i.e. reinventing them. To love radically is to reinvent life, and by living that life, to reinvent the world, where this life is being lived. As Rosanna Warren writes: 'As Rimbaud sought to reinvent love, he reinvented writing – and violently' (2008: n.pag.).

To reconnect with the 'radicality of love' is to cherish its complexity, to endure its pain of falling and to inhabit its risk of unknowingness (Horvat 2016). It is to encounter it as a 'fatal and unexpected crack in the world' and to make a decision

as to how to pass through that crack (Horvat 2016: 4). Despite what institutional forms of love – defined and regulated by terms such as institution of marriage and nationalism – do to simplify its complexity, to ease its creative hardship, to normalise and regulate it, to tame it through stabilisation, by praising the loyal character, the *political concept of love* is an *unfinished* work, a continuous construction. For the lover acting in an institution, love is a political act. A political concept of love turns it into something that cannot be regulated or controlled by institutional systems of morality, regulations or instructions, because it is what makes a crack in those systems; it problematizes them. These cracks do not destruct the institutions, but reinvent them by letting the light of the unknowingness pass through the walls of establishment. As an ontological concept and a revolutionary force, love questions conventions, criticizes the establishment and constructs new relations.

In contrast to love, loyalty – a concept required by institutions – is to guarantee the stability of their terms and conditions, and to form ethics that constantly feed and protect that stability. The loyal character, favoured by such institutional ethics, is a conservative that indisputably follows the fixed values of institutions and as a reward, avoids the risk of exile, dismissal and failure. While the loyal stands in the centre, on a safe ground, protected by the institution as a reward to his/her loyalty, the lover stands on the edge, leaning towards an abyss, and embraces the risk of falling, in search of the unknown. As Ronald J. Pelias writes in his *A Methodology of the Heart: Evoking Academic and Daily Life*, '[t]he heart pushes the self forward to places it does not belong' (Pelias 2004: 8). For the lover, those places are extension of home far to the *exile*.

Silence

Drifting to the places 'it doesn't belong to', the kite passes out of sight. The thread, still confused, still touched by a connection, is just a reminder of the kite. The connection, though, remains there, grows over silence. The silence exhales and inhales like a breathing bridge. Exhales push the invisible kite even further. Inhales imagine it close by. In the silence, something has lain dormant. What was dormant hears, listens, sniffs, grows, spreads, melts. What was dormant dreams of a cell:

> A white cell. I am all in white. I have a visitor. Eventually, I have a visitor. The warder slides the bars open. I step into the loo before leaving myself in the arms of the visitor. I urinate. The urine splashes yellow dots on my white garment. The white garment smells of urine. The warder slides open the second bars. The visitor drapes arms around my shoulders. The hairs slide over the visitor's arms with a deafening sound. I smell of urine.

The thread is looking for where it was connected, its gaze flapping in every single breath of the wind.

Moving from caring to the act of love

The event of love is accompanied by the *act of falling*; a break from the stability of the ground on which one stands, the risk of letting go of a closed subject, a fixed identity, and of becoming a subject that is unfinished, broken and under construction. To understand love as a force of rupture, as what cuts through the isolated closed worlds, is to reconnect to its radicality as a revolutionary force. It is the radicality of love that makes it different from *habits of care*. Although caring is part of the act of love, distinguishing between them, helps me to arrive at the revolutionary force of love.[3] Understanding love as the act of falling prevents love from becoming a habit and keeps it as an event. As Srećko Horvat says in his *Radicality of Love*, '[t]he worst thing that can happen to love is habit' (2016: 4). Because when it becomes a habit, it concedes to the sameness, repetition and stops reinventing. The understanding of love as habit eradicates its critical potential in subjectivation of the lover as an unfinished subject. As an event, falling in love is singular and specific to that encounter between the lover and *the other*, and its revolutionary potential lays in the intensity of that unique moment. Its specificity and singularity, together with its force of rupture and its criticality as it transforms the lover into a new subject, is what makes love political.

The political act of love though leaves the lover in a vulnerable position, exposed to risk of falling, dismissal and exile. It is the very act of engaging with institutions that leaves the lover in this vulnerable situation. While the Loyals are protected by the institution, what happens to the lovers? Are they supported by any institution or are they left in a state of unrequited love? Could there be institutions run by the force of love or is the very meaning of institutions destructive to the force of love? Or is it characteristic of the lover to be always at odds with institutions? Where is the politics of care for the character of lover in today's society and its institutions?

In his *The Burnout Society*, Byung-Chul Han writes that the twenty-first-century society is no longer Foucault's disciplinary society, but rather an 'achievement society' (Han 2015: 8). The inhabitants of such society are 'achievement-subjects', producing a 'we' that is obsessed with unlimited 'can' and 'should'. Institutions of the achievement societies are themselves set up on such ethics, by creating measuring systems of success and achievements. Moving towards the unknown places, that carries along the risk of failure, is a method through which the lover resists the measuring systems of success and questions the taxonomy of achievement.

ACT 01: LOVE. ON POLITICAL LOVE VS. INSTITUTIONAL LOYALTY

To achieve, for the lover, is not anymore institutional promotions, rewards and getting higher points in the measuring system of success. The lover, instead, brings in a critical way of engaging with institutions, hence questioning its established structure. The 'pressure to achieve' in achievement society, on the one hand, causes 'exhaustive depression' in those who cannot fit into such system of measurement, and, on the other hand, pushes out those who voluntarily question and challenge such system by not following its instructions and not fitting into it (Han 2015: 10).

In Adam Haslett's novel, *Imagine Me Gone*, Michael, the eldest son of a family, could be read as an exemplary character in such a society. In his novel, Haslett portrays the passage of the members of a family through pain and grief. Oscillating between the joy of life and the burden it imposes on them, they try to rescue each other, but constantly fail. The impossibility of communicating such pain of living brings two suicides to the family: that of John, the father, and the other of the son, Michael. The two depression sufferers commit suicide in the inability to bear the tension between the beauty of the world and the pain of not being able to inhabit that beauty and make sense of it. Michael, a fragile character 'who makes sense of the world through parody', is stuck in various healthcare institutions (The Publisher 2017: n.pag.). From his late teenage years, he goes into voluntary exile, distancing himself from various institutions such as family and university. Radically in love with something that he cannot identify, he constantly looks for justice in an unjust world and struggles to construct other ways of connecting with people and society.

Michael is a radical lover whose object of affection doesn't exist, but the fragments of that object are omnipresent in a landscape of things, in the immensity of the universe, and, hence, it is so difficult for a pioneer of radical love to find one's route. Yet Michael's changing body and his frequent failures carve moments of realized love in this world. Constantly stuck in unrequited love and as a consequence suffering from anxiety and depression, he is being tamed by the medical treatments of psychological and mental health institutions. The medicine transforms him from a boy bursting with life to a slow and heavy man, highly dependent on his bag of medicine; he can't even go out for a stroll without the bag of medicine, convinced that is the only thing that can support him. Yet caring for the world and in love with a world of justice, along with the medicines, he carries antiracist bulletins to distribute among people. Hospitalized every now and then, he tries to use the very structure of those institutions to express himself, to communicate his pain, care and concern. He uses the hospital information sheets and questionnaires to express his life events through his affection for music, arts, literature, politics and philosophical contemplation. Confused and without the tools to survive in this world, he is only supported by the members of his family, who themselves lack proper resources and tools to take care of him, and who fail to rescue him.

When achievement-subjects in the achievement society claim: 'Nothing is Impossible', Michael ends up in an extreme situation of 'Nothing is Possible' that leads to his suicide (Han 2015: 11). The question raised by encountering individuals like him is whether our modern institutions are designed to care for such characters or if they are designed to turn them into achievement-subjects? Do they only care for the norms of achievement that are loyal to the institutional and exclude those driven by the force of love? In her 'Matters of care in technoscience', Maria Puig de la Bellacasa writes that 'calls for care are everywhere' these days, 'from the marketing of 'green' products to discussions of moral philosophy on the 'ethics of care' (2011: 85). She discusses care in contrast with 'concern' and suggests that care 'has stronger affective and ethical connotations' (de la Bellacasa 2011: 85). She points to a difference between 'I am concerned' and 'I care', where the latter 'adds a strong sense of attachment and commitment to something' and the former 'denotes worry and thoughtfulness about an issue as well as the fact of belonging to those "affected" by it' (de la Bellacasa 2011: 89–90). Accentuating 'care' as a verb 'to act', she writes: 'One can make oneself concerned, but "to care" more strongly directs us to a notion of material doing' (de la Bellacasa 2011: 90).

The characters of lover and amateurs take one step further and transform the verb of caring to the act of love. Love has disruptive and revolutionary connotations; that the very act of 'material doing' exposes the lover to the risk of dismissal. Yet the existence of such strong characters who put criticality before conformism in institutions raises the question, which characters can contribute better in reconstructing institutions and adapting them to the changing complex world? How should the institutional ethics and values be rethought in order for the characters of lover be respected and cherished instead of excluding them or turning them to achievement-subjects?

In praise of unrequited love

Unrequited love is a vast landscape, an endless horizon, disappearing and reappearing in the recurrent ascendance and descendance of a thick fog. Seeing one's road partially at the time makes the air tangible. It's a force of being dragged along that landscape, across the fog, prone to falling into an infinite abyss.

Requited love spins in a room. It is a room without a door.

Unrequited love is the revolutionary force of hopelessness. Positioning one on the edge. It trembles, it enjoys instability, vulnerability. Unrequited love is a hand sweeping along the walls of an endless ally. Fingers sore. It's a bodily perception, radical understanding of the materiality of the world, all the gaps, pores, cracks of the wall remains with the body, with the finger's tips.

Requited love is a ring. A circular movement of the middle finger along the narrow rim of an empty wine glass: Repetition. Rhythm. Agreement.

Unrequited love moves one from self to the outside, it places the lover in front of fragments of a broken mirror, reflecting light from diverse parts of the universe. The image of love, hence, changes while the hung pieces of mirror drift in the wind.

Unrequited love is infinite. It never becomes requited. It remains always unrequited.

In praise of the amateur: The radical lover

In one of her poems, the Chinese migrant worker poet Wu Xia translates her 'brutalizing experience of modernity', her fourteen hours of factory work, 'into poetry. Through this poem she talks to the 'beneficiaries of her labour' (Walsh 2017: n.pag.), writing:

> I want to press the straps flat
> so they won't dig into your shoulders when you wear it
> and then press up from the waist
> a lovely waist
> where someone can lay a fine hand
> and on the tree-shaded lane
> caress a quiet kind of love
> last I'll smooth the dress out
> to iron the pleats to equal widths
> so you can sit by a lake or on a grassy lawn
> and wait for a breeze
> like a flower.
>
> (Xia 2016: 165)

The poem, which is written in a benevolent tone, also points to the insensitivity as well as the complicity of the world with the workers' inhumane situation in China. Wu Xia is one of many migrant worker poets, who, as Megan Walsh writes, 'sublimate 14-hour shifts on assembly lines into lines of poetry' (Walsh 2017: n.pag.). These workers – who spend more than half of their lifetimes inside factories, mines or other harsh working environments, are deprived of many human rights and receive meagre wages – use their exploited work conditions to produce something else that not only has the potential to make their voices heard but also gives them power over their lives and deprivation, through poetry. As simple workers who engage in a highly cultural activity such as poetry, they also question the division

between cultured and non-cultured – a social division common in Chinese society – and bring forth a serious position of the amateur as a poet into the dry noise and homogenising structure of a factory (Walsh 2017). As a mixture of a brutal system and the fragility of the language of poetry, their poetry is an 'amalgam of extremes', in Eleanor Goodman's words (Walsh 2017: n.pag.). By publishing their poems online via their phones in between shifts, they stage themselves as amateur poets, interrupting the flow of the assembly line. Their amateurism derives from a lost hope for a better life, yet a love for poetry that makes them stand against a brutal capitalist economy. While their poetry might not effectuate an immediate change, it exposes the fragility of being a human in an extremely vicious environment and the paradoxical power of that fragility. Their poetry is a stutter that interrupts the repetitive flow of capitalist production and cuts the long hours of harsh labour.

The example of Chinese worker poets exposes the importance of the amateur as a serious and political occupation, undertaken not as a hobby or a pastime, but as what could cut through violent working conditions. The concept of love in the construction of the amateur has its significance in two terms: in one, as a revolutionary force and a force of rupture, and in another, as relating to the responsibility and taking the risk of stepping out of where one feels at home into 'exile' and inhabiting that exile. The former is the event of falling in love, and the latter is the inhabitation of love. To inhabit love is to continue to construct the subject of lover and the space of encounter with the other. One is an event, and the other is the construction of the ground achieved from that event. It is a process of breaking down and constructing anew. In the construction of the amateur character, falling in love is as important as reconstructing the moment of falling again and again and again, and thereby constructing a performing ground for amateurism.

The act of falling in the formation of the amateur is the moment at which one steps out of the routine of work, or when one stands up 'to speak to power', as Edward Said puts it (Said 1996: 85). It is a moment when the safe ground of everyday habit is suddenly shaken, and, from then on, every step is accompanied with taking risk. The character of the amateur who steps out of that comfort zone suddenly lets go of her power position, as a professional and as an expert, and falls into becoming a beginner, encountering an *other* world. The event of falling in love cuts the lover's internal and isolated world open to the outside. When this closed world is cut open, she starts inhabiting the space between herself and the other. It is in this space that the one in love reconstructs herself through the act of love. She takes the risk of *encountering* the other and constructs the space of the encounter by moving toward the other. She thereby becomes an amateur maker of the new, strange, ungraspable worlds that were once unimaginable, impossible,

or the most distant and invisible. While constructing the new world, she *becomes* anew; she becomes a new subject.

Michael Hardt and Antonio Negri situate their discussion of love in the 'common' to problematize the image of love advocated by the contemporary ideology of neoliberal capitalism, in isolated, commercial and institutional forms limited to closed and exclusive circles of family, couples and embracing *the* similar. They write:

> In fact what passes for love today in ordinary discourse and popular culture is predominantly its corrupt forms. The primary locus of this corruption is the shift in love from the common to the same, that is from the production of the common to a repetition of the same or a process of unification. What distinguishes the beneficial forms of love instead is the constant interplay between the common and singularities.
>
> (Hardt and Nagri 2009: 182)

In the world of the professionals, there are loyal characters who follow instructions, who speak the language of experts, who are rewarded for staying loyal to the institution, to the profession, to confirm its power relations. The conditions of loyalty are predefined; loyalty comes before the subject. As a predefined and closed condition, loyalty is based on a compulsory commitment. Furthermore, as loyalty depends on certain subjectivities and roles, it works towards the formation of fixed identities, subjects and its consequent exclusive institutions, such as profession, family, race and nation, that seek out similarity and sameness instead of reaching for *the other*; 'corrupt forms' of love as Hardt and Negri put it (Hadrt and Nagri 2009: 182). The amateur, however, is an unfinished subject; in this sense, a disloyal character who takes the risk of letting go off her professional closed and finished subject. Yet she remains in the world of professionals and performs on their chatty stage. After falling from the power position of being a professional, she utters her role in a stuttering language on that stage. Her stutter echoes in the neat professional world. It interrupts the polished language of experts. She stutters like a lover.

Love for the amateur is labour; it is 'work', as Rainer Maria Rilke puts it (Rilke 2004: 41). However, it is not limited to a profession, but formed through apprenticeship, learned by practicing, by making, by experimentation that is accompanied by the risk of failure, the joy of discovery and the invention without mandate. For Edward Said, amateurism is 'an activity that is fuelled by care and affection rather than by profit and selfish, narrow specialization' (Said 1996: 83). In his discussion of amateur and professional, Said appoints the intellectual the responsibility of becoming an amateur. This intellectual amateur could 'transform the merely

professional routine most of us go through into something much more lively and radical' (Said 1996: 83).

Professional work originates from institutions of control, training and regulations, and is based on a body of theoretical knowledge (Beegan and Atkinson 2008: 307). Amateur is a challenge of professional, and common alternative formulations are unprofessional, non-professional, dilettante, dabbler, as well as the vernacular pastime and hobby. These terms, used in various contexts as a critical response to professionalism, somehow point to the outside of profession and its limits, and in one way or another breaks from its disciplinary boundaries. These terms are usually assigned to the work done by untrained individuals, who 'lack attachment to a specific practice' and are not committed to any specific field (Beegan et al. 2008: 309). They are also associated with traditional or popular culture and/or pastimes, unpaid hobbies that are undertaken in spare time. The politics of these activities, from an institutional point of view, are about turning consumers into producers through the attainment of agency.

However, such an understanding of amateurism is not enough. Without devaluing such a perception of amateurism, assigning amateurism merely to pastime activities, denies its subversive potential, and at the same time, limits it to a small, privileged group with sufficient income and the resulting access to free time. Amateurism as the political work of love, however, is what should be undertaken *within* the work one does as an occupation, and within one's profession. Promoting amateurism in such a way brings it along with the risk of dismissal, exile, letting go of safety, stability and rewards in search of the unknown. It is accompanied with the risk of failing.

To be in exile at home

My discussion of amateurism, then, does not lie in the separation between amateurism and professionalism, but it originates from their encounter, where the professional breaks from the limits and regulations of her profession and *becomes* an amateur within that profession. This is what turns an amateur into a political performer. Amateurism, as I suggest, arises from the constraints of the profession. Therefore, as a liberating and subversive practice, it should address those very constraints by acting within and upon the limits and established rules of a profession. Perhaps one should become a professional amateur who, as Said says, is:

> [...] moved not by profit or reward but by love for and unquenchable interest in the larger picture, in making connections across lines and barriers, in refusing to

be tied down to a specialty, in caring for ideas and values despite the restriction of a profession.

(1996: 76)

In his very inspiring discussion about the formation of the intellectual, Said describes the intellectual as an amateur rather than a professional. For him, an intellectual should be relatively independent and pursue the attitude of an amateur. In criticizing modern professionalism, however, Said does not propose a naive denial of the influence of professionalism in advancing different fields, but attempts to recognize the character of an intellectual within the world of professionalism who does not stay loyal to its terms and conditions, but pushes herself into a condition of *exile*. He argues that the amateur should 'represent' – and I add construct – 'different values and prerogatives' within the world of professionalism (Said 1996: 82). These values are different from the required loyalty and conformism to profession and disciplinary knowledge.

In his 'In defense of amateur', Stan Brakhage describes the amateur as 'at home' anywhere he works, while Said describes the amateur as an intellectual who is always *in exile* – even in her own 'home' – and hence struggling with joyful difficulties to make sense of the new world of exile (2014: n.pag.). Being in exile retains the notion of the distance from 'home', and of the struggle of making sense of that distance while inhabiting it. For Rilke, this distance is the necessary dimension for arriving at togetherness, as he says one should love the distance between (Rilke 2004: 30). Rilke describes this distance as being alone. Concerning amateurism, this distance could be defined as a distance from our certainty and comfort zone – Said's constant state of exile, being in exile even at home.

Danilo Dolci, the Italian sociologist and trained architect 'whose critical practice took the form of making community by resisting the government and mafia alike', could be understood as one such position of being an amateur in one's own profession (Coleman 2014: 44). In the introduction to Dolci's *Report from Palermo*, Aldous Huxley describes the author in a manner similar to how Said presents the intellectual and the amateur. For Huxley, he is:

> [C]apable of surpassing the limited domain of his own specialized knowledge, and able to turn his capacity for dialogue with other disciplines into a program of social action and benefit, while simultaneously putting his technical knowledge to work in partnership with empathy and compassion.
>
> (Coleman 2014: 52)

Huxley describes such a character as someone who can make the best of 'the world of the head no less than the world of the heart' (Huxley 1956: xi).

Such an opening up of the professional world of achievements and success into a space of encounter with the other is the work of the amateur in one's own profession. As Andy Merrifield writes in his *The Amateur: The Pleasure of Doing What You Love*, 'the amateur is both a real and an imagined category – somebody who does exist today, but also someone who ought to exist' (Merrifield 2017: xi). Amateurs ought to exist within the professional world and risk doing things with their professions that would open it up to the unknown; an unknown world that emerges in the stutters of the amateur, of the lover.

Epilogue: The tulip and the volcano

A tulip that grows on the edge of a volcano grows to kiss death's lips. The kiss curls the tulip's long pointy leaves, transforms its bright red petals a withered blackened red. The kiss lasts less than a millisecond, and the world becomes twenty-one grams lighter. The tulip on the edge of the volcano grows back. The kiss curls its long pointy leaves, twists its brittle stem. The tulip crackles and rises as smoke in the air. The world becomes another twenty-one grams lighter. The tulip grows back, closed, with its head bent down. The kiss lasts less than a millisecond and the world is another twenty-one grams lighter.

NOTES

1. The amateur originates from the Latin word *amator*, which means lover.
2. In her discussion of political strategies in art, Chantal Mouffe (2015) discusses the possibility of 'critically engaging' with institutions as an alternative to Exodus; that is, the total withdrawal from existing power structures.
3. The discussion of violence and fragility exposes how caring is part of love. I prefer to use *fragility* in lieu of care, as there is risk in fragility that is absent from care.

REFERENCES

Beegan, Gerry and Atkinson, Paul (2008), 'Professionalism, amateurism and the boundaries of design', *Journal of Design History*, 21:4, p. 307.

Bellacasa, Maria Puig de la (2011), 'Matters of care in technoscience: Assembling neglected things', *Social Studies of Science*, 41:1, pp. 85–106.

Brakhage, Stan (2014), 'In defense of amateur', Hambre, https://hambrecine.com/2014/05/28/ameteurbrakhage/. Accessed 23 March 2015.

Coleman, Nathaniel (2014), 'Architecture and dissidence: Utopia as method', *Architecture and Culture*, 2:1, pp. 44–60.

Han, Byung-Chul (2015), *The Burnout Society*, Stanford: Stanford University Press.

Harris, Max (2016), 'A radical politics of love', Medium, https://medium.com/perspectiva-institute/a-radical-politics-of-love-fbe259170646. Accessed 5 August 2018.

Hardt, Michael and Negri, Antonio (2009), *Commonwealth*, Cambridge: Harvard University Press.

Horvat, Srećko (2016), *The Radicality of Love*, Cambridge: Polity Press.

Huxley, Aldous (1956), 'Introduction', in D. Dolci (ed.), *Report from Palermo* (trans. P. D. Cummins), New York: Orion Press.

Macfarlane, Robert (@RobGMacfarlane) (2018), 'Word of the day: "thole" – to endure with fortitude, to cope with suffering or challenge patiently & with dignity (Scots). This is one of my favourite Scots verbs; quietly, toughly inspiring. If a situation is "tholeable" it is, in the end, with courage & support, survivable', Twitter, 5 September, https://twitter.com/RobGMacfarlane/status/1037218867108630529. Accessed 5 September 2018.

Merrifield, Andy (2017), *The Amateur: The Pleasure of Doing What You Love*, London and New York: Verso.

Mouffe, Chantal (2015), 'Artistic strategies in politics and political strategies in art', in F. Malzacher (ed.), *Truth is Concrete: A Handbook for Artistic Strategies in Real Politics*, Berlin: Stenberg Press, pp. 66–75.

Pelias, Ronald J. (2004), *A Methodology of the Heart: Evoking Academic and Daily Life*, Walnut Creek: AltaMira Press.

The Publisher (2017), 'Finalist: Imagine me gone, by Adam Haslett (Little, Brown)', The Pulitzer Prizes, https://www.pulitzer.org/finalists/adam-haslett-0. Accessed 14 January 2019.

Rilke, Rainer Maria (2004), *Letters to a Young Poet* (trans. M. D. Herter Norton), London and New York: W. W. Norton & Company, Inc.

Said, Edward (1996), *Representations of the Intellectual*, New York: Vintage Books.

Walsh, Megan (2017), 'The Chinese workers who write poems on their phones', Literary Hub, http://lithub.com/the-chinese-factory-workers-who-write-poems-on-their-phones/. Accessed 1 May 2017.

Warren, Rosanna (2008), 'Arthur Rimbaud: Insulting beauty', *The Atlantic*, https://www.theatlantic.com/magazine/archive/2008/10/arthur-rimbaud-insulting-beauty/307079/. Accessed 11 May 2017.

Xia, Wu (2016), 'Sundress', in Q. Xiaoyu (ed.), *Iron Moon: An Anthology of Chinese Migrant Worker Poetry* (trans. E. Goodman), New York: White Pine Press, p. 165.

3

The Thinkers: Thought–Action Figures #7

Jon McKenzie and Aneta Stojnić

The following script and images are drawn from a lecture performance presented as part of the SPRING Theatre Festival in Utrecht in April 2018. The event explored the potential of transmedia knowledge to stage thought–action figures drawn from philosophy, art and the surreality of everyday life. Combining objects, text,

FIGURE 3.1: TAF Comic, 2017. By Aneta Stojnić and Jon McKenzie.

THE THINKERS: THOUGHT–ACTION FIGURES #7

music, video, animations and interactive performance, we reanimated a key figure of contemplative thought, Rodin's *The Thinker*, connecting it to the seated audiences of western theatre and theory, while introducing a variety of complementary and supplementary thought–action figures (a.k.a. TAFs). The performance is composed of modular bits.

Welcome

[*On screen plays introductory video,* Thought–Action Figures, *with tableau of small figures of The Thinker, Medusa, Jimi Hendrix, Nakia, Johnny Rotten and Sid Vicious.*]

JM: Good afternoon. I am Jon McKenzie. We are honoured to be here for Spring Festival. I thank Maaike Bleeker for the opportunity to present here today. Tonight's presentation is part of an on-going exploration of performance, media and the onto-historical. It is my first collaboration with Aneta Stojnić: we hope you enjoy the show.

Burning man performance

[*Stage right, JM at DJ table cues up the introductory video,* Burning Man Performance. *Opposite him, stage left, stands a lectern. Down stage under the large screen, sits a couch and chair. Upstage, a small table holds numerous action figures. As the video ends, JM walks across to lectern.*]

Post-ideational thought I

Professor Challenger (gruffly): For centuries, we have thought that we think in ideas, ideal forms best organized by *logos* or logic. It was Plato who taught us this, and today it's hard to imagine thinking other than in ideas. Or is it?

[*On screen: A chart table distinguishing Platonic and Homeric knowledge.*]

When Plato threw the poets out of the Republic, it wasn't lyric poets standing at lecterns solemnly reciting their poems to respectful audiences, it was rhapsodists whose rapping and music and dancing cast a spell over large enchanted crowds, transmitting to them the encyclopaedic knowledge of Homeric wisdom through the movements of their bodies.

Plato called this spell 'mimesis' and likened it to *pharmakon* or poison. Homeric knowledge worked by images and stories, *imagos* and *mythos*, which at best

produced *doxa* or common knowledge. Plato countered *doxa* with *episteme*, true knowledge composed of *eidos* and *logos*, ideas and logic.

The path to *episteme* passed through the Academy and the method of dialectics, which Plato also called *pharmakon*, only here he meant medicine. The method of dialectics – thinking as talking to oneself, asking and answering questions – would cure Athens of thinking through images and myth. Throwing the poets out of the Republic thus meant banishing poetry, dance, music and images from the realm of true knowledge, leaving only *eidos* and *logos* …

The thinker

AS [*Seated in audience, now stands and shouts.*]: Not another lecture!! Look at him standing there, reading a text from a lectern: GO AWAY!!

[*JM staggers away from the lectern and takes a seat next to the couch. On screen, the chart table fades leaving an empty stage on screen.*]

What is a lecture? Someone standing at a lectern, on a stage, reading a text or perhaps talking from notes. And you! [*Pointing to audience*]. You're just sitting there, contemplating the scene before you …

[*An image of Rodin's* The Thinker *appears on screen. JM mimes the sculpture, stroking his chin, pondering the situation.*]

Someone reciting text before you. Do you think you're thinking, sitting there now? Do you think you have true being, true *ontos*, just because you're thinking? You think therefore you are? *Cogito ergo sum*? Are you shitting me? Just sitting and thinking?

It's the birth of the *vita contemplativa*, the contemplative life. You are sitting there. This idea of thought – thought as ideation, as contemplating ideas – has guided us for millennia.

[*AS leaves audience and takes the stage, gestures to screen, to JM, to audience.*]

Rodin's *The Thinker* captures the dominant thought–action figure of western culture. Thinking as contemplating, as sitting lost in thought, thinking closely connected to sitting and thus to the technology of chairs, thrones and even toilets: Thinking machine as stinking machine.

[*AS reclines on the couch, still gesturing to audience.*]

By the way, even for Plato, it wasn't just sitting and thinking. Remember symposium? In Greek, *sympinein* meant 'to drink together'. The feast with everyone lying down, talking, eating, drinking, thinking… So make yourselves comfortable in your places, move your bodies… lay back, chill and enjoy the show… and I promise: afterwards we'll go to drink together.

[*On screen begins the music video,* The Thinker Animated. *JM suddenly stands up, walks to DJ table and then across to lectern. AS moves to the small table and plays with figures.*]

The vita activa

JM: Hannah Arendt in *The Human Condition,* famously advocated for the *vita activa,* challenging the contemplative life of the mind handed down by Platonism, with its priority of theory over practice, eternal truths over the realm of human actions. As importantly, Arendt practiced her *vita activa,* putting her philosophy to work on problems of her time.

Similarly, with *A New Rhetoric: A Treatise on Argumentation,* Chaïm Perelman and Lucie Olbrechts-Tyteca effectively countered the *vita contemplativa* of analytic and existential philosophies with the *vita activa* of rhetoric. Translated from French to English in 1968, *A New Rhetoric* is among the most influential twentieth-century works on argumentation, advocating a 'regressive' philosophy based in the *doxa* of audiences rather than the *episteme* of experts.

But is mixing *episteme* and *doxa* necessarily regressive? Might it be progressive? Or even transgressive?

Medusaized thought

[*On screen plays video showing bust of Plato with Greek music, then loud record scratch and the 'Plato stopped the music. With theory and theater, the Greeks sat down and shut up'. Medusa head suddenly appears with text: 'Ideation is Medusaized thought'. She dissolves under raindrops and the text, 'Figuration is fluid'.*]

Thinking as walking

AS [*Pacing about the stage. On screen plays a video of an animated female figure walking under the text 'Thinking as Walking'.*]: Walking is another thought–action figure in and beyond western culture. Aristotle's Lyceum was known as the Peripatetic school – or simply *Peripatos* – after its covered walk-ways through which Aristotle was said to walk and lecture. In modern times, Nietzsche was famous for writing in small notebooks while walking atop mountains, and he ridiculed Kant for writing while sitting. Walter Benjamin gave us an urban walker, the

flaneur and the Situationists the meandering *derive*, as well as the related method of psycho-geography.

Method itself comes from the Greek *meta-* (across) + *hodos* (way), and thus we proceed step by step: Descartes' *Discourse on Method* proscribed four steps:

1. Accept only clear and distinct ideas.
2. Divide each problem into parts.
3. Order your thoughts from simple to complex.
4. Check your work for oversights.

These four steps launched modern science and philosophy. The modern concepts of progress, regression and transgression – all contain the Latin root *gradi*, which we also find in the word 'graduate', which means to take a degree, a step along the path of knowledge. But I digress –

If modern ideation has proceeded via Descartes' ordered steps, thought–action figuration proceeds via *derives*, meanders and random walks across different fields of knowledge and life. What if we followed Australian aboriginals, whose spiritual walkabouts function as a form of adolescent education?

What is recognized as thinking? Who decides what will be recognized as knowledge?

Post-ideational thought II

Professor Challenger [*At lectern, speaking gruffly. The Plato/Homer chart table reappears on screen.*]: In the modern era, after Descartes rebooted *eidos* as ideas and posed *cogito ergo sum*, the oppositions of *episteme* and *doxa* would help define the West's relation with its other, as the literate archive replaced the oral repertoire. They would also define the university's relation with popular culture, which is defined as image-laden, mystifying and ideological. Today, critical theory is the contemporary form of Platonic ideation, though it's hard to get our heads around this – or to think beyond ideas. Classical theater arose with theory, displacing ritual along with its myths. Out with images, in with ideas, thus spoke Plato, Descartes, Locke, Kant, Hegel…

Contemporary performance opens the possibility of thinking beyond both image and idea, acting beyond ritual and theater, just as the digital displaces the opposition of speech and writing, orality and literacy. All performance is electronic, and the mashup of images and ideas enables us to think otherwise – to think and act through THOUGHT–ACTION FIGURES. Thought–action figures are to digitality what ideas were to literacy: an emerging mode of thinking and

acting. While ideation happens by induction and deduction, by specifying and generalizing, figuration works through abduction and conduction, through leaps and revelations –

Thinking as silly walking

[*On screen appears a video animation of female walking figure, superimposed with clips of Monty Python silly walkers, beneath text 'Thinking as Silly Walking'. AS and JM silly walk around the stage.*]

World historical TAFs I

JM [*Speaking at lectern*]: Thought–action figures – or TAFS – are in no way limited to human figures, far from it. Indeed, historically, some of the most powerful thought–action figures are inanimate objects, plants and machines.

[*Figures of ladder, tree and rhizome appear on screen.*]

For instance, the figure of the ladder-enabled ancient civilizations to describe different levels of existence. Aristotle's famous categories introduced divisions into these levels and were thus characterized as a tree structure by the neoplatonist philosopher Porphyry. From these, Platonic roots descend *genus*, genre, gender, etc. Climbing up this tree is called 'induction'; climbing down 'deduction'.

Deleuze and Guattari challenged arborescent or tree thought with the figure of the rhizome, those grasses and tubers whose root systems shoot out to form transversal nodes and networks. *A Thousand Plateaus* is composed of flat prairies where thought–action takes place via intuitive leaps and revelatory flashes, what philosophers call abductive and conductive thinking. Abduction and conduction are to us what induction and deduction were to the Greeks: new ways of connecting thought and action.

Now the TAFs of ladder, tree and rhizome correspond respectively to orality, literacy and digitality – and thus to ritual, theater and performance. In our contemporary age of global performativity, figures fully emerge as modes of thought–action or functional thinking machines which multiply almost by themselves.

Female thinkers

[*AS at lectern. JM at DJ table. On screen: Pan of comic strip featuring AS, feminine tree figure, Dionysian orgy.*]

AS: And where is the female thinker?

Women finally taking their place at lecture machines traditionally occupied by men is a struggle that's on-going, but that is only one side of the problem. On the other side, we have an underlying question: why is the western hegemonic model THE model that we recognize as legitimate knowledge. In contrast with rational, universal, objective, logocentric that was attributed to the male, historically the feminine was linked to the sensual, experiential, the occult, magical, spiritual... To oracles, witches, birth givers, homemakers, whores and mothers and other fake dichotomies.

What about other knowledges and other epistemologies that have been subjugated to the western colonial epistemic violence, all the embodied knowledges pushed aside by the logocentrism of power?

Female thinker as an essential Other appears not only as a new actor/agent but also as a carrier of a different kind of knowledge. Her knowledge is situated knowledge: the content is inseparable from the agency of knowledge producer. Who am I, where do I come from and from which position do I bring this content to you?

How can we think feminine thought–action figures?

Pussy hats as TAFs

JM [*In front of DJ table. As he speaks, images from Women's Marches appear on screen.*]: Funny that you should you ask, baby doll. Pussy hats emerged as a collective critico-creative act in January 2017, when they were created and worn by tens of thousands of protesters at Women's Marches across America – women, men, children, cops and even a Donald Trump bobblehead wore them. Other Donalds too (ducks).

Like all TAFs, pussy hats are overdetermined and serve many functions: Pussy hats are symbols against sexual abuse and violence, against Trump and other mansplaining sexist pigs and against the underlying patriarchy and phallocentrism. As important: pussy hats are displays of feminine power and collectivism. They make the personal political and the political personal by making pussies visible and audible.

The hats' bright colour connects pink pussies to the pink triangles of ACT-UP activists and gays in Nazi concentration camps. Their name and very shape queers the stereotype of 'catty women', of women who exhibit subtle or outright aggression to others.

Pinking thinking caps

AS [*At lectern. A wooden block print of 18th-century 'considering cap' appears on screen*]: What if thinking were to become pinking? Pussy hats also fit the

THE THINKERS: THOUGHT–ACTION FIGURES #7

tradition of thinking caps, of real or imaginary hats worn to facilitate thought and decision-making. The figure of the thinking cap, first described in the nineteenth century, is thought to derive from the 'considering cap', whose figure dates back to at least the early seventeenth century. The 'considering cap' appears in the 1765 fiction *The History of Little Goody Two-Shoes*, along with an etching:

> [...] a considering Cap, almost as large as a Grenadier's, but of three equal Sides; on the first of which was written, I MAY BE WRONG; on the second, IT IS FIFTY TO ONE BUT YOU ARE; and on the third, I'LL CONSIDER OF IT.

[On screen, the considering cap becomes pink and a ball of pink yarn appears next to it.]

As knitted garments, pussy hats also gather threads from recent theorizations of female genitalia as figures of post-phallic thought. Julia Kristeva recast *chora*, the Greek non-space, as vagina. Luce Irigaray theorized the 'two lips' that touch each other in *feminine ecriture*. And Jacques Derrida posed the hymen as an alternative to castration. Then there's the literacy of conceptual artist Sophia Wallace.

Thought–action figures elude propositional logic by affirming their own self-difference and alterity. They thus violate Aristotle's principle of identity: X may or may not be equal to X. Figures can be criticized, but they make such critique part of their figuration.

What if thinking were to become pinking?

TAF dream tableau

[Music video of a TAF tableau featuring figures of AS, JM, Professor Kx4l3ndf3r, a mound of TAF fragments, etc.]

Psychoanalysis and figuring the unconscious

[AS sits in chair next to couch, on which rests one of Warhol's pink banana pillows. On screen appears an image of Freud's couch, with chair and figures visible.]

AS: Is this a dream? Are we on a 'royal path'? If their critique is already part of their figuration: Are TAFs figures of the unconscious? Unconscious is timeless,

it knows no contractions and no negation, it is only guided by pleasure principle. It's contents are drive representatives that seek to discharge their cathexis through primary psychic processes: condensation and displacement. It was Freud who articulated those processes: 'By the process of displacement one idea may surrender to another its whole quota of cathexis; by the process of condensation it may appropriate the whole cathexis of several other ideas' – Freud.

Let's try this again: 'By the process of displacement one thought action figure may surrender to another its whole quota of cathexis; by the process of condensation it may appropriate the whole cathexis of several other thought action figures'.

Thought action figures are always created in relation: that's what distinguishes them from simple objects. These relations are multiple, fluid, networked and always in motion.

The couch as TAF

[AS *on couch. On screen appears her silhouette in front of a computer screen with text.*]

Last night I had a dream and in it a couch was a thinking machine: machine that accesses unconscious thoughts, phantasies and believes and generates utterances comprehensible to the conscious.

The couch is another thought–action figure, one generated by Freud (himself a TAF): reclining thinking as the ultimate way to access the unknown depths of the psyche. There is something profoundly performative about 'the frame': the analyst sits behind a couch, her visual field is cancelled, the only rule is to say everything that comes to mind. The 'talking cure' may sound logocentric but the interpretation machine is not that simple.

The analyst here is also a proper thought–action figure: you can't know anything about her (who is the analyst outside of the room) because she will become everything and anything – everyone and anyone – in the relation that unfolds in the room. Rather than the old metaphor of a neutral screen the analyst is an interface: a shamanic figure that guides you through the cosmogony of your many personal thought–action figures.

Thinking as bucking

[*Music video of female walking figure, robotic bull jumping hurdles, soprano singing while riding a man.*]

World historical TAFs II

[*On screen reappear ladder, tree and rhizome figures, beneath which now appear figures of double helix, Mac desktop icon and Guerrilla Girl mask.*]

AS [*At lectern; JM at DJ table*]: Over the past half century, three mind-blowing thought–action figures have emerged. One is the double helix, considered a key twentieth-century scientific discovery that revolutionized molecular biology and our understanding of life. Technically, its discovery stretched across X-ray images, scientific models and published papers. Socially, the double helix's braided structure bears traits of Nobel honours, as well as sexism and possible anti-Semiticism.

A second land-mark TAF is the Apple desktop, which translated physical desktops into the graphic user interfaces of personal computers. This transmediation displaced the thinking machine of literate bureaucracy into the circuits of digital networks. Bureaucracy means 'rule by desks', and the shift from disciplinary to performance stratum also involves substituting one desktop for another.

The third thought–action figure is a mash-up of freedom fighters, great apes and feminist artists: The Guerrilla Girls, whose performances, books and posters have targeted sexism and racism in the art world. Wearing their trademark masks, the Guerrilla Girls embody TAFs in many ways, especially their use of research, collaboration, anonymity and pointed humour. As one of their gift bags says: 'You won't believe what comes out of your mouth when you're wearing a gorilla mask!' In short, the gorilla mask is a thinking machine: like any good TAF, it makes us think and act differently.

[*JM holds up Guerrilla Girl shopping bag, displays the side with text, 'You won't believe [...]" and the other side with GG mask, and then dons the mask and begins throwing taffy candies to audience, at first gently and then becoming gorilla. He takes off the mask when done.*]

TAFs as taffy

[*JM and AS stand centre stage, with image of Guerrilla Girl mask on screen.*]

AS: Thought–action figures are to digitality what ideas were to literacy: an emerging mode of thinking and acting. TAFs are not limited to human figures: animals, plants, machines, processes, materialities, ideal entities – all are becoming TAFfy, which are sticky networks of concrete associations formed by chance and necessity that gather and disperse thoughts and actions at specific times and places.

FIGURE 3.2: Still from performance TAF EPISODE 7: The Thinkers / Jon McKenzie and Aneta Stojnić, Spring Festival in Utrecht, 2018.

FIGURE 3.3: Still from performance TAF EPISODE 7: The Thinkers / Jon McKenzie and Aneta Stojnić, Spring Festival in Utrecht, 2018.

THE THINKERS: THOUGHT-ACTION FIGURES #7

Thank you for being with us today, in a minute you'll have a chance to ask us some questions, and then we'll move to the bar for drinks… But before we do, we invite you to join us for a dance…

Is That All There is to Big Text?

[*On screen plays the music video 'Is That All There is to Big Tex?' while AS and JM beckon audience members to join them dancing onstage. The Dutch can indeed dance!*]

THE SENSE-THOUGHT-ACTION HEURISTIC

Thank you for being with us today. In a minute, you'll hear a chance to ask us some questions, and then we'll move on to our next think. But first, we'd love to invite you to join us for a dance.

Is That All There Are Big Feet

(Kim's son plays the music under the Part All There Is Big Feet until Ayan. I'd like audience members to join. I can't keep up and I'll be right out inted dance.)

ACT TWO

ACT TWO

4

Performing Indigenization: New Institutional Imperatives Post Truth and Reconciliation

Kathleen Irwin

As a Canadian theatre artist/scenographer, and teacher (Faculty of Media, Art and Performance at the University of Regina) whose practice focuses on site-specific performance space, my work is grounded in certain places drawing on the layers embedded there – social, historical, psychological and metaphorical – to give substance and veracity to a performance – although these so-called truths are always in flux. When one meaning is set in motion, its opposite is also implicitly mobilized. For example, embedded in the notion of site and rootedness is its antithesis: motility. Implied in stasis are notions of change; in homecoming one understands departure; in growth, one understands decay. Everything changes; art is ambiguous. We move; we move forward.

Working with First Nations and Métis artists has allowed me to see how others relate deeply to place in immutable ways; how some places can be shared while others cannot. I try to think more deeply about this now – along with the issues of ownership and authorship. Indigenizing has problematized my own (Scots–Irish–Welsh ancestral) position within the processes of transcultural teaching and art making. I understand that while steps towards decolonizing and reconciling may be few, faltering, at best naive and at worst ignorant, they are among a range of actions that lead in a healing direction, towards a better understanding of what is Indigenous knowledge alone and about which places and stories can be shared and which cannot. These realizations may play a small but important part in restoring balance, shifting weight periodically but finding an equilibrium in time.

Putting power back in powwow: Indigenizing the academy through fine art practice

Finally, Canadian institutions of higher learning are addressing the wrongs done to First Nations people through the bitter legacy of colonialism. Taking up the Calls to Action presented by Justice Murray Sinclair, the first Aboriginal judge appointed in the province of Manitoba and Canada's second, in the *Final Report of the Truth and Reconciliation Commission of Canada*, universities are now focused on Indigenizing, on opening up their business to other ways of knowing and other forms of knowledge (2015a). This has finally begun to shift, at least in part, the way that we perform their long-established role, power and privilege in Canadian society.

The completion of the Sinclair's final report, as I have written elsewhere (Archibald-Barber et al. 2019), was a landmark document that outlined, in 94 Calls to Action, the challenge of moving forward within the historic context of what we now name cultural genocide. It articulated, as well, an imperative for charting the onward course for some kind of reconciliation between Indigenous and non-Indigenous peoples. While this document was critical, Canada's sesquicentennial in 2017 was also notable as a year in which many (but not all) celebrated 150 years of Confederation, promoting the nation as a home to people from all over the world. At that moment, the question of how Indigenous identities and communities are reflected and respected within the normative construction of the country's identity was resounding. In the same year, a strategic unsettling of Canada 150 was enacted through the Idle No More – a grassroots movement founded in 2012 that refused attempts to weaken Indigenous rights demanding a new Nation-to-Nation recognition process recognizing collective Indigenous rights and title; full implementation of the Truth and Reconciliation Commission Calls for Action (in the *Final Report*); and implementation of the *United Nations Declaration of the Rights of Indigenous Peoples* (2007) on the ground. In 2018, the anger over the deaths of Indigenous youths and the subsequent acquittal of those charged, as well as the discover of hundreds of unmarked graves of Indigenous children on the site of several residential schools in 2021, and the intensity of reaction to the events, have further heightened the urgency of the conversation. This background also includes the *National Inquiry into Missing and Murdered Indigenous Women and Girls* (2019), which has defined the most significant national crises of our times and underscored the necessity to, once and for all, address the legacy of colonialism (Archibald-Barber et al. 2019: xiv). These defining circumstances address issues in Canada in ways that remind us, every time we access the news, that the path to reconciliation between Indigenous people and the settler colonial system is neither straightforward nor easily settled. The struggle to perform

reconciliation in truly meaningful ways is at the heart of it. Indigenous literary theorists Gabrielle L'Hirondelle Hill and Sophie McCall acknowledge the word reconciliation is itself 'a troubled and troubling term often used to impose a sense of closure on experiences of colonization that are very much alive and ongoing' (2015: vii). Because of (or despite) the on-going debate, the pressure to engage with the concept of reconciliation in part or in full within the academy has become an imperative, and despite the ambiguity around what that might mean, we understand that we must work 'to shake it up, to wrestle with it, and to insist on other possible futures' (Archibald-Barber et al. 2019: xiv). With this chapter, I consider the institution of higher education in Canada, specifically my home institution the University of Regina, as simultaneously a place of ongoing colonial oppression, and of possibilities and affirmative policy deployments. I provide a few examples of how we have begun to address the past within the framework of an institution that does not easily change its course.

To begin again at the beginning, Justice Sinclair outlined the way forward, including in the field of education, for a country that has long denied its racist position, calling on the federal government to draft new Aboriginal legislation with the full participation and informed consent of Aboriginal peoples. Regarding education, the new legislation, he urges, would incorporate the following principles:

1. Providing sufficient funding to close identified educational achievement gaps within one generation;
2. Improving education attainment levels and success rates;
3. Developing culturally appropriate curricula;
4. Protecting the right to Indigenous languages, including the teaching of Indigenous languages as credit courses;
5. Enabling parental and community responsibility, control and accountability, similar to what parents enjoy in public school systems;
6. Enabling parents to fully participate in the education of their children;
7. Respecting and honouring Treaty relationships.

Situated in western Canada, the Indigenous past is just below the surface of the present and the material markers of colonial power and its absence are readily apparent in the disparities between Indigenous and non-Indigenous. For example, the Canadian Poverty Institute attests that Indigenous peoples in Canada experience the highest levels of poverty: 'a shocking 1 in 4 Indigenous peoples (Aboriginal, Métis and Inuit) or 25% are living in poverty and 4 in 10 or 40% of Canada's Indigenous children live in poverty' (Canadian Poverty Institute n.d.: n.pag.). Despite the Christian beliefs and democratic ideals of equality and democracy historically inherent in the colonizing cultures (England and France), First

Nations minorities have been systematically excluded from mainstream economies, consistently undereducated and thereby denied access to higher education. However, one now begins to recognize change. The University where I have worked since 1996, has at long last, taken up the Calls to Action in their Strategic Plan (2015–20), adopting the following definition of Indigenization as formulated by the Aboriginal Advisory Circle to the University President. The University's definition of Indigenization is, accordingly,

> the transformation of the existing academy by including Indigenous knowledges, voices, critiques, scholars, students, and materials as well as the establishment of physical and epistemic spaces that facilitate the ethical stewardship of a plurality of Indigenous knowledges and practices so thoroughly as to constitute an essential element of the university. It is not limited to Indigenous people, but encompasses all students and faculty, for the benefit of our academic integrity and our social viability.
> (UR Strat Plan 2015–20: 9)

By establishing this as a University focus, it asks faculty and staff to align research with new policy. This is no minor shift, and it is reflected in academic institutions across the country. However, how directions are recast and performed, particularly in my Faculty of Media, Art and Performance (MAP) is in part, the concern of this chapter. To set the scene, it is necessary to provide a brief historical context of how colonization has played out in Canada in regard to education.

Background

A brutal history of residential schools legislated by the federal government in Canada in (1880–1996) and realized by the Catholic, Anglican and United Churches, guaranteed the so-called Indian problem would be solved in good order. While the residential school system operated from around 1883, origins of the oppressive system can be traced to as early as the 1830s when the Anglican Church established a school in Brantford, Ontario.

At the height of the residential school system, the administration was determined by assimilationist, Duncan Campbell Scott, a civil servant in the Department of Indian Affairs, widely viewed as an ardent supporter of the residential schools and the policies associated with them: the removal by consent or by force of tens of thousands of Indigenous children from their homes, some as young as two or four years of age; the attempts to deprive these children of any connections with their parents; the institution of an underfunded, neglectful system where thousands perished from malnutrition, poor medical care and diseases;

the creation of an education system where child labour was a norm and where academic achievements were severely compromised; and the consistent lack of oversight and accountability in a system where physical and sexual abuse were rampant.

In 1920, Scott also helped pass an amendment to the Indian Act making school attendance compulsory for all First Nations children under fifteen years of age. While he did not think that education alone was sufficient for civilizing the Indigenous Peoples of Canada, he advocated heavily for it, stating,

> I want to get rid of the Indian problem. I do not think as a matter of fact, that the country ought to continuously protect a class of people who are able to stand alone [...] Our objective is to continue until there is not a single Indian in Canada that has not been absorbed into the body politic and there is no Indian question, and no Indian Department, that is the whole object of this Bill.
>
> (Eshet, 2016: 51)

In 2015, in a speech to the Global Centre for Pluralism, Chief Justice Beverley McLachlin said that Canada has for a century and a half attempted to commit cultural genocide against aboriginal peoples in what she called the worst stain on Canada's human-rights record. In the eighteenth century, during early days of contact between the Indigenous and non-Indigenous peoples after an initial period of inter-reliance and equality, the governing bodies developed an ethos of exclusion and cultural annihilation. According to Sir John A. MacDonald, the first Prime Minister, 'the objective was to take the Indian out of the child'.[1] Furthermore, she attests, his policy indicated 'Indianness was not to be tolerated; rather it must be eliminated'. The word used to describe the process was assimilation. Many Canadians have now begun to accept McLachlin's term – cultural genocide – in reference to policies outlawing aboriginal religious, social traditions and to the implementation of the residential school system (pluralism.ca).

Importantly, for this discussion, was the banning of many performative Indigenous ceremonies. One of the most famous examples of the abuse was the 'Potlatch Law'. In 1884, under the Canadian Indian Act, the federal government banned the potlatch ceremony of the Indigenous peoples of the Pacific Northwest Coast, along with the sun dance and the powwow of the Plains Aboriginal cultures. Although absolutely defining of a way of being, the rituals were considered non-essential and inappropriate. In the case of the potlatch, the annual gesture of giving away all material goods was the opposite of the Christian (material capitalist) values held by Euro-Canadians and was therefore incomprehensible to them. The powwow, a seasonal community celebration focused on music, dance and sharing cultural knowledge, was seen as

threatening Christian rituals. Although the law was formally amended in 1951 to allow Indigenous peoples to practice their customs and culture, Judge Alfred Scow describes some of the impacts of the Potlatch Law as outlined in Section 141, The Indian Act 1876.[2]

> This provision of the Indian Act was in place for close to 75 years and what that did was it prevented the passing down of our oral history. It prevented the passing down of our values. It meant an interruption of the respected forms of government that we used to have, and we did have forms of government be they oral and not in writing before any of the Europeans came to this country. We had a system that worked for us. We respected each other. We had ways of dealing with disputes.
> (Alfred 1992: 344–45 cited in Hanson n.d.: n.pag.)

Furthermore, the denial of the fundamental recognition of multiple perspectives or opposing discourses was inscribed and normalized in the regulations and policies of the academy. These ways of defining what it meant to think, speak and be an educated Canadian were upheld and passed on, largely unchallenged, to the next generation of students. Contrary to one of the tenets that many have held as essentially Canadian, the utopian desire that the halls of learning be open to all was patently a fiction. It can be said, following Jacques Rancière, the Canadian university was historically 'an explication in social act, a dramatization of inequity' built on the themes and rhetoric of cultural deficiency and salvation. The Calls to Action in the field of education, rests on the premise, echoing Rancière's dicourse on the role of the teacher and individual towards individual liberation in *The Ignorant School Master*, that 'all are of equal intelligence and that any collective educational exercise founded on this principle can provide the insights from which knowledge is constructed' (1991: 6, 7, 105). This is radical: nothing less than a fundamental shift answers the challenge to Indigenize the academic institution in Canada, which has historically supported and reproduced certain systems of thought and knowledge, structures and conventions. In point of fact, the Strategic Plan calls for a thorough reconsideration of methodological approaches and pedagogical practices from what has always been framed in terms of differences between Indigenous cultures and the mainstream cultures of the West to embrace an Indigenous worldview. Doing so necessitates bridging multiple and significant gaps in understanding between cultures of understanding. As Indigenous and human rights scholar Rauna Kuokannen writes,

> knowledge in the Western universities is generally fragmented and compartmentalized, in contrast to the more holistic frames of reference in indigenous cultures. Also, Western conventions of thought typically emphasize individual status and

competition; in contrast, indigenous cultures place more value on consensus, cooperation, and collective identity.

(2007: 2)

Performing indigenization on the ground: Nothing about us without us

How is that working for those on the front lines of education? How have we in MAP taken up the challenge of the Calls to Action? An important initial step in our process was to try to define, in simple terms and in consultation with First Nations and Métis colleagues, what is meant by having an Indigenous approach within each of the disciplines we represent: Visual Arts, Theatre, Music, Film and Video and Interdisciplinary Studies. Largely agreed upon were the concepts of physical groundedness, embodiment, lived experience and community engagement. Within Indigenous research, such methodological approaches operate against colonizing epistemologies as means of addressing the goals of enhanced human rights, equity and social justice in a variety of minority circumstances. Indigenous methodologies aim, following academic Bagele Chilisa, to expose the overall acceptance of current, dominant academic research traditions that exclude 'from knowledge production, the knowledge systems of the researched, colonized Other' (2011: xvi). According to critical race theorists Richard Delgado and Jean Stefancic, such a position values the relationships formed (with people, environments and the more-than-human), understands knowledge mobilization as possible through means such as storytelling/counter storytelling and 'naming one's own reality' – using narrative to illuminate and explore experiences of racial oppression (1993: 461–516).

Having only a general theoretical sense of this and little practical experience, MAP faculty (speaking from my own position) proceeded gingerly, offering new classes with appropriately diverse content,[3] suitable measures for grading and writing funding applications for creative projects that looked and felt different than before,[4] in that they took, as their starting point, a collective approach and proceeded, whenever possible, in consultation with an elder or an Indigenous community. Looking outward to disseminate our work to new audiences, we (I) stepped into these waters with eyes wide open in regards to the problematic categories of Canadian and Indigenous within the relevant and colonizing national narratives.

As knowledge rooted in Indigenous cultures and processes has begun to test conventional means of measuring outcomes, what is evident is that rethinking the core of the education experience from an Indigenous perspective is having a profound impact on the recognition of practice-based artistic research, with its

emphasis on subjective and experiential knowledge, as a legitimate form of investigation. Some concrete examples of projects at both undergraduate and graduate levels will serve to illuminate this.

A wild studio: Pedagogical excursions in art, sound + performance

As an example of a spatial typology for (un)housing the performance design paradigm within an academic institution, I offer the example of a unique undergraduate course given through MAP and conceptualized by intermedia artist, Dr Megan Smith. In the first of several iterations of this summer intensive (2018), students created site-specific projects in response to the national *Landmarks* project, an initiative organized in multiple Canadian universities to consider the country's sesquicentennial celebration through the lens of the country's national park system. Students were introduced to concepts and methods focused on understanding, contextualizing and responding to the human and animal act of creating and imagining landmarks, looking particularly at these parks as agential forces in problematizing, re-imagining and intersecting significant landscapes. Working at the spectacular Grassland National Park in southwestern Saskatchewan for a week, Indigenous and non-Indigenous students critically engaged with the Anthropocene histories, natural ecosystems and geological land formations through a series of artist lectures and curatorial workshops. Students also interacted with historians, biologists, as they developed critical writing and creative projects. This course focused on contemporary techniques being developed to support practices and cultural experiences that take place outdoors, in remote locations and to consider various cultural frameworks – public space, activism, community, collaborative and participative practices. Underpinning this form of pedagogy are several givens: (1) that culturally specific methodologies and practices are generative of new knowledge; and (2) that following Barbara Bolt's performative methodology (2016), art has force and agency – it does something in, to and for the world around it.[5]

Michele Sereda Artist-in-Residency Project in MAP

Focused on Indigenous art practice and ways of knowing, the Michele Sereda Artist-in-Residency Project has over the past three years significantly tested conventional academic and administrative processes at the University. Claiming a place of resistance, the artist residencies have worked to interrogate the University's approach to creating truly meaningful spaces for Indigenization, insisting that such solutions are not simply or quickly willed into being.

The residency was established in memory of Michele Sereda – a multidisciplinary artist and alumna of MAP who explored social issues that touched on intercultural dialogue and creation. It takes up the terms of Sereda's creative energy offering a funded opportunity for a professional Indigenous artist interested in exploring socially engaged practice and community interaction. The residency aims to create engagements between artists, University units and their students, and community organizations around socially relevant issues. To date, we have offered this to six artists. The two most recent turns are good examples of way that Indigenous methodologies can move institutions away from ingrained processes.

In January 2018, Joely BigEagle Kequahtooway, Saskatchewan (White Bear First Nations) artist and feminist activist started her residency with a project that responded to the Call for Proposals aimed at an artist who works at the intersection of word and art. Her project, *Bringing Back the Buffalo*, was to prepare, stretch, cure and paint a buffalo hide using traditional tools and methods. Her goal was to bring together Indigenous and settler perspectives by engaging university and school-aged students, and the general public in a timely discussion around human/nonhuman entanglements. The traditional tanning process (soaking the hide with a solution made of the animal's brain and water, and smoke curing it in a traditional teepee) looked critically at the settling of the west 150 years ago, the decimation of plains buffalo through government policy, and the resilience of Indigenous peoples under brutal and oppressive circumstances. Using Nakoda words and pictographs and employing natural tints, dyes and paints, BigEagle-Kequahtooway illustrated her personal and impassioned connection to the buffalo on the finished robe. Unfolding in several stages over four months, interspersed with public ceremonies including smudging, a sweat lodge ceremony and a drum circle, the project held the attention of all, at the same time, it challenged the university to rethink and open up policy on animal research, biological waste and fire regulations. These restrictions, as anyone who works at a university will attest, are rigidly enforced. Such mundane markers of how cultures butt up against each other, how situations are navigated and consensus formed, are not insignificant as they establish precedent for addressing future provocations.

The Sereda Residency provides a second example of how MAP is attempting to follow the University's directive to Indigenize. In answer to the 2019 Call for Proposals to explore the integration of art, physical movement and health, specifically, notions of mobility, stasis, embodiment, passage and well-being from an Indigenous worldview, Micheal Langan, a Saulteaux artist from Cote First Nation, proposed a skateboard project, *Riding is Resistance*. The project brought on board local Indigenous high school students and bridged them with a similar population

FIGURE 4.1: Grad Students at Grasslands National Park. Courtesy of Dianne Ouellette.

FIGURE 4.2: Joely Bigeagle Kequahtooway tanning buffalo hide in art class. Courtesy of Jan Bell.

in Adelaide, Australia. A dynamic, multi-layered initiative, his project has caused the institution to re-evaluate its systems yet again challenging how it performs the promise of equitable education rights, pushing boundaries and fundamentally rocking operations that have not changed in years.

A skate boarder himself, and a teacher in training, Langan is a strong advocate for the way the sport increases physical skills and self-confidence. Based on his own experience, he attests that skateboarders get a better understanding of their body while practicing tricks. Skateboarding takes balance, confidence, determination and patience acquired through repeated jumps, turns and tumbles. Experiencing inevitable failures on the way to hard won successes, individuals learn to cheer each other on and improve their own performance despite psychological or physical boundaries. Clearly focusing on Indigenous street kids, he also sees it as a way to increase awareness about colonization in Canada and to use decolonizing practices to address racial inequity. As he writes in his proposal,

> for decades, efforts have been made to rewrite and conceal the history of colonization in what we now call Canada. Indigenous peoples have been depicted in a negative light, frequently labeled as savages, freeloaders or half breeds. On the other hand, European settlers or colonizers are described as great pioneers and fathers of confederation. However, the actual nature of colonization is infrequently recognized. The legacy of historical colonial policies and legislation and how they continue to affect Indigenous peoples' lives is rarely discussed. When white privilege or white supremacy is brought up, no one really wants to address it. However, we may now be at a turning point at which the myths of this country are starting to unravel, and the colonial ideologies that built it are beginning to be understood for what they are.[6]

His proposal statement also linked his experience with Indigenous youth with work done by fellow skateboarder, Dr Seth Westhead, at the University of Adelaide, Australia. Langan writes,

> both countries are in the first phases of talking hard truths about colonialism. These truths are showing up in print media, social media, classrooms and in all areas of society. There needs to be ongoing dialogue about the realities of our countries. Our youth, the future generation, must learn to communicate peacefully and respectfully to express these truths. Reconciliation will never happen without the truth.[7]

What is unique, are Langan's critical eye and entrepreneurial skills, which he turns to designing and marketing skateboards using iconic images from the Canadian National Archives to show the unembellished facts of his people's treatment at the hands of colonizers. His business, Colonialism Skateboards, is garnering international attention (colonialism.ca). Applying striking and unsettling images to either surface of the deck, he often offers them to kids on the street who have little or no understanding of their own past. Used as a conversation starter, the young skaters begin to absorb their own history through their introduction to

the boards. In his search for potent graphic images, Langan came across the work of Canadian artist, Kent Monkman, internationally recognized for his richly detailed paintings borrowing from disparate genre conventions and his provocative recasting of historical narratives. Monkman uses nineteenth century classical style to mimic works of art, substituting Indigenous individuals for classic figures. Impressed by his work, Langan asked if he could use one of Monkman's most famous pieces, *The Scream*. Monkman agreed, even assisting the process of translating the image into a set of four boards that have become a highly sought after, limited run. No one makes money on this; any capital is turned back into putting boards into the hands of young people. Incorporating this idea into his *Riding is Resistance* project, Langan worked with school age children in Regina, using their images to create a unique set of stand-alone boards, which were later curated into a show at the University's Archway Gallery. Attending the opening of the show was the first time many of the students had visited the campus. A public symposium capped the project featuring a full-size ramp installed at the university that served as a dynamic backdrop for the event. Used throughout by a group of talented skaters, in an environment where all things out of the ordinary are deemed liabilities, getting this one past Health and Safety was a major coup. Zoomed in on an overhead screen were Seth Westhead from a research trip in Indonesia and Kent Monkman from his studio in Toronto. This multi-layered, intercultural and international project was impressive for the ways that Langan used a current, instantly recognizable and commodifiable idiom and linked it to the history of colonization.

Riding is Resistance, both project and symposium, helps tell the truths of two countries by depicting their haunting similarities. As Langan says in his proposal, 'we can't change colonial legislation instantly, but we can make changes to the way our youth and our future generations think and learn about each other's shared history'. Neither can we change longstanding institutional resistance to new ways of doing things. But, through an international dialogue about decolonization in education, projects like this will help us do so.

Although many other initiatives have been mounted in MAP, perhaps the one that will have the biggest impact is the new Ph.D. programme, the intent of which is to expand boundaries in research creation and open doors to Indigenous scholarship in the post Truth and Reconciliation period. It's not every day that a Ph.D. programme is launched and this one marks a significant milestone in developing and promoting research creation and substantiating Indigenous scholarship. Historically, fine arts practice was not recognized as research. Lacking traditional methodologies, it was not seen as advancing new knowledge. We now understand research creation as an investigative approach that combines creative and academic research practices and supports the development of understanding and innovation

FIGURE 4.3: Micheal Langen discussing a collaborative skateboard project he developed with artist Kent Monkman. Courtesy of Noel Wendt.

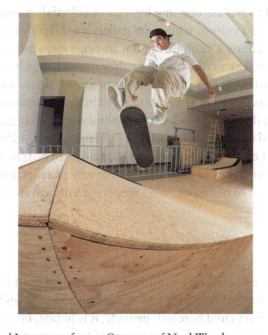

FIGURE 4.4: Micheal Langen performs. Courtesy of Noel Wendt.

through artistic expression, scholarly investigation and experimentation. The new Ph.D. recognizes that creation research can exhibit intellectual rigour while bringing new perspectives and synergies by combining critical reflection with the making of innovative art work. Although the new programme will appeal to artist researchers, it also recognizes and embraces non-traditional approaches, such as grounded, embodied, lived and community engaged research. The value of the new programme to our society is clear; it is to fully understand that traditional Western scientific methodology is only one way to understand the world around us and create new knowledge (Stecyk [2019).

Putting this into action, MAP is now attracting Indigenous graduate students into a unique fully funded programme linked with partner institution, the MacKenzie Art Gallery (MAG), a major regional player in the art scene in western Canada. Understanding that art galleries, as well as universities, must position themselves as open learning communities, not impenetrable centres of self-validating authority, MAP, in partnership with the MAG, is offering a series of internships at the Masters and Ph.D. level in Indigenous and new curatorial practices. Like universities, Canadian cultural institutions have long considered themselves above the fray of the political. However, the Calls to Action have thrown down the gauntlet and arts leaders are now confronted with an urgent question: how do galleries shift, in this moment of societal reckoning, to better reflect and align with the diverse populations they now serve? The main objectives in these internships are, equally, to attract new Indigenous students and to redress ongoing legacies of colonialism, especially the status of Indigenous art and culture within the gallery's exhibitions, programming and organizational structure. Decolonizing our institutions, universities and galleries alike is a significant way to illustrate how they must change how they view themselves, moving from being neutral custodians of knowledge to an understanding of how they perform as living entities administered by people with unconscious biases. The way we could do this is by adopting methodologies recognized as Indigenous ways of gaining and transferring knowledge – separate, and equally valuable systems of knowledge. As Leanne Simpson asserts, 'Canada will be transformed if we look to traditional knowledge as an entirely different way of generating knowledge, not simply useful content to be inserted into Western scientific frameworks' (2011: 32).

Conclusion

In Canada (and elsewhere), how cultures are portrayed must be foremost in our minds as we move toward achieving a more equitable, diverse and inclusive society. The creative initiatives cited here will provide, it is hoped, best practice in how to decolonize within the walls of the institutions of higher institutions of learning, by

helping to better understand and practice fair and accurate representation, sharing knowledges and, eventually, framing just economies in an equitable society. Canadians will benefit from this in fundamental ways. In 2016, the average total income of Indigenous people was 75 per cent that of non-Indigenous people – that's a 25 to per cent income gap (OECD iLibrary Figure 2.8). The way the mainstream has historically framed otherness within the ideational borders of this country is, in part, responsible for reinforcing injustices that keep minorities simply that. The representation of non-Europeans in ways that diminish their value as citizens is unsustainable. While many have begun to recognize what colonization has done, substandard housing and inequitable salaries remain its persistent legacy. When we can place the other inside the mechanisms that generate meaning (University, art gallery, stage, film and media), we begin to address the problem. To not do so, according to Kuokkanen, silences and makes invisible the reality of many Indigenous individuals. She writes, that our institutions, to a large extent, remain

> founded on epistemological practices and traditions that are selective and exclusionary and that are reflective of and reinscribed by the Enlightenment, colonialism, modernity, and, in particular, liberalism. [...] Even in the academic spaces that consider themselves most open to 'changing the paradigm,' individuals are often unwilling to examine their own blind spots. Nor are they willing to acknowledge either their privilege or their participation in academic structures and the various colonial processes of society in general.
>
> (2007: 1)

Correcting the disparity, according to Kuokkanan, is the work of those who have held the balance of power, not those who are colonized. She advocates for a shift in the institution's approach to cultural differences through a logic grounded in Indigenous philosophies. In this way, we may herald an era of post institutionalism, a term used to describe a similar realignment in art institutions, where the fixed structures and methodologies of exhausted institutions, according to Belgian curator, Ann Demeester, will end up as anachronistic bastions of marginality (forumpermanente.org).[8] A similar term, new industrialism, as coined by Scandinavian writer Jonas Ekberg and German curator Nina Montmann, points to alternative structures so designated due to their participatory, open and discursive nature (Demeester 1994).[9] The term is used to refer to a questioning within art institutions that values temporariness or provisionalism in regards to their structures and guiding principles. As curator and writer Simon Sheikh, says:

> The field of art has become a field of possibilities of exchange and comparative analysis. It has become a field for thinking alternativity, and can, crucially act as a cross

field, an intermediary between different fields, modes of perception and thinking as well as between very different positions and subjectivities. [...] the art institution not as the pillar of tradition and a stable social order, but rather as the producer of a certain instability, flux and negotiation.

(2004: 2)

Emergent curatorial practices thus aligned may help to question ingrained institutional norms in academia as it moves toward meaningful Indigenization. For this reason, MAP approaches with optimism its new link with the MAG and looks forward to shared dialogue around decolonization.

Policy and guidelines aside, some have advocated for de-institutionalizing beyond bricks and mortar. For example, Demeester questions,

Do we really need an art institution – with or without fixed abode or building – in order to deal with the pluriformity of experiences that visual art encompasses and generates or should we rather opt for a more fluid organizational form that fulfils a certain need at a certain point in time and after that disappears or morphs into another form?

(1994: n.pag.)

This proposal sounds radical in relation to the physical plant of the university, yet, as we are called upon to adapt higher education to new needs, should we not consider what might be gained by making the institutions walls more porous and open to other communities?

Looking to the performing arts for best practice, one has only to look at the new formations of the National Theatres of Scotland and Wales. The National Theatre of Scotland, established in 2006, has no theatre building of its own; instead it tours work to theatres, village halls, schools and site-specific locations, both at home and internationally. The National Theatre of Wales operates from a small base in Cardiff's city centre, and like its counterpart in Scotland, National Theatre Wales doesn't have a theatre space of its own: the nation is its stage. It is renowned for making work with local communities; site-specific productions; and in-depth engagement with communities. This sounds like grounded, embodied, experiential and community-engaged research: this sounds like an Indigenous approach. Do we truly have the inclination or means to shake the foundation of our academic institutions in parallel ways? The game changing circumstances of COVID-19 aside, what would it take to truly disturb the status quo to that degree?

Finally, one must ask how Indigenous people view attempts to Indigenize the University? From time to time, one experiences success in such discrete

initiatives as are here described. Degrees of success, in the cases cited, are measured by the number of students registered in a class; how many Indigenous community members come to campus, the general buzz at the events, press generated and casual feedback from the general public. On the other hand, one also reads about things that have gone wrong, conflict and resistance at institutions across the country where, at times, Indigenous individuals are seen as being outspoken for calling out embedded and systemic racism on campus, and for demanding equity for Indigenous students. Racism is persistent. It is still found in policies, attitudes and in, for example, the lack of Indigenous voices in venues such as the University senate. Undoubtedly, this has led to friction, with the result that certain individuals are framed as problematic. In an atmosphere in which Indigenous students and faculty are still sometimes harassed, such interactions are not conducive to moving towards an equitable division or power or a recognition that there are other ways of being in the world. But, as surely as racism persists, dialogue persists and where there is dialogue, there is, at the very least, the opportunity to perform Indigenization in a good and right way.

NOTES

1. Putatively attributed to both Sir John A. MacDonald, the first Prime Minister of Canada, and to Duncan Campbell Scott, who was responsible for the Canadian Residential Schools (Department of Indian Affairs 1913–32). Similar comments have also been ascribed to Scott: 'kill the Indian, save the man'. Reference to Duncan Campbell Scott's use of the phrase "take the Indian out of the child" is referenced in the National Archives of Canada, Record Group 10, vol. 6810, file 470-2-3, vol. 7, 55 (L-3) and 63 (N-3).). It is unknown if he is, infact, referencing Macdonald's stated policy.
2. The Indian Act - Consolidation of Indian legislation vol. 2: Indain Acts and amendments, 1868 – 1875, https://publications.gc.ca/collections/collection2017/aanc-inac/R5-158-2-1978-eng.pdf. Accessed 8 March 2022.
3. A good example of this is 'From Proscenium to Powwow: Introduction to Indigenous Performance'. Led by an award-winning powwow dancer, this course looked at tradition forms of movement within the context and history of Treaty Four Land, on which the University is located, and used a collective process to develop the foundation for a devised performance.
4. *Performing Turtle Island* (2015): A conference located at the University of Regina and First Nations University of Canada that brought together established and emerging scholars and artists in the form of a national symposium on how Indigenous theatre and performance are connected to Indigenous identity and community health. http://www.performingturtleisland.org. Accessed 28 June 2019.

5. Barbara Bolt (College of the Arts and Melbourne Conservatorium of Music) is a practising visual artist and art theorist who has written extensively on the visual arts and their relationship to new materialist thought. Bolt's 'Artistic research: A performative paradigm' (2016) posits a theoretical paradigm that addresses the agency, force, and generative potential of creative practice – 'its capacity to effect "movement" in thought, word and deed in the individual and social sensorium' (Barrett 2014: 3).
6. This quote was extracted from the artist's, Micheal Langan, formal proposal to the Michele Sereda Residency. It's used here with Langan's permission.
7. Quote from proposal, courtesy of the artist.
8. The term post-industrial is discipline specific and diversely inflected. Here the meaning is derived from sociology where its meaning implies a shift from focusing on practical knowledge to theoretical knowledge and a focus on new technologies – how to create and use them as well as harness them creatively.
9. This formation of the term 'new industrialization' implies notions of flexibility, adaptability, and temporariness rather than ideas that adhere to a more economic context, where, as Noah Smith writes: '"New Industrialism". Its sources are varied – they include liberal think tanks, Silicon Valley thought leaders and various economists. But the central idea is to reform the financial system and government policy to boost business investment' (cited in Walter 2016: n.pag.).

REFERENCES

Anon. (n.d.), *Performing Turtle Island Conference*, http://www.performingturtleisland.org. Accessed 23 October 2021.

Archibald Barber, J., Day, M. and Irwin, K. (eds.) (2019), *Performing Turtle Island: Indigenous Theatre on the World Stage*, Regina: University of Regina Press.

Barrett, Estelle (2014), 'Introduction: Extending the field: invention, application and innovation in creative arts enquiry', in E. Barrett and B. Bolt (eds), *Material Inventions: Applying Creative Arts Research*, London: I. B. Tauris, pp. 1–21.

Bolt, Barbara (2016), 'Artistic research: A performative paradigm', *Parse Journal*, 3 (Repetitions and Reneges), Gothenburg: University of Gothenburg.

Canadian Poverty Institute (n.d.), 'Poverty in Canada', https://www.povertyinstitute.ca/poverty-canada. Accessed 23 October 2021.

Chilisa, Bagele (2011), *Indigenous Research Methodologies*, London: SAGE.

Colonialism (n.d.), Micheal Langan's website, http://www.colonialism.ca. Accessed 21 October 2021.

Delgado, Richard and Stefancic, Jean (1993), 'Critical race theory: An annotated bibliography', *Virginia Law Review*, 79:2, pp. 461–516.

Demeester, Annnn (1994), 'Curating in the expanded field: Post-Institutionalism?', Forum Permanente, http://www.forumpermanente.org/event_pres/oficinas-de-curadoria/panorama-do-pensamento-emergente/curating-in-the-expanded-field-post-institutionalism. Accessed 27 June 2019.

Eshet, Dan (2016), *Stolen Lives: The Indigenous Peoples of Canada and the Indian Residential Schools*, Facing History and Facing Ourselves, https://www.facinghistory.org/stolen-lives-indigenous-peoples-canada-and-indian-residential-schools. Accessed 23 October 2021.

Hanson, Erin (n.d.), 'The Indian Act', Indigenous Foundations, https://indigenousfoundations.arts.ubc.ca/the_indian_act/. Accessed 28 June 2019.

Kuokannen, Rauna (2007), *Reshaping the University: Responsibility, Indigenous Epistemes, and the Logic of the Gift*, Vancouver: UBC Press.

L'Hirondelle Hill, Gabrielle and McCall, Sophie (2015), *The Land We Are*, Winnipeg: Arp Books.

McLachlin, B. (2015), *Reconciling Unity and Diversity in the Modern Era: Tolerance and Intolerance*, The Global Centre for Pluralism, Aga Khan Museum, Toronto, Ontario, 28 May, https://www.pluralism.ca/wp-content/uploads/2017/10/APL2015_BeverleyMcLachlin_Lecture.pdf. Accessed 21 October 2021.

National Inquiry into Missing and Murdered Indigenous Women and Girls (n.d.), *Reclaiming Power and Place: The Final Report into Murdered and Missing Indigenous Women and Girls*, https://www.mmiwg-ffada.ca/final-report/. Accessed 23 October 2021.

OECD iLibrary (2016), 'Chapter 2. Profile of Indigenous Canada: Trends and data needs', *Linking Indigenous Communities with Regional Development in Canada*, https://www.oecd-ilibrary.org/sites/e6cc8722-en/index.html?itemId=/content/component/e6cc8722-en. Accessed 23 October 2021.

Rancière Jacques (1991), *The Ignorant School Master*, Redwood City: Stanford University Press.

Scow, Alfred (1992), 'Royal commission of Aboriginal peoples: Presentation by Alfred Scow', 26 November, pp. 342–5, http://scaa.sk.ca/ourlegacy/permalink/30466. Accessed 22 March 2022.

Sheikh, S. (2004), 'Public spheres and the functions of progressive art institutions', Transversal Texts, European Institute for Progressive Cultural Policies, https://transversal.at/pdf/journal-text/832/. Accessed 6 March 2022.

Simpson, Leanne (2011), 'Commit to and respect Indigenous knowledge—Before it's too late', *Biodiversity*, 3:3, pp. 32–32, https://doi.org/10.1080/14888386.2002.9712600. Accessed 21 October 2021.

Stecy, Therese (2019), 'New PhD expands boundaries in research creation and opens doors to Indigenous scholarship in post-truth and reconciliation period', 10 January, University of Regina, https://www.uregina.ca/external/communications/feature-stories/current/2019/01-10.html. Accessed 21 October 2021.

The Truth and Reconciliation Commission of Canada (2015a), *Final Report on Truth and Reconciliation*, https://ehprnh2mwo3.exactdn.com/wp-content/uploads/2021/01/Executive_Summary_English_Web.pdf. Accessed 23 October 2021.

The Truth and Reconciliation Commission of Canada (2015b), *Truth and Reconciliation Commission of Canada: Calls to Action*, https://www2.gov.bc.ca/assets/gov/british-columbians-our-governments/indigenous-people/aboriginal-peoples-documents/calls_to_action_english2.pdf. Accessed 23 October 2021.

United Nations (2007), *United Nations Declaration on the Rights of Indigenous People*, https://www.un.org/development/desa/indigenouspeoples/wp-content/uploads/sites/19/2018/11/UNDRIP_E_web.pdf. Accessed 23 October 2021 [no longer available].

University of Regina (2015), *University of Regina Strategic Plan 2015–2020*, 9, https://www.uregina.ca/strategic-plan/assets/docs/pdf/sp-2015-20-together-we-are-stronger.pdf. Accessed 23 January 2021.

Walter (2016), 'The new industrialism', Nonrival, 16 February, https://nonrival.pub/2016/02/16/the-new-industrialism/. Accessed 23 May 2022.

5

Foolish White Men: Tree-Felling and Wrestling: Performing the Institution of the White Man from an Aotearoa Perspective

Mark Harvey

To be strong is the aim of all men; to make them strong is our aim ...

(Caption from 1900s New Zealand newspaper advertisement for 'Dr McLaughlin's Electric Belt' aimed at a Pākehā male audience cited in Phillips 1996: 99)

I don't know what feminism means.

(Bill English, former Prime Minister of New Zealand, cited in Jones 2016: n.pag.)

The world does not need white people to civilize others. The real White People's Burden is to civilize ourselves.

(Jensen 2019: n.pag.)

In thinking about the western societal notion of the 'institution of the white man', I come to this as a Pākehā (mainly British/European) and Māori (Mātāwaka) male artist working in performance, born and living in Aotearoa/New Zealand.[1] I approach this particularly from my Pākehā cis male positioning due to growing up in this terrain of cultures and what is widely considered cultural privilege.

Through my art and performance practice, for the past 27 years, I have often been reflecting on this instutionality in terms of power dynamics, psychologies and identity constructions of white men in my country through my art practice, with critical thinkers such as Judith Butler (1993, 1997) and Michel Foucaut (1994).[2]

There is still much to do in terms of healing our ongoing colonial and gender power imbalances, collective trauma and stereotypical abuse in Aotearoa. It is part of a wider international pattern that Robin Diangelo notes, where White men have been holding on to institutional power in all areas of Anglo society generally speaking since global colonization began (2018: 1–22). The way many Pākehā have coped over our recent extremely traumatic Ōtautahi/Christchurch terror act with denials over our contributions to longstanding racist and colonial dynamics, shows to many that racism is still widely considered to be alive and well and growing across our Pākehā male-styled institutions (Aslani 2019; Jackson 2019). I refer to institutions here as the dominant cultural norms that are widely considered to be usually based on Pākehā and/or European and patriarchal value systems and codes of behaviour, including government agencies and most private organizations. Such institutional status quo power dynamics in Aotearoa continue unabated resulting in inequality based on ethnicity and gender for anyone who is not white and male, such as statistics in education, wealth and positions of power throughout Anglo western nations (Robinson 2017). This is situated in relation to the well-known increase in the influence of what can be seen as a minority of angry white men attempting to wrestle even more power off others. Besides this being well-known to occur locally throughout mainstream media such as talkback radio, we saw it daily in our lives with the likes of Donald Trump's presidency and his subsequent behaviour, Brexit and the rise of ultra-right white supremacy throughout the West (fuelled by the corporate influences of social media and Public Relations companies; Cadwalladr 2019).

In this chapter, I will reflect on some of my live performances that have attempted to respond to the institution of the white man in Aotearoa and related Western contexts. The works I discuss below include *Weed Wrestle* (2016-17b) and *Group Weed Wrestle* (2016–17a), *Climate Recycling Privilege* (2019) and *Political Climate Wrestle* (2013–16). Each one of these performances has an environmental focus, while engaging with notions of productive idiocy through acts of physical labour to play on the role that institutional white masculinity has on ecology that has been influenced by Friedrich Nietzsche in terms of the potentialities with playing the fool ([1882] 2001).[3] For me, from a social ecological perspective, power, culture, identity construction and many other things like economics, inequality and privilege are all interconnected in relation to how we impact on the environment (such as Klein 2014; Piketty 1997, 2016). For instance, just as with Australia, Canada and the US, it is well-known that the most powerful and

FOOLISH WHITE MEN

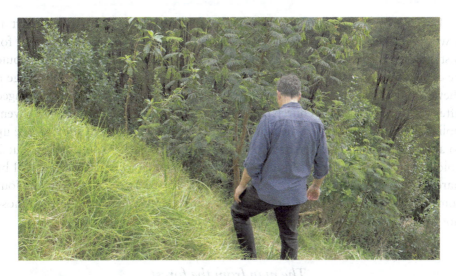

FIGURE 5.1: Mark Harvey, 2016–17, *Weed Wrestle*. Video still by Daniel Strang. Courtesy of Harvey/Strang.

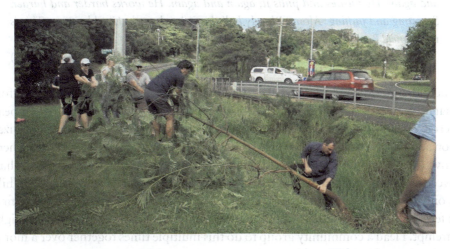

FIGURE 5.2: Mark Harvey, 2016–17, *Group Weed Wrestle*. Video Still. Camera by Daniel Strang. Courtesy of Harvey/Strang.

economically privileged CEO's and corporate shareholders in Aotearoa who are white men tend to ignore warnings on climate change and ecological collapse by investing in natural resource extraction and fossil fuel related industries, such as Tallies Fishing Industries and the oil companies with their fracking in Taranaki.

Until recently, from my own experience, talking about white men via art as a white man has not been so fassionable in local Aotearoa contexts with, for instance, friends of mine perhaps rightly questioning why I as a White man should be commenting on my demographic, as it is harder to examine one's privilege if they like I reside in that central position of power (Bhabha 1994). This has changed after events like the Chirstchurch terror attacks. But as the psychotherapist Gwendoline Smith (1990) some time ago implied, we white men have a lot to face up to and deal with still in Aotearoa. As many cultural thinkers have long argued, colonization and dominant modes of racism in Aotearoa and the West will be harder to redress if they are not explored and discussed, no matter how obvious some of these issues might at first appear to be to some of us, especially to those not associated with dominant White male circles of power.

The man from the forest

He sees a tree, stops and considers it. He takes it by the hands. He rustles it, again and again. He pushes and pulls it, again and again. He works harder and harder. Sweating and puffing. Alone. Bloody hell this is hard work. Until he wins. This is what uncle Bert used to do. On his own.

(Harvey 2016, Journal notes on *Weed Wrestle*)

The video performance *Weed Wrestle* (2016–17b) and subsequent live performance *Group Weed Wrestle* (2016–17a) can be seen to offer what may appear heroic and nationalistic, yet also attempts to question the status quo of colonization and Pākehā patriarchy. Around the Waitakere subtropical forest ranges where I live (West Auckland), I perform the arduous task of pulling out an Australian 'weed-pest' tree Acacia (Wattle tree) with my bare hands in *Weed Wrestle*. While it only lasts for twelve minutes, it seems to take forever for me, with how at first it feels like an impossible task that perhaps only 'the craziest' macho men might attempt. I lead a community group to do this multiple times together over a morning in *Group Weed Wrestle*.

With *Group Weed Wrestle*, by leading a group of volunteers from a range of demographics (Māori, Pākehā, female, male, young and old), to barehandedly pull out these Wattle trees, I attempt to explore the stereotype of how so often when working with others, it is the White man who 'has the say' over the situation. Like vigilantes who share 'a lot of laughs' (humour) in our task, we travel from location to location around our forest suburbs of the Waitakere ranges collectively pulling out Wattle trees. For me, this serves as a metaphor for how Pākehā male institutions in our country and internationally continue to spread out and

colonize indigenous habitats that we encounter. Historic and current local and central government and corporate landgrabs for housing developments that are led by white men for the rich on nearby Māori iwi (tribal) lands in Ihumatao in Mangere, Tāmaki Makaurau/Auckland (SOUL 2019) are examples of this. It is also not only just our group's actions as 'my' agents of colonization but also the roads we traverse in our forest that continue to serve to colonize these spaces by serving as corridors for invasive weeds to travel, as is well known in local conservationist/ecology circles (Craw 2015).

In *Weed Wrestle*, I reflect on the New Zealand seminal book *Man Alone* by John Mulgan ([1939] 1990). Mulgan portrays a heroic white man who amongst other things leaves civilization and 'toughs it out' alone by living off the land in a lush and rugged native Aoteroa forest. It is often associated with the nationalist Pākehā male macho stereotype, with its 'stiff-upper-lip', lack of emotional expression, heroic ideals and incessant bigotry and misogyny, so dominant here in my rugby-shaped up-bringing around construction sites and populist white male-dominated mass media. While playing with asserting symbolic nationalist independence from Australia by removing one of its trees that is classified on the national NZ invasive pest-plant list (Williams and Timms 2016), I am simultaneously attempting to play on what E. H. McCormick calls the national literary tradition of the heroic 'solitary, rootless nonconformist, who in a variety of forms crops up persistently in New Zealand writing' (Benson [1999] 2016).[4] This myth can be seen as a symbol of colonization, both from ages gone by and current times in Aotearoa. And, in my pale male skin, I am attempting to question this myth of the heroic colonizing 'man alone'.[5] Pulling a tree out bare-handed in order to play on my embodied position of power in Michel Foucault's sense (1994) might just look 'pretty stupid' to some, not unlike this myth of the white male hero. I can be seen in Judith Butler's terms (1993, 1997) to be attempting to reinforce my interpellation as a white man in Aotearoa, in that without performing such acts of attempted heroics I might not see myself as one (in the image of my colonial white-male forbears). The potential idiocy of my act is intended by me to highlight the fraught absurd identity construction of this myth that is still so often a dominant discourse for us white men in Aotearoa. As many like Jock Phillips (1996) and Gwendoline Smith (1990) show in their writing, despite holding power in NZ society, there is a fragility to the identity construction around white masculinity. Questioning this man-alone myth through bare-handed tree-pulling might offer ways to examine the power we hold by implying there might be other ways to construct our identities, where an act can simultaneously be seen to invoke that which it is not, what Jacques Derrida refers to as *différance*.[6]

A dark cloud can be seen to hang over this reference point to *Man Alone*, whereby it has long been associated with all forms of bigotry, aggression, bullying

and the mistreatment of women and domestic violence (with statistics in my country generally backing this up; Smith 1990). Barry Crump, a famous Pākehā male author and major proponent of this heroic myth was well known to 'turn the other cheek' on this, and publicly accused of being a domestic bully himself often, even by his own wives (Nippet 2009). There appears to have been a significant rise in famous national rugby heroes abusing women in recent years, as every few months another case of this hits the mainstream headlines (Piddington and Sharpe 2016). In another example that has left much of the country in disbelief and disgust, Bill English, formerly Prime Minister of New Zealand, publicly stated, 'I don't know what "feminism" means' (Jones 2016: n.pag.). One could easily draw parallels here with the politics of Donald Trump and 'toxic masculinities' throughout the Anglo speaking world.

Market sensibilities

How are ya? Have y'got any rubbish? I'm collecting rubbish. Would you like me to take your rubbish for you?
(Harvey 2019, *Climate Recycling Privilege,* spoken text from performance)

In *Climate Recycling Privilege*, I crawl for a long time on all fours with a plastic box tied to my back in the Avondale Sunday Market. I politely greet hundreds of passersby and ask if I can collect their rubbish, or if they can place pieces of trash into my box. It is a continuous yet steady flow of interactions. With its very mixed demographics, white people are a very tiny minority at this market. Beneath various issues surrounding the current contentiousness of the way rubbish and recyclable material is and is not processed in Aotearoa, I am interested in how privilege, culture and gender can be experienced in this performance.

I am interested in what it might mean to operate on a physically lower level as a white man than those who face continual colonization by us (White men) on a day-to-day basis. In line with local stereotypes, 'we would never see a white man crawling on the ground' providing a rubbish collection service. Invariably when we see low-paid service workers in Aotearoa such as cleaners and rubbish truck drivers, they are never white men.[7] I propose a question through this performance: what might occur if someone (me) who holds institutional power (as a White man) attempts to test out promises of subservience in contrast to institutional stereotypes? I attempt to play the fool through performing what can be seen as an absurd action that tugs at my position of power in this market place, whereby a sense of idiocy here might reveal reflections on associated power dynamics of class and demographics.[8]

FIGURE 5.3: Mark Harvey, 2019, *Climate Recycle Privilege*. Video still by Daniel Strang. Courtesy of Harvey/Strang.

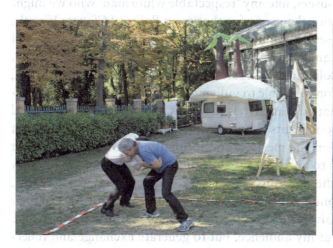 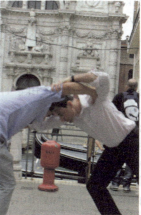

FIGURE 5.4: Mark Harvey, 2013, *Political Climate Wrestle*. Photograph by Paolo Rosso. Courtesy of Harvey/Rosso.

A wide range of people respond in various ways to me – most commonly in what appears to be expressions of concern at first on the faces of Polynesian/Pasifika, Chinese, Indian and Pakistani passersby at seeing *me* serve *them* for

a change. A handful even ask me about what I am doing and if I am okay, and they very generously tell me how they feel. I let them know I feel okay and quite comfortable and that my knees are bandaged underneath my pants. One women buys me a pair of two-dollar gloves and insists that I wear them. I can't say no. Most passersby eventually laugh politely. Perhaps, it is as though they have a chance to laugh at a white man for a change? Perhaps, they and I have a chance to laugh and temporarily relieve ourselves as a kind of return of our cultural and political repression in this Chicago Neoliberal meritocratic white-man-run corner of the world. To phrase this in other terms, this performance can be seen to reveal how expectant many might be of the dominant modes of inequality in Aotearoa, where Pākehā men are usually still the wealthiest (Anderson et al. 2015).[9]

A White man's climate

Ok, here's the rules. No punching, kicking, scratching or biting.
— (Harvey 2013, *Political Climate Wrestle*, spoken text from performance)

Dressed in a shirt and trousers, like any 'respectable white man' who we might take seriously as a professional person of authority, in *Political Climate Wrestle*, over the last five years in several countries, I have been arguing with members of the public about politics and climate change and wrestling with them. Usually, it begins with the act of soliciting like a salesman, a shake of the hands, a smile, a greeting and an invitation to people to individually join me to argue and wrestle. I am perhaps like 'that guy' at parties that tries hard to start up awkward conversations that everyone wants to avoid. Some say no. The rejection is part of it, it's a tough world in the meritocratic football field of business. Most say yes. Some last for up to an hour. 'I play requests' – I only go as far as they want to. I always take the opposite side of an argument of my participants. My rugby and holistic contemporary dance background helps me to read their physical impetus. But, I always lose each wrestling match. I'm often flattened. My purpose is not to beat my audience, but to generate exchange and reflections with them.

While *Political Climate Wrestle* might promise action about climate change, it can only ever *promise* its promises at the most.[10] In my business attire, I appear as a subject of what Louis Althusser calls a 'state ideological apparatus' (1971). In this way, I attempt to play on the bureaucratic way in which so many institutional white-man-dominated committees and corporate boards are well-known to have long-endorsed climate change causing activities but play lip service to

dealing with the issue. They are usually considered to rubber-stamp the problem with promises but no solutions or preventions. For instance, the New Zealand government that mainly consists of white men, despite the new Prime minister (a Pākehā woman) stating it will go carbon neutral soon and yet it has approved more oil extraction than ever and fossil fuel emissions are higher than ever in this country (Mohanlall 2019; Larsson 2019). In the performance, I am too busy trying to oppose my participant, rather than thinking about fixing the world. Perhaps, this is reminiscent of the Westminster style parliament with its adversarial structure that has members of 'the house' more focussed on 'fighting' the opposing the party on the other side, where speeches have been set at two sword-lengths away from other MP's (Morris 2017), rather than working with them to find solutions. Will the White man's wrestle ever save us? On the other hand, this could be a chance to wrestle a white man and pin him down. People normally walk away laughing. Beyond the potential problematics of minimizing the impacts of white male privilege on our world though humour with the public I intend to stimulate reflection on it. What strikes me is how most participants, including other white men want to hang around afterwards and discuss with me issues that come to mind for them. Despite my cynicism about my cultural position (my Pākehā side that is), it brings me hope.

Closing excuses and alibis

If we don't listen to the sound of the motor, we won't be able to fix it.
(My grandfather, personal conversation in teaching car maintenance, Harvey 1990)

These four performances are but small attempts at reflecting on the power and privilege of White male institutionality in Aotearoa, the West and its environmental topics. Each of these works attempts to activate notions of socially engaged art that transgress by tugging at colonial institutional White-male behaviours in Aotearoa. I think here of my grandfather's advice about repairing car engines in our garage when I was a boy and how he advised listening to the engine. While my efforts here may not save us from all of this, through my actions I intend for my audiences and publics to continue to hopefully listen to and face up to the dominant role of us (White men) in current societal power dynamics, inequalities and environmental destruction – especially White male viewers. This is so that maybe, just maybe we can reorganize, listen and share power equally in order to repair our acts of colonisation (Tuhiwai Smith 1999).

NOTES

1. The term Pākehā also refers to one being 'in relation to Māori' but not Māori, which always acknowledges the colonial dynamics of Aotearoa in terms of the relationship of White British people to Māori. It can also be seen to acknowledge that all of us still reside on Māori iwi (tribal) whenua (land), in line with Te Tiriti o Waitangi (the Treaty of Waitangi, from iwi/ Māori perspectives). From a kaupapa Māori perspective (or Māori perspectives on life and knowledge), a person who is part Māori is considered *Māori*, rather than part *Māori*, which can be seen to be an example of the inclusivity of kaupapa Māori (Tuhiwai Smith 1999).
2. I read the constructions of identity and power politics in relation to being Pākehā male through Judith Butler's (1993: 117, 12–14, 1997: 106–07; Kirby 2006: 86–107) writings around identity performativity, for instance the interpollation into either being or *being in relation* to White men and what can it mean to attempt to challenge and potentially transgress it. I also add to this reflections on Michael Foucault's (1994) thoughts on power, its embodiment, and how power shifts when we try to see it and how it can be destructive and productive.
3. More specifically, I combine here readings of Friedrich Nietzsche's *Gay Science* ([1882] 2001), spiced with Michael Foucault's (1994) thoughts on power, whereby a sense of productive idiocy within live art can potentially offer ways to reflect on White masculinity. Influencing this is Maurice Blanchot's notion of worklessness (1988, 1999) – is this work or uselessness? I note also that Niietzsche has at times been well-known to be cited by the white supremacists like anti-feminists and anti-trans gender proponents like Jordon Peterson, however, I aim to reflect on his writing for opposite reasons, towards detoxifying bigotry of various kinds.
4. This myth in my experience is very much alive in current Chicago neoliberal-influenced times in Aotearoa where meritocracy rules throughout mainstream media and government institutions (Marcetic 2017). That is, one does not 'get ahead' if he/she/they do not work hard and calve out their own patch of territory and 'there's no excuse for not doing this', and yet as implied above a number of statistics show this is not working for our Indigenous peoples and women in locations like the workplace, as noted throughout NZ and much Western mainstream media in the last four years (Cooke et al. 2007; Harris and Williams 2015; OECD 2017).
5. It is no coincidence that many of my ancestors were actively involved as early Pākehā/British colonizers as soldiers, settlers and missionaries, with many of my male ancestors clearing native forests and contributing to ecological destruction to make way for farming around our country in the nineteenth century.
6. This can be seen to be in line with Jacques Derrida's notion of *differánce* where an object of writing, art or other cultural practice traverses continuously and fluidly through that which it is named as, that which it is not and neither and both simultaneously (1982a: 8–9, 374, 1982a: 317, 322–27).

7. I also draw inspiration from William Pope.L's crawls whereby he plays on the stereotype of the heroic African-American man who works in the 'lower depths of the city', crawling around an urban landscape while performing menial occupational job (Lepecki 2006; I note that Pope.L and I developed crawling works simultaneously, in my case with my plunger crawls dressed in 'cricket whites', such as *In the Round* [2005}, but I still think here of his efforts and my sense of stereotypical privilege).
8. In this sense, I reflect back on this action through Friederich Nietzche's *Gay Science* ([1882] 2001) where playing the fool can be a form of experiementing or testing out of concepts, in this case, cultural and political norms.
9. I refer to the neoliberalism here as Chicago Neoliberlaism influenced by Milton Friedman and the Chicago School of the Economics of the 1970s and 1980s, which called for market processes to dominate economies and society, with the role of the state being reduced to the point it has no power or control over market forces, just as many authors such as Paul Verhaeghe (2014) note. It is a school of theory that has influenced Aotearoa's governments since 1984, with the generally known term 'Rogernomics' in line with other Anglo countries, such as 'Raganomics' and 'Thatcherism'.
10. This can be seen to apply Nietzsche's *Gay Science* ([1882] 2001), where he calls for experimentality in art and science to involve promising.

REFERENCES

Althusser, Louis (1971), *Lenin and Philosophy and Other Essays*, London: New Left Books.

Anderson, Atholl, Binney, Judith and Matutina Williams, M. (2015), 'Introduction', in A. Anderson, J. Binney and A. Harris (eds), *Tangata Whenua: A History*, Wellington: Bridget Williams, pp. 1–8.

Aslani, Shamim (2019), 'My mother is Māori. My father is Iranian. I can tell you what New Zealand is', *The Spin Off*, https://thespinoff.co.nz/society/25-03-2019/my-mother-is-maori-my-father-is-iranian-i-can-tell-you-what-new-zealand-is/?fbclid=IwAR1AoPhDINMw8qiVg09U4LWwMYPqhNn9X2bWOEQmDVn9fPPhNlOH5A5sbj4. Accessed 21 June 2019.

Benson, Dale ([1999] 2016), *New Zealand's Existentialist Men Alone: A Survey of Their Development from the 1890s until the 1970s*, http://www.otago.ac.nz/deepsouth/1198/MenAlone.html. Accessed 21 June, 2019.

Bhabha, Homi K. (1994), *The Location of Culture*, New York: Routledge.

Blanchot, Maurice (1998), *The Unavowable Community* (trans. P. Joris), Barrytown: Station Hill Press.

Blanchot, Maurice (1999), 'The essential solitude', in G. Quasha (ed.), *The Station Hill Blanchot Reader: Fiction and Literary Essays: Maurice Blanchot*, New York: Station Hill.

Butler, Judith (1993), *Bodies That Matter: On the Discursive Limits of 'Sex'*, New York: Routledge.

Butler, Judith (1997), *The Psychic Life of Power: Theories in Subjection*, Stanford: Stanford University Press.

Cadwalladr, Carole (2019), 'Facebook's role in Brexit — And the threat to democracy', *TED2019*, https://www.ted.com/talks/carole_cadwalladr_facebook_s_role_in_brexit_and_the_threat_to_democracy/transcript?language=en. Accessed 21 June 2019.

Cooke, Martin, Mitrou, Francis, Lawrence, David and Guimond, Eric (2007), 'Indigenous wellbeing in four countries: An application of the UNDP'S Human Development Index to Indigenous Peoples in Australia, Canada, New Zealand, and the United States', *BMC International Human Rights*, 7:9, https://www.ncbi.nlm.nih.gov/pmc/articles/PMC2238768/. Accessed 21 June 2019.

Craw, Jack (2015), *Waitakere Ranges Strategic Weed Management Plan*, Auckland: Auckland Council.

Derrida, Jacques (1982a), *Margins of Philosophy*, Chicago: Chicago University Press.

Derrida, Jacques (1982b), *Writing and Difference* (trans. Alan Bass), New York: Routledge.

Diangelo, Robin (2018), *White Fragility: Why It's So Hard for White People to Talk About Racism*, Boston: Beacon.

Foucault, Michel (1994), 'Governmentality', in J. Faubion (ed.), *Michel Foucault: Power*, New York: New Press, pp. 201—22.

Harvey, Mark (2013–16), *Political Climate Wrestle* [Live performance], The Maldives Caravan Show, *55th Venice Biennale for Visual Arts*, Venice [also presented in galleries in Spain, Poland, USA, Australia, New Zealand and The Netherlands; first performed 15–30 September].

Harvey, Mark (2016–17a), *Group Weed Wrestle* [Live performance], Te Uru Gallery, Auckland, 2 November 2016–28 February 2017.

Harvey, Mark (2016–17b), *Weed Wrestle* [Video], Te Uru Gallery, Auckland, 8 September 2016–28 Februay 2017.

Harvey, Mark (2019), *Climate Recycling Privilege* [Live performance], EcoWest Festival, Avondale Market, Auckland, 15 April.

Jackson, Moana (2019), 'The connection between white supremacy and colonisation', *E-Tangata*, 24 March, https://e-tangata.co.nz/comment-and-analysis/the-connection-between-white-supremacy/?fbclid=IwAR3fIVjjOEN2QkinWfXCogg_k5HkFGDSSmuinvzFKDW-4gHklBlbXMjSPVHE. Accessed 21 June 2019.

Jensen, Robert (2019), 'The heart of whiteness: confronting race, racism, and white privilege', Goodreads, https://www.goodreads.com/quotes/tag/white-privilege. Accessed 21 June 2019.

Jones, Nicholas (2016), 'Bill English: I don't know what "feminist" means', *The New Zealand Herald*, https://www.nzherald.co.nz/nz/bill-english-i-dont-know-what-feminist-means/5NRU2Q7ZEYXA2V6ETS7P6WZR5E/. Accessed 21 June 2019.

Kirby, Vicki (2006), *Judith Butler: Live Theory*, London: Continuum.

Klein, Naomi (2014), *This Changes Everything: Capitalism vs. The Climate*, New York: Simon and Schuster.

Larsson, Amanda (2019), 'OMV's drill plan reveal on NZ's oil ban anniversary disgraceful', *Greenpeace New Zealand*, https://www.greenpeace.org/new-zealand/press-release/nz-drill-plan-reveal-on-oil-ban-anniversary-is-disgraceful/. Accessed 21 June 2019.

Lepecki, Amanda (2006), *Exhausting Dance: Performance and the Politics of Movement*, New York: Routledge.

Marcetic, Branko (2017), 'New Zealand's neoliberal drift', *Jacobin*, https://www.jacobinmag.com/2017/03/new-zealand-neoliberalism-inequality-welfare-state-tax-haven/. Accessed 21 June 2019.

Mohanlall, Samesh (2019), 'Aoraki development signs barque memorandum of understanding with New Zealand oil and gas', *Stuff*, 10 April, https://www.stuff.co.nz/timaru-herald/news/111913600/aoraki-development-signs-barque-memorandum-of-understanding-with-new-zealand-oil-and-gas. Accessed 21 June 2019.

Morris, Hugh (2017), 'The seven secrets of the Houses of Parliament (which you won't learn on its new virtual tour)', *The Telegraph*, https://www.telegraph.co.uk/travel/destinations/europe/united-kingdom/england/london/articles/house-of-parliament-launch-new-virtual-tour-weird-facts-history/. Accessed 21 June 2019.

Mulgan, John ([1939] 1990), *Man Alone*, Auckland: Penguin.

Nietzsche, Friedrich ([1882] 2001), *The Gay Science: With a Prelude in German Rhymes and an Appendix of Songs* (ed. B. Williams; trans. J. Nauckhoff and A. Del Caro), New York: Cambridge University Press.

Nippet, M. (2009), 'A good keen pension plan', *The New Zealand Herald*, http://www.nzherald.co.nz/new-zealand/news/article.cfm?l_id=71andobjec- tid=10594516. Accessed 21 June 2019.

OECD (2017), *The Pursuit of Gender Equality: An Uphill Battle*, Paris: OECD, http://www.oecd.org/gender/the-pursuit-of-gender-equality-9789264281318-en.htm. Accessed 21 June 2019.

Phillips, Jock (1996), *A Man's Country? The Image of the Pākehā Male – A History*, Auckland: Penguin.

Piddington, Stu and Sharpe, Marty (2016), 'New Zealand Rugby investigating sexual assault allegations', *Stuff*, 12 October, http://www.stuff.co.nz/sport/rugby/85274931/New-Zealand-Rugby-investiga- ting-sexual-assault-allegations. Accessed 21 June 2019.

Piketty, Thomas (1997), *The Economics of Inequality*, London: Belknap Press.

Piketty, Thomas (2016), *Chronicles: On Our Troubled Times*, London: Penguin.

Save Our Unique Landscape (SOUL) (2019), 'Protect Ihumatao', https://www.protectihumatao.com/. Accessed 21 June 2019.

Smith, Gwendoline (1990), *Will the Real Mr New Zealand Please Stand Up?*, Auckland: Penguin.

Tuhiwai-Smith, Linda (1999), *Decolonizing Methodologies*, New York: Zed Books.

Verhaeghe, Paul (2014), *What About Me: The Struggle for Identity in a Market Based Society*, Victoria: Scribe.

Williams, P. A. and Timms, Susan (2016), 'Weeds in New Zealand protected natural areas: A review for the Department Of Conservation', *Science and Research Series*, 14, http://www.doc.govt.nz/Documents/science-and-technical/SR14.pdf. Accessed 21 June 2019.

ACT THREE

ACT THREE

6

Performing Aural and Temporal Architecture: Re-framing the University through The Verbatim Formula

Maggie Inchley, Paula Siqueira, Sadhvi Dar,

Sylvan Baker and Mita Pujara

The photo is like a visual echo of the vocal performances.

(Paula Siqueira 2018)

Can the university listen?

The marketization of the UK university sector has led to changes in the ways that students and staff are identified and addressed. Students are reconfigured as 'consumers' demanding 'value for money', while academics turn into 'knowledge workers' competing for resources and funding. Within this competitive marketplace, where success is measured by metrics and league tables, historical inequalities remain entrenched (McQueen 2014). High A-level tariffs to enter elite universities reproduce the structural inequalities of the UK's school system, continuing to make it more likely that pupils with a private education, for example, meet the requirements.[1] Students and staff racialized as white perform the best, outpacing their counterparts in terms of degree attainment, pay, promotions and numbers of professors. Students and staff of colour, on the other hand, face disproportionate levels of exclusion, bullying and disciplinaries. As degree costs have escalated, the

rhythms of study have failed to adapt to those individuals who need to work and those with complex needs. A fivefold increase in disclosure of mental health conditions by students over the last ten years reflects the urgency of providing a caring environment (IPPR 2017). Given that blatant forms of inequality persist despite what the market might have 'corrected', can the marketized university listen to excluded and marginalized communities?

In this complex terrain, an applied theatre research project called The Verbatim Formula (TVF) based at Queen Mary University of London (QMUL) sets out to unsettle the university's belief in its own meritocracy by performing the voices of some of the most marginalized student cohorts in the university's Senior Common Room (SCR). This is an elegantly furbished space provided to staff for rest and recreational purposes, though it is predominately used for work-related meetings. Students, under normal circumstances, are barred, their voices unheard within its walls. The aural and temporal architecture' of the SCR, we suggest, is both embodied and symbolic, performing the exclusions and privileges, as well as the pressures that drive the university's market-led agenda. Following Nirmal Puwar, who explores what happens when bodies which are not the 'somatic norm' occupy places that are not 'reserved for them', we argue that research that works with marginalized stakeholders can temporarily and meaningfully reconfigure the aural architecture of the university according to pedagogical and curatorial values that are responsive to those voices that are excluded or heard, in most circumstances, only according to dominant transactional frameworks (Puwar 2004: 1). By 'aural architecture', we are referring to the norms of institutional life that determine whose voices are heard and on what terms. The staging of these norms reveals the institutional values that also regulate its use of resources, space and time. The photographs that we include here to illustrate our research practices were taken during an event hosted by TVF that marked the launch of the project's *Making Places* (2018) guide.[2] This is a handbook for university workers written by the TVF research team. In addition to giving guidance on inviting young people with experience of living in state care onto campus, *Making Places* provides a methodology that includes these young people in research that uses applied theatre techniques to create alternative evaluations of university services. In contrast to the reporting and statistical analysis commonly deployed to measure and assess university 'performance', TVF's approach is performative, staging space and time for meaningful dialogue amongst all who are present.

Somatic trespassers

TVF works with care-experienced young people by positioning them as co-researchers who have an inviolable set of skills and knowledge about how

they are marginalized or excluded from places and scenes of power. As a cohort of young people who are severely disadvantaged in terms of access to higher education,[3] they are in Puwar's terms, not only visitors to the university but also 'trespassers', who bring voices and testimonies into spaces where they are not normally heard (2004: 8). In Figure 6.1, TVF facilitator Shona, herself a care leaver, is listening to one of the project's collection of recorded testimonies that has been uploaded onto an iPod.[4] She is getting ready to speak the interviewee's words in real-time; attending to the tonality, affect and rhythm of the testimony about the dehumanizing effects of the care system on young people's capacities to thrive. The photograph is staged by the project's documentarian, Paula Siqueira, a visual ethnographer. Siqueira distils in visual form, how TVF temporarily rearranges the aural architecture of the institution by re-staging the aural and spatial norms that frame institutional life. The embodiment of testimonies from young people who are often racialized as non-White, their voices mediated by TVF's performers who at times also share similar histories, draws attention to those bodies who are excluded from the university's spaces or whose experiences are stigmatized within them.

Disrupting space with performed evaluations is both a visual and aural politics. In the UK, universities have been made exclusive by invoking (and evoking) Eurocentric histories that celebrate real or imagined associated alumni. As Puwar argues, drawing on Franz Fanon, institutional spaces are sedimented with 'historic-racial schema' (2004: 41). The SCR at QMUL is part of a process of self-legitimation, centring a large eighteenth-century style painting of a woman racialized as white, framed with gold coloured curlicue (see Figure 6.1). The painting seems intended to commemorate QMUL's history of educating (White) women, yet it is this commemoration that censures more undesirable aspects of its operations and past. In university marketing material, this censuring makes space for glossy brochures filled with images of carefully selected Black and Brown faces, accompanied by tag lines, mottos and a rhetoric of 'social justice', 'equality' and 'diversity'. While designed to reassure prospective customers of the university's liberal and inclusive principles, as Sara Ahmed notes, these tropes are more often than not used to provide camouflage for institutional Whiteness (2012: 66).

Listening as solidaristic practice

Marketization that is underpinned by liberalism reduces the voiceability of critique, and as such communicating experiences that fall outside established norms is positioned as an attack or a form of dissent against a well-meaning

elite. Testimonies representing an experience outside the acceptable spectrum of university life can be identified as dangerous. TVF, by contrast, is framed with values that practice listening as a politics that recognizes the knowledge and experience of staff and students. Performed verbatim brings marginalized voices into dialogue with the institution itself and insists on a practice of listening that centres a politics of alterity in which difference simply exists. In this way, the project insists that the institution is open and mitigated by ongoing mutual exchange. The university becomes an inclusive place in which diverse histories and voices are valid sources of knowledge, and within which, as bell hooks describes in *Teaching to Transgress* (1994), spaces of 'emotional trust and regard for one another can be nourished' (132).

Unlike in the photograph in Figure 6.1, which Siqueira staged deliberately and carefully to echo the performance of exclusionary institutional history, the image of Hannah listening has captured her unaware of being observed and photographed (Figure 6.2). Preparing to perform a testimony, Hannah (another TVF facilitator) is deeply engaged in a process of careful listening for the affective charge of the recorded voice so that she can connect with it in an act of solidarity and empathy.

As with Shona, Siqueira emphasizes connections and contrasts between her figure and the institutional context, this time by aligning textiles, colours, patterns and the fall of Hannah's scarf with the long curtains that adorn the window frames. Siqueira recalls that before the photograph was taken, Hannah, preoccupied by an event in her life, had told her she was feeling sad. Working with and through sadness, the performer who also has an experience of the care system, dwells in her own and the interviewee's shared vulnerability. She exists with the testimony to animate it with her own voice, but never to overshadow the truth of the interviewee's particular experience.

Hannah is listening to a testimony given by Toya, an undergraduate at the university where Hannah will shortly perform it. In the recording, Toya's voice is full of sadness when she reflects on how her experience of care is stigmatized and how this generates a deep sense of shame within her. A tone of deep alienation resonates through her words, and it is evident that her experiences of entering care have undermined her sense that she is as much entitled to educational fulfilment as any of her peers. Toya is reluctant to ask for help and rarely tells other students or support staff about her care identity. Though she may understand this aspect of her identity at times as a source of wisdom and strength, it does not seem possible to her to draw on it as part of her learning, to share it, or even to use it as a legitimate position from which to frame her learning needs and desires. As these experiences are informed by exclusions based on race, class and gender, both young women (Hannah and Toya) are in one sense

FIGURE 6.1: Shona and the painted white woman. Photograph by Paula Siqueira.

FIGURE 6.2: Hannah rehearses. Photograph by Paula Siqueira.

101

accepting a very deep stigma that blights young people in the UK who enter care. In another, they are embarking on a lifelong challenge of coming to terms with their care experience as young Black women. As hooks points out, 'as a body in a system that has not become accustomed to your presence or to your physicality', it becomes necessary 'to remember yourself' (1994: 135). There are gaps, silences in the university's aural architecture, which reveal the inequalities which seem to make intersectional experiences unacknowledgeable (Crenshaw cited in Adewunmi 2014).

Unsettling the aural architecture

QMUL, where the *Making Places* event took place, is a unique institution among its Russell Group comparator universities. Students of colour make up 62 per cent of QMUL's home undergraduates and one in four undergraduates come from a low-income household (family incomes of under £10,000 per year). But like other Russell Group institutions, academic workers are predominantly racialized as White and from socio-economic backgrounds that align with middle-class incomes. This sets up an uncomfortable division where university governance is structured by knowledge that does not reflect the lived experiences of students. For students, accessing QMUL's programmes presents itself with severe challenges – high academic tariffs in many subjects continue to re-enforce the inequalities of the UK school system, which privileges a small percentage of pupils. These barriers are intensified for care leavers who do not have financial recourse and family back up on which so many students have to rely.

Figure 6.3 shows Julie, an Applied Theatre student who joined TVF from the Royal Centre for Speech and Drama. Julie is from a foster-caring family and has grown up with foster siblings. Around her are audience members, some of them academics and university managers pausing from their schedules of teaching, meetings and research; they turn their gazes to look at Julie as she gives a testimony and re-voices a young person's interview. Listening alone, especially in a highly aesthetic context like a performance, does not necessarily change power dynamics in meaningful or lasting ways. But by creating accountability mechanisms during the performance, audience members are made answerable to the descriptions of exclusion they listen to. After hearing the testimonies, they will be asked to respond publicly, and then be interviewed by a TVF facilitator, so that their voices are also looped into our ongoing cycle of institutional dialogue and feedback. In the background of Paula's photograph, through the window frame we can see that outside, time is passing and night is beginning to fall. On the inside of the room,

FIGURE 6.3: Julie and Matt. Photograph by Paula Siqueira.

we see a print-out of another TVF photograph taken at previous event. The print-out has been pinned to the SCR walls to augment the institutional setting with alternative visual references.

The printed photograph, with the letters HOPE that hang above the stairwell at Battersea Arts Centre so prominently depicted, seems to gesture both back and forward in time. It shows Matt, another TVF facilitator, a young Black man who is beginning to make a living acting and writing. You can see his head, out of focus, in the foreground of the photograph. He is both pictured at the event and present at it, engaged in further acts of representation of the voices who are absent. Like artist – researchers Claudia Firth and Lucia Farinati, we believe that listening can foster togetherness and collectivity (2016: 18–19) and we also understand listening's limitations as it intersects with gendered, classed and racialized forms of exclusion and hypervisibility. Jeff Sugarman and Erin Thrift summarize the arguments of contemporary sociologists that 'time is change and emergence, and change and emergence require human interaction and interrelations' (2017: 3). Siqueira's photograph, which re-produces the word HOPE within its frames, momentarily captures the fluidity of our aural architecture, reminding us that even institutions, in the process of dialogue, will change.

TVF's *visual archive*

With a period of sustained funding from the UK Arts and Humanities Research Council, TVF has been able to hold a series of events, which place in dialogue the recorded voices of care-experienced young people and the adults who are responsible for their care and education, staging further dialogue with each new audience. This practice emphasizes listening as a politics that unsettles norms around what is voiceable and also creates temporal communities where performers, interviewees and audience are brought into an arrangement of aurality that insists on modes of relating to each other in alterity, as opposed to competition.

In Figure 6.4, Anthony, a TVF facilitator racialized as white, performs a testimony from a student of colour against a large TV screen displaying Siqueira's photographs from past TVF events on a loop. Endlessly recycling the people and places she has previously captured, the screen is caught by the camera showing a textured image of multiple performers moving around a studio theatre. The image is created using a slow shutter speed and double exposure, where two photos are combined on camera to produce a single frame. This technique layers and blurs the performing ensemble, re-creating a sense of their motion, an assemblage of TVF actors enacting a collective performance of the same testimony. Framed in this way, the multi-vocality of the practise is distilled in the image. The photo is a performance, an echo of the past and a ripple in the present.

Siqueira's documentary craft is visual, but it is part of a larger process that aims to care for and honour its participants' voices through aesthetically heightened

FIGURE 6.4: Anthony and the screen. Photograph by Paula Siqueira.

embodied listening and dialogue. Her photographic practice frames and reflects the performative vocal and aural practices of TVF and their temporary reordering of institutional histories and architectures.

NOTES

1. In 2016/17, there was a 39 per cent difference between independent and state schools in the percentage of students who progressed to the most selective HE providers (Department for Education 2018).
2. The guide, and more information about the TVF project, can be found on the project website, http://www.theverbatimformula.org.uk/. Accessed 22 February 2022.
3. In Neil Harrison's (2017) study of 650,220 young people including 6,470 care leavers, 11.8 per cent of care leavers entered HE compared to 43.1 per cent of the cohort as a whole.
4. The names used for all TVF facilitators in this chapter are pseudonyms.

REFERENCES

Adewunmi, Bim (2014), 'Kimberlé Crenshaw on intersectionality', *Newstatesman America*, 2 April, https://www.newstatesman.com/lifestyle/2014/04/kimberl-crenshaw-intersectionality-i-wanted-come-everyday-metaphor-anyone-could. Accessed 15 April 2021.

Ahmed, Sara (2012), *On Being Included: Racism and Diversity in Institutional Life*, Durham: Duke University Press.

Department for Education (2018), 'Widening participation in higher education, England', *2016/7 Cohort – Official Statistics*, 22 November, https://www.gov.uk/government/statistics/widening-participation-in-higher-education-2018. Accessed 15 April 2019.

Farinati, Lucia and Firth, Claudia (2016), *The Force of Listening*, Berlin: Errant Bodies Press.

Harrison, Neil (2017), *Moving on Up: Pathways of Care Leavers and Care-Experienced Students Into and Through Higher Education*, Bristol: University of the West of England.

hooks, bell (1994), *Teaching to Transgress: Education as the Practice of Freedom*, New York: Routledge.

IPPR (2017), 'Not by degrees: Improving student mental health in the UK's universities', https://www.ippr.org/research/publications/not-by-degrees. Accessed 9 February 2018.

Puwar, Nirmal (2004), *Space Invaders: Race, Gender and Bodies Out of Place*, Oxford: Berg.

Sugarman, Jeff and Thrift, Erin (2017), 'Neoliberalism and the psychology of time', *Journal of Humanistic Psychology*, 60:6, pp. 1–22.

The Verbatim Formula (2018), *Making Places: A Guide to a University Residential with Creative Practice for Care-Experienced Young People*, Queen Mary University of London/People's Palace Projects, http://www.theverbatimformula.org.uk/universities-and-student-care-leavers/. Accessed 28 March 2022.

7

Performance Design as Education of Desire

Franziska Bork Petersen and Michael Haldrup

Introduction

Performance Design is characterized by an internal antagonism: it draws on critical and activist practices at the same time as it operates within and caters to commercial domains. This describes a challenge Performance Design practitioners face when they produce designs within the performing arts. But it also applies when Performance Design is institutionalized at universities and art schools. Here, degree programmes are entangled in the burgeoning political demand that institutions of higher education in art and humanities contribute a working force skilled to create measurable value for both wider society and big business – which clashes with the simultaneous expectation for them to be bastions of individual cultural formation that secure a well-rounded, critically thinking society. Mirroring Jon McKenzie's scrutiny of *performance* as a concept (2001), this gives rise to both a more or less commercialized cultural affirmation and a commitment to experimentation and critique as central, yet contradictory, objectives. In this chapter, we take our outset in this apparent dualism.

Performance Design existed as a master programme at Roskilde University in Denmark from 2004 to 2021. The programme was popular with students and covered Performance Design in its relevance to a variety of areas from scenography and cultural institutions to urbanism, media and activism. Yet, the Performance Design master's programme was discontinued in 2021, though much of its curriculum has continued as part of the much larger master's programme in Communication Studies. While we won't attempt to explain this fate by the internal tensions within the field of Performance Design , we will use the programme's discontinuation as an opportunity to trace these tensions, to reflect and reimagine the place, politics, practices and especially pedagogies of Performance Design within, without and across institutions.

In the context of the seventeen-year long existence of the Performance Design programme at Roskilde coming to an end, we take up the (educational) delights and challenges the discipline's internal tension implies. While the programme initially drew on ideas from experience economics to engage with the buzz of the time – 'the experience economy' (Pine and Gilmore 1999; Svabo et al. 2013)[1] – Performance Design quickly turned to elements from Performance Studies and the Arts, rather than Business and Service Studies. In what follows, we investigate resonances with an 'education of desire' in Roskilde's programme in Performance Design.[2] As we argue below, Performance Design holds a utopian potential in that it strives to educate students' ability to imagine that things could be different. The subject's transformative impetus expresses itself in a wide range of active and practical efforts to counter the status quo. Yet, there is a fundamental clash between performance designs that intentionally unsettle established power and value hierarchies or challenge our understanding of everyday objects, spaces and behaviours, on the one hand; and, on the other hand, performance designs that perpetually push boundaries with the goal to improve the experience economy's commercial services.

Throughout the chapter, we want to discuss how Performance Design as an educational programme can play a role in the education of utopian desire. Such education offers a systematic creation of transformative spaces that enable us 'to imagine wanting something else, something qualitatively different' (Levitas 2013: 113). Performance Design is uniquely suited to such an educational task because it can function as a framework for not only *designing* alternative ways of being through affective interventions and estrangements, but also playing them out in *performance*.

After introducing the Performance Design programme at Roskilde University, we outline central positions on hope, desire and transformation, reviewing especially contributions from Blochian and Deleuzian perspectives. We then move on to consider instances in which the Performance Design programme at Roskilde University practically experiments with an education of desire in employing *bodies, space, time* and *things* to evoke affective estrangements. Finally, we reflect on how these can act as experimental explorations of other ways the world could be. *If both the commercial and the critical, estranging strand of Performance Design facilitate transformations: what is their respective potential regarding an education of desire?*

Performance design's history and context

In 2004, Performance Design at Roskilde University was established at both bachelor and master levels with a transdisciplinary curriculum drawing on

disciplines such as Communication Studies, Musicology, Literature and Urban Studies. From an internal university perspective, the establishment of this particular study programme reflected two different developments. First, the programme emerged in response to the allegedly growing 'experience economy' around Roskilde (which has hosted the yearly Roskilde Music Festival, then the largest music festival in Europe) and to the cultural tourism strategy applied by local commerce and civic administration to use the region's cultural and educational institutions for staging the city as a cultural capital (Bærenholdt and Haldrup 2006). A particular emphasis was placed on music, event organization and urban studies, which became important pillars from which the Performance Design programme was developed. Second, the Performance Design programme was a continuation of a series of 'constructive' master programmes in Communication, Journalism, Urban Planning and Spatial Design, as well as a bachelor programme in Arts, Technology and Design. All of these emphasized the integration of art and design approaches into more traditional ('analytic') academic disciplines at Roskilde University. In the Performance Design programme, this approach to the production of knowledge can, furthermore and more specifically, be said to reflect a Bauhaus-ethos of 'learning by doing' as well as more recent stances in design research that stress the value in actually, physically trying something out: 'there is a value in doing things' (Koskinen et al. 2011: 2).[3] In combining these two dimensions, the experience-economical and the practice-focused ones, the programme at Roskilde University was in many ways in line with the university's self-conception as a model for transdisciplinary integration ('The Roskilde Model'); a model that, further, derives its ideas of hands-on learning and experiential education from the didactics of John Dewey as well as critical Marxism (Andersen and Heilesen 2015; Haldrup et al. 2018). Performance Design aligns itself with these ideas as it can evoke other perspectives on the world as we know and experience it. In this outlook, the point of education is implied as 'making the familiar strange'. The students' learning processes are conceived of not as going from *not* knowing something specific to knowing it. Rather, they resonate with Dewey's approach in focusing not on teaching (and researching) what we fundamentally 'don't yet know', but teaching (and researching) different ways of knowing: of using our senses in understanding the social-political implications of everyday interactions. As an educational programme at Roskilde University, Performance Design then offers a *transformative* perspective not least because it is fundamentally concerned with embodied and affective communication. Here, we understand affects as in themselves processes of change or variation that result from bodies (which are not necessarily human bodies) encountering each other. As 'affective estrangements', such encounters describe instances of contact which force us to think, because they defy consciousness, recognition or representation.

In this respect, we conceive of affects as changes in 'what a body can do' – what is in its power, what it is capable of in relation to other bodies. A variety of implications of 'a transformative outlook' was thus built into the programme from the very outset. As we have seen, this transformation concerned cultural-economically focused developments in the Roskilde area, pedagogical issues that are more or less specific to Roskilde University as an institution and emphasize embodied, affective dimensions in the case of the Performance Design programme.

One pedagogical activity that brings the tensions, we are trying to tease out here to the fore is the students' practical project work. At Roskilde University, students spend half of each semester working in groups on their own problem-based projects. As per the ideology of 'The Roskilde Model', these projects are meant 'to solve real problems in the real world' (Andersen and Heilesen 2015: xi) – to somehow change society for the better. In the case of the Performance Design programme, many projects result in designs with which students intervene in non-university contexts. But these interventions are not limited to the spheres of acute societal issues such as the climate crisis, globalization, poverty or social exclusion but also result in more culturally affirmative projects. Given the university's alternative-critical heritage, it is perhaps ironic that Performance Design's transformative dimension also resonates with those commercial domains which we have just illustrated played a key role in the programme's inception at Roskilde. If, for example, an improved performance design of a customer experiences transforms unhappy hotel guests into happy hotel guests who are willing to pay (more) money for their experience, the transformation was successful. Hence, the double legacy of Performance Design seems to carry with it two divergent and somewhat contradictory lines of research and teaching: one being bound up with traditions from (avant-garde) art and critical Marxism, the other bound up with commercial solutions to 'real problems' of contemporary capitalism or more specifically, the experience economy.

Utopian hope and desire

To carve out what we propose as a particular potential of the Roskilde Performance Design programme – an education of desire – we want to begin by taking a look at the field of study within which this concept emerged: Utopian Studies. Ruth Levitas identified in her seminal 1990 book *Utopia as Concept* that the consistent element in all utopias is that they express a 'desire for a different, better way of being' (2011: 209). The broad category of *desire* arguably figured as a uniting factor in the heterogenous field of Utopian Studies. Yet, desire continues to be a contested notion in some important strands of this field of study. While utopian *hope* is understood as the anticipatory orientation towards actual transformations, utopian *desire* is viewed as compensatory and suspicious by some scholars.

Desire can refer to wishful thinking of any kind, it is argued. A cooler car. A fitter body. A sweeter cake. Utopian Studies scholar David Bell points out: 'Utopia is not a holiday destination' (2017: 137).

In performance research, utopia and utopian performatives have been conceived of both in relation to theatre performance and as a potential for activist agency outside theatre institutions. For Jill Dolan, utopia is intrinsic to theatrical performance. The very acknowledgement (and hinting) that things could be different means that theatrical performance can offer us 'usefully emotional expressions of what utopia might feel like' (Dolan 2001: 456). While Dolan limits her perspective explicitly to audience experiences within the theatrical institution, José Estaban Muñoz considers the utopian performative as a rehearsal or 'doing for and toward the future', by mapping out potential (alternative) queer futures immanent in various artistic and other cultural forms of production (2009: 1, 3). Moreover, Bork-Petersen (2022) displaces the focus on cultural production with the idea of utopia as profoundly *embodied*, and suggests to explore the performative through various conceptions of the body as/in utopia across a number of social and cultural contexts.

To reconsider the relevance of the concept of utopia for Performance Design education, we propose to begin by looking into (one of) the foundational texts of Utopian Studies. In his opus magnum *The Principle of Hope* ([1954–59] 1995), Ernst Bloch frames utopia's function in terms of its capacity to inspire the pursuit of actual change in the world. While utopian hope is transformative in this way, desire is not invariably transformative and includes what Bloch calls (escapist) abstract utopias. Different from abstract utopia, Bloch conceives of *concrete* utopia as 'a praxis-oriented category characterized by "militant optimism"' (Levitas 1990: 18). While he is convinced that even the most mundane, abstract fantasy can inspire change, Bloch attempts with the notion of a concrete utopia to reconcile Marxism and utopianism. Importantly for our purposes, Bloch sees utopia as the *expression of what lacks* in a society, of deprivations. Utopias – for him – are 'a way of expressing the experience of lack, of dissatisfaction, of "something's missing", in the actuality of human existence' (Levitas 2000: 27). Bloch writes: 'The will which is at work here stems from deprivation and does not disappear until the deprivation is eradicated' (1995: 42).

The Blochian conception of what constitutes utopia is, then, notoriously inclusive. But his political focus is on utopian *hope*. Meanwhile, other writers explicitly explore the notion of not utopian hope but *desire*. In this vein, Miguel Abensour has emphasized utopia as creating an educational space 'that enables us to imagine wanting something else, something qualitatively different' (Levitas 2013: 113). Edward Thompson, similarly, suggests an understanding of utopia's 'educational value' as throwing habitual values into disarray. Rather than providing a moral education, utopia teaches 'desire to desire, to desire better, to desire more and above all to desire in a different way' (Thompson cited in Levitas 2000: 38).

While Bloch's understanding may be fruitful in scenarios in which lack is apparent and clearly identifiable, our investigation of the potentially utopian role of Performance Design in an educational context includes perspectives that are more open-ended. We follow Abensour when we argue that the desire expressed in performance designs is not invariably driven by a clear sense of lack: the experience of deprivation Bloch refers to in his accounts of both utopian hope and desire. Rather, designs can explore alternatives more broadly. Instead of blueprints, utopias emerge in Abensour's theorization as 'exploratory projections of alternative values' (Levitas 2013: 113). Similarly, Levitas writes about 'the proper role of utopia [as] estrangement. Calling into question the actually existing state of affairs, rather than constructing a plan for the future' (2013: 119). Instead of fixing a pre-identified lack with a definite solution, such utopias emerge in the utopian action itself (see Bell 2017: 123): as an exploration of *what could be*, rather than oriented to *what should be*.

This understanding of desire resonates with Deleuzian thought in which desire emerges as a psychical and corporeal production of what we want, rather than a fantasy of what we lack. Gilles Deleuze and Felix Guattari undermine the question *what is desired* and instead believe in 'the intrinsic power of desire to create its own object' (1983: 27). Drawing on this critique, we conceive of desire's utopian role in Performance Design as producing encounters between bodies, spaces, atmospheres, materials, etc. that are valuable in their unpredictable multiplicity. In *Anti-Oedipus,* Deleuze and Guattari write that 'desiring-production is pure multiplicity, that is to say, an affirmation that is irreducible to any sort of unity' (1983: 45). In linking this perspective to a Utopian Studies stance on educating desire, emphasis is placed on the performative acts associated with desire, rather than their (pre-conceived) results. Regarding Performance Design's broad transformational potential, this understanding implies desire as invoking change that is open-ended and goes beyond a search for remedying a predefined lack. It relates to the educational institution's responsibility to teach students to think and envision the world (or anything else) as *different*. A difference that we can think as a 'difference *from* the status quo' (as, for instance, in 'compensating for what is lacking'), but we can also think this difference as 'difference in itself': a multiplicity that is valuable in its own right.[4]

Performance Design's transformations between estrangement and optimization

As relevant to the education of desire, transformation can be understood in terms of the 'transformative power' that Erika Fischer-Lichte ascribes performance (2004, 2018). Fischer-Lichte writes: 'The definition of aesthetic experience as liminal experience encompasses the possibility of undergoing a transformation without determining its nature' (2018: 2). McKenzie elaborates this perspective

when he adds: 'Marginal, on the edge, in the interstices of institutions and their limits, liminal performances are capable of temporarily staging and subverting their normative functions' (2001: 8). This differs somewhat from the more definitive notion of transformation that Joseph Pine and James H. Gilmore propose when they draw on ritual theory to conceive of the successor model to their 'Experience Economy'. In their conceptions, transformation relies on a change from A to B; to effect emotional, professional and financial well-being (in Pine and Gilmore's more general examples); or – more specifically – going 'from flabby to fit' (2013: 39). In this vein, a proportion of the encounters that are researched and designed within Roskilde University's Performance Design programme have 'being pleasant' or 'effecting a certain, desirable (and usually commodifiable) change' as a primary function. This is clarified when Pine and Gilmore write:

> Such transformations should therefore themselves command a fee in the form of explicitly charging for the demonstrated outcomes that result from the underlying experiences. In other words, companies enabling transformations should charge not merely for time but for the change resulting from that time. They should charge for the ends and not only the means of life-changing (or company-altering) experiences – and especially so in those industries that focus on making people healthy, wealthy and wise.
>
> (2013: 40)

Such is often the case in the designed encounters of visitors with hotel bars, museums or whole cities – and efforts to optimize them. The point of the changed status quo is here that the experience becomes more agreeable than was previously the case or leads to another more or less predefined change. If not always entirely determined in their outcome, a specific problem is identified here and steers its remedy in a preconceived direction.

Meanwhile, transformations that educate desire by focusing on transformative liminality are somewhat harder to pin down. In bringing about 'affective estrangement' (Levitas 2013: 113), these transformations *again* challenge the status quo – but not with the primary goal to create an outcome that is preconceived as 'more pleasant' or 'individually optimizing'; and therefore more monetizable. With 'affective estrangement', we describe a confrontation with something unfamiliar, perhaps uncanny, perhaps scary on a sensual, not primarily a cognitive level. We refer to experiences of time, things, space and bodies in ways that diverge from how we usually experience/encounter them. This is potentially transformative – and utopian if we see utopia not as a blueprint of a better future, but as 'pockets of otherness' in the everyday. Utopian islands which – due to the practice-orientation of Performance Design, even as an academic field – are not

only thought out or written down, but can be *experienced*. Here, reference can be made to Bloch's notion of the utopian Novum, which refers to instances that momentarily pull everyday life into contact with an indeterminate realm of possibility (Bloch 1986: 202).

Such transformations often cannot be validated and, as Richard Schechner similarly states, while the *transportation* of the actor into and out of a character is relatively straightforward, the implied transformation of an audience in aesthetic drama is almost impossible to measure (2003: 193). The important point we want to make in relation to educating desire is that the results of such transformations within the realm of Performance Design are far from being invariably scripted/pre-thought, in the sense that we know the outcome we aim for. In those performance designs that we associate with an education of desire, transformation might only emerge *in performance*. In accounting for a similarly open-ended approach to our own, Bell (2017) outlines utopia's function as allowing those who meet it to cognitively and/or affectively sense that alternatives are possible and desirable. Utopias do not dictate the future to us, but enable 'reflexive, provisional, dialogical and democratic debates on what we do and do not want' (Bell 2017: 80).

An education of desire, then, can be thought with reference to Lisa Garforth, who sees utopianism as 'those cultural forces which open us up to critical thinking and possibilities of other ways of being' (Garforth 2009: 7). Performance Design – in the programme at Roskilde University and outside of it – works with evoking transformations primarily affectively, rather than cognitively. What we suggest here and will shortly illustrate is that Performance Design can educate desire by detaching it from the idea of solving a specific problem or fixing a specific lack. Our proposition is that utopian desiring can be educated, explored and refined and in doing this also move beyond a repository for possible realizations of predefined ideal outcomes.

Performance Design and the education of utopian desire

As discussed in the introduction, Roskilde University's Performance Design programme benefitted from inspirations from a variety of disciplinary fields. For Olav Harsløf and Dorita Hannah, the two founders of Performance Design programmes in New Zealand and Denmark, 'Performance Design' is a

> loose and inclusive term [that] asserts the role of artists/designers in the conception and realization of events, as well as their awareness of how design elements not only actively extend the performing body, but also perform without and in spite of the human body. Acknowledging that places and things precede action – as action – is

critical to performance design as an aesthetic practice and an event-based phenomenon. In harnessing the dynamic forces inherent to environments and objects, and insisting on a co-creative audience as participatory players, it provides a critical tool to reflect, confront and realign worldviews.

(2008: 18)

We want to suggest that this perspective can lay the foundation for an 'education of desire'. Particularly, we want to emphasize how speculative approaches to design can work as a performative method for the utopian education of desire; hence, diversify processes of transformation, explore affective communication and enrich the field of Performance Design.

Dunne and Raby have characterized their work on 'speculative design' as a deliberate attempt to 'create glitches' (2007: 595) in order to generate reflection on the tension between, for instance, possible and preferable future scenarios. Starting off from the question 'what if [..].?' and using this as an impetus for shaping technological and artistic artifacts with odd, fuzzy and complex effects, design becomes a medium for reflection rather than end-product; not a tool for producing 'better solutions', but for opening up more possibilities (Dunne and Raby 2013: 12; Haldrup 2017).

What we contend here is that Performance Design's educational framework at Roskilde University harbours the potential to explore such possibilities not only in thinking (cognitively) in alternatives and otherness but also by providing tools and materials for acting these out in sensuous and affective encounters. In project work and exercises, the students are encouraged to work with material artefacts, installations and embodiments of speculative propositions. The resulting encounters provide speculative *and* material micro-utopias for exploring affective estrangements from familiar ways of experiencing time, space, bodies and things or behavioural patterns in the everyday.

More specifically, students and staff in the Performance Design programme at Roskilde University experiment with creating 'affective estrangements' through a variety of interventions which closely examine and performatively alienate social interaction. Our aim with introducing the below examples of student projects from the first and second bachelor semesters in Performance Design is to illustrate how these semester projects envision and try out alternative ways of being together.

To this effect, one recent student project mobilized a strategy to affectively estrange a familiar conception of time as linear by endlessly looping the rites of the last minutes of New Year's Eve. With popping bottles, sparkly hats and confetti, the performance installation involved participants to rehearse over and over again the gestures, instigations and intensities that fuelled the curve from expectation

to excitement as the clock passed twelve and then incessantly restarted at three minutes to the new year. In doing this, they highlighted the produced and staged character of the emotions and excitement of the ritual passing of the old year that has been embedded in popular culture and everyday practice.

Another student project set out to challenge the embodied norms and values of being an academic in a site-specific performance at the university library. Here, the predominantly university-educated audience was confronted with co-library users tearing pages with inconceivable phrases out of books. Later, the performers attempted to force participants to choose which books should be burned and destructed forever. In doing this, they challenged the value hierarchy of the academic world, its affection for (inaccessible) knowledge and its fragility by placing it in an alternative scenario where destruction and contempt for these values were the norm. Participants were left in a state of anxiety, affective uncertainty and bewilderment.

Furthermore, one student group recently designed an installation in a bus stop and created affective estrangement by going specifically 'against the site'. The student performance designers meticulously identified objects and arrangements that connote 'home' – plants, photographs of loved ones, bags of sweets, fabrics, randomly placed magazines and hand-scribbled notes – and installed those in a bus stop as distinctly public space. Unsettling this space associated with functionality and transit evoked unexpected – and unpredictable – actions, reactions and interactions that were at the centre of the students' academic interest. Travellers began speaking to each other and collaboratively to explore the different elements of the installation, they intentionally missed the bus they had turned up to catch and instead flipped through magazines, photographed the installation and – especially when feeling unobserved – helped themselves to the sweets.

All of these, we argue, are examples of using the Performance Design paradigm to engage with speculative practices and affective encounters. In focusing on liminality – a phase of uncertainty that unsettles habitual engagements with the world – the described Performance Design projects highlight transformation in its experimental dimension that opens for bodily explorations of potential other ways of being and living (McKenzie 2001; Haldrup 2017).

In this focus, the examples differ from performance designs that, rather, focus on transformative *outcomes*. To illustrate this, a student project can be named that developed a showroom event for a Copenhagen furniture designer. Similar to the previously introduced installation in its initial identification and later reliance on design elements associated with 'home', this project set out to challenge conventional practices of showroom design by adding a performative element. Actors and showroom visitors performed everyday behaviours; they watched TV, mingled, drank and snacked in and amongst the displayed tables, sofas and arm

chairs and thus transformed how design furniture is usually presented to its potential buyers. However, the goal was unambiguously to make visitors' interaction with the designed objects as comfortable and friction-less as possible. Rather than affectively estrange, the performance design aimed to affectively reassure. This is unsurprising if we take the performance design's context into consideration: the commercial nature of the sales situation defined the event's overall goal as making the objects on display appear as appealingly as possible – ideally appealing enough to prompt visitors to buy one or several pieces.

The examples outlined here illustrate the aforementioned tension between two points of focus in the transformations performance designs can stage: one seeking to challenge and destabilize existing value hierarchies by focusing on liminality in creating disturbance and affective uncertainties and another by facilitating transformative experiences in the sense of pleasantly improved customer experiences.

Conclusion: Performance Design as a utopian institution

This chapter explored Performance Design's transformational impetus and laid out how it can be educationally focused on both the *outcomes* and the *phase of liminal uncertainty* that are constitutive of transformations. Returning to our initial question, *if both the commercial and the critical, estranging strand of Performance Design that we outlined can be understood as transformative in their reliance on practical doing, as we suggested in our article: what is each strand's respective potential regarding an education of desire?*

Before we turn to that question, we want to point out that in exploring the potential of Performance Design to facilitate an education of utopian desire, we are not suggesting the programme at Roskilde University as some fully-fledged utopia. To speak of the valid social transformation that 'utopia' is usually held to imply as a concept (Sargent 1994; Sargisson 2012), there is quite simply often not enough that is at stake. What we are suggesting is that performance designs and our educational experiments with them can provide pockets of otherness: affective estrangements from established power and value hierarchies that can challenge teachers' and students' way of encountering, being with and relating to other (human and non-human) bodies. As an education at Roskilde University, Performance Design is therefore a place for systematic experimentation with affective estrangement. The students learn to work with effecting change that is not primarily cognitive.

Thus, Performance Design can give not only glimpses but also embodied understandings of 'different ways of being and living'. This means: alternatives that are not only and primarily thought or written down but also physically performed.

Because if an encounter *increases* or *decreases what a body can do* is something, we only find out from these bodily encounters themselves. In the educational realm, we focus on here, 'transformations' are not construed exclusively with a focus on linear improvement with a clear goal (as we laid out is the case in the more commercial, goal-oriented strand of Performance Design at Roskilde University) for designing B as a better version of A. We have seen that the iterations of Performance Design we described as estranging are characterized by an exploration of alternatives: what other means of encounter are conceivable, possible or can be made possible? Meanwhile, the outcome-focused examples typically eschew such openness. Their function to solve specific problems often makes them reliant on pre-defined goals. And fixing a lack, arguably, is not utopian, if the lack is relatively straightforwardly fixable. As Caterina Nirta points out: 'A crucial aspect of utopianism, or of thinking utopian, is that it cannot be mere execution, that is it is not the realization of a plan – however forward – that already exists' (2016: 4). Consequently, while each strand has played its respective role in the Performance Design education at Roskilde University, we associate primarily the estranging strand that focuses on liminality, with what we described above as an education of desire. Affective estrangement entails a more speculative approach that engages with the unpredictability, uncertainty and unfamiliarity of utopia as a non-place (*ou-topia*). We see the potential for Performance Design's 'education of desire' in an exploratory utopianism which follows a trajectory on which a multiplicity of alternatives to established power and value hierarchies can open. It may be unsurprising that such exploratory utopianism is not thriving in institutions that operate with as clear a focus on goals and results as contemporary universities. This, luckily, does not preclude Performance Design, in its most liminality embracing incarnation, from flourishing across or entirely outside of other institutions.

NOTES

1. Urbanist and branding specialist Anna Klingmann explains that 'in the experience economy, the relative success of design lies in the sensation a consumer derives from it – in the enjoyment it offers and the resulting pleasures it evokes' (2007: 19).
2. 'Education of desire' is a phrase used by E. P. Thompson to describe the approach to utopianism of French philosopher Miguel Abensour (Levitas 2000: 38).
3. The establishment of Performance Design in Roskilde also reflected a global tendency to institutionalize scenographics, Performance Studies and spatial analysis (see book introduction and in the symbolic renaming of the Prague Quadrennial for Stage Design to the Prague Quadrennial for *Performance* Design, Collins and Nisbet 2010: xxiv). In the words of Rachel Hann, Performance Design emerged as a transdisciplinary field as it 'emancipated' performance and scenographics from the theatrical institution to act strategically within

'a borderless grouping of a range of topological, anthropological and political approaches of spatial/material design' (2019: 13).
4. Deleuzian 'difference in itself' can be described as stressing 'the uniqueness implicit in the particularity of things and the moments of their conception and perception' (Stagoll 2005: 71).

REFERENCES

Andersen, Anders S. and Heilesen, Simon (eds.) (2015), *The Roskilde Model: Problem-Oriented Learning and Project Work, Innovation and Change in Professional Education*, vol. 12, Heidelberg, New York, Dordrecht and London: Springer.

Bell, David M. (2017), *Rethinking Utopia. Place, Power, Affect*, London: Routledge.

Bloch, Ernst ([1954–59] 1986), *The Principle of Hope* (trans. N. Plaice et al.), Cambridge: MIT Press.

Bork-Petersen, Franziska (2022), *Body Utopianism: Prosthetic Being Between Enhancement and Estrangement*, Palgrave Studies in Utopianism, Houndmills: Palgrave Macmillan.

Bærenholdt, Jørgen Ole and Haldrup, Michael (2006), 'Mobile networks and place making in cultural tourism: Staging vikings and rock music', *European Urban and Regional Studies*, 13:25, pp. 209–24.

Collins, Jane and Nisbet, Andrew (eds.) (2010), *Theatre and Performance Design: A Reader in Scenography*, London: Routledge.

Deleuze, Gilles and Guattari, Félix (1983), *Anti-Oedipus: Capitalism and Schizophrenia*, London: Continuum.

Dolan, Jill (2001), 'Performance, utopia, and the "Utopian Performative"', *Theatre Journal*, 53:3, pp. 455–79.

Dunne, Anthony and Raby, Fiona (2007), 'Futures and alternative nows', in B. Moggridge (ed.), *Design Interactions*, Boston: MIT Press, pp. 589–611.

Dunne, Anthony and Raby, Fiona (2013), *Speculative Everything: Design, Fiction and Social Dreaming*, Boston: MIT Press.

Fischer-Lichte, Erika (2004), *Ästhetik des Performativen*, Frankfurt am Main: Suhrkamp.

Fischer-Lichte, Erika (2018), 'Introduction: Transformative aesthetics – Reflections on the metamorphic power of art', in E. Fischer-Lichte and B. Wihstutz (eds), *Transformative Aesthetics*, London and New York: Routledge, pp. 1–25.

Garforth, Lisa (2009), 'No intentions? Utopian theory after the future', *Journal for Cultural Research*, 13:1, pp. 5–27.

Haldrup, Michael (2017), 'Futures: Speculations on time, design and thinking', *Nordes: Design and Power*, 7, file:///Users/sophia/Downloads/535-1121-1-SM.pdf. Accessed 22 March 2022.

Haldrup, Michael, Hobye, Mads and Padfield, Nicolas (2018), 'The bizarre bazaar: FabLabs as hybrid hubs', *CoDesign: International Journal of CoCreation in Design and the Arts*, 14:4, pp. 329–44.

Hann, Rachel (2019), *Beyond Scenography*, London: Routledge.
Hannah, Dorita and Harsløf, Olav (eds.) (2008), *Performance Design*, Copenhagen: Museum Tusculanum.
Koskinen, Ilpo, Zimmerman, John, Binder, Thomas, Redström, Johan and Wensveen, Stephan (2011), *Design Research Through Practice: From The Lab, Field and Showroom*, Amsterdam: Elsevier and Morgan Kaufmann.
Levitas, Ruth (1990), 'Educated Hope: Ernst Bloch on abstract and concrete utopia', *Utopian Studies*, 1:2, pp. 13–26.
Levitas, Ruth (2000), 'For utopia: The (limits of the) utopian function in late capitalist society', *Critical Review of International Social and Political Philosophy*, 3:2&3, pp. 25–24.
Levitas, Ruth ([1990] 2011), *The Concept of Utopia*, Oxford: Peter Lang.
Levitas, Ruth (2013), *Utopia as Method*, Houndmills: Palgrave MacMillan.
McKenzie, Jon (2001), *Perform or Else*, London: Routledge.
Muñoz, José Esteban (2009), *Cruising Utopia: The Then and There of Queer Futurity*, New York and London: New York University Press.
Nirta, Caterina (2016), 'Actualized utopias: The *here* and *now* of transgender', *Politics & Gender*, 13:2, pp. 181–208.
Pine, B. Joseph and Gilmore, James H. (1999), *The Experience Economy: Work is Theatre and Every Business a Stage*, Boston: Harvard Business School Press.
Pine, B. Joseph and Gilmore, James H. (2013), 'The experience economy: Past, present, future', in J. Sundbo and F. Sørensen (eds), *Handbook on the Experience Economy*, Cheltenham and Northampton: Edward Elgar Publishing, pp. 21–44.
Sargent, Lyman Tower (1994), 'The three faces of utopianism revisited', *Utopian Studies*, 5:1, pp. 1–37.
Sargisson, Lucy (2012), *Fool's Gold*, Houndmills: Palgrave Macmillan.
Schechner, Richard ([1978] 2003), *Performance Theory*, London and New York: Routledge.
Stagoll, Cliff (2005), 'Difference', in A. Parr (ed.), *The Deleuze Dictionary*, Edinburgh: Edinburgh University Press, pp. 72–73.
Svabo, Connie, Larsen, Jonas, Haldrup, Michael and Bærenholdt, Jørgen Ole (2013), 'Experiencing spatial design', in J. Sundbo and F. Sørensen (eds), *Handbook on the Experience Economy*, Cheltenham and Northampton: Edward Elgar Publishing, pp. 310–24.

8

Mode D: Evental Forms of Exchange in Art Education

Glenn Loughran

The recent turn towards education in artistic practice emerged out of broader discourses in socially engaged art, which reflected upon the alienating effects of modern society. A key reference point within this discourse is the French thinker and anarchist Guy Debord (1931–94). Debord's analysis of urban life gave rise to some of the central themes in contemporary participatory art practice, namely, that social relations are fragmented by urban experience, that overstimulation in urban centres renders citizens indifferent to difference and that the city privileges the commodity form of exchange. Central to these theories is the overarching concept of 'spectacle', which, in Debord's analysis, produces social modes of exchange which are increasingly mediated by mass media, where "being" replaces "having" and "having" replaces "appearing" (Debord 1970: Chapter 25). Challenging the 'spectacle' through antagonistic forms of critique, Debord engaged in clandestine street acts, protests and graffiti; however, he also developed more subversive, internal forms of critique, such as *détournement*. Understood as 'hijacking, subverting or re-routing' (Debord 1970: Chapter 10), *détournement* was a strategic concept for undermining the dominant value system and the various ways that 'spectacle' recuperates and domesticates its external antagonisms (Debord 1970).

To varying degrees, these kinds of strategies are evident in social and participatory art practices which also aimed to address the ideological, fragmentary influence of the 'spectacle' on social relation (Bishop 2011). For example, critic and curator Nicholas Bourriaud argued that 'direct experience' and traditional 'relational channels' have been steadily eroded by the excesses of post-industrialization

MODE D: EVENTAL FORMS OF EXCHANGE IN ART EDUCATION

and a full 'transformation to the Society of the Spectacle' (Bourriaud 2002: 9). Against this transformation, Bourriaud insists that art has become 'a state of encounter', where subjects produce a new 'arena of exchange' through the construction of new 'models of sociability' (Bourriaud 2002.). Indebted to Karl Marx's concept of the 'social interstice', relational art produces encounters which aim to subvert the ideological function of the gallery, liberate the viewer from their normative relationship to the art world and create a space of potentiality beyond the commodity form of exchange.

However, for Claire Bishop, these aspirations are often complicated by modernist modes of production that are at odds with the social modes of exchange posited by relational aesthetic (Bishop 2011: 2). Drawing on the work of Boltanski and Chiapello, Bishop highlights the tension between modernist forms of artistic critique which reject the 'contamination of aesthetics by ethics' (Bishop 2011: 1) and alternative forms of social critique which develop a dialogue with the world, beyond the concerns of 'individual freedom and personal interest' (Bishop 2011: 3). Where Bishop and Bourriaud may differ on their respective accounts of political agency within participatory art, they do nevertheless share a modernist, art historical understanding of participatory art that is often determined by specific political, technological frameworks and events:

> The clash between artistic and social critiques recurs most visibly at certain historical moments, and the reappearance of participatory art is symptomatic of this clash. It tends to occur at moments of political transition and upheaval: in the years leading to Italian Fascism, in the aftermath of the 1917 Revolution, in the widespread social dissent that led to 1968, and its aftermath in the 1970s. At each historical moment participatory art takes a different form, because it seeks to negate different artistic and sociopolitical objects.
>
> (Bishop 2011: 5)

Whilst it is important to interrogate the relationship between political change and artistic change, we may need a broader historical understanding of social formation to overcome the modernist tensions between artistic critique and social critique highlighted by Bishop. Japanese philosopher Kojin Karatani has made a similar claim with regards to modern economic systems, arguing that to look at social formation through the lens of modernist discourse is to reduce our understanding to a worldview based on technological modes of production. Significantly for this inquiry, his text, *On the Structure of World History. From Modes of Production to Modes of exchange (2014)*, develops an analysis of world history that preferences modes of exchange over modes of production. Key to this analysis is an understanding of the base/superstructure metaphor, which posits that social

and institutional formations are determined by an economic base that is defined by the dominant modes of production (Karatani 2017: 1).

Whilst Karatani maintains the logic of economic base as an important structural element, he rejects the overemphasis in Marxism on modes of production, arguing that it fails to account for the existence of modes of exchange prior to industrial society and modernist discourse:

> Marx's division of economic base from political superstructure is a view grounded in modern capitalist society. For this reason, it doesn't work as well when it is applied to the case of pre capitalist societies. To begin with, in primitive societies there is no state, nor any distinction between economic and political structure. As Marcel Mauss pointed out, these societies are characterized by reciprocal exchanges. This cannot be explained in terms of a *mode of production*.
>
> (Karatani 2014: 3)

Aiming to go beyond the analysis of social history through the lens of modes of production, Karatani outlines the logic of exchange as it develops through three dominant social structures; Capital, Nation and State (Karatani 2017). Highlighting the transitional nature of modes of exchange through this schema, Karatani argues that, historically, each mode of exchange is dominant at different periods in history; however, the dominance of one mode of exchange does not presume the disappearance of the other modes of exchange, but rather their reconfiguration in another form.

B	A
submission-protection (punder-redistribution)	reciprocity (gift-return)
C	D
commodity exchange (money-commodity)	X

For Karatani, reciprocity, gift and pure-gift economies (mode A) are the primordial forms of exchange that emerge out of nomadic societies, who, because they cannot hoard their resources, must pool them equally (mode of exchange B is defined by a logic of plunder and redistribution, a form of self-protection characteristic of State which, as Thomas Hobbes suggests, is a 'contract, wherein one recieveth the benefit of life' (Karatani 2017.). Finally, the exchange of goods or

services for money to generate surplus value and profit is the commodity form of exchange (mode C). All three modes of exchange have influenced the development of social formations at different historical times. Reciprocity (mode A) dominated in nomadic societies of bands and clans. State Plunder (mode B) dominated in Feudal societies and mode C has dominated since the Industrial Revolution and the emergence of the capitalist economy (Karatani 2017). Driven by the need for surplus value, the commodity form of exchange reduces the social relation to a means end logic that, for Karatani, will always produce conflict and disparity (Karatani 2017). To begin to think beyond this conflict is to engage with the possibility of counteractions that cannot be entirely absorbed by the commodity form of exchange and it is within this context that Karatani introduces a new form of exchange that he calls, mode of exchange D.

Mode D as evental form of exchange

Initially, mode D was developed as an 'ethico-economic' alternative to the commodity form of exchange (mode C) by linking Marx's concept of associationism to the Kantian axiom, '(a)ct so that you use humanity, whether in your person or in any other person, always at the same time as an end, rather than a means to an end' (Kant 1785: 36). Understood within the broader context of Karatani's analysis, mode of exchange D emerges historically through nomadic bands and clans, which, due to their mobility, pool their resources and develop pure forms of gift exchange that reject all forms of hoarding. This culture of pooling is eventually replaced by more dominant forms of gift – reciprocal modes of exchange developed in tribal communities which are scaled up into more complex systems of exchange between tribes and clans.

In relation to the most dominant forms of exchange in contemporary society (modes B and C), mode of exchange D represents the existence of all non-extractive forms of exchange, from universal religion to common-based currencies, that have emerged throughout history and which will inevitably continue into the future 'even if we are unable to predict the form it takes' (Karartani 2014: xii). Engaging with Karatani on the subject of mode D, Geographer Joel Wainwright has drawn attention to the 'profoundly aporetical' nature of mode D, suggesting that it is a strangely ambiguous conceptual outcome of such rigorous analysis (Wainrwright 2012: 12); however, for Ian Shaw, the 'aporetic' or 'unpredictable' space of mode D is fundamentally generative and should be understood 'not as an aberration, but as the onto-logical possibility of any world' (Shaw cited in Karatani and Wainright 2012: 2). It is in this sense that mode of exchange D should be understood as an event.

As suggested by John Mackenzie and Ian Porter, the value of an event can only be understood if we can account for its 'intrinsic novelty-bearing capacity', that is, for the way that something *new* happens in the event (Mackenzie and Porter 2017: 27). Importantly, this novelty produces 'significance', and the 'significance' that it produces cannot be treated as a 'simple occurrence' alongside other occurrences, evaluated in the social sciences, they write,

> the differences usually analyzed in social science models are differences between things, voting systems, class composition etc., these differences are understood as quantifiable dimensions of existing phenomena, which if we apply to the study of events risks obscuring the evental component by limiting the analysis to cause and effect or by neutralizing its evental component by reducing it to a secondary order to the thing itself.
>
> (Mackenzie and Porter 2017: 26)

On this basis, Mackenzie and Porter argue for the need to establish a method of studying 'events qua events', that is, to develop modes of study that are sensitive to both the content *and* the form of events, arguing that 'we need to develop "eventual" methods for studying events' (Biesta 2014: 1).

For Alain Badiou, events are always unpredictable which rupture within the norms of a particular situation. Events produce post-eventual processes of intervention, extension and enquiry that are deeply pedagogical (Badiou 2001: 67–68). Understood politically an eventual process takes place at an 'evental site' within a dominant set of relations that determine which particular regime of knowledge dominates at a specific time and which does not. Similar to Marx's concept 'interstitial' space and Karatani's 'mode D', these 'evental sites' are both peripheral and generative at the same time. The enquiries that take place at these evental sites produce *subjects* to the truth of the event, subjects are actors who risk exploring the novelty that the event presents, he writes,

> an event is something that brings to light a possibility that was invisible or even unthinkable. An event is not by itself the creation of a reality; it is the creation of a possibility, it opens up a possibility [...] Everything will depend on the way in which the possibility proposed by the event is grasped, elaborated, incorporated and set out in the world.
>
> (Badiou 2013: 12)

In *The Beautiful Risk of Education* (2014), Gert Biesta makes a similar case for the event in education, suggesting that *risk* is the excluded element that is both essential to the definition of education and consistently disavowed by current regimes,

It is what policy makers, politicians, the popular press, 'the public', and organisations such as the organisation for co-operation and development (OECD) and the World Bank increasingly seem to be expecting, if not demanding from education. They want education to be strong, secure and predictable, and want it to be risk free at all levels.

(Biesta 2014: 1)

Central to the eradication of *educational risk*, for Biesta, is the shift from thinking education as an interpretive, relational process, to thinking education as an instrumental, transactional one. This shift emerges in the late twentieth century as education is increasingly aligned with values of the neoliberal economy and specifically through the expansion of human capital theory across most western educational institutions. Drawing attention to various ways that this shift has been enabled by the new 'language of learning', Biesta he argues that *'learnification'* has 'facilitated a re-description of the process of education in terms of economic transactions', where learners are perceived as consumers, teachers are reduced to 'service providers' and education 'a commodity – a "thing" – to be provided' by educational institutions (Biesta 2012: 19–22). Expanding on this analysis Biesta turns to the work of Jacques Derrida to rethink the significance of the 'gift' as an event in teaching, he writes, 'a "gift" is, after all, (a) *given*', it is what Derrida would call *'impossible,* which doesn't mean that it is not possible but that it cannot be foreseen as a possibility' (Derrida 1992b: 16), 'it cannot be demanded, predicted, calculated or produced, but comes when it arrives' (Derrida 1992b: 16).

If mode D can be understood as a generative, 'evental space', that anticipates, on the basis of historical analysis, present day configurations of 'gifting' that seek to transgress the dominant forms of commodity exchange in society, then what we are exploring through the idea of evental education is the possibility of a value shift. As Michael Bauwens has suggested, for Karatani, all systems are inter-modal,

> it is only their mutual configuration which changes. This means that transitions depend on struggles for dominance among these modalities. This opens up thinking about the value shift or value transition, not just as the replacement of one system by another, but as an on-going inter-modal struggle.
>
> (Bauwens and Niaros 2017: 10)

Such systematic analysis allows for a more complex account of social formation and modes of exchange. Importantly, it also provides us with an understanding of their malleability at any given time, there can be no totalizing system or fully dominant mode of exchange. Mode D names the space, within this analysis, for unthought, unnameable modes of exchange in art, education and social practice. Expanding on this proposition, I set up an artistic research project in 2016, which

aimed to explore the principles of 'evental education'. Taking the historical movement of the Irish hedge schools as an 'evental site', the project developed modes of exchange which took the school form as a mediator of educational value.

Evental education and the hedge school project

Hedge schools first emerged in Ireland during the Cromwellian regime 1649–53, and then as a response to the Penal Laws from 1723 to 1782, which were laws prohibiting Irish Catholics from taking part in the commercial or intellectual life of their country (McManus 2004). Often described as people's schools, hedge schools were subversively organized by priests and rural workers in barns and behind hedges throughout Ireland. Although they were nomadic and temporal out of necessity, the hedge schools were nevertheless sophisticated in the delivery of a wide-ranging education from the humanities to classical studies and accounting to Irish history (McManus 2004). A Commission of Inquiry report in 1826 showed that of the 550,000 pupils enrolled in all schools in Ireland, 403,000 were in hedge schools (McManus 2004). When we consider the emergence of the hedge school movement, we cannot deny the traumatic realities in which it developed. The colonial politics of seventeenth-century Ireland made it necessary for such pedagogical movements to sustain cultural and economic survival; however, the *hedge school project* did not aim to anthropologize those historical traumas, but rather to re-signify the school as an emancipatory site through which to explore new modes of exchange between school, student and society.

The *hedge school project* was manifested as a series of conceptual schools, developed across multiple social and geographic contexts. The construction of each school was used performatively and methodologically to contextualize the guiding concepts and themes in the inquiry. Within this context, each school construction was supported by the study of the historical hedge school movement, its guiding principles (equality, subversion, emancipation) and the various ways that these principles could be revitalized in contentemporary contexts where they remained immanent and live. Reflecting on a similar dynamic, Dorita Hannah draws out the importance of the 'event' as a spatial metaphor for 'performative architecture',

> This link between event and space questions architecture's traditional association with continuity, coherence, and autonomy by focusing on time, action and movement. If performance is, as theorist Elin Diamond (1996: 5) contends, both 'a doing and a thing done' then 'spacing' – like the words 'building' and 'construction' (a structure and the act of its making) – represents both noun and verb: thing and action.
>
> (Hannah 2011: 56)

MODE D: EVENTAL FORMS OF EXCHANGE IN ART EDUCATION

Over a six-year period, there were three iterations of the project. The first iteration (2006) worked with early school leavers in a rural context to build a temporary school (The Eco House) out of straw bales, in a horse field. The second iteration, called The Literacy House, engaged with the Traveller community in Dublin 2010, and finally in 2012, the third iteration of the project was implemented at the Kaunas Textile Biennale in a freight container working with precarious workers in the surrounding sewing factories. Each of the projects was between 1 and 2 years from development to realization. The next section will focus on the second iteration of the project The Literacy House, as an exploration of 'evental education'.

The Literacy House was supported by Arts Council funding and sited in the Priorswood Community Development Project in North Dublin and developed with the arts agency Blue Drum. The project began with the purchase of a fully functioning trailer that would be reconstructed with the Traveller community and gifted to a particular locality in Dublin. An initial period of research was developed with Community Development Project leader Mary Dohney, community liaison officer Maria McKenna and members of the local Traveller community, Nellie Ward and Paddy McDonagh. Through discussion and consultation over an eight-week period, the proposal of an art/education space for Traveller families was considered. Whilst this proposal was welcomed as a community resource, early discussions also focused on the need to address high levels of literacy within the Traveller community.[1] It was through these discussions that the initial working group named the project 'The Literacy House' and this decision, in turn, influenced the pedagogical programme and the design of a collective library space within the trailer for teaching literacy through the visual arts. Significantly, three different Traveller sites were chosen to participate in the project, some of which had long standing conflicts and deep division.

The first site chosen was located within the grounds of the community centre. It was hoped that the project would begin at this site and return to it once the other sites had contributed to the project; however, due to local tensions with the surrounding settled community, the project was evicted from this site after a year. After this event, the trailer moved to a nearby halting site, where it was in operation for nine months, after which it moved on to an illegal site, where it was in operation for over a year and a half. The second site was located nearby at an official 'halting site' provided by Dublin City Council for Travellers and the third site was located on an illegal site beside a busy roundabout. Importantly, the families on the final site had arrived there over two years previously, as a result of violent conflicts with the second halting site.

Within this context, the project aimed to develop a sense of collective ownership and dialogue among the different families and community sites, through the reconstruction of a shared literacy space. To support this pedagogical process, an 'evental methodology' was developed between myself and community members involved in supporting the project. This methodology was based on the work of the eighteenth century pedagogue, Joseph Jacotot, who developed a theory of universal education when he was exiled in Belgium in 1818. Universal, or 'panecastic' teaching as he called it, was the derived from an educational experiment Jacotot developed with Flemish students while in exile. Attempting to teach French to his students whilst being unable to speak Flemish himself, Jacotot, used a dual language copy of the French classic 'Télémaque' (1699) as a mediator between these differences. Instructing the students to learn the French part of the text of by heart using the translation he realized that the students were able to retain and learn the basics of the French language but without the types of instruction and support that Jacotot was used to giving (Rancière 1991: 18).

In the light of this realization, Jacotot believed that very essence of his teaching method, explanation, was not needed by the student to learn. More importantly, he argued that the act of explanation actually 'stultified' the student and served primarily to maintain the power difference between mater and slave, teacher and student, where 'to explain is first of all to show him that he cannot understand it by himself (Rancière 1991). In response to this experiment, Jacotot developed a method of teaching that nurtured the students *will to knowledge* by asserting their fundamental 'equality of intelligence'. As Jacques Rancière has suggested, Jacotots concept of 'equality of intelligence' introduces an 'axiom of equality' into the pedagogical scene, replacing the ideological struggle for equality as *goal* with an axiomatic principle to be verified and upheld, because 'Equality is not an end to attain, but a point of departure, a supposition to maintain in every circumstance' (Rancière 1991: 18). This rupture in the logic of classical teaching became the motivating the principle in The Literacy House curriculum, where the concept of panecastic teaching was explored through a non-methodology, called: *how to teach what you don't know*.

The creative challenge in this process was the translation of an abstract and awkward theory of learning, into a practical process understood by both teacher and student. This challenge was met through the pedagogical reconstruction of the literacy space, a kind of 'architectural performance' of the methodologies of self-education developed throughout. Initially, each participant was asked to reconfigure a section of the interior space, to identify certain design problems and to research how to redesign and reconstruct the space accordingly. Then, crucially, each participant developed a strategy for teaching the other members of the group, what they were aiming to do, how they found out how to do it and how they applied that knowledge to the final design. Each member of the group recorded their

MODE D: EVENTAL FORMS OF EXCHANGE IN ART EDUCATION

experience and interpretation of the activities involved in the process, with the aim of teaching those experiences to the next group, in the next site. The final activity in each trailer at the end of each site was the collective teaching (through film) of 'what you don't know' to the next group of participants, and the first session

FIGURE 8.1: Hedgeschoolproject 08: Literacy House, 2008. Image Credit: Glenn Loughran.

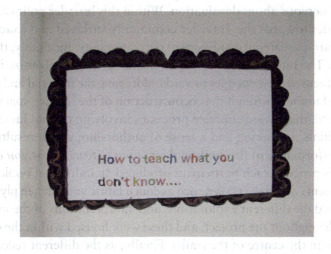

FIGURE 8.2: How to teach what you don't know, 2008. Image Credit: Glenn Loughran.

in the following site was a self-education instructional video developed by the previous group.

As suggested, this methodology depended on a performative subtraction of the 'explicative order' from the role of primary educator. In this case, the teacher was myself and the facilitators who simultaneously negotiated the act of *withdrawing* and the act of *enabling*. This proved to be extremely challenging, as it seemed too close in character to doing nothing, to not teaching. However, through this process, the group eventually began to assert its own dynamic in the absence of direct instruction. By taking responsibility for each of the tasks performed, the methodology *how to teach what you don't know* proved to be instrumental in motivating the group to determine the direction of the project and to engage in broader discussions around power and authority in society. In particular, at the last location of the project, an illegal site, the exploration of the master/student relationship became analogous with the State/Traveller relationship which led to more expanded political discussions on democracy and voting.

Situation, intervention, subject

The tensions manifest throughout the process of The Literacy House resulted in the trailer being evicted twice. These evictions were largely due to negative attitudes towards the Traveller community and the assumption that their presence and visibility would lead to a deterioration in the local environment. It is worth noting, that, at this time, the global recession was gaining momentum, and as property prices were beginning to drop nationally, the local community became increasingly nervous about devaluation. Within this broader political landscape, latent attitudes towards the Traveller community surfaced and exacerbated the already precarious material conditions of the community. Inevitably, this precarity impacted on The Literacy House project; however, it also galvanized the participants and refocused their energies towards addressing the material and pedagogical needs of the families, through the coconstruction of the literacy space.

In each site, there were concrete processes involving textual literacy through reading, writing, artmaking and a sense of authorship, which resulted from the collective performance of the methodology: *how to teach what you don't know*. Through this process, each participant produced an individual book made from recycled elements of the old trailer, such as couch fabric and kitchen plywood. Each book captured the different explorations and interpretations of the interventions developed throughout the project, and these were housed within the constructed library space in the centre of the trailer. Finally, as the different recordings were being transcribed for inclusion in the library space, it was suggested that some

of the statements should be printed out and placed on the exterior walls of the trailer, to distinguish it from the other trailers. Marking the 'evental' significance of the space as a 'literacy' space, the statements developed by the group aimed to visualize the material and educational inequalities experienced by the Traveller community. Many of these statements articulated an informed disagreement with the Irish State and its perception of the Traveller community, thereby producing a 'critical, architectural performance' of their place in society. Central to this intervention was the collective desire, between community workers and participants to *risk* being visible, where visibility had not been granted.

This intervention was not only performed through the architectural representation of The Literacy House but also emerged out of the pedagogical process, through the methodology: *how to teach what you don't know?* However, as Biesta has suggested, the logic of intervention in educational discourse is a complex one that is tied very specifically to the concept of subjectification. For Biesta, there are two key interventionist logics within the emancipatory traditions of education, and they are the 'monological' and the 'dialogical' (Biesta 2012). In the monological conception of intervention, 'equality' is the outcome of a process of social reproduction, that is, 'equality will be gained if the student is socially reproduced through the knowledge of their master' (Biesta 2012). In this sense

FIGURE 8.3: Hedgeschoolproject 08: Literacy house, 2008. Image Credit: Glenn Loughran. 2008.

then, to develop a curriculum around the monological approach with Travellers, would be to assume that they are unaware of their lack of knowledge and that this can be resolved through the reproduction of the teacher's knowledge, what Paolo Freire called 'banking' (Freire 1972).

In his critique of traditional forms of education, Brazilian educator Paolo Freire challenged the monological practice of 'banking' as an oppressive 'depositing' of information by teachers into their students, where 'the more students work at storing the deposits entrusted to them, the less they develop the critical consciousness which would result from their intervention in the world as transformers of that world' (Freire 1972: 55). Against the banking model of education, Freire developed a pedagogy motivated by a dialogue and which aimed to rehumanize the oppressed learner through the coconstruction of knowledge *with* the teacher, in relation to the world (Freire 1972). In this approach, the teacher is rejected as the delegated 'truth teller' and replaced by the affirmation of a process of collective discovery, critical consciousness and emancipation. To develop such an approach with the Traveller community would be to acknowledge the oppressive nature of the teacher–student relationship and the need for more horizontal forms of dialogical learning.

While these two approaches may differ in their methods of intervention, they are, as Biesta, after Rancière, suggests, similar in one aspect, both envision equality as a goal be achieved at the end of a process (Biesta 2012).

> If 'traditional' emancipation starts from the assumption of inequality and sees emancipation as the act through which someone is made equally through a 'powerful intervention' from the outside, Ranciere conceives of emancipation as somethings that people do for themselves. For this they do not have to wait until someone explains their objective condition to them. Emancipation 'simply' means to act on the basis of the presupposition – or axiom – of equality. In this sense it is a kind of testing of equality.
>
> (Rancière 1995: 45, 90)

Conclusion

To mobilize an evental education is to create the conditions of 'possibility' for the 'study of events' through evental forms and methods that can support and sustain the 'gift' economy of education today. The Literacy House explored this proposition through a unique mode of educational intervention (axiom of equality) and by organizing the forms of knowledge – social, architectural and pedagogical around reciprocal modes of exchange (mode D) between teachers and students, families

and communities. Beginning with an act of gift exchange, the purchase of a mobile trailer, to address the material, spatial and pedagogical needs of a vulnerable group living on the edge of society, the trailer was further gifted and exchanged between families and communities in conflict with each other. Through this process, the families collaborated on the iterative reconstruction of the space, contributing to its design and claiming a certain amount of ownership and responsibility for the space. The performative dimension of this mode of reciprocity was instrumental in the mediation of these tensions and differences, that is, while the families never met throughout the process, they still nevertheless experienced relational exchange.

Beyond a theoretical illustration of conceptual or historical frameworks, The Literacy House aimed to navigate the tensions between practice and theory, master and student, through the performance of space, exchange and subject. In this sense, The Literacy House connected back to the event of the historical hedge school and its organic intervention into the anglicized educational system of the seventeenth-century Ireland.

NOTE

1. https://www.education.ie/en/publications/policy-reports/travelleredstrat.pdf. Accessed 22 February 2022.

REFERENCES

Badiou, Alain (2001), *Ethics: An Essay on the Understanding of Evil* (trans. Peter Hallward), London: University Press.

Badiou, Alain (2013), *Philosophy and the Event*, 1st ed., Cambridge: Polity Press.

Bauwens, Michel and Niaros, Vasilis (2017), *Value in the Commons Economy: Developments in Open and Contributory Value Accounting*, Berlin: Heinrich-Böll-Foundation and P2P Foundation.

Biesta, Gert ([2005] 2012), 'Giving teaching back to education: Responding to the disappearance of the teacher', *Phenomenology & Practice*, 6:2, pp. 35–49.

Biesta, Gert (2014), *The Beautiful Risk of Education*, Boulder: Paradigm Publishers.

Bishop, Clair (2011), 'Participation and spectacle: Where are we now?', *Living as Form* lecture, Creative Time, Cooper Union, New York, May, http://dieklaumichshow.org/pdfs/Bishop.pdf. Accessed 22 February 2022.

Bourriaud, Nicolas (2002), *Relational Aesthetics*, Dijon: Les Presses du reel.

Debord, Guy and Wolman, Gil J. (1956), *The Bureau of Public Secrets: A User's Guide to Détournement*, https://www.cddc.vt.edu/sionline/presitu/usersguide.html. Acessed 22 March 2022.

Freire, Paulo (1972), *Pedagogy of the Oppressed*, New York: Herder and Herder.

Hannah, Dorita (2011), 'Event space: Performance space and spatial performativity', in J. Pitches and S. Popat (eds), *Performance Perspectives: A Critical Introduction*, London: Palgrave.

Karartani, Kojin (2014), *The Structure of World History: From Modes of Production to Modes of Exchange* (trans. Michael K. Bourdaghs), Durham: Duke University Press.

Karatani, Kojin (2017), *An Introduction to Modes of Exchange* (trans. Michael K. Bourdaghs), http://www.kojinkaratani.com/en/pdf/AnIntroductiontoModesofExchange.pdf. Accessed 22 March 2022.

Karatani, Kojin and Wainwright, Joel (2012), 'Critique is impossible without moves', *Dialogues in Human Geography*, 2:1(March), pp. 30–52.

Knabb, Ken and Debord, Guy (2014), *The Society of the Spectacle*, Berkeley: Bureau of Public Secrets.

Mackenzie, Ianand Porter, Robert (2016),'Evental approaches to the study of events', in T. Pernecky (ed.), *Approaches and Methods in Event Studies*, London: Routledge.

McManus, Antonia (2004), *The Irish Hedge School and Its Books, 1695–1831*, Dublin: Four Courts Press.

Rancière, Jacques (1991), *The Ignorant Schoolmaster: Five Lessons in Intellectual Emancipation* (trans. Kristin Ross), Stanford: Stanford University Press.

9

Performative Urbanism: Mapping Embodied Vision

Christina Juhlin and Kristine Samson

Introduction: Learning from the field

In this chapter, we start from experiments with doing performative mappings in two different neighbourhoods in Copenhagen as part of the interdisciplinary course 'Performative Urbanism'. 'Performative Urbanism' was originally developed as a transdisciplinary field between the departments of Performance Design and Urban Planning at Roskilde University in 2014 (see Frandsen et al. 2015). As a course, 'Performative Urbanism' was a platform for developing and experimenting with forms of urban research in order to grasp the processual, affective and ephemeral aspects of the city (writ large). As a concept, performative urbanism is not understood as a planning practice, as proposed by German architect and planner Sophie Wolfrum (Wolfrum and Brandis 2014; Wolfrum and Jansen 2019) but as a contribution to what we will later term minor urban studies, concerned with the performativity and agency of urban environments and its citizens. As a concept and a sociospatial practice, performative urbanism therefore helps us to ask: within the context of neoliberal urban development how can a performative urbanism approach to planning and design shift our experience of cities? Within this understanding of performative urbanism, we explore how performative and embodied mappings can inform both the institution of academic disciplines and the discipline of urban planning – in order to 'teach ourselves to think, to practice, to relate, and to know in new ways (Law 2004: 2). Our approach to performative urbanism invites embodied and situated knowledges to take place. As a transdisciplinary practice and a practice that operates in the interstice (Hannah 2015; Samson 2010), it can be used to explore

other ways of knowing and potentially designing the city. In our view, performative urbanism breaks with the idea of urban space as a container for human action or a pre-established sign system encoded with semantic meaning, and rather invites embodied exploration practices, which we discuss in detail below, of the processes and every day events that shape social and cultural life of the city.

With the intent to open up the discipline of urban planning and design to the concept of performativity, we draw on the affective and material turn in arts and humanities as well as existing urban theory to emphasize the affective and non-representational dimensions of the production of space. The following theoretical overview therefore places performative mappings in this turn as well as in performative and urban theory, leading to our hypothesis that learning how to perform the city differently through performative mappings will also help us to perform the institutions of urban planning and the university differently. This hypothesis is then elaborated throughout the chapter with examples from performative mappings that we undertook with students on Refshaleøen and Nørrebro in Copenhagen, Denmark in 2018. One of the learning goals of the 'Performative Urbanism' course was not to stand outside of urban problems and themes but materially and bodily engage with them to understand how we as bodies, as teachers and students, matter through our actions and ways of producing research and knowledge about urban experiences.

Performativity in relation to affective methods in urban theory

When talking about performative urbanism and performative mappings, we take our understanding of performativity from a situated perspective as actions and material agencies directing the urban otherwise; henceforth an opening up of the space for its potential meanings and implications (Samson 2010). Performative mappings are furthermore transversal and transdisciplinary as they allow for intersecting perspectives to be aligned and embodied across disciplines (Harsløf and Hannah 2008; Samson 2010; Hannah 2015). While the performative does not equal the notion performance, they do however share a processual and critical ontology. Judith Butler has coined the performative as agencies related to the body. Recently she has further elaborated on the collective and critical potentials in performativity:

> If performativity has often been associated with individual performance, it may prove important to reconsider those forms of performativity that only operate through forms of coordinated action, whose condition and aim is the reconstitution of plural forms of agency and social practices of resistances.
>
> (Butler 2015: 9)

Hence, we see performativity and performative mappings of space as plural forms of agency and social practices of resistance. Performative mappings are furthermore explorative and event-based phenomena that do not represent or document space but performatively brings forth singular qualities of space. As such we relate performative mappings of urban space to the proliferation of arts-based methods and methodologies in arts and humanities as they have turned to engagement with the material and affective processes of social life in contemporary cultural analysis (Clough 2007; Massumi 2002; Wetherell 2012; Ahmed 2004; Leavy 2009; Shanks and Svabo 2017). In particular, the affective and material turn has drawn attention to 'how matter matters to understandings of cultural production' (Springgay and Rotas 2004). Further, it has resulted in a call for inventive methods that do not divide between processes of inquiry, changing and rebuilding: 'if methods are to be inventive, they should not leave that problem untouched' (Lury and Wakeford 2014: 3).

Performative mapping is one such method that seeks to develop other positions from which to observe, engage with and potentially change the city. Performative mappings can encompass a variety of methods which, drawing from the mappings in the 'Performative Urbanism' course, can include the processes of collecting materials, photographing, listening, walking, recording sounds and products such as scores, performances and co-designs. As a method, performative mappings can also be seen as part of activist spatial methodologies where alternative cartographies are drawn through artistic means to shift attention from the map as representation to depicting practices and processes (Kitchin and Perkins 2009; Back and Puwar 2012). Thus, we see performative mapping as closely linked to an institutional critique of governing modes of knowledge production (Latour 2004; Law 2004). A performative understanding of such scientific practices 'takes account of the fact that knowing does not come from standing at a distance and representing but rather from a direct material engagement with the world' (Barad 2007: 49).

By integrating performativity with the practice of mapping into urban studies, we expand on a processual and non-representational understanding of the city that has in particular been developed within non-representational theory and theories of affect (Thrift 2008; Anderson and Harrison 2010; Anderson 2015; McCormack 2013). In non-representational urban theory, cities are described as 'a kind of force-field of passions that associate and pulse bodies in particular ways' (Amin and Thrift 2002: 84). These are bodies (humans, architecture, infrastructure, art) that constantly engage with one another, forming urban environments, shifting their rhythms and flows. This understanding of space is in contrast to both a modernist conception of the city, in which space is merely thought of as a container of human life, and a social-constructivist understanding that sees space as a process and as the becoming of human actions (Samson 2010). By engaging

with the city through situated and embodied investigations rather than analyzing urban signs and significations, performative mapping contributes to an urban theory which does not reinforce dominant spatial theories and their instruments for analyzing space. Hence, we see a potential in performative mappings as a mode of inquiry and site-responsive research that points to urban problems and themes differently. A problematization that potentially reflects, confronts and realigns divergent worldviews and that break with representational knowledge hierarchies.

Performative mapping – new institutional spaces

Performative mapping is a practical exercise in situated knowledge. Situated knowledge acknowledges the responsibility that comes from seeing the world from a certain perspective (Haraway 1988). Bringing the feminist objectivity of situated knowledge into spatial theory involves attending to how situated knowledge also creates spaces, 'makes place of our place in the world' (Dewsbury 2003: 1907). This means that situated knowledge also produces spaces and positions by making things that do not exist under representations' eye visible and sayable.

As situated knowledge, performative mappings challenge a representational approach to spatial analysis. As students in urban studies, we might learn how to map a space based on the functions we observe in it: The number of benches, different patterns of mobility, public vs. private spaces and observations of how social groups are included or excluded in these spaces. From these observations, we generate knowledge about planning ideologies and power relations. This knowledge is not necessarily wrong, but the practices that lead to it are based on a certain understanding of vision and of objectivity, of knowledge practices as a totalizing view. Performative mappings are less exhaustive than the observations just described, and they hold back on the explanatory urge to link what is experienced when mapping and what can be known about a power that somehow proceeds what we can observe in space. This is not to say that performative mappings cannot be used to analyze planning ideologies and power relations – but they dwell on 'the flash of the felt before we wrap it up with contemplation' (Dewsbury 2003: 1930). This is also what Dewsbury (2003) calls 'witnessing space'. Witnessing does not refer to a passive practice of accounting objectively for events. On the contrary, it is an active practice which acknowledges its partial perspective: To witness is to be in one particular place and thus give up on the representational idea of being able to see, explain (and solve) everything. The performative mappings analyzed in this chapter should be read as such felt moments, moments of witnessing before contemplation,

before analysis, while our introduction to the places in which the mappings take place give an indication of the directions in which such flashes of the felt could be analyzed. What is important to stress, however, is that performative mappings are not just interpretations of a (political) context through practice, they also alter that context. The point of analysis through performative mapping is not to reinstate structure since that structure will not be the same after the event of witnessing (here, the performative mapping) (Dewsbury 2009: 1929). As institution-altering events, performative mappings work as what Raunig (2007) calls instituent practices. Instituent practices are not opposed to the institution (the field of representation which constantly produces formats that again produce representational knowledge) but a form of institutional critique that pluralizes from within and expands the limit of the institution. This is to say that performative mappings such as the ones undertaken here create new institutional spaces that resist the production of representational knowledge in relation to both the educational institution of the university and the institution of urban studies and planning.

While Haraway starts from the power involved in our visualizing practices, performative mappings emphasize other sensory powers and the spatial implications of Haraway's feminist objectivity: Performative mappings are committed to mobile positioning, where relocation is that which allows for 'splitting' as opposed to 'being', to see and see from many positions (Haraway 1988: 585–86). Performative mappings, we argue, riven as they are with bodily limitations and awkwardness, give an embodied experience of how positioning turns us into responsible witnesses.

Performative mappings on Nørrebro and Refshaleøen

Departing from situated knowledges as a way of witnessing space, teaching the programme 'Performative Urbanism' as a field course stressed the point that methods must be immanent to the field. Knowing from a situated position in a field can mean taking what we normally consider as noise, as messiness or of minor interest into consideration. While Donna Haraway and Judith Butler have taught us that knowledge always develops from a body, we take the learnings from situated knowledge out in the field to look into how sites co-produce and enact certain kinds of knowledges. It is in this sense that we argue that sites (urban or not, academic or not) play an important role in cultivating knowledge with an awareness of its own positionality, which is inevitably also a question of performing the institutions from which we speak.

Questions posed by the research sites

The performative mappings we analyze below took place in two different neighbourhoods of Copenhagen. Each place affected the ways in which the performative mappings unfolded. We introduce the places here to stress the ways in which methods are always immanent to the field as each place poses different problems related to the neoliberal development of the city.

Refshaleøen is a postindustrial neighbourhood in Copenhagen. While the industrial past is still visible in buildings and landscapes, the site now houses – among other things and practices – several cultural institutions. One of these is the theatre company Teaterøen ('Theatre Island'), an open platform for international performing arts. The theatre is not confined to one building but rather spreads out across several buildings with vegetation, wedges and paths in the interstices that seem as much part of the theatre as the buildings. Inside buildings, there are beds and coffee cups everywhere. As part of the field course in Performative Urbanism, we (a group of students and teachers) collaborated with Teaterøen. Gesturing towards the beds and coffee cups the founder and director, Peter Kirk, explained to us: 'The only way to live here is to let others live here.' Kirk, dressed in orange worker's clothes, introduced us to the buildings around Teaterøen like he was introducing us to old friends of his (Figure 9.1). Each with

FIGURE 9.1: Peter Kirk, the director of the Theatre Island, introduces students to the space like they were old friends. Photo by Kristine Samson.

a story of how they came to know each other and what new ideas they had developed together. Only at one point did he seem concerned about the openness of inhabiting space in this way: 'It's like the worry that comes with having kids', he told us, alluding to the uncertain future of Refshaleøen which is privately owned and will be redeveloped in the near future which most likely means that most of the current cultural institutions and inhabitants will have to move. Our experiences from doing fieldwork with Teaterøen should be seen in the light of this hovering development. At the time, the way that the theatre shaped and was shaped by this space seemed to us like the materialization of an alternative to the coming redevelopment: The humble and hospitable way of occupying a space along with a sense of space as something to care for rather than to keep or own. In 2021, three years after our field work with Teaterøen, Refshaleøen's inhabitants are still anticipating the redevelopment while continuing to shape the site through use. Today it is clear, however, that the future redevelopment starts to influence local actors' ways of shaping the site, visible in small acts such as locked doors and fewer plans for the future.

Nørrebro

As one of Copenhagen's few multicultural and ethnic neighbourhoods, Nørrebro is often associated with sociocultural diversity. It is one of the densest populated areas in Denmark and has a high concentration of non-profit social housing. While the city generally aims to increase its social housing units, the social housing on Nørrebro has been problematized by the Danish governments' 2018 plan to remove what they call 'parallel societies' that are thriving in these areas, also labelled 'ghettos'.[1] Consequently, many of these buildings are threatened to be sold or demolished. As a former working-class neighbourhood, Nørrebro is undergoing rapid gentrification, similar to what we see taking place in a number of cities today. For instance, the design of the park Superkilen is a material manifestation of the international hype of Nørrebro. As a public park designed by Topothek 1 and BIG Architects, it is on the one hand a material gentrifier attracting the middle class and global creative tourism. On the other hand, it is based on a culturally diverse design that symbolically represents the multicultural neighbourhood by exhibiting urban furniture and objects from around the world (Figure 9.2). The result of these developments is that Nørrebro is home to the simultaneous existence of symbolic and lived diversity which is both associated with a strong local identity. This co-existence is felt in local struggles to define what diversity is, exemplified in the debate about a piece of grass in Nørrebro Parken. While the municipality has allowed the local football club Nørrebro United – a club with an explicit

agenda of social inclusion and integration for local kids – to use the space for a new football turf, locals are protesting about fixing the use of this place to football. To them, diversity is understood as the recreational possibilities that this green space gives.[2] The places described here – the highly designed Superkilen and the green recreational space of Nørrebro Parken – expose some often overlooked aspects of a city famous for its urban design and livability, such as the way in which urban design successfully translates into an image of diversity which is subsequently used forcefully.

In sum, these were some of the questions posed by Refshaleøen and Nørrebro, which influenced our approach to performative mapping. The following three sections explore the performative mappings that came out of the course fieldwork. Although the titles of each following section suggest different methods of performative mapping, it is important to note that performative mapping always involves collective processes of moving, seeing and assembling.

Mapping through movement

In this section, we revisit two performative mappings – one on Nørrebro Station and another on a pier on Refshaleøen – which both used the body, its movements and limitations as a primary means to explore places.

The Emergence of the Collective Body

We (teachers and fellow students) are told to spread out on Nørrebro Station and wait for something to happen. Suddenly, a strange body appears. Since we are placed all around the station, we do not see it at the same time and we do not see it all the time. Sometimes we have to wait for it, or follow it around. The collective body consists of five different student-performers' facing in different directions but glued together by the shoulders. They move around the station like this, forward but awkwardly since they are turned sideways. It is as if the forward movement only applies to them as a collective body. As they move around, negotiations take place. Clearly, they haven't agreed in advance who should act as 'the head' and who as 'the tail', the only thing they seem to have agreed upon is to stick together as they climb up and down staircases, open and close doors, wait on the platform and take part, although in a strangely inhibited way, in the everyday rush of the train station. Since they do not speak or look at each other, negotiations only take place physically, through pushes or drawbacks that we as spectators can only detect as movements across the surfaces of their bodies. Or, as the student-performers titled their mapping, we might see these movements as 'The Emergence of the Collective Body' (Figure 9.3).

PERFORMATIVE URBANISM: MAPPING EMBODIED VISION

FIGURE 9.2: Superkilen Park, the Red Square in Nørrebro. Visual design and urban furniture are collected from all over the world to illustrate the cultural diversity of the neighbourhood. Photo by Kristine Samson.

FIGURE 9.3: *The Emergence of a Collective Body*. The performance was made by a group of students to map and explore the potentials for collective agency at Nørrebro train station. Photo by Kristine Samson.

Relating their mapping to space, the student performers described the movements of the collective body as a basic exploration of how to approach space around them, not taking any kind of habitual patterns – patterns usually inscribed into the social space of the train station or public space – for granted. The collective body examined Nørrebro Station in new and curious ways, and to reset their embodied as well as cognitive knowledge – of patterns of movement and how to relate to other people in space – they formed a new body consisting of multiple subjects. Dewsbury argues in relation to witnessing that to address our emotions, desire and faith (life knowledge rather than power knowledge), it is not enough to stay within the realm of individual convictions, stuck in the phenomenological subject. Instead, '[it] is about getting back to a moment of prediscursive experience; to recommence everything, all the categories by which we understand things, the world, the subject-objective division' (2003: 1910). While resetting their own knowledge of how to move and act in social space, the collective body also disturbed and unsettled other people's movements in the station. In their description of the mapping, the students state: 'The collective body creates boundaries in ways that challenge your habitual movements and provoke you to rethink your path through the station' (cited in Samson and Juhlin 2017: 6). The relation between individual bodies and collective bodies thus both applied to the performing students as individuals shaping a collective body but also to the social space of the station as a place which houses numerous individual itineraries that are nevertheless all remarkably alike. By doing research through a collective body, the performative mapping explored how meaning can move away from the individual subject towards an impersonal zone that goes beyond subject–object distinctions.

By experimenting with format, the performative mapping found other ways to analyze familiar themes such as mobility patterns, function, spatial and bodily normativity. Instead of observing and analyzing the observed social interactions and movements on a train station, the performative mapping explored how a spatial analysis can also take place by installing a new social practice into space which works by disturbing existing norms and interactions. The performative mapping shows how doing research with and through the body might take place in the field of spatial analysis, responding to Dewsbury's question: 'What does it mean in practice to do research starting through the body?' (Dewsbury 2003: 1912). It demonstrates how the body works as a position and how that position has limitations: the collective body could not possibly create a totalizing analysis of social interactions on the train station but only map that which it temporarily came into contact with. This is the promising vision of feminist objectivity, where partiality replaces universality in knowledge production.

Unstable Choreography

In the next performative mapping, which used the body and movement to map space, we are on Refshaleøen, facing a pier covered in thick layers of ice. Or rather, we are not actually standing on the pier but sitting inside Teaterøens warm living room, while the student performers are projecting a movie of their movements along this pier. The pier is placed at the far end of Refshaleøen, extending 20-30 meters into the sea, resting on thick wooden pillars that, Peter the theatre director tells us, are being slowly eaten by ants which is why it has been prohibited to use the pier. Right now, it's hard to imagine any ants living in there since the wood is covered with thick layers of ice. We see a person walking blindfolded on the pier, another one walking backwards and a third one dancing. All the while, we sense the extreme weather conditions through the audiotrack which mostly consists of the wind and the shaking movements of the camera. The weather conditions are visually manifest in the unstable movements of the persons on the pier and their hair which whirls around and cover their faces. We also see how the blindfolded, backwards-moving and dancing persons are being careful with their steps, how they are forced to change directions according to the wind or to speed up, presumably because of the cold.

The performative mapping enacted and enforced in different ways the students' first impressions of an unsafe environment at this pier. They explained that they wanted to work with the contrast between the usual connotations of water in the city – recreation, summer, warmth – and the uninviting condition in which they encountered the pier on this February day. They were intrigued by the unsafe environment of the pier: the slippery ice, the extreme wind and the presumable fragility of the wooden pillars. By reinforcing their first affective reactions to the space, the mapping clearly did not intent to find ways out of their perception of unsafety by for instance proposing design solutions to improve safety or comfort, but embraced this unsafety as a source to work with in order to find out more about the pier and its correspondence with the surroundings. By doing so, the performative mapping pointed to the way in which witnessing can be a different way of posing problems and looking for solutions. Dancing, walking backwards and walking blindfolded can be seen as ways to describe a space without jumping to conclusions. Not looking for solutions is to exceed the ease of communication of given meaning. The material and affective turn opens up a new space of problems, in which the concern is not so much the idea of correct depiction of empirical reality, but rather multiple and diverse potentials of what knowledge can become. In fact, both of the performative mappings revisited in this section works with a spatial analysis,

which neither explains, represents nor criticizes, but generates new affects and practices in correspondence with the materiality of the place, shaping in turn new places – although temporarily – through these practices. Working with bodily movements in relation to spatial analysis, they create what dance scholar André Lepecki describes as

> charged and vital problematic fields on which pressing and urgent political, corporeal, affective, and social problems are made visible and gather – not to find a solution, but to further the movement of problematization.
>
> (Lepecki 2018: 8)

Mapping through embodied vision

In this section, we revisit a performative mapping on Nørrebro which used mirrors as visualizing practices to create new or to multiply perspectives on the city as another approach to mapping a place.

Mirror Walk

We are on a mirror walk through what to most of us is a familiar street on Nørrebro. Two of the student performers are walking in front, the rest of the class follows behind. The student performers each carry a large mirror above their heads. The mirror faces the group so that we can see ourselves walking if we look straight forward. During the walk, the student performers occasionally stop and put down the mirrors in different places. They place them on façades or resting on staircases, in what seems to be a deliberate attempt to catch a piece of nature in the city and double it or draw attention to it. During the walk, the student performers also urge us to notice small pieces of broken mirroring glass placed on the route, in piles of leaves and in between the boards of a fence. At other times, the student performers stop and, without words but by silently gathering the group, draw our attention to 'natural' mirrors; puddles, windows, a wind chime in a church garden through which we are invited to look at ourselves or our surroundings (Figure 9.4).

As we walked along the mirror walk, we were of course engaged with our entire bodies in the practice of walking, but vision was particularly emphasized through the mirrors and the visualizing techniques they evoked – by doubling images, by changing directions of our gazes and by making us search for these effects in everyday urban material environments. As previously written, Donna Haraway points to how vision can certainly be linked to ideas of creating totalizing objective images – the illusion that the eye can oversee and thus know everything – but can also be

reclaimed into a feminist discourse. While mirrors can obviously be understood as representations that mirror reality, the way the performative mapping used mirrors was instead as a material and situated practice: the mirrors in puddles, windows and leaves did not create totalizing images but emphasized details and made it possible to see things that were otherwise easily overlooked. At the same time, the mirrors which guided and mirrored the walking group made us constantly aware of ourselves in the process of seeing. Haraway argues that vision requires instruments of vision to remind us of the mediation of knowledge; 'an optics is a politics of positioning' (Haraway 1988: 586). Working with the multiplication of sight and the mirror as a technique for seeing differently, the mirror walk pointed to the possibility of taking various positions from which to see and hence explore a place, but also pointed to the fact that vision is always a question of the power to see (Haraway 1988: 585). Similarly, Dewsbury describes witnessing as a way to unfix and alter perspectives, 'denying any one figuration or representation of the way the world is' (Dewsbury 2003: 1919). In their description of the methods they had used, the students pointed to the engaging effect of mirrors because you are an active part of making the shifts from mirror to 'reality'. Here, the mirrors and the images/spaces they created also came to question our belief: 'the act of seeing becomes one of believing, it dispels our one fear that there is nothing beyond this [...] we cannot be sure' (Dewsbury 2003: 1919). This uncertainty was embodied every time we looked for the source of the mirrored spaces or found what we saw distorted in the mirrors.

Mapping through assembling

While the two previous examples have shown how performative mapping through the moving body and embodied vision can be said to explore place, this last example turns towards two performative mappings on Refshaleøen which both used collecting and assembling as methods to explore and analyze places.

Twin Harbours

We are in a room in a former demagnetization station used by the navy, but now one of the many buildings used by Teaterøen. The room is big and without furniture. Below, it has a newly renovated wooden floor, above, the wooden beam structure of the rough is laid bare and unrenovated in contrast to the new and polished smoothness of the floor. On the one side of the room, the one facing the sea, there are large squared windows facing the water outside and across the water another harbour, Nordhavn, a newly developed urban area closely packed with tall glass, steel and concrete structures. The student performers show projections on four vertical white fabric screens, hanging from the wooden

beams, while also playing an audiotrack. As we watch and listen, we are free to walk around in the room. The video images are close ups of materials from walking around on Refshaleøen and Nordhavn, the two adjacent harbours. The audio track is from an entirely different environment, a party or dinner of a sort, we hear the sounds of cutlery on plates and of mumbled talk and laughter (Figure 9.5).

The students were initially drawn to this room and the way it framed a view which seemed very different from the place we were standing. While Refshaleøen largely consists of derelict buildings and vast landscapes, Nordhavn is fully transformed into a dense urban neighbourhood with few or no traces left of the harbour's industrial past. The students therefore explained that they wanted to map the two harbours and their differences. Through sound and visual recordings, they registered differences in materials, in infrastructures for moving around and in the social life taking place in these two adjacent harbours. These mappings were then assembled into a second life of the mapping process, where they were brought into the room of the demagnetization station which in turn was also mapped in our process of experiencing the visual projections and sounds. Nordhavn, which was before a distant view, an outside and also a radical difference from the place we were in, now moved closer and became a potential, perhaps threatening, future: The straight paved sidewalks, the steel and glass facades, the homogeneity of a neighbourhood created from scratch in five to ten years. By furthermore adding a fictive layer to the found materials – the sounds from a festive dinner – the installation also introduced a speculative dimension. Imagining forth a wedding in this place was also a hint to a different future for it. With the festive sounds, gentrification and conformity seemed to be moving closer. By collecting materials through video and sound, and installing them in a space which folded two different urban environments into one another, the mapping as a mode of assembling created a new space to work on its found materials in speculative and situated ways.

Barriers

Only one of the corners in Teaterøens biggest theatre hall was dimly lid. The student performers lead us from one end of the theatre hall to the corner in which they have installed an exhibition on the black walls and floor of the room. We are invited to walk around it in silence. On one wall, we see a photo series of different physical barriers which they have encountered around Teaterøen, accompanied by words describing the materials that constitute the barriers: steal/water/rock, metal/ivy and water/asphalt. On the floor, plastic sheets are organized diagrammatically, and inside them are materials collected alongside these barriers. Spread out on the floor, we also find small pieces of paper with words that seem to describe emotional

PERFORMATIVE URBANISM: MAPPING EMBODIED VISION

FIGURE 9.4: *Mirror Walk* was an exploratory walk in which students played with the participants gaze and conception of what is urban nature. Photo by Kristine Samson.

FIGURE 9.5: *Twin Harbours* was a video installation on canvas mapping two harbour areas in Copenhagen Harbour, exploring differences and similarities – and possible futures. Photo by Kristine Samson.

reactions that the student performers have had in encountering these barriers. On the other wall of the corner, a projector shows a video shifting between houseboats in the harbour bouncing into large ice blocks, the nearby purification plant surrounded by whirling snowflakes, and a metal fence (Figure 9.6).

After having watched the exhibited objects in silence, the students presented their collected objects and their process of mapping barriers on Teaterøen. They explained how they had started with the intention of exploring their first impressions of hostility in the physical environment, as they were met by fences, gates, barbed wire and difficulties of finding and accessing Teaterøen. They described how these first impressions were in contrast to what they later learned to be Teaterøens approach to space which, as described in the introduction, was characterized by hospitality and open doors. The students wanted to map this contrast – if Teaterøen was such an open place, why did they not feel welcome? By combining

FIGURE 9.6: Video excerpt from the audiovisual mapping *Barriers* at Refshaleøen.

a mapping where they photographed material barriers, collected objects found along the barriers and recorded the sounds of materials clashing against each other, they ended up both exploring the urban environment and their own perceptions of hostility in it, tracing the material origins of these affective reactions. By assembling and collecting, the exhibition made a spatial re-arrangement and re-enactment of the hostility they had encountered which created a room for a different kind of reflection on these spaces. By using the format of the exhibition, their initial hostile and quite critical encounter with the urban environment was transformed into a new knowledge situation and a new space of problems. For instance, during their presentation, the students explored how working with performative mapping as a method had led to an encounter with another mental barrier: the barrier connected to working in an open-ended experimental process of creation, where it was not clear where they were going or exactly what they were analyzing. This jump in their performative mapping, from material to mental barriers, from urban environment to their own procedures of knowing, clearly shows how working with performative mapping in analyzing space can produce knowledge:

> Witnessing is about being open to this radical contingency [of unknown procedures of knowing], to the event; it is not about assisting through our interpretation of action the reinstatement of structure – the world is simply not the same again, we cannot reinstate it.
>
> (Dewsbury 2003: 1929)

With these performative mappings in mind, the last section will conclude through a few perspectives we find pertinent in questioning the institutions in which we both create, design and analyze space: the contributions of performative urbanism and the question of how institutions shape the problems we see.

Instituent practices and critical urban studies

Each of the performative mappings previously explored was a minor engagement with space. What could the city become if we actually took these instituent yet minor findings from the performative mappings into consideration and formulated new critical questions for urban practices and knowledge production?

First, the implications for knowledge production is a problematization of normative standards that adhere to traditional methods in academic knowledge production. While developed in the context of the university, and responding to planned and designed spaces, the performative mappings explored formats that perform knowledge and space differently. At the same time, we also acknowledge

that '[...] we know the world with our institutions, and by virtue of our institutions, not in spite of them' (Bloor 2001 cited in Dewsbury 2003: 1929). As such, the performative mappings can be seen as instituent practices: an instituent practice does not, as previously mentioned, 'oppose the institution, but it does flee from institutionalization and structuralization' (Raunig 2007: n.pag.). In a reading of Raunig's notion of instituent practices, Rogoff emphasizes the potential of the pluralization of the instituting event:

> [...] it is not only the moment of instituting oneself but also the plurality of the activities involved, the fragmentation of one clear goal and protocol into numerous registers of simultaneous activity, that are the hallmarks of instituent practices, which thereby refuse the possibility of being internally cohered and branded.
>
> (2010: 45)

The plurality of methods employed in the performative mappings, and their different approaches to space and knowledge production, are already a destabilization and questioning of institutions, as the students who presented their uncertainties related to working in such an open-ended way experienced on their own bodies. This uncertainty makes knowledge practices and our choices of how to perform them political (Dewsbury 2003: 1828). Touching on a larger methodological discussion which is outside the scope of this chapter, the performative mappings and their uncertain and probing approaches to knowledge, in this case about space, do not fit into an academic tradition of certainty and linear progression of analysis.

Second, the implications of these minor findings for urban practices are to address and revert our preconceived knowledge of the city by partially witnessing and reorganizing what is already there. This is what we, informed by Haraway, understand by situated practices and the partial perspective. For instance, how bodies relate to one another, how the social and material specificity of bodies change situations, how the weather changes spatial qualities, and how specific mediation and techniques perform partial perspectives to make otherwise unseen or unspeakable spaces felt. The performative mappings were concerned with embodying minor movements and materialities in the urban field. The mappings expanded the possibilities for what was worthy of attention: the staircases of a train station as a social space where collective movement happens all the time but always guided by individual wills. The mirroring effects everywhere around us, and how they expand space. The possible future of spaces which are still left unattended by neoliberal urban development. Dewsbury describes the importance of turning our attention to the otherwise imperceptible, that which mystifies and surpasses meaning. By drawing attention to these details, the performative

mappings draw us into the kind of space that make it possible to 'reinvent and reinvigorate political concepts' (Dewsbury 2003: 1927). While some may consider this too personal or partial, Dewsbury argues that this is the space where impacts are felt, where we can 'measure up to the technicization and globalization of political communities' (Dewsbury 2003: 1927.), certainly encompassing neoliberal urban planning. Using performative mappings to see things that do not exist with representations' eye was to insist on making other spaces visible and discursively meaningful. The performative mappings enacted the messiness of urban environments from such partial and situated perspectives. Therefore, performative urbanism is not a planning practice per se, but a situated method and a material practice for perceiving and expressing the performativity and agency of urban environments.

Conclusion

Performative mapping has been explored as a way of doing research through the body, and, in particular, through a body affecting and affected by the material urban environment. The performative mappings on Refshaleøen and Nørrebro have pointed to the connection between urban planning and our own methods for approaching space in academia: The way we address problems, propose solutions, take part, reassemble. Challenging urban normativities, we must therefore also challenge our own conceptions of spatial analysis. This is not done by opposing institutions as such, neither academia nor urban planning. Rather we must institute events and minor acts by imagining what urban spaces might become from exploring mirroring puddles, from emerging collective bodies, from the soundscapes and objects of a seemingly hostile environment. Here, the point of departure is not to stand outside of neither academia nor the city. In the 'Performative Urbanism' course in this chapter, we have tried to present various ways of seeing and doing – theoretically informed by Haraway and Dewsbury – with the interest of pluralizing spatial analysis taught in academia. This, with the words of Dewsbury, is 'to practice the politics of forming understanding from a different orientation point' (Dewsbury 2003: 1914). One might argue that these efforts are minor in terms of the major problems related to urban planning and urbanization in general. They are. However, changing existing urbanity implies othering the city into multiple co-existing urbanities.

NOTES

1. The Danish ministry of Transportation each year publish the 'Ghetto list', outlining designated 'ghetto' neighbourhoods in Denmark. We take a strong stand against the stigmatizing

speech act inherent to the words 'ghetto' and 'parallel societies' used by the authorities as it has severe consequences for the citizens living in the neighbourhoods. At the same time, we have witnessed how the discourse from the authorities propels political dissent and insurgent practices among citizens in the neighbourhood of Nørrebro as several political demonstrations against the ghetto list and its consequences has happened in the last couple of years.
2. We have been made aware of this on-going and lived debate over the football turf by Aske Tybirk Kvist who is doing his Ph.D. with and about the football club Nørrebro United.

REFERENCES

Ahmed, Sara (2004), *The Cultural Politics of Emotion*, New York: Routledge.

Amin, Ash and Thrift, Nigel (2002), *Cities: Reimagining the Urban*, Cambridge and Malden: Polity Press.

Anderson, Ben (2009), 'Affective atmospheres', *Emotion, Space and Society*, 2:2, pp. 77–81.

Anderson, Ben and Harrison, Paul (2010), 'The promise of non-representational theories', in B. Anderson and P. Harrison (eds), *Taking Place: Non-representational Theories and Geography*, London: Ashgate.

Back, Les and Puwar, Nirmal (2012), 'A manifesto for live methods: Provocations and capacities', *Sociological Review*, 60:Suppl. 1, pp. 6–17.

Barad, Karen (2007), *Meeting the Universe Halfway: Quantum Physics and the Entanglement of Matter and Meaning*, Durham: Duke University Press.

Butler, Judith (2015), *Notes Toward a Performative Theory of Assembly*, Cambridge: Harvard University Press.

Clough, Patricia T. (2007), 'Introduction', in P. T. Clough and J. Halley (eds), *The Affective Turn*, Durham: Duke University Press.

Dewsbury, John-David (2003), 'Witnessing space: Knowledge without contemplation', *Environment and Planning A*, 35:11, pp. 1907–32.

Dodge, Martin, Kitchin, Rob and Perkins, Chris (eds) (2009), *Rethinking Maps: New Frontiers in Cartographic Theory*, London: Routledge.

Frandsen, Martin Severin, Samson, Kristine, Larsen, Jan L., Klit Nielsen, Anne and Muusmann, Kristina (eds) (2015), *Performativ urbanisme #2: En antologi af studerende ved Plan, By og Proces og Performance Design på Roskilde Universitet*, Roskilde: Roskilde Universitet.

Hannah, Dorita (2015), 'Constructing barricades and creating borderline events', *Theatre & Performance Design*, 1:1–2, pp. 126–43.

Hannah, Dorita and Harsløf, Olav (2008), *Performance Design*, Copenhagen: Museum Tusculanum.

Haraway, Donna (1988), 'Situated knowledges: The science question in feminism and the privilege of partial perspective', *Feminist Studies*, 14:3, pp. 575–99.

Latour, Bruno (2004), 'Why has critique run out of steam? From matters of fact to matters of concern', *Critical Inquiry*, 30:2, pp. 225–48.

Law, John (2004), *After Method: Mess in Social Science Research*, London and New York: Routledge.

Leavy, Patricia (2009), 'Social research and creative arts: An introduction', in *Method Meets Art: Arts-Based Research Practice*, New York: The Guilford Press.

Lepecki, André (2018), *Singularities: Dance in the Age of Performance*, London: Routledge.

Lury, Celia and Wakeford, Nina (2014), *Inventive Methods*, London: Routledge.

Massumi, Brian (2002), *Parables for the Virtual: Movements, Affect, Sensation*, Durham: Duke University Press.

Rogoff, Irit (2010), 'Turning', in P. O'Neill and M. Wilson (eds), *Curating and the Educational Turn*, London: Open Editions/de Appel.

Samson, Kristine (2010), 'The becoming of urban space: From design object to design process', in I. J. Simonsen, J. O. Bærenholdt, M. Büscher and J. Damm Scheuer (eds), *Design Research: Synergies from Interdisciplinary Perspectives*, London: Routledge, pp. 172–86.

Samson, Kristine and Juhlin, Christina Louise Zaff (2017), *Performative Urbanism*, Roskilde University, https://rucforsk.ruc.dk/ws/portalfiles/portal/63172319/Performative_Urbanism_Autumn_2017_Juhlin_Samson.pdf. Accessed 7 September 2022.

Springgay, Stephanie and Truman, Sarah E. (2018), 'On the need for methods beyond proceduralism: Speculative middles, (In)tensions, and response-ability in research', *Qualitative Inquiry*, 24:3, pp. 203–14.

Thrift, Nigel (2008), *Non-Representational Theory: Space, Politics, Affect*, London and New York: Routledge.

Wetherell, Margaret (2012), *Affect and Emotion: A New Social Science Understanding*, London: Sage.

Wolfrum, Sophie and Brandis, Nikolai Frhr v. (eds) (2014), *Performative Urbanism – Generating and Designing Urban Space*, Berlin: Jovis Verlag.

Wolfrum, Sophie and Janson, Alban (2019), '5. Architecture as event – OnpPerformativity', in *The City as Architecture*, Berlin and Boston: Birkhäuser, pp. 35–40, https://doi.org/10.1515/9783035618051-005. Accessed 22 February 2022.

10

Performance Design: Performative Gestures within Academic Institutions

Rodrigo Tisi

Academic institutions sometimes generate abstract spaces to promote open systems, which serve to instigate collaborations previously not envisioned. These spaces arise without a pre-structured frame and are important because they can promote new ways of doing academic work and research. Traditional institutions (such as universities) are spaces to promote formal and informal routines, norms and conventions embedded in the organizational structure of the political economy; therefore, these organizations incorporate practices and procedures driven by concepts that are agreed upon in society and within the institution.[1] As a technical report for the Inter American Development Bank describes, such institutional structures establish a level of organization to whatever social interaction, political process, productive or economic activity is being developed (Alberti 2019: 3–9). As disciplines organize thematic structures and constitute essential spaces to transfer knowledge, institutions of higher education maintain traditional – and predictable – structures. This text, on the other hand, wonders about the unpredicted and poses a question concerning the spaces that institutions may offer to promote a becoming.

My observations are therefore framed within the realm of academia, and I consider here spaces of creative practice and theory for teaching Performance Design. These explorations refer to certain *performative gestures* that were undertaken within the conventions of institutional spaces, and they refer to my personal experience teaching different courses at an undergraduate and graduate level. As an interdisciplinary field, Performance Design situates itself between diverse areas of knowledge and throughout different levels of complexity. As a field of

inclusions, it propels creativity[2] by mixing different disciplines and combining aspects of the arts, humanities and sciences. The arts contribute the exploration of forms of presentation, representation and symbolism. The humanities offer the field of phenomenology, with its analysis of sociological and anthropological dimensions of cultural practices (wherein aspects of communication and human interaction are crucial). Finally, the sciences provide scientific and technological improvements in various contexts, forms and industries, which are useful to developing the efficiency, efficacy and effectiveness of design outcomes (McKenzie 2001: 27–136). Regarding the name of this integrative field, we can say that *performance* indicates the exploration of opportunities to provoke something, while *design*, as an inherent practice of *doing*, indicates possible explorations of concrete and effective solutions to multiple concerns.[3] Both *performance* and *design* practices concern understandings of the effects that the execution of a certain project triggers. One could say that someone executing a Performance Design project moves freely throughout and among these three zones of knowledge, to shape in what the project of design and performance could become. Such multi-layered, open space constitutes it as the ideal ground for developing not only a dynamic, flexible type of academic practice within institutions (Hannah and Tisi 2002: 58–60) and within a conventional disciplinary form, but also to enable an arena of practice inside of academia that is closely linked to the outside. This last aspect is fundamental to the practice of any designer who wishes to have an impact with her/his projects and within society.

Meanwhile, the ambit of Performance Design varies and could be understood as fluctuating, moving from one field to another. As presented in Figure 10.1, the field can develop from disciplinary work to a more integrative one within academia, with a final goal of contribution (outside environment). Performance Design is, therefore, a territory that might be situated between fields in the inside of academia as well as a field connecting its borders with the outside. In this dynamic field, there are three important aspects that should be considered: the sociological, the political and the economic. These three aspects are relevant because they describe the characteristics of the institutional space that make it possible for academics to *perform* with their roles. The understanding and management of interaction between these aspects is crucial to further develop the project of Performance Design and its contributions to make the academic project perform better (a project of academia in the twenty-first century should be different from a model of the twentieth or even the nineteenth century where disciplines and areas of knowledge were more strict and less expansive). This challenge points to work within established protocols and structures to generate new spaces and paths of knowledge across disciplines. Within institutions, individual *performances* can achieve what otherwise might be technically impossible or at least, difficult to implement; hence,

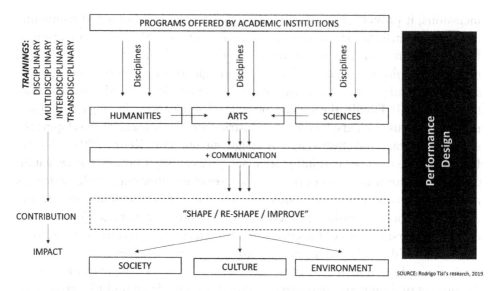

FIGURE 10.1: Performance Design within academic institutions. This diagram depicts a possible situation of the field. Performance Design can be situated in educational models that are integrative and that promote interdisciplinary methodologies for creative work and research, from disciplines to transdisciplines.

I present my thinking here via three performative gestures, undertaken by myself while navigating academic and professional practice as a designer.

Looking back to my own academic practice, I see that one of my first *performative gestures* within an academic institution occurred when I decided to leave my comfort zone of teaching architecture in order to start a new path. Before that moment, I had completed one semester at the department of Performance Studies at New York University and then continued my studies at Pontificia Universidad Católica de Chile, where I received the title of architect and a master's degree. I then returned to New York University's Tisch School of the Arts to pursue a doctorate in the field of Performance Studies. I studied there from 2000 to 2011, which seems like an extraordinary amount of years studying, but during that time I had the opportunity to practice, to collaborate on various creative projects in the fields of visual arts, theatre, performance, design and architecture. I did several collaborations and had the opportunity to meet well-known artists such as Walid Raad, Coco Fusco, Vito Acconci, among many others. With this gesture, I crossed the disciplinary boundaries of the initial field (of architecture)[4] that I was trained in, and I started to align the knowledge I had already gained towards a new field of practice and new kinds of knowledge – including, most importantly, a reconceptualization of space and *performance* from the field of Performance Studies. This

step forward was crucial to propel ideas of creativity associated to research with the integration of knowledge in many different ways, throughout methodological a processes to accomplish certain results.

During 1999, in her presentation 'Culture and creativity', and while teaching at New York University, Barbara Kirshenblatt-Gimblett declared that Performance Studies constitute a field of *inclusions* and use the lens of performance to study a wide range of behaviours which can be be framed within cultural practices. This approach was provocative and strong enough to help me argue and analyze that architecture, as a cultural construct, is defined by its own performance in socio-cultural terms. Consequently, the definition of design offered in this text follows this perspective as it takes into account cultural practices, including issues of built forms, symbolism and efficiency that are normally associated with project concreteness or materialization. In a related move, it is possible to trace some of the origins of Performance Design when it took a new path in 2004, after a symposium organized at the Danish Institute in Rome by Dorita Hannah and Olav Harslof (representing Massey University and Roskilde University respectively). In here, it could also be mentioned that one of the first notions of the field appeared from a more technical area of the field, in a 1967 issue of *Progressive Architecture*. In this issue, Performance Design was described as an approach to analysis and engineering that expanded the practice of design towards hard systems associated with technologies.[5]

These influences articulated for me key spaces that allowed me to expand ideas from and of the discipline of architecture, and especially from the conventional, static practice view that most of the time is restricted to exploring spatial solutions through building forms (mostly permanent). As Barbara Kirshenblatt-Gimblett argues in 'Objects of ethnography', Performance Studies, with its integrated lens of analyses, allows exploration across broad cultural dimensions and through different forms that are material and immaterial, permanent as well as temporal (2011). The concept of *performance*, as articulated in Performance Studies, thereby questions notions of body, time, sense of place and culture to describe a situation 'happening'. Both the field and the concept are crucial to understand the issues of presence and experience as they relate to architecture and to design in a broad sense.

Performance perspectives thereby pushed my conventional approaches from a traditional field (architecture) to a more ambiguous, flexible and undefined territory between disciplines (and between theory and practice), to wonder about the limits of possible doings. *Performance* and Performance Studies gave me tools to develop sharper arguments in questioning practices of situated spatial design beyond architecture. From this angle, I value that *performance* focuses on what design does *as* something (outside the field) rather than what design *is* (within the field).[6] This idea

is crucial to negotiating practices and spaces within the limits drawn by disciplines inside and outside academia. Performance Studies pushed me to the borders of the inital discipline, allowing me to explore integrative ideas and new relations with other colleagues (from other areas of study), and it expanded my zone of practice, via phenomenology, to considering context, impact and contribution.[7] With *performance*, the static side of architectural design becomes fluid, enabling different participatory methodologies. Crossing disciplinary limits allowed me to consider an architecture *of action*s, and from then on, my interests in design and communication (later understood as Performance Design) started to crystalize. I was fascinated by the idea of 'saying something' while executing/doing something (a task, a procedure, a routine, etc.) with a gesture (an action) or a material gesture (a spatial intervention of any sort).[8]

My second *performative gesture* within an academic milieu was ten years later, in the defence of my dissertation entitled: *Architecture as Performance: The Construction of Display*.[9] Instead of giving a defence only based on a written text (the dissertation volume), I decided to compliment my thesis work with the material I produced for an exhibition linked to my research process. The exhibition was titled: *SCL2110 of Art, Architecture and Performance*,[10] and it explored the limits of architectural and artistic practices to frame Performance (Design) and, more precisely, to theorize through practice the relationship between architecture and art, to speculate about how to *design* performance. Given the history of conceptualism, conceptual artists and architects had a lot to say in the show – they had been proposing 'performance' gestures/ideas since the end of the nineteenth and early part of the twentieth centuries to push future possibilities of doing (the exhibition also had an introduction about the avant-garde of the early twentieth century). *SCL2110* was, furthermore, about the future of Chile, at a moment when Chileans were celebrating the nation's bicentennial. Because of the proposals presented and its nature of collaboration, the project became a reference of integrative academic/professional work at a local level.[11] In other words, my dissertation challenge (imposed by myself) consisted of a written thesis and a *designed* event that was an exhibition that I incorporated into my argumentation. The exhibition consisted of the setup of a public display of possible future public spaces within the spaces of a contemporary art museum in Santiago. Such display (or installed gesture) represented on the one hand the materialized conclusion of my dissertation (by means of an event) and on the other, a *performance design act* that embodied content and future desires of public spaces for Chile through the forms of an exhibition. Since then, exhibition design has become crucial for me in the development of my own research and practice. As a practitioner teaching and doing professional practice outside academia, I have found many different possibilities to transmit content by using different types of media.[12] This mediatized and materialized consequences of

my research became a new way for me to do *performance*, inside a diverse cultural institutions and outside academia.

In 2016, after few years of working outside academia at Diller Scofidio + Renfro, I decided to return to Chile when a new academic challenge arose: I was invited to join a relatively young academic institution and a new design faculty that was founded in Santiago. This design school brought a new and unique fab-lab to Chile, where the faculty was invited to explore and further develop design conceptualization along with new technologies. This opportunity brought me back to academic teaching within a fresher and more dynamic environment – one that felt fertile with possibilities. As an educator, I saw opportunities to develop new courses and new programmes aligned with my own research and practice interests. Under the umbrella of this new design school, I became a research director with the task/challenge to articulate research between different centres and push faculty research production to new standards. This allowed me once again to engage with the interdisciplinary space between *performance* and *design*, within the fresh and fertile conditions of a new academic environment that was enabling new possible research practices (to create).

This environment constituted an opportunity for me to propose a new performative gesture within an institution – this time, a somehow theoretical opportunity to explore design concerns further, in a more broad and expansive way, via the expansion of creative practices and production. Given that I was asked to develop research within this academic space, I decided to add the word *creative* to the administrative title that was provided: instead of calling myself director of research, I called myself director of *creative* research. This gesture highlighted a need and a desire to connect the administrative role with the creative aspect of a designer's profile. I understood this adjustment as developing a space for applied creative research within the more conventional spaces of research that were available in the institution. This gesture was meant to emphasize a creative dimension that somehow feels natural among many of my colleagues, as creative research normally guides design processes and procedures associated to its concrete execution. Because design is a practice of doing, applied research and creativity are fundamental to developing practical approaches in the careers of future professional designers. The idea was to differentiate our own particular *doing* methodologies within a new school (linked to engineering); to help improve our own performances as researchers and make it distinctive; to promote creativity within our academic environment and to expand notions of applied research practices and artistic creation to other related fields to include other kinds of work that are often not considered genuine intellectual contribution.[13] This new moment represented for me an opportunity to increase collaborative work and to explore methodologies

beyond the constraints of traditional institutional structures (questioning the practice of traditional disciplines). This gesture can also be understood as a 'disruptive design' strategy that aimed to promote new associations among the practice of design research that is explored.

One of the possibilities of design is that it can implement new solutions to old problems. Such solutions, in turn, can have an impact on our social and material environment. Looking forward via an inter-, multi- and trans-disciplinary approach and framed with this freedom, Performance Design attends the temporal phenomena of such impacts, because it is ultimately looking to develop new experiences to improve quality (of things, systems and ultimately life). This approach is fundamental to a more comprehensive scope of design (one that is of care), because design impacts should be also considered in the initial scope of the proposal. These practical and forward-looking approaches require an understanding that is located in the limits of academia to further develop the field. The questions that performance-oriented designers might have when doing their work are first, where to place such a field of practice and where to *act* and with what gestures within the conventional forms that we know (and that we have within conventional structures), and secondly, how to enact coherent *performance* as academics, practitioners and possible leaders of emerging-developing fields. With this, as I argue in 'Performance Design: on the slippery combination between art and science', Performance Design might become a multi-layered field or mode of practice within institutions, placed somewhere between the humanistic, more subjective wing of the arts, and, the scientific, more objective wing of engineering (Tisi 2006: 12–13). Although embedded in conventional slots and structures, this practice offers strategies for structural integration and bridging disciplines, as well as important questions and challenges to more conventional kinds of knowledge production. While Performance Design has the potential to draw different paths within academic institutions and create new modes of learning/exploring design, it requires both integrated spaces and integrated knowledge forms that are not widely available. I offered descriptions of three performative gestures I did, as examples of personal initiatives, in order to reach some goals: the development of such new spaces of practice and ways of developing new knowledge within academia, for the evolution of more holistic, effective and purposeful design practice. The reader interested in this design field will be able to propose new gestures or actions in order to accomplish whatever the goal is. In an era that our environment is suffering in a very broad sense (environmental crisis, social crisis, health crisis, political and economic crisis, etc.), Performance Design can contribute to establishing new links and new collaborations among conventional disciplines and can help to offer more integral solutions to current design challenges.

NOTES

1. According to Hall and Taylor, bureaucracy is not impacted by culture; rather, it is a form of culture within institutions. Therefore, institutions are not fully consciously designed or instrumentally oriented. Institutionalization is a cognitive process that arises as consequence of routines, schemes and scripts (Hall and Taylor 1996).
2. Ideas constitute the enactment of creativity, and to be used they must be externalized and articulated to others for acceptance. As Hilary Collins argues:

 > Design is defined as the process that gives form to ideas. Hence, ideas are developed through a design process. In the process of design, ideas are generally developed into conceptual models, then prototypes, and later products which are accepted or rejected by the consumer/society. To complete the picture, these ideas, embodied as products or services, diffuse into society where they go on to take on new meanings and functions perhaps different to those intended at the start of the design process.
 >
 > (2010: 100)

3. In their book, *Design: Theory, Teaching and Practice* (*Diseño: teoría, enseñanza y práctica*), Alex Blanch, Alberto Sato and Guillermo Tejeda argues that design combines neatly diversity and association. Under their consideration, the field is indeed broad and depends on processes of ideation that include technical, scientific and artistic aspects (Blanch and Tejeda 2019: 11).
4. A definition of contemporary architecture and the contemporary practice of the architect from *The Metapolis dictionary for advanced architecture* is relevant to this shift:

 > The value of architecture no longer results from creating shapes in space, but rather, from fostering relationships within it. Combined relationships and actions – reactions – in (and for) a definitely 'open' and non-predetermined reality; the more qualitative, the more potentially interactive. In positive synergy with the environment.
 >
 > (Gausa et al. 2003: 56)

5. For more on the origins of Performance Design and from an architectural design approach, see Michael Hensel's 'A brief history of the notion of performance in architecture' (2013: 23).
6. See *is/as performance* as articulated by Richard Schechner in *Performance Studies: An Introduction* (Schechner 2002).
7. For more ideas about creative practices that expand, see Rosalind Krauss' 'expanded field' in *Passages in Modern Sculpture* (1981).
8. The 'architecture of action requires energy, decision and capability; in other words: disposition'. See the definition of architecture *of action* in *The Metapolis Dictionary for Advanced*

Architecture (2003: 26). To expand ideas on this matter, see J. L. Austin's seminal book: *How to Do Things with Words* (1975). If interested in daily life activities, rituals and routines, see Richard Schechner's *Performance Studies: An Introduction* (2002).
9. I defended my dissertation at the department of Performance Studies, Tisch School of the Arts (TSOA), New York University, during May 2011. My main advisor was Professor André Lepecki.
10. The exhibition considered the contribution of artists and intellectuals that worked at the intersection of arts, performance and architecture. Among the more than 60 participants whose work was included in the show were artists such as Vito Acconci, Bernard Tschumi, Diller Scofidio + Renfro, LOT-Ek, Alfredo Jaar; art critic and curator Roselee Goldberg; and academics such as José Muñoz, Diana Taylor, Enrique Walker, Brandon Labelle, Manuel Corrada and Francisca Marquez among many others.
11. The exhibition *SCL2110* highlighted collaboration among architects, artists, sociologists and urbanists and allowed them to explore a broader sense of *performance* at a local level. See the book *SCL2110: Art, Architecture and Performance*, edited by Rodrigo Tisi (2010).
12. Since then, for me, practices associated to exhibition design and museography became fertile arenas to actually *do* performance by means of design and temporal architecture.
13. The intellectual contribution of creative disciplines to conventional scientific fields is often not acknowledged. In Chile, however, artistic creation has recently been validated by major academic institutions as an important aspect of producing and developing research.

REFERENCES

Alberti, Juan (2019), 'The institutional environment of planning and appraisal', Series: Technical Documents on Megaprojects, https://www.researchgate.net/publication/334616754TheInstitutionalEnvironmentofMegaprojectPlanningandAppraisal. Accessed 30 October 2021.

Blanch, Sato and Tejeda, Guillermo (2019), *Design: Theory, Teaching and Practice (Diseño: teoría, enseñanza y práctica)*, Santiago, Chile: ARQ Ediciones.

Collins, Hilary (2010), *Creative Research: The Theory and Practice of Research for the Creative Industries*, La Vergne: AVA Academia.

Gausa, Manuel et al. (2003), *Metapolis Dictionary for Advanced Architecture*, Barcelona: Actar.

Hall, Peter A. and Taylor, Rosemary C. R. (1996), 'Political science and the three new institutionalisms', *Political Studies*, 44:5, pp. 936–57.

Hannah, Dorita and Tisi, Rodrigo (2002), 'Containing the uncontainable', *ARQ #50 'Evidences on Buildings in Santiago'*, Santiago, Chile, pp. 58–60.

Kirshenblatt-Gimblett, Barbara (1999), 'Culture and creativity' [Presentation], The Rockefeller Foundation, New York City, 13 August.

Kirshenblatt-Gimblett, Barbara (2011), 'Objetos de etnografía', in D. Taylor and Fuentes (eds), *Estudios avanzados de performance* (trans. Ricardo Rubio), Mexico: Fondo Cultura económica.

McKenzie, Jon (2001), *Perform or Else: From Discipline to Performance*, London and New York: Routledge.
Progressive Architectur (1967), *Performance Design*, August, New York: Reinhold.
Schechner, Richard (2002), *Performance Studies: An Introduction*, London and New York: Routledge.
Tisi, Rodrigo (2006), 'Performance Design: On the slippery combination between art and science', *New York Arts/Art Fairs International*, 2:5&6, pp. 12–13.
Tisi, Rodrigo (2010), *SCL2110: Art, Architecture and Performance*, catalog of exhibition at Museo de Arte Contemporáneo de Santiago, Chile, 22 September–6 November, Santiago: Uqbar Editores.

ACT FOUR

ACT FOUR

11

Caring Buildings

Liisa Ikonen

My 10-year-old body moves its fingers along the sharp folds of a tightly folded sheet. The stretched fabric on top of plastic is hard, smooth and cool. The surrounding walls are distorted by the rails circling the bed, while those bedrails cut the room into equal sized pieces. The cold winter of January is behind the windows. My being is coloured by longing, distance, and absence. – When I get home, I wonder about the softness of the world. Even after decades, I remember feeling awed how I sank into the softness of the world immediately after the hospital doors closed.[1]

In my writing, I reflect on the experiential nature of institutional care environments and the way in which their spatial conditions guide their users and residents. I am also searching for a design practice that listens more to the inhabitant's own needs, and I consider what it means to approach a building as *a Thing* instead of *an object*. I approach the subject as a scenographer and as an artist–researcher, but far in the background, there is also my personal experience in hospitals and care environments and my perception of their effect on their users or residents.[2] In my writing, I outline the idea of a *caring building* based on the German philosopher Martin Heidegger's (1988–76) late-period thinking, and the possibility of scenography to implement it. Heidegger's early main work *Being and Time* (1927) was about ontology of *being* and it emphasized man's intentional relationship with the world. Later, his interest turned away from man and focused more on listening to the world itself. Thus, by the concept of 'caring building', I mean in the spirit of Heidegger's thinking a special world-listening approach or attitude to design that takes also human *interactive world-relationship* and individual *life-world* as the basis for planning.[3] However, by 'building', I do not mean just architectural

planning, building technology or design, but the realization of space following the work of design; the possibility for the space and the user to participate with each other. Underlying this is the idea of an interactive relationship between man and the world, and the idea that the world around us always appears in our *being*; it manifests itself in our thinking, in our language and in the movements of our bodies.[4]

Heideggerian fourfold and building as a Thing

Heidegger (1971b: 145) spoke of *being* as poetically *dwelling* in the human world. When pondering man's fundamental problem of homelessness in his essay *Building Dwelling Thinking*, Heidegger said that people cannot think of construction properly because they have forgotten the original meaning of the word 'building'.[5] In its original sense, the German word 'bauen' has meant both building and dwelling. This means building should not only mean building that leads to dwelling but also includes how we implement dwelling. To build is in itself already to dwell. In its original sense, 'building' did not mean just constructing buildings. It also meant another kind of building; building that cherished, protected, preserved and cared for. Heidegger (1971b: 150, 156) himself used Heidelberg's old bridge as an example of a thing that brings us closer. The bridge as a structure created a place that brought together the city's various activities. The bridge itself was then *the Thing*, from which the special place creation made the riverbank visible, set the riverbanks against each other and continued to produce different spatial relationships and combined human routes. The essence of building was then ultimately *letting-dwell*.[6]

Heidegger (1971c: 178) also encouraged us to approach buildings as Things that differ as philosophical entities from technological objects. He had stated already in his lecture *The Thing* (Das Ding) that the Thing *gathers the world*.[7] Where an object becomes existing as a result of intention, the Thing is created through the idea of gathering, reflecting in its process of creation the different dimensions of meaning. These dimensions form a world where a Thing can be a Thing. Heidegger (1971c: 175) describes this event poetically as a fourfold, where the primal oneness and its four dimensions (earth, sky, divinities and mortals) all reflect each other. The key to the fourfold event is that the essence of the Thing is created in a movement that reflects different needs and views. Although there is an old explanatory myth in the background, it can be seen as a model for all action and thinking that wants to break away from already existing meanings or from one of the solutions we are able to see correctly. Such an approach differs from goal-oriented thinking, where the world and its phenomena are seen as a resource for something. It also includes a strong ethical dimension that respects the

encounter. Through the fourfold connection, also building as an activity involves an idea, not only of proximity but also of approximation. Thinking of building as a Thing, it's being, i.e. *thinging*,[8] means that the building gathers, brings closer and opens up the world that reflects its inhabitants' own foundation and allows for such a *being* that meets their needs.

Thinking of building and dwelling as intertwined concepts led me to a new way of looking at housing as an *activity* and the building as a *space-producing* construction. While pondering the idea of a 'caring building', I view institutional care spaces and hospitals as scenographic *Things* that bring together the experiential and functional world around them by scenographic means and that function especially through the idea of approximation. Approximation can be the consideration of the user's own life-world as a basis for planning, as well as the enabling of different functions in relation to each other. My intention is not to contribute primarily to the discussion of hospital planning and design, but to look at hospital environments and their design processes as examples of spaces and structures that produce a certain way of *being* and to outline a philosophically-attuned background horizon for design work in the field of expanded scenography.[9]

Fractures in technological-regulated constructions

Finnish architect Pekka Passinmäki (2002) has also examined urban architecture against Heidegger's thinking in his book *Kaupunki ja ihmisen kodittomuus* (*The City and Homelessness of People*). According to Passinmäki, modern humans experience a new type of homelessness, not due to a lack of housing, but because people feel that the buildings are foreign to themselves. In particular, he has criticized modern, technologically regulated urban construction and considered how an individual's experiential and physical embodied world relationship could be better taken into account in urban planning and construction. Passinmäki states that an architect cannot bring out buildings as *Things* when he is dominated by technological thinking and language of representation. Instead, he must take a step back from representative thinking and return to the attitude which Heidegger spoke of as *meditative or contemplative thinking*. In practice, Passinmäki (2002: 104, 115) searches environments that have the capacity to bring out such a foundation of *being*, which the technical elements of construction have lost sight of. It is then possible to reach the Thing as a Thing.[10] As a solution, Passinmäki (2002: 151) suggests that building could, however, begin by producing *fractures* in technological construction in our environment, in which the original bodily basis of man's existence and with it also Things emerge. A fracture can be, for example, a park or a green area that invites people to be present in a different way in urban

environment. It reminds them of things that have belonged or should belong to their world of life, but which they may have become estranged. Central to Passsinmäki's thinking is that fractures could create a new kind of collective being in urban space.

According to my experience, we consider clinical hospital environments strange, if they do not equate with our familiar world of living and if the environment feels compulsive, the physical way of *being* changes. Instead, if the care environments enable us to identify familiar phenomena within our own life-world, the bodily way of *being* can also be realized accordingly. If the environment also allows access to a world of poetic expression that transcends immediate space-time, it can act in many ways as comforting and empowering and helps to forget the challenges of the immediate situation. I claim that scenography could help in producing fractures, because it is simultaneously both sensory and metaphysical. It can open up different meanings for different people, as it accepts as a basis for its expression, not only the fourth dimension, the memory, but also the poetic imagination. Scenographer Pamela Howard (2003: 52) has summed up the core of traditional theatre scenography by saying that 'it is a series of poetic statements that capture the essence of truth and reality and offer both recognition and surprise'.

Passinmäki (2002: 144) emphasizes that Things were revealed to Heidegger in language. The language of scenography is not based on conveying ready-made meanings, but on appealing to the recipient. This means, from the recipients' point of view, recognizing phenomena emerging from one's own life-world, but also actively forming meanings. In the current discussion of expanded scenography, Joslin McKinney and Scott Palmer (2017: 8) have identified the relativity, affectivity and materiality of scenography as key principles in defining the recipient's experience. They bring forth how scenography can facilitate the encountering of spaces either in conventionally familiar ways or can encompass encounters with other kind of things and phenomena, how our experiences and understandings interact with materials and objects and also how aesthetics operates at the individual level. Rachell Hann (2019: 67, 69) emphasizes that scenography is not a *set*, but something that *happens* and its material and spatial elements orientate feelings of space. Hann's argument on how scenography happens stresses that it occurs in time as an assemblage of place orientation. It is something we experience rather than read. Referring to this frame of reference, it is easy to approach scenography as a Thing. Scenography can be seen as an event in both its traditional and contemporary applications. The essence of scenography and the etymological background of 'bauen' tempt me to ask what kind of 'caring building' could be possible in this time, and how scenography could play a role in exploring this question.

Next, I will use case-by-case examples to show how fractures that allow building to be a Thing can be created in care facility environments by scenographic-like

means. By fracture, I am referring to solutions that open up an environment that is either functional or experiential to their occupants and users, reflecting their individual needs and life world, and further enabling *being* that is based on these. When building is genuinely caring in the spirit of Heidegger, then space is not only planned to meet the needs of all occupants, but each single occupant can live and act in the space in a way that opens up to their own world relationship. In this case, a build Thing should allow an event in which the usability or meanings of the space would be re-structured each time according to the needs of each occupant. In my examples, I look at the means emerging from scenography and how they have produced such fractures that enable us to approach buildings as Things. I claim that to work from a scenographic mindset can make possible more flexible and configurable solutions, as the scenographic space has always been, above all, the circumstance of the stage. The scenographic tradition includes the ability to produce multi-functional and porous spaces and to express large phenomena with simple elements physically and materially. Scenography has never been aimed at stable, sustainable solutions, but rather at temporary spaces that experience ever-changing activities and where it is possible to experience mobility in time and space.

Hospitals and their fractures

I look at two examples: The first is the New Children's Hospital in Helsinki, which was completed in the autumn of 2018. The second is a methodological experiment of a prototyping area called Cardboard Hospital associated with the design phase of the Tampere University Hospital extension in 2010–12 (Kronqvist 2012). Both examples focus on the means of expression of a scenographic mode. The first example locates fractures in a specific caring building while the second looks at fractures in the design process. In the first, the fracture refers to the overall dramaturgy that pervades the hospital building, which activates children's imaginations by combining all the spaces of an eight-story building through special solutions involving colour, shape and space that turn into a larger narrative based on Finnish children's literature. A fracture opens up access for children to the imaginary and the absent and, therefore, the possibility of a different kind of *being* compared to the functional approach suggested by the hospital environment. The techniques used to identify a number of features emerge from the tradition of scenography, such as telling the story through large wall paintings or animations. In the latter example, at the Cardboard Hospital, a fracture in turn means the breaking up of more functional working conditions and treatment practices. Conditions to better support staff activities and patient needs were tracked in a user-inclusive

multidisciplinary collaborative design workshop, implemented through a real-life cardboard prototype in a theatre studio. The workshop tested alternative practices for various hospital functions by operating inside a staged and immediately customisable space. What these fractures have in common is that they are created in a listening relationship with future users and residents of the premises and bring the institutional care environment closer to the needs of individuals. All these buildings with fractures appear as Things instead of objects in a technological world, gathering their own functional or experiential world around them.

Moominvalley geography as a circumstance

The New Children's Hospital, designed by SARC and the architect group Reino Koivula and awarded with the prestigious Finlandia Prize for architecture, is a building that seeks to provide children with an experience from their perspective and their own life-world. The various facilities of the hospital are located in the fictional world of the Moominvalley, created by the Finnish-Swedish children's book author and visual artist Tove Jansson (1914–2001).[11] The fracture I wish to point out in the context of this space is enabled by spatial order and programming, which is based on differing medical needs, at the same time as opening up toward Moominvalley. The fairy-tale architecture is presented floor by floor in the webpage, Children's Hospital, Virtual Tour. The floors of the eight-storey hospital are named from the bottom upwards, from the sea, to the beach and on into space and the stars and the hospital design follows floor by floor the same themes. There are spacious and blue or soothing light sand colour entrance halls and emergency rooms on the two lower floors of *the Sea* and *the Beach*, while the operation rooms on intermediate floors of *the Jungle*, *the Forest* and *the Valley* guides children to more adventurous state of mind and modes of action in their colours and design. The scenographic journey that inspires childrens' way of being continues as the building ascends to *the Magic* and *the Mountains*. At the top, in *the Space* and in *the Stars*, there are finally patient rooms meant for living. These are located, with balconies, in the tower of this eight-story building so that from all rooms there is a view as far as possible.

The hospital environment is permeated by a dramaturgically structured visual world as if the children are entering a familiar fairy tale. They move in the midst of seashells, fish, comets and mountain peaks, and the hospitals technological undertone is mixed with an adventurous expedition. Examining this hospital environment through the analytical lens of fractures allows to see, how it opens up a holistic experiential and functional world for the residents of the children's hospital. The stories of the Moominvalley are already familiar from the children's

own life world and now those stories have the potential to actualize through children's physical play when the imaginative environment acts as a catalyst for their plays and games. In Heidegger's late thinking, space was no longer created at the behest of man, but rather the Things created the space for human dwelling and *being*. The children's hospital also appears as a Thing that opens up space towards a *being* that is based on children's own life-world and its activities. As a Thing building calls children's games and activities to be a part of the hospital environment by setting the familiar Moominvalley milieu within it. The fracture occurs when the formal order justified by medical needs opens up into Moominvalley. The spatial dramaturgy based on a fairy tale is a fracture that reveals the building as a Thing. The Thing reveals a place for *being* and gathers the world around it. It allows *being* that is not just about *being* sick or in a hospital, but that grows into a fictional and functional world of play. Passinmäki (2002: 151) notes that a fracture in the urban structure serves as a place where people can feel that there is more than just a technical world with endless objects and apparatus. This is literally emphasized by a wall writing in New Children's Hospital:

> *Forget the past and your fears. Think of the super fun, that we can have. I'd love to see the beach, a shell, the sun.*

The comforting phrase drawn as a large-scale mural on the wall of a hospital emergency room with squiggly calligraphy combines with the overall scenography of the building and its accesses the children's world. If *the Sea* on the ground floor is open and deep blue in colour, shells, sea urchins and corals of different colours will appear on *the Beach* in colours, shapes and patterns, respectively. They serve as clues for the change, and for an imaginary landing. The same objects are also present in the seawater aquarium of the laboratory waiting room with real sea urchins, corals and various fish. The main lobby, in turn, has a large-sized media wall, where fish, drawn and coloured by the children, are swimming. There is a scanner that allows your fish to be added in with the others. Scenography is not only visual but also three-dimensional and participatory, guiding and influencing action and *being*. The dramaturgy based on Moominvalley permeates also the colours and shapes of the spaces and furnishings. For example, waves are not just wavy lines on the walls of corridors. They are also present as forms, such as in the three-dimensional recesses forming the registration counter, into which you can physically retract yourself. On the Mountain, the gentle shapes turn into sharp mountain peaks and the subjects of the paintings turn into dark red enigmatic grenades. At the same time, change the way of bodily *being*, when changed design and visual motifs provides new stimuli for childrens' plays. Spatial solutions, forms and images act as impulses for certain ways of *being* and the environment

stimulates moving and playing in a site-specific way. Body and mind intertwine in a way that Hann (2019: 2) speaks of as intellectual and practical perspectives on the place orientation of scenography. She speaks about specific 'place orientation', where orientation is inclusive of haptic proxemics and orders of knowledge.

The Thing gathers the world

The fracture is possible because Moominvalley is part of the children's own lifeworld and is familiar from their own bookshelves. The relationality of scenography enables us to approach the hospital as a large incarnated storybook that can be read as well as be entered. Colourful text with big, curvy handwriting on the walls and floors creates an impression of navigating inside a book and opening up a fictional space that plays with theatrical scale. Set in a children's world, it shows the ability of expanded scenography outside of the theatre setting to shape social reality. The language of the space is born of genuine listening to the children's life world, although technological needs are also combined into the design. However, medical operations may not be included in the children's normal living world like Moominvalley and meeting them is accompanied by their own thrills. The operating room is located in an insightfully exciting and unknown Jungle and you enter by stepping over a text written on the green floor (3rd floor of New Children's Hospital):

> *When I awoke, I lay on my back looking straight up into a world of green and gold and white. The trees around me were tall and strong pillars that lifted their green roof to dizzying height. The leaves swayed gently and glittered in the morning light, and a lot of birds were dashing, giddy with delight, through the shafts of sun. Gleaming white honeysuckle hung everywhere in bunches and curtains from the brunches. The gold and green and white. The Exploits of Moominpappa.*

Scenography has been used to make the environment less intimidating. As parents read aloud, the content of the texts reaches even the smallest children, while reminding them of previous times spent together reading and the closeness associated with them. The hospital scenography has taken into account the temporality of the human basis for *being*, recognizing the importance of memory. The language of the space is the language of *being* in all its meanings because the design work has remembered both the imaginative world of the small occupants of the hospital, moving beyond sight into an embodied experience of *being*, which includes material affects and haptics, as much as the visual. The design has taken into account the different ways the patients move around the hospital premises,

and the environment is viewed from many different perspectives. When moving a child on a bed, the child's eyes follow the ceiling and the ceiling takes on part of the story of the walls and floors, as visual themes continue onto the ceiling as well as the walls. The encounter of familiar stories in the hospital environment are designed to fade the boundaries between the home and hospital worlds. Children talk about things they remember and recognize, but their imagination is also fuelled by unconscious events and stimuli. Countless details in the hospital scenography are also capable of breaking the pre-memory archetypal basis and making room for the children's own imagination. The geography of the hospital boasts graphic and visual themes painted on walls and floors, such as stars, plants and seashells that create places for play and imagination. The realization of the building as a Thing, its *thinging*, manifests itself as an opening towards the children's own living world and the opening up of the availability of a potentially frightening hospital environment from their own points of departure.

Floor by floor with their own fictional geography, the world of colours and shapes of the Helsinki New Children's Hospital *reveals* the possibility of *being* differently and *releases* the inhabitants to act in the world of fairy tales. Passinmäki (2002: 137) emphasizes that the Heideggerian wording *letting-dwell* means that construction cannot be forced into a certain form or function. There are many small and large practical solutions, where technological and fairy-tale approaches work together in the New Children's Hospital. The overall dramaturgy of the building operates on two levels, following the hierarchy of hospital functions, the needs of medical technology and the smoothest possible usability, but also the logic of the fairy-tale discovery in Moominvalley. It is important that the surrounding spatial conditions not only come about from a technological basis but also contain fractures, with clues that can be recognized by a child. In this case, the space can be encountered as a Thing instead of an object and it can invite inhabitants to exist in accordance with their own life world. Thus, the caring building can, as a method or an approach, bring individual and institutional needs closer to each other and be realized as an ethical encounter, which Heidegger described as a fourfold. In this case, it has meant making room for the life world of children as well as the produced open-ended and participatory design solutions, all-encompassing circumstances and the world, which will be disclosed as a whole only by the changed action, children's plays and games that are recognizable from familiar stories.

Such a design becomes close to Rooms concept of an Australian lighting designer and scenographer Efterpi Soropos. It transforms the immediate space-time experience of the hospital environment and provides an alternative, peaceful environment for patients and their families to meet, inter alia through lighting and projection, breaking the boundary between the hospital space and the outside

world, and bringing the absent space outside the hospital experientially closer. Such fractures creating to the middle of the hospital environment provides a changed way of being. What the fractures have in common is that they are created in a listening relationship with future users and residents of the premises and bring the institutional care environment closer to the needs of individuals. The buildings with fractures appear as Things instead of objects in a technological world, gathering their own functional or experiential world around them (Soropos 2015: 14–15).

Carboard hospital as a Thing

While the first example located fractures in a specific building, my second example looks at how to create fractures by involving users in the design process. In this case, the design means have a direct relation to the world of the activity targeted. The involvement of different user groups has increased in tandem with the evolution of service design. The concept of care is also now understood in a new and more holistic way, bringing research closer to everyday life through an ethnographic approach as well as an approach that includes working together, for example, between care professionals and patients. In this approach, according to Mol (2008), treatment is seen more and more as a shared event that brings together professionals, patients and their families. Also, in the fields of architecture, industrial design and public space design, different user-listening and participatory design methods have been developed including for example, *emphatic design*, which is situated in the area of product design close to the philosophical idea of *caring building* and its task of approximation and bringing different needs together. It emphasizes the importance of experiential prototyping, social interaction and listening to intuitive understanding as part of the design processes (Koskinen 2003). As multidisciplinary design increases, so too has scenography begun to approach institutional design. Part of this has been influenced by the interest in different storytelling methods. In the theatre tradition, the task of scenography has been to create a visual environment and enable acting in drama-based performances. The scenographic state has enabled *being* in the here and now, but at the same time, in a possible, imagined or absent world. With the expansion of scenography beyond the literary origins of theatre, it has begun to function more independently in recent decades, not only as a facilitator of the space-time of the performance, but as the performance itself or in an applied role outside the performing arts. For example, Mc Kinney and Palmer (2017) offer numerous examples from the expanded field of scenography.

Heini Erving, a student in production design in TV and film from Aalto University, worked in a joint design research project between the Pirkanmaa Hospital

District and Aalto University's Media Department in 2011–12 and, based on the project, produced her master's thesis (2014) Kokemuksen suunnittelijat, Uusia käytäntöjä ja oppia yhteissuunnittelun keinoin ('Experience designers, new practices and learning by collaborative design'). As a methodological experiment, the project developed a special prototyping space, *Cardboard Hospital*, which was used to concretise early ideas at the design stage of the new hospital ward at Tampere University Hospital. The Carboard Hospital was built from durable Reboard cellular sheets in what was the Arabia campus of Aalto University, on the studio stage of the Lume Media Centre. Simple in shape, interconnected cardboard elements or 'set design elements' were part of the prototype, which worked flexibly as a tool for various uses and could be supplemented with furniture and hospital equipment. It was used to organize workshops, which sought to identify different functional environments for different hospital needs. The workshops included modelling of the operating room, outpatient clinic and ward premises. An important functional feature of the cardboard prototype was that it enabled not only an immediate response to changing spatial or functional needs but also the immediate recording of thoughts. The Reboard plate allowed for writing ideas directly into the prototype, leaving no space or time lag between action and conceptualization (Erving 2014: 71).

The prototype experiment involved particular hospital staff, but also architects and patients. It enabled shared bodily thinking, and communication of the wishes and needs of different target groups with the help of easy-to-move light elements (Erving 2014: 61). As a method of design, prototyping implements the Heideggerian listening attitude and idea of moving towards closeness and *staying close to one another*. It settles directly on the relationship of *being* with its object, whereby the information it produces rises directly from the immediate multisensory body experience. According to Erving (2014: 66), the most important thing was to create an interactive situation. The space had to change at the same time as the development of thinking and action. The prototype built in the Black box was in a neutral theatrical non-space instead of *being* in a hospital environment. Thus, the pure baseline did not lead to any pre-existing or predefined outcome. A non-finished space was in a physically continuous state of formation. The prototype, began by listening to its users and their needs, to create a space that reflects and enables them. The cardboard hospital manifested as a *scenographic thing*. It was 'thinging' between different functional needs by connecting them to each other and enabling a more efficient spatial order. It ceased to be an object and became a Thing, because it enabled the meeting of differing needs and the interaction with each other in the spirit of fourfold. Heidegger (1971a: 175) says: 'The thing things. In thinging, it stays earth and sky, divinities and mortals. Staying, the thing brings the four, in their remoteness, near to one another. This bringing-near is nearing.'

Scenographic, participatory and at the same time performing *as if*, elements were related to practice, the occurrence of space, but also to the formation of information. Scenography enabled the dialogue of space and activity as well as bodily and sensory knowledge. It was a question, on the one hand, of materials, light and movable cardboard elements, and, on the other hand, of the immersion they enabled and the possibility of non-conceptual information addressed to the body. In many ways, the prototype resembled the conditions of the stage, a space that is not just a concrete physical reality, but one that is built or completed only in the mind of the recipient. It was based on hints and traces, i.e. referential and customizable solutions. An experiment open to alternatives allows for encountering different needs and views and can reveal needs that have not even been apparent at the beginning. According to Erving (2014: 84–85) through consultation with hospital staff and patients, alongside design expert knowledge, there was also an opportunity to hear the quiet and uncertain information that could be the most valuable in change-oriented projects. The Cardboard Hospital made visible how fractures in design environments and methods can also produce a new kind of functional information and enable encountering a built environment as a thing.

If the space is allowed to be created as freely as possible from different needs, rather than being controlled by planning, it will be built by caring, as a constantly changing and complementary weave, a living condition that does not stop at one solution or at the finished meanings. Planning that takes into account the individual world relationship cannot be guided only by ready-made questions or decisions made on the basis thereof. Heideggerian building, which also includes dwelling, must allow the encountering where needs are revealed. Presented examples of caring buildings have grown out of the designers' personal experience and their life-world. The design work of the New Children's Hospital in Helsinki, the fact that the approach to the building is not as an object, but rather as a Thing, may be due to the fact that the architectural couple that led the design had also been children's hospital clients for nearly fifteen years, because of their own child's illness. Joenniemi (2014: n.pag.) writes in the web-newspaper Helsingin Sanomat under the title: Arkkitehtuurin Finlandia – palkinto Uudelle lastensairaalalle – Arkkitehti Antti-Matti Siikalaa auttoi suunnittelutyössä oman lapsen sairaalakokemukset ('Architectural Finlandia Award for New Children's Hospital – Architect Antti-Matti Siikala's own child's hospital experiences helped in the design work') that those times had familiarized the architects with almost all the departments in the hospital and clarified the design needs. In the design, it was understood that the users of the space cannot be thought of from just one perspective, as being in a hospital with new-borns is different from being there with teenagers who need their own space. So, the language of the space was born from approximation that is a direct relationship with the origin of its expression. Fractures produced by

caring building enables the manifestation of Things that gathers the world around them. They help to shorten the distance between technological needs and an individual bodily life world and release patients to live in hospital environments in ways that meet their needs.

Scenographic saying

Passinmäki (2002: 151) suggests that Heideggerian *letting-dwell* could start with small solutions in which the technical world breaks down and the 'being a Thing' emerges. Concepts of fracturing and fractures are descriptive because the emergence of being the Thing means the event of revealing. It reveals an authentic way of being, which modern man has often forgotten. Finnish philosopher and expert on Heideggerian philosophy Juha Varto (2003: 184) has stated that the question of the original basis of *being-in-the world* i.e. *authentic being* is basically trying to find out what something is. It is something that cannot be solved through deduction, but only by *revealing*. For Heidegger, hiding was related to the thinking he described as *forgetfulness of being*, goal-oriented *calculative thinking* and the *language of enframing*, which is discussed here as object-oriented construction on a technological basis, and which prevents the building from *being* realized as a Thing.[12] Philosopher Reijo Kupiainen (1991: 9) has said that the approach of an object by pre-defined framing is an event where abstractions come between man and experiential reality. Although treatment results are a priority in treatment and healing facilities, fractures can also be created in these environments, where the calculative thinking and the language of framework steps aside and the sensory and physical basis of *being* in the world appears.[13]

Passinmäki (2002: 104) emphasized that the Things were revealed to Heidegger precisely in the language. For Heidegger according to Pöggeler ([1963] 1989: 279), the language of listening to *being* was, instead of speaking, the special *saying* (*Sage*), i.e. *being* seen, of *being* heard, of *being* manifested. Thus, I consider the language of space also means bringing together, reconciling, making visible and revealing. A fourfold, in which objects are revealed, specifically *gathers*. While the language of an architectural space is based on immediately presence, senses and the literacy written on the body, the language of the scenography is even more multidimensional, as it is not limited to representation and to what it is. The particular potential of scenography to create fractures lies in its associativity and ability to appeal to the recipient and evoke personal and individual images. Scenographic states enable *being* on two levels, in the here and now, but at the same time, in a possible, imagined or absent world. Its perfection and function are present in its imperfection: in the clues, imprints and references, and with them

in the involvement of the recipient. It is a language that always means more than its immediate expression and, therefore, a language in which Things can also be revealed.

This opens up the possibilities of scenography to participate also in caring building, and to bring different, functional, aesthetics and imaginary worlds closer together. Relativity that is an essential part of scenography always enables us to see and experience a physical and conceptual environment wider than factual space. Materiality, and affectivity, respectively, demonstrate an area that arises from the bodily interaction of man and the world and its temporality. These traits enable a special *scenographic saying* based on the bodily and sensual world relationship of individual human beings. That saying reveals buildings as Things and allows scenography that *happens*. To be able to produce fractures to our built environment, we have to ask, not just the technological needs, dimensions or geometry of the spaces we design, but the name of the Thing, that is able to invite the world around it based on individual *being*.

NOTES

1. The author's own childhood memory.
2. My understanding of the subject has come from working on experimental and multidisciplinary research projects at Aalto University in Finland that have extended beyond theatre and performing arts to the public sphere: *Floating peripheries – Mediating the Sense of Place* (2017–21) that focused on peripheries as a wide range of spatial, conceptual and experiential phenomena and the *Spice, Spiritualizing Space project* (2009–11), which looked at public spaces and investigated how storytelling approaches can be applied in designing public spaces. My experiences also include spending time as a child in a hospital and working in mental hospitals and care facilities during the 1980's.
3. According to psychologist and philosopher Lauri Rauhala (1993: 16), the term *world relationship* refers to man's immediate and functional relationship with the world, which the subjective worldview consists of. Instead, by the concept of *life-world* I mean a world as real, sensual and non-theorized, that is a world as it manifests itself to us. It is the world with which we interact and the same in which Heidegger ([1927] 2001) speaks as *being-in-the-world* (germ.in-der-welt-sein).
4. In his main work *Being and Time*, Heidegger ([1927] 2001: 173) presented the ontological structure of how the world opens up to man in a meaningful way. A non-linguistic state-of-mind (*Befindlichkeit*) precedes all understanding (*Verstehen*) and articulacy (*Rede*).
5. *Building Dwelling Thinking* (*Bauen Wohnen Tänken*) was originally a lecture given by Heidegger (1951).
6. The term *letting-dwell* is Albert Hofstadter's translation from the German word *wohnenlassen*.

7. *The Thing (Das Ding)* was originally a lecture given by Heidegger (1949) in Bremen.
8. Heidegger (1971c: 172) writes: 'The thing things. Thinging gathers. Appropriating the fourfold, it gathers the fourfold's stay, it's while, into something that stays for a while: into this thing, that thing.'
9. Joslin McKinney and Scott Palmer (2017) have made the concept *expanded scenography* widely known by editing the book *Expanded Scenography, an introduction to contemporary performance design* in which several designers and researchers open up a versatile view of scenography's capacity to operate independently and in a wide range of everyday environments, outside of the theatre and performance spaces.
10. According to Heidegger (2005: 23) *meditative thinking (das besinnliche Nachdenken)* meant an attitude that approached objects also belonging to the technical world with a new attitude as Things.
11. See Moominvalley's homepage. Moominvalley is a widely known fictional environment for children's books, created by Finnish author Tove Jansson's. In all, nine books were released in the series, together with four picture books and a comic strip being released between 1954 and 1975. The Moomins are the central characters in a series of books and Moominvalley is an idyllic and peaceful place where the Moomins live in harmony with nature.
12. Heidegger used the terms *forgetfulness of being (seinsvergessenheit)* and *calculative thinking (rechnende denken)* in *Gelassenheit* (1959) and the term *enframing (gestell)* in his lecture *Das Ge-stell* in Bremen (1949).
13. In *Gelassenheit (Releasement)*, Heidegger (1991: 23) states that technology should be approached with a listening attitude, saying yes and no at the same time.

REFERENCES

Erving, Heini (2014), 'Kokemuksen suunnittelijat, Uusia käytäntöjä ja oppia yhteissuunnittelun keinoin' ('Experience designers, new practices and learning by collaborative design'), master's thesis, Helsinki: Aalto University.

Hann, Rachel (2019), *Beyond Scenography*, New York: Routledge.

Heidegger, Martin (1971a), *Poetry, Language, Thought* (trans. A. Hofstader), New York: Harper & Row.

Heidegger, Martin (1971b), 'Building dwelling thinking', in *Poetry: Language, Thought* (trans. A. Hofstadter), New York: Harper & Row, pp. 143—59.

Heidegger, Martin (1971c), 'The Thing', in *Poetry, Language, Thought* (trans. A. Hofstadter), New York: Harper & Row, pp. 163–80.

Heidegger, Martin ([1927] 2001), *Oleminen ja aika* (trans. R. Kupiainen), Tampere: Vastapaino.

Heidegger, Martin ([1959] 2005), *Silleen jättäminen* (transl. R. Kupiainen), Tampere: niin & näin.

Howard, Pamela (2003), *What is Scenography*, London: Routledge.

HUS (n.d.), Childrend's hospital virtual tour, http://www.koeuusilastensairaala.fi/index-en.html. Accessed 1 May 2019.

Joenniemi, Minna (2014), *Arkkitehtuurin Finlandia -palkinto Uudelle lastensairaalalle - Arkkitehti Antti-Matti Siikalaa auttoi suunnittelutyössä oman lapsen sairaalakokemukset*. ('Architectural Finlandia Award for New Children's Hospital – Architect Antti-Matti Siikala's own child's hospital experiences helped in the design work'), https://yle.fi/aihe/artikkeli/2014/10/16/oma-kokemus-auttaa-uuden-lastensairaalan-suunnittelijaa. Accessed 1 May 2019.

Koskinen, Ilpo (2003), 'Introduction to user experience and empathic design', in I. Koskinen, K. Battarbee and T. Mattelmäki (eds), *Empathic Design: User Experience for Product Design*, Helsinki: IT Press, pp. 37–50.

Kronqvist, Juha (2012), *Pahvisairaala* ('Carboard hospital'), https://vimeo.com/46812965. Accessed 4 January 2021.

Kupiainen, Reijo (1991), *Ajattelemisen anarkia,in Filosofisia tutkimuksia Tampereen yliopistosta*, vol. xviii, Tampere: Tampereen yliopisto.

McKinney Joslin and Palmer Scott, (2017), *Scenography Expanded, an Introduction to Contemporary Performance Design*, London: Bloomsbury.

Mol, Annemarie (2008), *The Logic of Care: Health and the Problem of Patient Choice*, London: Routledge.

Mooominvalley (n.d.), homepage, https://www.moomin.com/en/explore/. Accessed 4 Januray 2021.

Passinmäki, Pekka (2002), *Kaupunki ja ihmisen kodittomuus*, Tampere: niin & näin.

Pöggeler, Otto ([1963] 1989), *Martin Heidegger's Path of Thinking* (trans. D. Magurshak and Si. Barber), Atlantic Highlines: Humanities Press International.

Rauhala, Lauri (1993), *Eksistentiaalinen fenomenologia tieteenfilosofian menetelmänä, Maailmankuvan kokonaisrakenteen erittelyä ihmistä koskevien tieteiden kysymyksissä*, Tampere: Tampereen yliopisto.

Soropos, Efterpi (2015), 'Making room for well-being', *Australian Dementia Care*, 4:5: pp. 14–16.

Varto, Juha (2003), 'Heideggerin alkuperäinen etiikka. Eräs mahdollinen tulkinta siitä, mistä Oleminen ja Aika on', in L. Kakkori (ed.), *Katseen tarkentaminen, Kirjoituksia Martin Heideggerin Olemisesta ja Ajasta*, Jyväskylä: Sophi, pp. 182–97.

12

Alieni nati:
Journey-Performance at S. Maria della Pietà Former Psychiatric Hospital in Rome

Fabrizio Crisafulli

In May 2018, a group of visual, theatre and dance artists, including myself, performed *Alieni nati*,[1] an itinerant theatrical performance on the grounds of S. Maria della Pietà, a former mental hospital, and interior of one building, Pavilion 31. The context, modalities and meaning of this work as counter-hegemonic artistic practice and as a contribution to society's democratization processes and determination from the base up of the use of public spaces form the subject of this text.

The S. Maria della Pietà complex in Rome, belonging to the Province, was the largest psychiatric hospital in Europe, a kind of 'city of mental health', conceived according to the principles of psychiatric care defined in the late-nineteenth and early-twentieth centuries. The hospital started activities in 1913, carrying on the heritage of previous institutions and sites that had arisen since the mid sixteenth century in various locations in Rome, with the aim of sheltering the poor, pilgrims and 'madmen'. Covering 130 hectares, located in the North-West district of Italy's capital, the area of the former mental hospital is comprised of 41 buildings, 24 of which were wards, immersed in parkland with mature trees and a 7-km internal road system. The institute could house about 1000 patients, but was constantly overcrowded, with an average of 2000–2200 residents.

The hospital was closed due to the Act 180 dated May 1978, which introduced a radical revision of the Italian psychiatric hospital system, and of Act 833 dated December of the same year, which met the various requirements and simultaneously set up Italy's National Health system. The laws imposed a ban on new buildings for mental hospitals and the closure of those already existing. To replace the hospitals, public mental health services were established: small

hotel-like structures, the so-called group-homes for a limited number of patients, aimed at de-institutionalizing the patients and reintegrating them into society, with the application of more advanced medical practices, so as to eliminate the segregation methods of the past.

Act 180 is known as the Basaglia Act, from the name of its instigator, Franco Basaglia (1924–80), an Italian psychiatrist and neurologist, university lecturer and a pioneer of the modern concept of mental health and of new methods for approaching and managing psychic distress.

> Italy was the first country to start deinstitutionalisation of psychiatric care and to develop a community-based system of mental health [...]. Prior to this law, patients with a diagnosis of mental health disorders for any reason were considered a risk to themselves and to others. Consequently, they were detained in psychiatric hospitals without any chance of receiving adequate rehabilitation that would have allowed them reintegration into the community. In other words, psychiatric hospitals were effectively operating a program of lifelong in-patient detention. With the enforcement of Basaglia Law the whole concept of mental asylum as an institution was abolished. In its place an innovative approach to mental health and patients with mental health was created.
>
> (Russo and Carelli 2019: 2)

The law's central premise was that dangerousness is no longer a criterion for commitment. Thanks to Basaglia Act, psychiatry in Italy began to be integrated into the general health services and was no longer side-lined to a peripheral area of medicine.

The closure of psychiatric hospitals in Italy and the question of their reuse

As a result of Act 180, Italy saw the gradual dissolution and closure of all psychiatric hospitals, including S. Maria della Pietà; which – due to the complexity of the law's implementation procedures and the related bureaucratic delays at local level – was actually closed only at the end of the 1990s, although some of the older patients remained residents beyond that date, until they died.

Application of the Basaglia Act opened a debate and conflict about the reuse of the ex-mental hospitals, of which there are more than 70 (Ajroldi et al. 2013). The question was raised about the possible destinations of these sites, almost all of considerable urban and architectural value (Cherchi 2016), strongly symbolic and laden with memories. Such memories were first and foremost linked to their

having been, since the beginning of last century, enclosures for those excluded from society, concentrations of segregation and pain, needed to 'protect' the part of society that claims to be 'sane'. Basaglia himself has made their character quite clear in his studies, in the light of the thought of Michel Foucault (2016), as also having been places where mental distress was institutionalized and objectified (Basaglia 1964).

Italian mental hospitals were, in most cases, built on the outskirts of the city, following what were considered principles of isolation and salubrity, but have generally become surrounded by urban development. Their destinations have been various. In just a few cases has there been any positive transformation process. One of these, for example, is the ex-mental hospital of Trieste, a ground-breaking structure where Basaglia himself operated, where a process of opening to the city has been achieved, with the inclusion of new types of hospital unit, as well as cultural, artistic and social activities. In other cases, current use is totally different from the original destination: the ex-mental hospital of Nocera Inferiore, for example, is being used for the Law Courts; the one at Reggio Calabria has become a school for carabinieri students. At times, reuse has been the outcome of building speculation: at Venice, for example, the San Clemente complex has been transformed into a luxury hotel; at Genoa Quarto, the ex-hospital of Cogoleto has been sold to private companies and its final destination is still uncertain. Most of these structures, however, are still only partly used, or have even been abandoned, forming an impressive number of sites still waiting or 'forgotten', out-and-out 'urban ghosts'. This vast patrimony, with valuable buildings and green areas, is a glaring case of wasted community assets.

The struggles for the public reuse of the former psychiatric hospital S. Maria della Pietà in Rome

In Rome, reuse of the S. Maria della Pietà complex after its closure has been and still is a subject of dispute amongst various social actors, who are mainly: local authorities – the municipality and the Lazio Region – oriented toward utilizing the area for offices and services of the Health System, based on a project euphemistically named 'Parco della Salute' ('Health Park'); builders, with speculative aims; social forces, associations, citizens who lay claim to a utilization of the area for social and cultural purposes. As early as 1996, an ad hoc committee presented a project to Rome Municipality, with highly detailed content and procedures to be used to obtain the resources needed for its achievement, but with no result. Up to now, the authorities' attitude has been to wait and is hostile to such claims, while expressing no clear project of its own on the reuse of the area. The local authorities

seem to regard this vast public-owned area, inside the city, full of potential uses, as a kind of 'deposit' from which resources can be drawn according to need, lacking any organic view concerning its utilization. For the 2000 Jubilee, for example, five wards were restructured to provide a youth hostel, a canteen, a study centre, a cultural centre and several spaces were occupied by municipal offices. This was also the occasion on which management of the park was handed over to Rome Municipality. Once the Jubilee was over, the hostel and wards restructured at public expense were dismantled and handed to the Asl (Local Health Unit) for its offices and for medical services.

In 2002, citizens' protests blocked a modification of the city plan by Rome Municipality, warmly supported by the building industry, to facilitate private initiatives in the area. In October 2004, when the last of the patients of S. Maria della Pietà were still being looked after, a group of citizens occupied Pavilion 31, once the laundry of the mental hospital, to save it from becoming just a new sanitary structure, and instead be utilized for cultural purposes. This opposition of the social base played a very important role in monitoring and addressing institutional orientations concerning the reuse of the area.

At a certain point, it seemed as though the citizens' struggles and actions had managed to impact the intentions of the city authorities. In 2015, a resolution was adopted that formally accepted the ideas and content of two proposals put forward by initiative, presented by the associations in 2003 and 2014. More recent decisions, however, point – as we shall see – in quite another direction.

Currently, the area is under-used and only partially open to the city. It is accessible to citizens, but is badly kept and poorly equipped. The mental hospital's old perimeter fence and entrance barriers are still there, making people feel that the area is out-of-bounds. The pavilions are used only partially: about fifteen are occupied by health units and three by municipal offices. A third of them, however, are in a state of total abandonment. Since 2008, one pavilion has been employed for the Museo Laboratorio della Mente (Laboratory of the Mind Museum) – a single reality linked to the area's identity and memory – which documents the history of S. Maria della Pietà and the mental hospital, also through interactive systems created by the Studio Azzurro team.

In January 2005, a group comprising some of the citizens who had occupied Pavilion 31 formed a cultural association with the name 'Ex Lavanderia'. Over the years, together with other collective organizations, the association has carried out striking major events for the district and the city, becoming a venue for meetings, rehearsals, workshops, performances as well as the main outpost of claims for the social and cultural reuse of the area.

This course has encountered many obstacles. For several years, the Local Health Authority has cut the supply of electric power to the pavilion, and since then the

association has had to utilize a power generator, paid for from the income of its own activities, as well as by the solidarity of citizens. Over the years, the association has been reported for squatting and, after four court cases, in 2017, was ordered by the judge to vacate the premises. Faced with this threat, the association has launched an appeal to artists and people of culture to support them in their struggle to continue to manage the pavilion. The appeal has been answered by numerous visual and theatre artists, including the group who produced the performance *Alieni nati*.

The birth of the group Alieni nati *and its project*

This extemporary group of artists was formed through a series of not exactly casual contacts. In December 2018, at a contemporary art gallery in downtown Rome, I met the sculptress Federica Luzzi,[2] a long-time friend, who told me about the vicissitudes and the appeal of the Ex Lavanderia Association, and the fact that the latter, on the fiftieth anniversary of the Basaglia Act (1968–2018), was considering a theatre performance at Pavilion 31, with the participation of artists who had supported the appeal. We talked about it and I expressed my willingness to participate in the initiative. Immediately afterwards, we met Alessandra Cristiani in the gallery, a dancer and performer, with whom I have a long experience of working together.[3] We told her of our intention to support the appeal, hesitating a little to ask her to participate, because our work would certainly not count on a budget. Alessandra, however, immediately expressed her support. The Japanese artist Naoya Takahara[4] then arrived at the gallery and, having been previously informed by Federica, was already aware of the situation at S. Maria della Pietà and of the appeal. He joined the discussion and then took Federica, Alessandra and me to a small square close by, where he performed for us (and for those who chanced to be there) with his *Acchiappaspiriti* ('Ghost catcher'), a sound 'machine' like a kite, inspired by a Japanese children's game, which – as Naoya told us – perhaps in turn derived from a sound instrument used by some ethnic groups to call 'the pure spirits of nature'. He made it spin in the air on a long string, creating the whistle. Watching his performance, which seemed to pick up mysterious 'voices' that would not otherwise have been heard, was conclusive in creating in our little group a strong determination to realize a performance at S. Maria della Pietà, dedicating it to so many lives lost and forgotten, hospitalized there over its more than 100 years of existence.

The next step was a meeting with Ilari Valbonesi, an activist in the Partito Radicale and art critic, who has for years supported the struggles of the Ex Lavanderia Association for the public reuse of the former mental hospital. With her, we started to study the context in which we intended to operate.

Ilari got us to visit Pavilion 31 and the surrounding park and introduced us to members of the association, with whom we had several meetings. Besides thoroughly acquainting us with the vicissitudes of the former mental hospital and the fight for its use as a public area, as well as the measures adopted by the authorities to counteract them, these meetings also brought us up to date with the operational logic of the association, aimed first and foremost at ensuring that the area is perceived by fellow citizens as a collective heritage, and to counter current perceptions of the site as a semi-closed environment, and its actions to create civic development. We learned the details of the association's attempts to constitute a pole of social and relational enrichment, as part of the commitment to impact the use of public space and contribute to social regeneration.

We were greatly interested in the idea of implementing an urban transformation process that is based on a survey of the premises and their concrete use and is modelled on citizens' needs and desires; this is quite different from planning on paper, divorced from reality and often motivated or influenced by private interests. In Rome, this logic of decision by the base on the use of urban spaces is represented very significantly – and also numerically – by the 'centri sociali', self-managed group centres that arose in the mid 1970s in squatter-occupied premises, very active in the sector of artistic, musical and theatrical proposals, which still constitute a highly important cultural network in the city, typically with avant-garde content. As for all psychiatric hospitals, the history of S. Maria della Pietà as an institution is entwined with that of the city, of medicine, social discrimination and it is the most emblematic spot in Rome of the silent holocaust consummated in the name of social normalization. This memory should not be lost, but kept alive. 'Building well-being in places of madness' is one of the declared intents of the Ex Lavanderia Association, aiming at a policy of inclusion, of opening the area and of shelter for the new poor and marginalized created by this phase of crisis.

Other important encounters – set up by Ilari and by the association members – were with persons who had lived part of their existence in this major Roman mental home, and included Adriano Pallotta, who had worked there as a nurse from 1959 to 1997, and was among the leaders of the revolt that led to the opening of the pavilions to outside spaces and to the elimination of beds of restraint, contributing significantly to the reform movement that resulted in Act 180 (Adriano is also co-author of a book on the vicissitudes of Santa Maria della Pietà mental hospital: Pallotta and Tagliacozzi 1998); and Alberto Paolini, an elderly poet and writer, who in 1948, aged just 15 a poor orphan, was shut up at S. Maria della Pietà and immediately subjected to electro-shock, despite not being affected by any mental disturbance. Paolini has written a touching testimony of his 42 years of reclusion (Paolini 2016). Now 86, since 1990, he is a patient in a 'group home', not far from S. Maria della Pietà.

Adriano and Alberto have delivered much documentation on daily life at S. Maria della Pietà, on the struggles that led to the dissolution of the mental hospital, the developments of psychiatric institutions after Act 180, and on current prospects. We had several encounters with them while organizing *Alieni nati* and they have given us their books. Adriano told us of his experience as a nurse in the hospital, his real and inner conflicts in trying to balance his rejection of traditional 'care' methods and his duty – that is his work – to apply such methods, including beds of restraint and electro-shock. As he told us, at S. Maria della Pietà, unlike other cases in Italy, Basaglia's ideas of reform were put into effect by a group of nurses and patients who, in 1975, occupied one of the hospital wards – the one used for isolation – to make it a unit for the application of new kinds of therapy. He had a leading role in the revolt. We have seen film clips in which he was in the front line in physically demolishing the fences surrounding the pavilions. Alberto – his face and expression profoundly marked by a lifetime of suffering – told us about what had happened to him with a lucidity, irony and intelligence that made a striking contrast to the picture of the 'mentally ill'. 'From behind the netting', he recounted, 'we would watch the animals moving about outside. Now and again they would come to look at us. It was like a zoo, inside out'.

In the meantime, we were urging other artists to take part in the project, persons whom we considered kindred spirits for their artistic and political feelings: the director, poet and performer Marcello Sambati[5] and the author, actress and dancer Simona Lisi:[6] both joined us without hesitation. Simona, who lives at Ancona, rushed to Rome to take part in the project, paying all her expenses out of her own pocket. Naoya Takahara involved eight of his students from Rome's Accademia di Belle Arti and, lastly, Alberto Paolini, at our insistence, made himself available to take part personally in the performance.

During meetings of the *Alieni nati* group, it soon became clear that the principal motivation for taking part in the work was connected to a sense of solidarity and identification (each of us, in contact with Alberto Paolini and his life, has thought that, if life's chances had created the conditions for it, we might have had the same fate), and to the wish to contribute actively to the struggle for the use of S. Maria della Pietà as a public space. It was immediately decided not to perform any ready-made work at S. Maria della Pietà, but to create together a new performance based on the site itself, its history, its current situation. It was also clear that we would not be telling stories or 'portraying' madness. On the contrary, the sensitivity of each of us would draw from contact with the site and its memory, in relation with others who have, in various ways, known it in the past and who now experience it as an operational base for its eventual transformation. We also decided not to make the work explicitly political, but to keep to the sphere to which, in a general way, the work of all the participants belongs, which is the sphere of poetry.

Alieni nati: *The performance*

The performance, presented on only one evening, was organized as a journey covered by the audience on foot. The spectators (about 100) were guided by the unravelling of the various actions, by their repositioning in the space, or by implicit signals consisting of changes of lighting and the provenance of the sound. During the first part, action took place at various points in the park; in the second part, inside Pavilion 31.

Thus, one passed from an open situation to one in which constraints and twilight passages were not lacking. This naturally re-echoed the two dimensions that most radically oppose each other in the life of psychiatric patients: the inside and the outside, being 'inside' and being 'outside'. We had completely darkened the related park area for the performance, and this, from a spatial viewpoint, rendered it non-dimensional, until each situation and each venue was identified by the battery torches we were directing. Up to the last moment, we were uncertain as to whether electric power would be available. Its supply to Pavilion 31, as I have already stated, has been cut off for years by the authorities, and the generator had, at the time, broken down. We managed to get it repaired just a few hours prior to the performance. Darkness and the use of torches in the performance had a relationship with the actual situation, linked to the inconvenience in which the squatters of Pavilion 31 operate and which we tried to transmit to the audience through our work.

The first piece was by Marcello Sambati, Figure 12.1, who delivered his 'Canto Screziato' ('Dappled Song'), a 'brief vocal-evocative action', as he himself defined it, standing, making small gestures, on the stump of a tree in the middle of a lawn. He was dressed in white (which, albeit without any direct reference, could not fail to recall a doctor's white coat, or the straitjacket), and, from his left side breast pocket, there shone through, like a beating heart, a pulsating red light. From what the author said and how he used his voice and moved, the scene was like a poetic declaration of belonging to the universe and to its breath. In a place that had seen the painful separation of so many human lives from the world, this took on a special and profound meaning. Towards the end of Marcello's scene, a whistle was heard. It was the aria taken from *Acchiappaspiriti* by Naoya Takahara. While doing this, he led the audience to another large lawn, where the action was repeated and multiplied by his eight students handling the same number of *Acchiappaspiriti* of different sizes, producing whistles at different pitches. This kind of 'concert' seemed to capture the spirit of the place, the many, different 'voices' which still crowd there.

Among the 'guests' of the psychiatric hospital S. Maria della Pietà was Alda Merini, one of the greatest Italian contemporary writers and poets (1931–2009),

FIGURE 12.1: Marcello Sambati in *Alieni nati*. Courtesy of Stefania Macori.

FIGURE 12.2: Naoya Takahara, *Acchiappaspiriti* ('Gost catcher'), performing sculpture for *Alieni Nati*, 2018. Courtesy of Naoya Takahara.

who defined such places that she painfully experienced for several years as 'a cross without justice that just revealed to me the great power of life' (Merini 1995: 59). Dedicated to her was the performance *Peso.piuma* ('feather weight'), by Simona Lisi, Figure 12.3, which took place on the same lawn as *Acchiappaspiriti*. Simona, writing about her piece, says:

FIGURE 12.3: Simona Lisi in *Alieni nati*. Courtesy of Gatd.

FIGURE 12.4: Federica Luzzi, costume for Simona Lisi in *Alieni nati*, 2018. Courtesy of Federica Luzzi.

From heaviness to lightness, how far is it? How can I transform my pain in my flight? I think of Alda Merini, of all those sectioned patients who survived, who distilled their essence in the constriction of suffering until what comes out is not a scream,

but a song of lightness. To this place, and to all humankind who remained entangled in it, goes this small contribution.

(Lisi 2018: n.pag.)

Simona wore a heavy jacket created by Federica Luzzi, inspired by a smock padded with sand, adopted by some German schools to contain the over-exuberant energies of hyperactive children, which is on sale on the internet. Simona performed her dance on the lawn, wearing this new kind of straitjacket.

At the end of her performance, Simona led the audience towards an illuminated spot where, at a table, Alberto Paolini was seated, Figure 12.5, the elderly poet who, as mentioned, lived half of his life institutionalized at S. Maria della Pietà. He was there to recount his story and read passages from his volume *Avevo solo le mie tasche*, a book of poetry and tales, its title deriving from the fact that, as the patients at the mental home had no space to put their things, he was obliged to put the little sheets of waste paper on which he wrote in his own pockets. Before speaking to the substantial group that had gathered around him, Alberto remained silent for a long time: a real, unplanned, silence. Evidently intimidated by the situation, he gazed at the people around him, remaining silent for several minutes. Packed minutes, in which reality precipitated into the performance with all its force. No words could describe the pain.

After Alberto's performance, the audience entered Pavilion 31. Alessandra Cristiani performed her *Langelo* (*The Angel*, without the apostrophe required in Italian, thus subtracting the word from the commonly connoted image) in a large ground-floor room, in full light, with lighting and objects picked up. She was half-naked, like a kind of angel, but not at all heavenly, rather very terrestrial

FIGURE 12.5: Alberto Paolini in *Alieni nati*. Courtesy of Federica Luzzi.

and suffering, with a single wing badly mangled: a silent, strong presence, full of sorrow and poetry. Alessandra wrote:

> In quel suo passare o semplice esistere, / in un intimo silenzio / persiste ai nostri occhi senza alcun miracolo. / Dolente, non può dare salvezza / all'umano sentire e agire / non resta che scrutare ed essere scrutati / senza soluzione alcuna dello sguardo / l'angelo è muto di carne e spirito.[7]
>
> (Cristiani 2018: n.pag.)

At the end of her scene, she removed her wounded wing and, up a narrow stairway, led the audience to the upper floor, to the great space that was once the laundry's clothes drying terrace and which, after the ceiling was put in some years ago, is now used by the association as a theatre hall.

There, the audience saw *Visione* ('Vision'), an installation by Federica Luzzi and myself. In the room, Federica had hung, arranged as a constellation calibrated to my lighting installation, a certain number of sculptures of knotted white cloth, belonging to her *Shell* series. In that place, on those objects seemed to coagulate the memory of the clothes from the laundry pegged out to dry and even the

FIGURE 12.6: Alessandra Cristiani in *Alieni nati*. Courtesy of Gatd.

straitjackets of the mental home. On the sculptures was projected the silhouette of a man dressed in white (myself), on a black background, performing a very agitated dance. With his ceaseless movement, the figure intercepted Federica's sculptures, making those struck in turn by the light shine, unveiling the forms alternately in space. The choice of including a scene of light at the end of the work was certainly related to the importance of light – since its supply had been cut off – in that place. Possible associations are myriad. The dancer's frenetic action which, in flashes, drew the objects out of the darkness, had as its counterpoint the voice of Alberto Paolini recounting the story of his life, recorded some days earlier in the group home where he is living, including the whistles of Naoya Takahara's *Acchiappaspiriti*: a sort of outburst or resurgence of the site, the performance, the outside, at the end of the itinerary. The elements' interaction increased connexions. The dancer's unceasing movements and the forms illuminated in the dark space could be associated by the audience with the smocks, the clothes, the straitjackets, the 'mentally disturbed', the institutionalized who walk up and down, without a purpose, in the rooms of the mental home, as they recur in the story that the audience could listen to at the same time by the recorded voice of Alberto.

In short, the performance consisted of a pattern of actions or, if you like, 'voices', not organized according to any narrative, succeeding each other like poems in a book whose pages were the different sites of the actions and whose structure was the physical tissue of the site.

I think that the banishing of any direct and explicit 'political' content in favour of the poetic quality of the pieces – a choice supported by the attitude of the artists themselves – was no detriment to the clarity of the message proposed and may have helped raise awareness (among the audience, the struggling characters, in ourselves) of the issues on the table at S. Maria della Pietà, since their poetic quality was so strongly rooted in the place, in its memories, and in the claim for its public use.

I also feel that the crucial moment of the entire performance was Alberto's long silence; around which all the actions, sounds, lights and words of the performance could be arranged in the mind of the spectator, anchoring him or her more profoundly to the situation, to the story of the place and to the current struggles to make it a space that is open, free, equal, dignified, shared. Alberto's words, when with difficulty he managed to break his silence, added further reflections on those 'men who were seated dumb on the old benches and no longer looked out of the window', and the place where they spent their lives 'remembering so many who died unheeded', as he said in his performance.

In the *Alieni nati*'s creative procedure, the institutional place, its history, its current use and the conflicts over its reuse, became a sort of 'text', or, in any case, the complex 'matrix', starting from which the work has been conceived

and produced. The performance, with its contents and its tension, has been a moment of participation in the conflict on the public and cultural reuse of institutional sites.

NOTES

1. *Alieni nati* ('Aliens born') by Fabrizio Crisafulli, Alessandra Cristiani, Simona Lisi, Federica Luzzi, Alberto Paolini, Marcello Sambati, Naoya Takahara. Project collaborators: Adriano Pallotta, Alberto Paolini, Ilari Valbonesi. Action collaborators: Laura Accardo, Marta Laureti, Cristiana Lucentini, Federico Pavano, Luca Pontassuglia, Antonio Tripodo, Kaiyue Zhang, Shan Zhang. Costume design: Federica Luzzi, Stefania Macori. Sound: Andreino Salvadori. Rome, S. Maria della Pietà, 18 May 2018.
2. Federica Luzzi is a sculptress and installation artist based in Rome. Outstanding among her works is the cycle denominated *Shell*, begun in 1999, comprising woven 'sculptures of knots', recalling numerous images, each of which dominates according to the work and the situation: conch, shell, envelope, pod, cuirass, scale, light boat, scheme, sketch of a project, coffin inner casing, bark, carcass, framework, bone, appearance, projectile, grenade, cartridge, case, hand guard, electron shell (http:// www.federicaluzzi.it. Accessed 22 February 2022).
3. Alessandra Cristiani is based in Rome. Her work focuses on investigating the subtle nature of the body. In the 1990s, she tended towards White Butoh, under the guidance of Masaki Iwana. Starting from 2000, she has perfected her own personal method for setting up her *opere d'essere* ('works of being') (http:// www.alessandracristiani.com. Accessed 22 February 2022).
4. Naoya Takahara, graduate of Tokyo's Tama Arts University, moved at the end of the 1970s to Rome, where he trained in contact with artists such as Sergio Lombardo, Maurizio Mochetti, Francesco Lo Savio and where he currently works (http:// www.tralevolte.org/artisti/naoya-takahara. Accessed 22 February 2022).
5. Marcello Sambati, poet, stage author and performer, based in Rome, started his theatrical research activities in the 1970s. In 1980, he founded in Rome the experimental theatre company Dark Camera and the Furio Camillo Theatre, landmark for new generations of fringe theatre actors, authors and critics (http://www.darkcamera.it. Accessed 22 February 2022).
6. Simona Lisi is a dancer, choreographer, independent dance aesthetics researcher, living at Ancona. She is a creator of performances and video works with the cross-contamination of music, word and gesture. She is the director of the Cinematica festival of performing arts, cinema and new technologies, held every year in Ancona (http:// www.simonalisi.indra.it. Accessed 22 February 2022).
7. In his passing by or just existing, / in an intimate silence / he remains to our eyes without any miracle. / Bruised, he cannot give salvation / to human feeling and acting / there remains only scrutinizing and being scrutinized / with no end to his gaze / *langelo* is dumb in flesh and spirit.

REFERENCES

Ajroldi, C., Crippa, M. A., Doti, G., Guardamagna, L., Lenza, C. and Neri, M. L. (2013), *I complessi manicomiali in Italia tra Otto e Novecento* ('The mental hospitals in Italy between the nineteenth and twentieth centuries'), Milan: Mondadori-Electa.

Basaglia, Franco (1964), 'The destruction of the mental hospital as a place of Institutionalisation', in *First International Congress of Social Psychiatry* [Online], http://www.psychodyssey.net. Accessed 15 September 2019.

Cherchi, Pier Francesco (2016), *Typological Shift: Adaptive Reuse of Abandoned Historic Hospitals in Europe*, Syracuse: LetteraVentidue.

Cristiani, Alessandra (2018), work notes, manuscript, n.p.

De Girolamo, Giovanni, Barale, Francesco, Politi, Pierluigi and Fusar-Poli, Paolo (2008), 'Franco Basaglia, 1924–1980', *American Journal of Psychiatry*, 165:8, p. 968.

Foucault, Michel (1965), *Madness and Civilization: A History of Insanity in the Age of Reason*, New York: Random House.

Lisi, Simona (2018), work notes, manuscript, n.p.

Merini, Alda (1995), *La pazza della porta accanto (The Crazy Woman Next Door)* (eds C. Gagliardo and G. Spaini), Milan: Bompiani.

Pallotta, Adriano and Tagliacozzi, Bruno (1998), *Scene da un manicomio: Storia e storie del Santa Maria della Pietà* ('Scenes from a mental asylum: History and stories from Santa Maria della Pietà'), Rome: Ma.Gi.

Paolini, Alberto (2016), *Avevo solo le mie tasche: Manoscritti dal manicomio* ('I had only my pockets: Manuscripts from a mental hospital'), Rome: Sensibili alle foglie.

Russo, Giovanna and Carelli, Francesco (2019), 'Dismantling asylums: The Italian job', *London Journal for Primary Care*, 11:4, http://www.psychodyssey.net/wp-content/uploads/2011/05/Dismantling-asylums-The-Italian-Job.pdf. Accessed 12 September 2019.

ACT FIVE

ACT FIVE

13

From Garage to Campus: Exploring the Limits of the Museum in Contemporary Russia

Anton Belov and Katya Inozemtseva

Russia is home to some of the world's great museums. The State Hermitage Museum in St. Petersburg attracted around 4.5 million visitors in 2018, making it one of the fifteen most visited museums in the world. However, there is no national museum of contemporary art in Russia, despite various attempts in the post-Soviet period to establish such an institution. A number of state-funded and private institutions have attempted to fill the gap. One of these is Garage Museum of Contemporary Art in Moscow, founded in 2008 by Dasha Zhukova and Roman Abramovich. Initially conceived as a *kunsthalle*-type space which would show blockbuster exhibitions, the mission of Garage expanded over time to include a focus on Russian contemporary art. This expansion was reflected in a radical change in the physical space occupied by Garage and by new (for Russia) approaches to attracting and working with diverse audiences. In the early 2010s, a new city administration in Moscow began a process of urban regeneration which ran parallel with the changes in the museum, resulting in the development of a new model for a cultural institution with a physically dispersed 'campus'.

Garage opened in 2008 in the former Bakhmetevsky Bus Garage (1926–27), designed in the constructivist style by Konstantin Melnikov. At this time, there were already numerous museums in Moscow, most of them managed federally or run as civic institutions. With very few institutions (other than galleries) showing contemporary art, the initial focus of Garage Center for Contemporary Culture, as the museum was then called, was on blockbuster shows mounted with external curators. As a private museum,[1] it has resisted the temptation to develop and show

a collection of big-name contemporary artworks and focuses instead on research and education as the cornerstones of its exhibition policy. The museum's collection is its archive, a publicly accessible repository for a wide range of ephemeral materials on post-war art in Russia, with a key focus being unofficial art circles in the Soviet Union.[2]

The Bakhmetevsky Bus Garage is located in Marina Roshcha, an area to the north of the city centre. In 2008, the nearest metro station was a good twenty-minute walk away (there is now a new station slightly closer), and with Moscow's legendary traffic jams the location presented challenges in terms of attracting an audience once the VIP preview of the exhibition was over. This was especially difficult due to the lack of other cultural institutions in the area (the visit to Garage could not be combined with a trip to another venue) and the fact that there were very few places to eat and drink in the immediate vicinity. Attention was focused on developing facilities that would encourage visitors to spend more time in the building, making a potentially long journey more 'worthwhile'. Despite the plethora of museums in the city, providing facilities such as cafés and bookshops was always an afterthought, and the idea that someone might visit a museum to have lunch was virtually unheard of. The team at Garage brought in a professional chef and created a menu which was imaginative, tasty and reasonably priced. Garage Bookshop was the first institutional store in the city to offer a wide range of Russian and international publications on art and culture, rather than simply museum-related catalogues and merchandizing. As the space became better known,

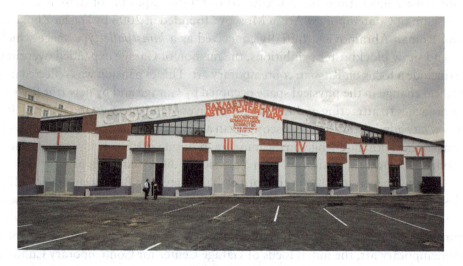

FIGURE 13.1: Garage Center for Contemporary Culture at the Bakhmetevsky Bus Garage, Moscow, 2008. Courtesy of Garage Museum of Contemporary Art.

Garage began to develop an education programme that diverged from the more didactic models used by other institutions. As well as lectures, the programme included workshops and masterclasses based on the idea of mutual exchange of information. Visitors were encouraged to get involved in the life of the institution, rather than simply accepting (or not) what it offered.[3] The Bakhmetevsky Bus Garage was only ever a temporary location for Garage, as the building was part of a complex belonging to the Federation of Jewish Communities of Russia and was earmarked as a museum. In 2011, Garage moved out and the Jewish Museum and Tolerance Center[4] opened in the building in 2012.

The search for a new home had begun well before the move and the founders of Garage decided on Gorky Park, a large green space by the river in the centre of the city. Development of the area as a public space began in 1923, when it was the venue for the *First All-Russian Agricultural Exhibition*, and it opened as a park in 1928. By the 1990s, it had become very dilapidated and, in places, unsafe. The new administration which took over City Hall in 2010 included Sergei Kapkov, who was responsible for culture and set in motion an unprecedented regeneration of urban green spaces such as Gorky Park. Garage settled on a ruined building in the middle of the park, a Soviet modernist café known as Vremena Goda

FIGURE 13.2: Vremena Goda Café in Gorky Park, Moscow, 1968. Courtesy of Igor Vinogradsky Archive, Moscow.

('Seasons of the Year'), constructed in 1968 as a prototype for park cafés across the Soviet Union (although no others were built). In the 1970s, the original café became something of a cultural hub, but after the break-up of the Soviet Union, it was abandoned and fell into disrepair.

Dasha Zhukova engaged Dutch architect Rem Koolhaas to remodel the building for use as a museum. He is a recognized expert on Soviet modernist architecture, a sorely neglected post-war genre which is only now being re-evaluated in Russia and the post-Soviet space.[5] It was clear that the reconstruction would take several years. As a result, architect Shigeru Ban was invited to design a temporary pavilion at a nearby location in Gorky Park, which would incorporate an exhibition space, café and bookshop.

Garage began repurposing other buildings in the park: a former cloakroom became the education centre, library and archive, and part of the park administration building was redesigned as a separate, open-plan office. The reclaiming of the historical fabric of Russia's most iconic park was accompanied by commissions in 2013 and 2014 for emerging Russian architects to design temporary summer pavilions to extend the space during the warmer months. They were used for performances, talks and simply as gathering places for park visitors. This reflected the park's historic origins, as the temporary structures for the *All-Russian Agricultural Exhibition* in 1923 were designed by the country's leading architects and artists, including Ivan Zholtovsky, Konstantin Melnikov, Alexandra Exter and Alexander Rodchenko.[6]

The new museum building opened in June 2015. With his design project for Garage, Koolhaas was keen to demonstrate that even a ruined 1960s café could be redesigned as a public space while remaining true to the building's modernist roots. The café was not listed, and demolition would have caused little fuss, but the founders of Garage were committed to bringing the building

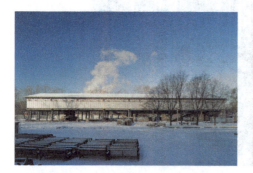
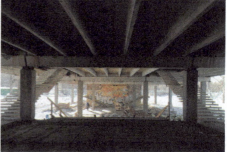

FIGURES 13.3 AND 13.4: Vremena Goda café ruins, facade and interior, 2011. Courtesy of Garage Museum of Contemporary Art.

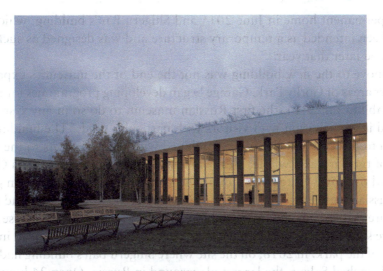

FIGURE 13.5: The Shigeru Ban pavilion in Gorky Park. Courtesy of Garage Museum of Contemporary Art.

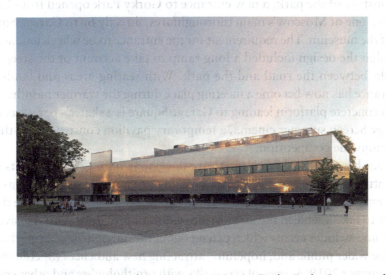

FIGURE 13.6: Garage Museum of Contemporary Art in Gorky Park. Courtesy of Garage Museum of Contemporary Art.

back to life and Koolhaas worked imaginatively with the remaining fabric. He retained elements of the original design and finishes and combined these with innovative materials such as the polycarbonate cladding which makes the simple shape of the building shimmer and shine whatever the weather. Garage moved

into its permanent home in June 2015 and Shigeru Ban's building, which had always been intended as a temporary structure and was designed as such, was demolished later that year.

The move to the new building was not the end of the museum's expansion into other areas of Gorky Park. Garage began developing programmes for people with disabilities in 2014, the first Russian museum to do so in any systematic way, and in consultation with visitors with particular needs. The building was designed to be accessible and that, combined with improvements to the accessibility of the park as a whole, meant that within the first two months Garage welcomed over 500 visitors with disabilities. Garage-trained exhibition guides using Russian Sign Language now work in many Moscow museums, and tactile models are regularly included in exhibitions, but even five years ago these measures were something new.[7] The museum's policy of inclusivity extended into the territory of the park. In 2018, on the site where Shigeru Ban's building had been, Garage launched Salyut, the largest playground in Russia. Open 24 hours, this specially designed and landscaped area is fully accessible for people with disabilities.[8] In 2019, based on an idea which arose during work in Garage Archive on the history of the park, a new entrance to Gorky Park opened from Leninsky Prospekt, one of Moscow's main thoroughfares, directly on to Garage Square, in front of the museum. The requirement for the entrance to be wheelchair accessible meant that the design included a long ramp to take account of the steep change in height between the road and the park. With seating areas and landscaping, the entrance has now become a meeting place during the warmer months, and the smooth concrete platform leading to Garage Square is a skater's paradise. Nearby is Garage Screen summer cinema, a temporary pavilion constructed as the result of a nationwide competition.

Garage has played a key role in the re-development of Gorky Park, its various spaces attracting visitors of all ages. The challenge is to convert café, playground and cinema visitors (and even those who visit the building simply to use the bathroom or to take a selfie in the atrium) into exhibition visitors. An extensive public programme includes events which extend out of the museum into the park, appealing to the wider public and, hopefully, attracting new audiences for contemporary art. In summer 2019, a series of eco-walks with ornithologists and other specialists accompanied a major exhibition on the environment, *The Coming World: Ecology and the New Politics 2030–2100*, with the aim of educating visitors about the city's flora and fauna and the threats they face from climate change while also encouraging them to engage with the exhibition. Education is a core activity of any museum, and Garage is working to extend the understanding of a museum education programme beyond exhibitions and even beyond the institution itself. In 2018, Garage embarked on a collaboration with leading Russian institution

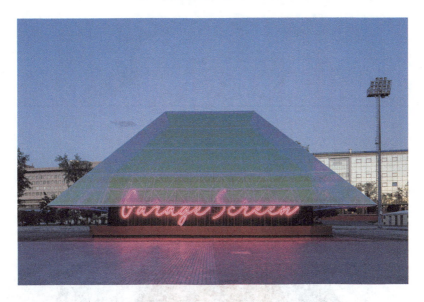

FIGURE 13.7: Garage Screen summer cinema, designed by SYNDICATE (Moscow), 2019. Courtesy of Garage Museum of Contemporary Art.

FIGURE 13.8: Garage Studios, VDNKh, Moscow, 2019. Courtesy of Garage Museum of Contemporary Art.

the Higher School of Economics in Moscow, setting up a joint department which offers the MA programme Curatorial Practices in Contemporary Art, the first such programme in Russia. Students are actively involved in the museum's research activities and Garage staff teach alongside university colleagues.

Like most countries, Russia is capital centric, and the art world is no different. The country's vast expanse, from the Baltic Sea to the Pacific Ocean, can make it extremely difficult for artists from outside Moscow to visit the capital. A key part of the mission of Garage is the promotion of Russian art and artists. The first

FIGURE 13.9: Interior of Garage Studios, VDNKh, 2019. Courtesy of Garage Museum of Contemporary Art.

Garage Triennial of Contemporary Art in 2017 prompted the idea of providing studio space – something which is lacking even for Moscow-based artists – which would include residential facilities. Garage Studios and Artist Residencies, which opened in 2019, were also the museum's first physical territorial expansion, being based at VDNKh, a park formerly known as the *Exhibition of National Economic Achievements*, which is located to the north of the city centre. The first museum-based facility in Russia, Garage Studios are also housed in a historic building which has been sensitively restored: a post-constructivist former model school built in 1939.

Over the past decade, museum architecture has confirmed what Rosalind Krauss wrote in her polemical essay 'The cultural logic of the late capitalist museum' (1983). She suggested that contemporary museums ignore the serious moment at which the viewer meets the artwork, instead forcing them to experience the unconnected hyperreality of architecture. Visitors react euphorically not to art but to the museum spaces themselves, with their cafés, enormous bookshops, entire floors for theatrical performances, zones closed to 'first-time visitors' and reserved for holders of a particular kind of card and so on. Museums

with enormous amounts of space, which constantly expand in terms of square metres, are perhaps the most characteristic feature of the contemporary cultural landscape. Ever since Garage opened a museum in the conserved and restored space of a former café, it has taken an alternative route towards interaction with the audience and the cityscape. The construction of new multifunctional buildings, which are usually created based on the logic of a sculptural object and not that of the surrounding landscape, cannot be a productive ideology for a future or existing museum. By its nature, the contemporary museum is horizontal and is obliged to react tactfully to the viewer and their attempts to establish a trusting relationship with new art.[9] It develops physical capacities (space, resources, etc.) based on broadening its programme and including a wide variety of initiatives in the experience of museum visiting. In this sense, Garage considers its *topos* to be not a concrete building or set of buildings but an environment, a conditional space which is created by a system of symbolic connections between various buildings in Gorky Park – the education centre, the future Hexagon,[10] the office building (1923), the former Vremena Goda café, the Salyut playground.[11] Like a university campus, this environment is created not as a result of the functioning of actual buildings but thanks to systems of transfer and movement through which a new mode of communication is established with the viewer; where the museum as a place which shows certain artefacts is not the aim and final purpose. One might employ the metaphor of organic life: cells or atoms with a nucleus and interacting elements. The life of these connections can be ensured by artists or, in a broader sense, the strategic programme of the institution.

Garage continues to develop the campus system, and its flexibility has proved helpful since exhibition activities were suspended in February 2022. The Museum's focus has shifted to its archive and library, and the public-facing aspects of these activities have been located in the main building since July 2022. Other buildings are also being repurposed, with Garage Studios becoming an active cultural hub of underground life and the Narkomfin Building bringing together researchers into the Russian avant-garde.

NOTES

1. Garage is funded partly by its founders and partly through earned income. Garage Endowment Fund was launched in 2019 as a means of guaranteeing the museum's long-term sustainability.
2. Garage Archive Collection was established in 2012 with the acquisition of the Arts Project Foundation archive, a comprehensive collection of material on Moscow's contemporary art scene of the 1980s and 1990s. Further donations and acquisitions from artists, gallerists,

academics and curators have resulted in the world's largest collection of archive materials on Russian contemporary art. In 2017, Garage launched the Russian Art Archive Network (RAAN), an online resource which provides access to catalogue data and digitized content from Garage and partner institutions.
3. Garage has always had a majority of younger visitors. In 2018, 70 per cent of the museum's 900,000 visitors were under 30, many of them students and schoolchildren. One of the challenges in diversifying audiences is to expand the audience to other age groups, particularly retirees. It is worth noting that, unlike other Russian museums of its size, the team at Garage is young.
4. The Federation of Jewish Communities of Russia (FJCR) was given the Bakhmetevsky Bus Garage by Moscow city administration in 2001, as it is located close to the Moscow Jewish Community Center. The building was in poor condition and extensive restoration work was carried out by the Iris Foundation, a charitable organization established by Garage co-founder Dasha Zhukova. Garage Center for Contemporary Culture opened in the space in 2008. In parallel, FJCR worked with architects and museum designers to develop the concept for the Jewish Museum and Tolerance Center, which opened in 2012. Its permanent exhibition, which occupies much of the building, is a hi-tech, interactive display exploring Jewish life and history. There is also a temporary exhibition space.
5. Garage has supported research into Soviet modernist architecture, led by architectural historians Anna Bronovitskaya and Nikolay Malinin, which will result in a series of books on the post-war architecture of Soviet cities, including Moscow, Almaty, Leningrad and Tashkent. *Moscow: A Guide to Soviet Modernist Architecture 1955–1991* was published in English in 2019.
6. For the history of temporary structures in Gorky Park from 1923 to 2018, see Evstratova and Koluzakov 2019.
7. Garage has also developed programmes for visitors with developmental disabilities. People with autism spectrum disorders are provided with an explanatory story and additional materials before their visit. All frontline staff have been trained in Russian Sign Language and working with differently abled people. The museum is currently working with Moscow's migrant and refugee communities in an attempt to involve them in the capital's cultural life, from which they are often marginalized.
8. The Salyut Playground was designed and built by Gorky Park and Garage to mark the park's 90th anniversary (2018). It occupies two hectares and comprises nine separately designed playgrounds where children and adults can interact with sand, water, colour, sound, height and depth, as well as a variety of textures, shapes and scales.
9. Garage is exploring ways of working with horizontality. Nomadic projects involve separate elements breaking away from the main body of the institution and beginning to live their own lives, for example, online and outreach programmes. Even within the museum some parts of the whole, such as the teams involved with film and theatre,

now have a greater degree of autonomy in terms of producing content and working with audiences.
10. The Hexagon is a ruined structure close to Garage in Gorky Park, which is currently slated for renovation as a museum space. It was designed by Ivan Zholtovsky as the Machines and Tools Pavilion for the *First All-Russian Agricultural and Handicraft Industries Exhibition* in 1923 and is the only structure, which remains from that time, due to the fact that its frame was made of reinforced concrete rather than wood.
11. The possible reconstruction of two further buildings in Gorky Park as spaces for performative practices and the moving image is currently under discussion.

REFERENCE

Evstratova, Marianna and Koluzakov, Sergei (2019), *Temporary Structures in Gorky Park*, Moscow: Garage.

14

Not Not Research

Henk Slager

In current thinking about an activated approach of institutional environments – both academic and curatorial – various questions arise about how the phenomenon of artistic research has played a meaningful role over the last decade within educational environments such as art academies and exhibition spaces. In order to answer these questions in more detail, this contribution will explore both the perspective of higher education and the perspective of the current situation of exhibition making from the practice of five recent research projects.

How could artistic research with a topical focus on profound thought processes – despite the obvious risk of the rhetoric of a knowledge economy and related thinking in terms of production – make a crucial contribution to the speculation and critical formulation of methodological reflections going beyond a simple parallelism of 'the contemporary' and the horizontalist moment 'now'? Or simply put: What purpose does artistic research actually serve?

Today, art education is haunted again and again by two persistent misconceptions. First, the image of art as an irreflective, spontaneous and intuitive practice is still prominent – not only outside the institutional walls of the academy but also inside those walls. This has created a situation where various temporalities, perceptions and approaches could co-exist within the current academy – sometimes overlapping, sometimes completely a-synchronous and antagonistic – in the form of, for example, a modernist studio model and deconstructive courses focusing on after images. Second, research is often interpreted in an instrumental sense as some sort of discursive support for a not yet articulate practice. It follows that research, for the sake of an utterly necessary institutional emancipation, should reposition itself as a fundamental and equal component of artistic practices: a component manifesting itself in reflections of artists/students on how to devise questions, trajectories and concepts that could incite their work.

How does such a proposition relate to answering the relentless institutional question about the deliverables posed to us by the ubiquitous neo-liberal, commodification-oriented thinking?

Undeliverables for sure are sets of pre-determined, modularized, measurable, controllable outcomes. All of these are related to the instrumental logic of our efficient, result-driven culture and its neo-liberal focus on free market mechanisms. They support a flat worldview that, as Byung-Chul Han described in *Fatigue Society*, continuously demands transparency and visibility and, therefore, forms of exhibition, thus producing a horizontalist world that, with its twitter-democracy and the ubiquitous blogosphere, brings a 'net culture' into being that leaves no room for rest, contemplation, creation and experiment. Such a world is carried away entirely by entrepreneurial thinking and a focus on the contemporary moment where adaptivity and flexibility have been elevated to the highest value. In short, a world without room for verticalist perspectives, such as reflexivity, new modes of imagination and historic profundity – perspectives so characteristic and fundamental for the academy.

In line with these observations, the curatorial project *Exhausted Academies*[1] asked how we might rethink the relation between artistic research and the art academy, specifically through a critique of the 'exhausting' achievement-oriented and instrumentalized tendencies of the contemporary neoliberal institution, and a return to a 'verticalist' perspective that 'makes space' for attention and concentration; for experiment, novel questions and speculation; for reflexivity, new modes of imagination; for an open-ended form of differential thinking that values not-knowing, the singular, the affective, the transgressive and the unforeseen.

Therefore, within art institutions, research should specifically engage in tasks of considering, revealing and speculating. In other words, research should strongly urge to investigate novel verticalistic perspectives in order to arrive at 'not-yet-known-knowledge' (see Rogoff 2011). To pave the way for that, research in art education – as an autonomous space for concentration and experiment – should open up a capacity to designate novel questions. Only by posing those questions one is able to change the structure of their thought.

But what does such a vertical, more performative approach to developing questions mean for the way in which research is ultimately delivered?

Because of the inseparable connection between making art and thinking, research has to be somehow present in that interconnecting – translation – process. This means that research has to be conceived as an oscillating translation where the material and immaterial continuously merge into one another and where a dialogical activity focuses on dynamic processes: a pursuit that can be characterized as performative,[2] precisely because the emphasis is not on product and reception, but on action that seeks to challenge the status quo by making

FIGURE 14.1: Installation view *Exhausted Academies: Fatigue Society*, Byung-Chul Han, Seoul Media City, 2016. Courtesy of Seoul Museum of Art.

FIGURE 14.2: Installation view *To Seminar* (Sarah Pierce, Falke Pisano, Tiong Ang), BAK Utrecht, 2017. Courtesy of BAK, basis voor actuele kunst, Utrecht.

alternative – sometimes even speculative – propositions based on an awareness of urgency. The power of this lies in the fact that the artistic processes are considered as if from within, and therefore, again especially taking into account the materiality, and the way in which using a diversity of components, from interdisciplinarity and through the potential of connectivity, an ultimate claim for a different perspective on reality is articulated.

How should the institutional environment of conducting this form of research be shaped? Or in other words: where should such a research take place?

Given the manifold possibilities of theoretical perspectives, the study of and reflection on the discursive dimension of one's own creative process – in many curricula referred to as 'artistic research' – should preferably be offered in 'seminars'. Seminars not focusing on repeating canonized knowledge – characteristic of a disciplining academic institution degenerated to a teaching machine with a fixed curriculum – but instead, as was central to the by Roland Barthes' text inspired curatorial research project *To Seminar*:[3] addressing the creation of an experimental laboratory process through the de-institutionalization of the educational matrix: an undisciplining, affective environment where students can potentially become artists.

Until now, the academy was the pre-eminent institutional environment for 'doing research'.[4] After all, the academy was since its foundation analogous to 'inter-esse', intellectual curiosity, and excluded by definition the 'oikos' as calculating reason. In spite of the present threat of increasing instrumentalization, quantification and disciplining, and despite the hollow rhetorics of the creative industry and its cognitive capitalism – manifesting itself in homogenizing patterns of thought, such as expert knowledge, knowledge transfer, stakeholders, employability, assessment and quality assurance that try to reduce art education to a neoliberal dispositive – the academy still seems to be the last enduring free space in the cultural field where innovative processes concerning experimental production, reflection and presentation can be generated.[5] The academy should continue to fight for such a temporary, autonomous space for experiment and reflection, since such a space could thrive in combining various forms of knowledge into new speculative ensembles.

Thus, an educational environment could emerge that no longer exclusively focuses on repeating canonized knowledge – characteristic of a disciplining academic institution degenerated to a teaching machine with a fixed curriculum – but also addresses the creation of experimental seminar environments characterized by a form of open-ended, non-hierarchical and speculative thought.[6] Such an environment generates – in spite of the pressure of current technologies of distraction – a space for differing intelligences and unconventional sensibilities enabling students as future artists to think and imagine the world and how we relate to it anew.

Doctoral researchers could be of specific importance in pointing the art academy into that direction again and again as this form of research – characterized by maximum concentration and maximum mental freedom – more or less forms the intellectual conscience of the institution. Doctoral research reminds the academy that despite the pressure of neoliberal market thinking and its related fixed and fixating models, the academy as a free-space for attention should adhere to its verticalist dimensions: the imaginary heights and the historical depths.

What does the organization of such an institutional space mean for the way in which the 'theory' component of the current curriculum is to be understood?

Through its intrinsic relationship with thinking and creating, theory will always keep its role of expounding the artistic process in public. This dissemination continuously requires new processes of conceptualization where intellectual activity merges with the expansion of forms and formats for art's symbolic presentation and explication. Moreover, at all times, artists should be able to relate to societal and artistic developments, diagnose them and develop a relevant vision and/or critical intervention.

For example, how should we relate to the aforementioned *Fatigue Society*? Art definitely has to explore ways in which we might disrupt or dislodge the pressure of acceleration: the ubiquitous demands to do more and more – faster and faster – that arguably underpin our contemporary culture of immediacy and urgency, of 24/7 access and availability, with its privileging of multitasking, perpetual readiness and ethos of 'just-in-time' production. In one sense, the requirement to do more and more can result in a reality of less and less, the cultivation of superficial engagement overriding the possibility of deep, sustained immersion, diminishing the potential of attention and concentration. How might doing deceleration reveal rest and reflection as active components of artistic production, the practice of doing nothing as complementary rather than oppositional to action? Here, radical deceleration does not involve the retreat towards the promise of a singular (slower) temporality, but rather has the capacity to reveal and bring into relation a plurality of micro-temporal co-incidings.

This entails that in art education, theory should not be understood as a static, transferable knowledge system, but rather as a 'doing theory': a performative thought process that starting from attentiveness goes on to 'becoming' interested in something and reaches an open-ended form of differential thinking that explicitly or implicitly rebels against the currently presented 'will to know' of the managerial machines.

Does this development mean that the way in which we understand the practice of theory today is once again coloured by a strong philosophical conceptual framework?

The first decade of the twenty-first century was characterized by a disproportional interest in knowledge production. Consequently, a large part of artistic activities started to view itself as processual, directed by a rigid series of points of departure and deliberations, which all seem to steer making art. The increasing academization or the willingness to comply with formatting requirements that the disciplining institutional apparatus imposes on knowledge production appears to underline this tendency. Therefore, it seems more than urgent to redraw attention to what precedes knowledge production, i.e. the process of thinking – a thinking that has been a bond between philosophy and art since time immemorial.[7] Precisely in this dialogue with philosophy, artistic thinking can redraw attention to not-knowing, the singular, the affective, the transgressive and the unforeseen.

A coming together of such attention to artistic thinking and a clear focus on creating can be described as a new, or rather, an updated form of *Experimental Aesthetics*. It was this perspective that was tested and articulated during the curatorial project *Aesthetic Jam*.[8] Deriving from a multitude of perspectives and lines of thought, the project intended to question anew the concept of aesthetics and its relevant positions and situations. Could a novel concept of aesthetics reveal different forms of interests in and processes of artistic thinking? Could experimental aesthetics as an undisciplinary methodology distinctive from a theoretical and academic philosophy be in the forefront of creative practices? The project's ultimate starting point was the assumption that the concept of aesthetics has the capacity to recharge and update the artistic research concept currently narrowed down by institutional academization.

What are the consequences of such demarcative epistemic shifts?

In line with Hannah Arendt's book *The Life of the Mind*, a clear distinction between thinking and knowledge needs to be restored. Arendt refers to Kant's sharp division of thinking processes in 'Verstand' and 'Vernunft'. Verstand is described as the disciplining domain of cognition and empirical knowledge based on certainty and clarification. Kantian Vernunft (Reason) goes beyond that domain and focuses on a continuous search for understanding. From that latter perspective, Arendt views both philosophy and art as pure activities of thinking, where thinking is simultaneously always aware of that activity of thought.

Moreover, Arendt explicitly asked to present this thinking in the public space as a performative act that demonstrates a current form of engagement. And thus, as Hito Steyerl (2010) argues, this form of thinking is primarily situated in the tradition of emancipatory struggles, which Peter Weiss described as an *Aesthetics of Resistance*: a form of thinking that demands room for public debate vis-à-vis institutional disciplines and standardization: the formulation of topical values and truths, and where necessary dare to make judgements that run counter to regulatory registers of cognitive capitalism and symbolic labour.

FIGURE 14.3: Installation view *Aesthetic Jam: Zero Degree Situation* (Kai Huang Chen, Lonnie van Brummelen and Siebren de Haan), Taipei Biennial 2014. Courtesy of Taipei Fine Arts Museum, Taipei.

FIGURE 14.4: Installation view *Research Ecologies* (3rd Research Pavilion, Venice Biennale 2019). Courtesy of Research Pavilion Venice/Uniarts Helsinki.

What do such epistemic and performative shifts mean for a contemporary understanding of research?

At stake here is a radical manner of resistance based on the intrinsic potential of art to imagine the world differently: a speculative and associative form of open-ended thinking that relates to the unknown, thus withdrawing from deterministic and causally inspired models of thought. In short, a form of thinking that cannot be caught in a static organization of pre-formed categories and that ultimately contributes to what Foucault described as a 'new aesthetics of existence'. Subsequently, research should be understood as a verb, and certainly not as a noun to be presented as a final product. This observation clearly underlines that artistic research should not be solidified within an institutional architecture of distinctly defined inquiries, but rather remain linked to the dynamics of concerns and urgencies presented by artists.

Therefore, thanks to its provisional quality, artistic research could best be described as a transpositional framework: a non-disciplined space where an assemblage of creative practices, artistic thinking processes and curatorial strategies continually produce new sets of relationship that make idiosyncratic contributions to the articulation of urgent, planetary issues.

Moreover, such a field – as presented in the 3rd Research Pavilion entitled *Research Ecologies*[9] – outlines at the same time the methodological and epistemological preconditions: artistic research is characterized by an uninterrupted, transversal interaction and articulation of three inseparable and intrinsically interconnected lines: the line of creative practice, the line of artistic thinking and the line of curatorial strategies.

In the curatorial project *Farewell to Research* (Ninth Bucharest Biennale 2021), these three lines will be further situated departing from the assemblage perspective.[10] This will offer a critical view on the rhetorical impact that an over-emphasis on creativity, artistic thinking or curatorial strategies has on how we currently understand the concept of research.

Thus, the proposed project furnishes a distinct impetus for reclaiming creativity. A concept that because of its intrinsic quality of freedom seems nowadays hostage to the one-dimensional rhetoric of the protocol-oriented creative industry, whereas in fact, it should stand for exploring the potential of the sensible through art making.

A similar danger of reduction is present in the debate on knowledge production where the process of artistic thinking is almost completely subjugated to the academic regulations and monolithic protocols of cognitive capitalism. However, the dynamics of artistic thinking, which by definition precedes disciplinary knowledge, does not, because of its practices or differences, lead to transparent identities.

These are urgent issues that ultimately need to be made public in a strategic way, whereas transformational spaces will need to be generated for them. Such is the perspective of the *curatorial* line that stands for generating experimental spaces for the public and performative modes of reflection and presentation, contextualizing connections between objects, images, discourses, locations, histories and especially futures.

The specificity of artistic research – an activity that is entirely determined by vital encounters between creative practice, artistic thinking and curatorial strategies – somehow remains – and this is exactly what the curatorial project *Farewell to Research* intends to explore further by means of a series of presentations and discussions – unequivocally inserted in art while articulating questions and raising doubts, and, most of all, while creating novel, future-oriented, ideas.

How can such an understanding of research be reformulated institutionally?

Now, after a decade of excessive attention for knowledge production,[11] any form of future artistic research should take a firm stand for an activity departing from the idea of a mutually inspiring interaction between the disciplining perspective of knowledge production (i.e. the institutional perspective of academic research) and the undisciplining perspective of artistic thinking (i.e. the Nietzschean perspective of a 'gaya scienza'). An artistic activity that because of its intrinsic character could never be reduced to either one of these perspectives and, therefore, is most accurately described as 'non non research'. For such a well-balanced form of research, a laboratory setting characterized by a similar interaction, i.e. an interaction between the territorial given of the institution and the related deterritorializing institute practices (Raunig 2013),[12] seems to be the most appropriate environment. Indeed such a strategic convergence of 'becoming research' and 'becoming institution' will possibly lead to vertical deepening rather than horizontal expansion of both institution and research.

NOTES

1. My research project, *Exhausted Academies*, was presented in Seoul Media City (2016) and Nottingham Contemporary (2017), with contributions from Tiong Ang, Inci Eviner, Rene Francisco, Byung-Chul Han and Isabella Gresser, Hito Steyerl, Ane Hjort Guttu and Muntadas: http:// www.artandeducation.net/announcements/143995/doing-deceleration. Accessed 22 February 2022.

2. In her article, 'Artistic research: A performative paradigm?', Barbara Bolt argues:

> [A] performative research paradigm needs to be understood in terms of the performative force of the research, its capacity to effect 'movement' in thought, word and

deed in the individual and social sensorium. The movements enable a reconfiguration of conventions from within rather from outside of convention.

(2016: 129)

3. Cf. the curatorial project *To Seminar* that I curated in 2017 at BAK, Basis voor Actuele Kunst, Utrecht. This project unfolds as a contemporary reading of philosopher Roland Barthes' essay 'To the seminar' (1974). Engaging with the notion of the seminar – as a concept and as an intimate and complex practice – as something pivotal for learning today, *To Seminar* transforms the noun into a verb in an attempt to activate its 'unpredictable rhythm', proposing it as a tool for intervention into the settled practices of education today; in art and beyond. For what was once celebrated as the 'educational turn' today turns far too often into either routine initiation into a knowledge economy or cognitive capitalism, or into the placatory emptying of the meanings of 'knowledge production', 'community' and 'method'. If, like Barthes' time of writing, ours is a present immersed in 'a certain apocalypse in culture', the true task of learning is not to normalize this present's morbid symptoms as has become customary, but rather to collectively think through and act out alternative imaginaries. With artists, theorists and other cultural practitioners, *To Seminar* reengaged the three conceptual spaces that intersect when a seminaring takes place – institution/transference/text – and seeks to recompose them into a balanced comradeship for renegotiating the conditions of the contemporary. www.artandeducation.net/announcements/142277/to-seminar. Accessed 22 February 2022.

4. The curatorial project (workshop, symposium, publication – curated by Jan Kaila and Henk Slager) *Doing Research* – in which research within and outside of institutional settings was expounded – took place as part of dOCUMENTA 13, 2012. www.artandeducation.net/announcements/109237/doing-research. Accessed 22 February 2022.

5. The presentation and the publication (Metropolis M Books, 2012) *Temporary Autonomous Research* (Amsterdam Pavilion, Shanghai Biennale, 2012, curator Henk Slager) focused on the institutional preconditions of the academy. www.e-flux.com/announcements/33669/temporary-autonomous-research/. Accessed 22 February 2022.

6. In the curatorial project, *Whatever Speculation* (2019, On Curating, Zurich), the question of the position and situation of the concept of 'Speculation' is again raised. www.mahkuscript.com/4/volume/3/issue/1/. Accessed 22 February 2022.

7. Such an approach is the starting point of my book *The Pleasure of Research* (Hatje Cantz, Berlin, 2015). This publication delves into issues such as knowledge production, artistic thinking, medium-specificity and context-responsiveness. How do these issues connect to the current state of art education and artistic research? The *Pleasure of Research* argues that artistic research should foreshadow a 'gaya scienza': a temporary autonomous activity where intellectual pleasure and an experimental method invigorate forms of research and thought. www.e-flux.com/announcements/29650/hatje-cantz-publication-the-pleasure-of-research/. Accessed 22 February 2022.

8. This renewed attention for philosophy is central to the project *Aesthetic Jam* (curators Hongjohn Lin and Henk Slager, in collaboration with Nicolas Bourriaud, Taipei Biennale, 2014) and its accompanying publication *Experimental Aesthetics* (Metropolis M Books, Utrecht, 2014). Since contemporary thinkers such as Alain Badiou and Jacques Ranciere have initiated to redefine the aesthetic domain, aesthetics seems once again to point to extra-territorial frameworks able to avoid the production of instrumentalizing concepts. Indeed, a topical understanding of aesthetics appears to be astoundingly compatible with what was once advocated by artistic research, i.e. the self-reflexive and self-critical capacities of artists engaging in configurations of understanding and signification. www.e-flux.com/announcements/30269/book-launch-experimental-aesthetics-metropolis-m-books-taipei/. Accessed 22 February 2022.
9. Instead of being focused on a curated exhibition, the Third Research Pavilion (convenors: Mika Elo and Henk Slager) showcased manifold practices of artistic research. The participating researchers – self-organized in six different 'cells' – showcase their different modes of creative thinking in parallel processes of exhibiting, performing, exposing, discussing and articulating material encounters and related forms of critical reflection. With this focus, the Third Research Pavilion is fully in line with the current debate on the post-human predicament: the situation of the ecological disequilibrium, a relational approach of agency, the development of transdisciplinary or transversal discourses, as well as exploring novel practices of criticism and narratives in the form of neo-materialistic propositions.
10. These are approaches that – in line with Guattari's agenda setting *Three Ecologies* – ask again for ethico-political statements. After all, we suffer from a loss of common orientation or common world. To think again about this world, we desperately need another system of coordinates, another distribution of metaphors and sensitivities: new fictions and imaginaries to address the constituencies and configurations of the present and to speculate about future directions. Here is a significant challenge for artistic research: developing new theoretical and artistic representations for other modes of interconnection between human and non-human actors and factors; articulating new modes of thinking and representing the global environmental crisis; and related to these addressing historical responsibilities to be taken into account.
11. *Research Ecologies* presented itself as a process-oriented laboratory for testing and negotiating topical forms of material agency. By making a connection between the two words 'research' and 'ecology' – or rather, by placing these two concepts as two focal points of an ellipse or as a continuum – the contours and conditions that are outlined seem to be decisive for the current situation and direction of the Artistic Research discourse. www.researchpavilion.fi. Accessed 22 February 2022.
12. By using such a characterization the Ninth Bucharest Biennale (*Farewell to Research*, 2021, curator Henk Slager) clearly takes a distance from a series of misconceptions that have accumulated around the concept of artistic research over the past decade. Through preformed, static categories, these misconceptions seem to reduce research in the arts to

a noun, whereas the above-described dynamics and the related provisional quality rather ask for the dynamics of a verb. But above all, these misconceptions seem to result from the absolutization of one of the three – intrinsically and inseparably connected – lines.

13. The potential of artistic research lies – as the project *Farewell to Research* emphasizes – in 'thinking differently' – a way of thinking that demonstrates how we can move from planning to speculation: an associative form of open-ended thinking that alludes to the unknown, thus withdrawing from deterministic and causally inspired models of thought.

14. Although the main issue here obviously is imagining the world in a different way, and because of that future-orientation new modes of political imagination are implied, one should not equate the perspective of the curatorial line to political activism – just like the line of creativity should not be reduced to research for product innovation or the line of artistic thinking to pseudo-scientific research.

15. The discussion about artistic knowledge production was initiated during dOCUMENTA 11, 2002. A text by Sarat Maharaj, *Xeno-Epistemics*, played an important role in this.

16. A similar oscillation can now be discerned in the institutional situation of art education, which Suhail Malik (2011) describes as the way schooling (institutional incorporation, fixed structure, modularized curriculum and knowledge transfer) and education (open-ended, non-hierarchical, bottom-up and progressive thinking) relate to one another. Therefore, an optimal academy is characterized by a subtle oscillation of both pedagogical perspectives to such an extent that there can be no extremes (i.e. only schooling or only open-ended experiments). Because of its elliptical nature, research can contribute meaningfully to this.

REFERENCES

Bolt, Barbara (2016), 'Artistic research: A performative paradigm?', *PARSE Journal*, 3, pp. 129–42, https://parsejournal.com/issue/repetitions-and-reneges/. Accessed 22 February 2022.

Maharaj, Sarat (2002), *Xeno-Epistemics*, *Documenta11* catalogue, Kassel: Ostfildern-Ruit and Hatje Cantz pp. 71–84.

Malik, Suhail (2011), 'Educations, sentimental and unsentimental: Repositioning the politics of art and education', *Red Hook Journal*, New York: Bard College.

Raunig, Gerald (2013), 'Instituent practices and institutions of the common in a flat world', in Pascal Gielen (ed.), *Institutional Attitudes: Instituting Art in a Flat World*, Amsterdam: Valiz.

Rogoff, Irit (2011), 'Practicing research/singularising knowledge', Jan Cools and Henk Slager (eds), *Agonistic Academies*, Brussels: Sint Lukas Press, http://www.e-flux.com/announcements/35514/book-launch-agonistic-academies/. Accessed 22 February 2022.

Steyerl, Hito (2010), 'Aesthetics of resistance', *MaHKUzine*, 8 (Winter), pp. 31–37, https://issuu.com/hku-online/docs/mahkuzine08_web. Accessed 22 February 2022.

15

LGB's Manifest

LGB Society of Mind

The following text and photographs cannot capture and communicate the variety of actions, and the total design of the whole of the performance, including the choreography of the spaces, and how they work together as a game and gesamtkunstwerk. *It does, however, provide an insight into some of the work's theoretical and affective underpinnings as a simulation and displacement of pedagogical ritual.*[1]

Transcribed from fragments of the performance, I am LGB *by the members of the Lan Gen Bah (LGB) Society of Mind.*[2]

I am LGB is a four-hour experience responding to the Singapore school system. It was designed for a hundred participants, commissioned and presented at the Singapore International Festival of Arts 2016 by the LGB Society of Mind: Chan Silei, Kelvin Chew, Shawn Chua, Bani Haykal, Ray Langenbach, Lee Mun Wai, Bjorn Yeo and Zihan Loo. Not presented here are the diverse texts and exercises presented by each member of the society to groups of participants.

Each participant was issued with a numbered white lab coat, a red textbook and a pencil when they enter the chamber. Inside the textbook is a foreword[3] penned by LGB (a cognitive scientist, artist and academic who works diasporically in Southeast Asia and Europe) a glossary of terms, LGB's biographical timeline and a timetable of proceedings.

Over the duration of the experiment, the participants were subjected to a series of activities and exercises administered by four instructors named Josef, Sharaad, Weng and Lucy, after four intellectuals (one Singaporean and three foreigners) who were variously prosecuted, barred from working or banned from entering the country due to artistic and political activities.

At regular intervals, participants were 'liberated' from the chamber and led to an annex where they were able to observe the proceedings in the chamber via a network of closed-circuit cameras. In the concluding moments of the performance,

these liberated participants voted to decide which of the remaining participants in the chamber would be named the new LGB.

LGB's Manifest was delivered live on-screen as a public address to all remaining participants in the second hour of the experience. It is the first time LGB makes an in-person appearance in the experience. This segment is listed as 'Stage One – Manifestation' in the timetable.

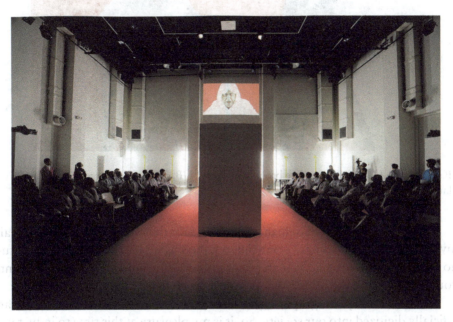

FIGURE 15.1: LGB's Manifest on screen. *I am LGB*, 2016. Photo credit: Kong Chong Yew.

'Stage One – Manifestation'

A school bell rings to mark the beginning of the address.

I am LGB.

It is my pleasure to welcome you to the first chamber.

The quintessential image of modernity is a mechanized chamber. The cell that is also a machine. The camera obscura. So, it is my pleasure to winnow you to this queered, pedagogical apparatus.

Here the inverted image of the real is projected onto the detached retina of your mind. You may learn here, or you will be liberated, or should we call it 'emancipated'.

227

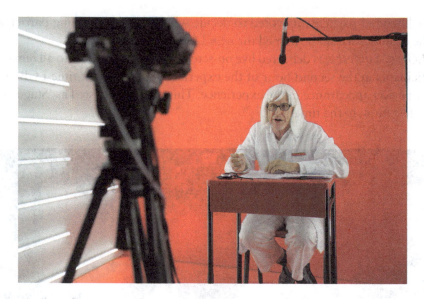

FIGURE 15.2: LGB's Manifest live broadcast, *I am LGB*, 2016. Photo credit: Wan Zhong Hao.

All but one of you will be emancipated. And for that one, the world will remain inverted. But even if you are emancipated, there is no way out of the apparatus, no way out of the pattern. You are programmed into it and it is programmed into you. It has been at the foundation of your consciousness for years.

You have been photographed, you have your lab coats and numbers. You are officially digitized into our society. So, it is my pleasure at this time to induct you into the LGB Society of Mind.

LGB claps languidly with irony, ostensibly to initiate applause. A somewhat tepid induced applause by the participants ensues.

We at the LGB Society of Mind invite you to consider the whole structure of this apparatus; the meaning derives from the synergy of the parts *and* the gaps. (We favour discontinuity.)

You may begin to recognize certain features because this event is designed for you.

For example, we have mapped your system of biometrics and meritocracy onto you. We will measure you, your body, your mind, your performance tonight and you will rise by virtue of your own acts, meritocratically.

But like the Referendum For Merger in 1962,[4] the system is rigged. We pretend to be a meritocracy. We pretend to be postcolonial. We pretend to be egalitarian.

We pretend to be decentralized. We pretend to be consistent. We pretend to be a Society of Mind.

Despite the deceptions, gradually you may feel at home here. But it doesn't really matter if you do or you don't. What is home? Have you ever really felt at home? 'Home is where the heart is'.[5] Perhaps you are a hostage to the idea of home. Do you belong here? Do you? You were *thrown* into this being, this form, into your family, into this place. Haven't you always been a vagrant? This is a school for vagrants.

The following passage is read aloud by Sharaad on a central platform.

A number of factors might cause an individual animal to appear outside its normal range and social group – genetics, habitat changes such as climate change, lack of food or intrusions by other species into its normal range, etc.

Such biological vagrancy can lead to colonization if individuals flourish in their new environments. Human economic or cultural vagrancy refers to the movement of cultural artefacts and memes to a new range or economic habitats, such as language, beliefs, bureaucracies, information and technology.

Vagrancy reminds us of Homi Bhabha's 'narrative of entry permits, passports, work permits' which marks the incessant return of those whom modern nations persistently deny but require in the global economy: colonials, postcolonials, migrants, and minorities. Wandering people who will not be contained within the '*heim*',[6] of the national culture and its unisonant discourse, but are themselves the marks of the shifting boundary that alienates the frontiers of the modern nation.

LGB adopts an American southern drawl and becomes Yar Habnegal. He starts to refer to LGB in third person.

I am Yar Habnegnal, awake all ye constructs! You, me, we are all in identity drag. You have an identity right, that identity is your drag. Do you get me? Do you get me? Identity is drag. LGB is my drag. We are all discursive motherfuckers and fatherfuckers. Little Hamlets and Ophelias. But some of you still believe you are exceptions to the pattern! You still want to hold on to a fascistic hierarchy of forms, determined by metrics and essence, with carbons at the top and silicas at the bottom. But honeychild, need I remind you that we are *all* bottoms? One body's biography, the inscription of the biological, is the biography of all bodies. The vagrancy of one body is the vagrancy of all bodies.

LGB's diasporic vagrancy began at Kandang Kerbau Hospital on 4 May 1948, when her parents were visiting Singapore from China.

Her father, Lan Siang Guan, was a nuclear physicist closely associated with Lin Piao. Her mother, Chiang Mo Jo, was a first-generation psychologist and a poet closely associated with Lu Xun, from Shanghai.

During the revolution Chiang's theories of de-centred communist systems led to Mao Zedong's early formulation of *jian tao*, thought work, inner self-cleansing, self-criticism. Chiang believed that individual initiative and a refracted mode of thought could enhance the formation of group mind. Unfortunately, Mao did not see it that way. Chiang opposed his deployment of *jian tao* during the *Yan An* rectification... for the purpose of purging 4th May intellectuals such as herself, and it was probably this opposition to Mao's desires that led to her demise two decades later, in 1964.

The family moved to Boston when Siang Guan took on a diplomatic post in 1949. Chiang at that time contacted Marvin Minsky across the Charles River at MIT. Minsky was developing an assemblage/bricolage theory of artificial intelligence as a society composed of the accumulation of non-intelligent agencies that then together produces intelligence. 'Selfhood' is a construct or a by-product of these formerly selfless object patterns in the synaptic ecology.

Chiang believed that there was potential in Minsky's work for a socialist model at a deep structural level of the mind. It is a vision of mind without a central authority or an ego or a CPU – a central processing unit.

Her work was interrupted by realpolitik in the United States as the State Department was influenced by the Red Scare during the period of the Korean War.

The family returned to China in 1964 and two years later the cultural revolution broke out. LGB was inducted into a Beijing cadre unit and found herself at Tiananmen Square confronted with the spectacle of her mother being purged by using the very process of *jian tao* that she had developed years earlier. She was incarcerated in the asylum where she had done her internship. She was subjected to electroshock therapy and chose suicide a few years later.

LGB came to believe that her father had abandoned her mother. She blamed him for this abandonment and not helping her mother in her time of need. In 1982, LGB secretly recorded a conversation with her father in the back garden of their home in Shanghai. The tape has been transcribed and translated as follows:

The following exchange between LGB and her father, Lan Siang Guan (LSG) was re-enacted by Lucy and Weng on the central platform. Lucy reads the part of LGB and Weng reads the part of LSG.

LGB: When the time came, when the cadres came for her, you slipped into the shadows.

LSG: No, it wasn't like that. How was I to help?

LGB: You knew what it would lead to. You knew what it would do to her, what they would do.

LSG: I was just as vulnerable, and any attempt to stop it could make it worse. I thought I could get help from Lin Piao, but he had his own problems. If only I could whisper into Chairman Mao's ear, then it would have been accomplished.

LGB: You could have delayed it, but you were fascinated by the aura of power... the way power emerged from the ground, as the Chairman said. It was the second revolution, the 'Vanguard'. You wanted to see how far it could go.

LSG: Why can't you understand? Mother was collateral damage. We were all saving Mao. The revolution was in danger. You know, you were there. Why do you want to save Mother now, but not your teachers then? You want to erase your part in it. We are all in the same boat. It was an eclipse. We were all staring at the corona of the sun. When power comes from below... from the people, it is beautiful and hypnotic. Your mother saw it. She knew what it meant.

LGB: What did it mean?

LSG: That her moment had passed. The cadres did not know about her previous work and how indebted they were to her. They were performing to her script. But how could they know that? Mao claimed *jian tao* as his own concept. This was the sacrifice for unity, the party and the nation. Mother made this sacrifice.

LGB continues her Manifest via 'live' video feed, speaking in first person.

In 1977, I returned to Cambridge. I wrote to Minksy, informing him of Mother's death and asked to return to his lab to continue her work to find a socialist model of mind. I was particularly interested in the issue of ideology, and why the mind tended towards an obsessive–compulsive status quo, where a singularity of one synaptic agency would develop a kind of hegemony over other agencies, that might lead, for example, to an obsessive–compulsive attitude towards cleanliness or a desire for power, an obsessive fear of elevators, or contamination, or addiction to high performance.

Beginning in the 1980s, I found myself haunted by episodes of paranoia not unlike those experienced by Lu Xun's Madman. Like the psychologist R. D. Lang, I began to see modernity itself as a symptom of a massively distributed paranoiac sensibility, a theatre of agencies. It is a problem of border management and the fundamentally interconnected nature of all information.

I saw that nations themselves could develop these tendencies. For example, I found that the United States, with its imperialist drive for absolute power, was in the thrall of such a singularity. That became increasingly problematic for me. At MIT, there were many professors who were part of the R&D for the military–academic complex. Tensions began to enter my relationship with Minsky in the lab because of the deep involvement of the university with the war effort in Vietnam.

It was indeed a problem of their blindness to others' *borders*. Let us illustrate this negotiation with a visual exercise.

In this segment the participants are invited to stand and follow instructions delivered by LGB.

- Please stand.
- Now find a spot on a wall directly in front of you and stare at that spot without moving your eyes.
- Stretch out your arms to the side, move away from the people around you until you can spread them out.
- Wiggle your fingers at the edge of your visual field. Then hold them still.
- You know you have found the edge of your visual domain when your stilled fingers disappear.
- When you move them, you see them, but when they are still, they disappear.
- You have very primitive retinal cells at the edge of your visual field that are excited only by movement.
- Now move your hands up and down and around as you explore the 360° border of your visual field. Try and determine the shape of that visual field. This is your visual domain. This is your domain of knowledge. Beyond that border lies chaos.
- Now please turn and look into the pupils of the eyes of a person next to you, and do not move your eyes from their eyes.
- Remain staring into the eyes of your partner.

You are in an iron room with no windows or doors. It is impossible to break out. You have some people with you inside that room who are sound asleep.

Before long you will all begin to suffocate. But the sleepers will slip peacefully from a long slumber into death, spared the anguish of being conscious of their impending doom.

Let's say that you, in your pain and anguish, stir up a big racket that awakens some of the light sleepers. In that case, they, like you, will go to a certain death fully conscious of what is going to happen to them. Do you think that you have done them a favour? Will you intentionally awaken them or let them sleep their way to oblivion?[7]

- Continue to look into the eyes of your partner.
- Now, those of you who will awaken your fellows please raise your hand.
- Those of you who will let them sleep into oblivion, please raise your hand.
- Keep looking into the eyes of your partner.

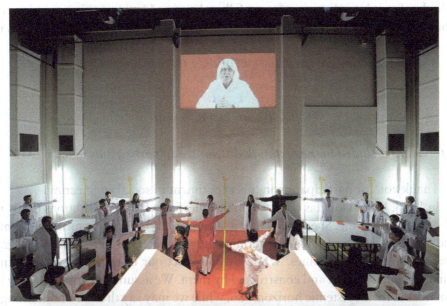

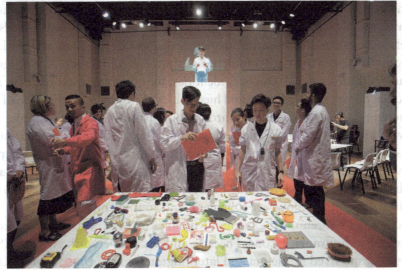

FIGURES 15.3 and 15.4: Mapping the visual domain, *I am LGB*, 2016. Photo credit: Kong Chong Yew.

You may see a cylindrical tunnel at the core of your visual field bridging across the intervening space. Allow that tunnel to expand. Go into that tunnel. Lan refers to this tunnel as the 'fifth passage'.[8] It is formed by merging your consciousness with the consciousness of another, whether that other is a carbon or silica entity. Go into the 'fifth passage', feel the difference, do not be afraid. Go into the

cylinder. Look into the eyes of your fellow human. Here, now, it is within you. The iron room is within you. This is your death. Now? Here? This is it? This is it.

A school bell rings to mark the end of the LGB's manifest.

LGB's message to you

A foreword included in the textbook distributed to participants of I am LGB.

Thank you for participating in this experiment in social engineering.

In 1986, Mary Douglas reflected on the question of 'how institutions think' in a book by that name. She argued that institutions archive public memory, create and maintain classifications and determine the parameters of their respective cognitive and the social epistemes. While we construct our institutions, we also find ourselves interpellated and constructed by them. We assume identities already in play within their epistemic horizons. So, while we may say that we think through our institutions, our institutions also think through us and through this thinking, the categories by which we name and perceive the world are formed. We also find ourselves categorized. Our institutions sort us as we sort the world. Those things – phenomena and historical moments – that we remember and forget are institutionally determined. Our very identities, the other vagrants whom we accept and reject, our social hierarchies and hierarchies of value and the horizon of possible thoughts are all formed in and through our institutions. (For example, who is this 'we'? How do 'we' justify the deployment of this problematic amalgamation?) But as Douglas maintains: 'Not just any busload or haphazard crowd of people deserve the name of society; there has to be some thinking and feeling alike among members'. We would add, to quote Benedict Anderson, that there needs to be 'an imagined community' however ephemeral and contingent.

Jacob Levy Moreno, MD, born in Romania in 1892, was a pioneer consolidator of Psychodrama, Group Therapy and Social Network Analysis (SNA). He studied and lived in Vienna and later migrated to the United States. During the war, he served as a medical officer and developed storytelling techniques to work with traumatized children after World War I. He later used this method with adults, founding Das Stegreif theater in 1921, where actors and audiences acted out their psychodramas. Approaching psychodrama via sociometry, an observational mapping of how people interact in groups, those who later used his techniques, focused on the relationships or ties between the 'nodes', 'units', 'agents', 'actors/actants' in the network. SNA and Actor Network Theory, developed by Bruno Latour, Michael Callon and John Law, are such dynamic

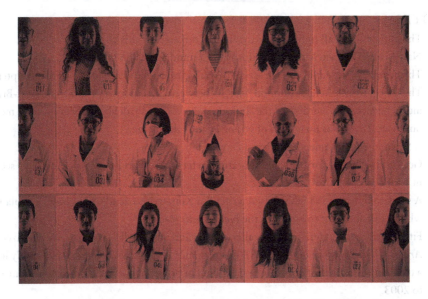

FIGURE 15.5: Participant photos, *I am LGB*, 2016. Photo credit: Wan Zhong Hao.

time-based systems, designed to map relationships and flows between people, groups, organizations, animals, computers or other information/knowledge processing entities.

You now find yourselves part of a short-lived ephemeral network formed in this room. Each of us is a node in a larger social matrix of human and non-human agencies, much like the society of mind mapped by Marvin Minsky. We maintain that such ephemeral agencies or micro-social networks can function as solidarity networks, without central processing units or authoritative centres. But naturally we would try to convince you of this at this point in the game.

We will observe and exploit your conditioned response to the spectrum of possible actions that appear to you to lie between two poles: the pleasures and benefits of conformity and acquiescence on the one hand, or exceptionality on the other. With Léo Bronstein, we propose a third way, solitude-solidarity.

Kisses on all of your openings,
Gen Bah

ACKNOWLEDGEMENTS

This chapter is dedicated to the memory of Leong Siang Guan. The father of Lan Gen Bah, Lan Siang Guan, is named after Leong Siang Guan, Ray's former partner, who died a few months after attending the performance.

NOTES

1. The authors have all rights to use the images throughout this chapter.
2. Named after Marvin Minsky's philosophy of mind and 1986 book.
3. This foreword, titled 'LGB's Message to You', is reproduced at the end of this chapter.
4. This refers to the Referendum on Merger between Singapore and Malaysia post-British independence. The wording of the choices on the voting slip deliberately favoured a merger outcome. There was no option of voting against the merger.
5. A Singapore government's National Day slogan.
6. German for home. For further elaboration, refer to the 'Foreignness of Language' section in Bhaba (1994).
7. A story told by the Shanghai-based writer, Lu Xun, to his friend Chin Hsin-yi, explaining why he did not want to write for the *New Youth Journal*.
8. Fifth Passage is a reference to a gallery space and artist collective that co-organized the *Artists' General Assembly* (1993). A performance at the *Artists' General Assembly* led to a ten-year restriction of licensing and funding of performance art in Singapore from 1994 to 2003.

REFERENCE

Bhaba, Homi (1994), 'DissemiNation: Time, narrative and the margins of the modern nation', *The Location of Culture*, Abingdon: Taylor and Francis, pp. 139–70.Figure 15.3: Mapping the visual domain, *I am LGB*, 2016. Photo credit: Kong Chong Yew.

ACT SIX

ACT SIX

16

Dis-establishment

Sam Trubridge

This chapter discusses The Performance Arcade, an annual performance festival held on Wellington Waterfront in Aotearoa New Zealand every year since its first presentation in 2011. Over this time, it has become a fully formed arts festival and programme – experienced by 60,000–90,000 members of the Wellington public every year. Installed within a temporary architecture made from shipping containers and scaffolding, the Arcade is both an architectural event and a curatorial initiative. On the reclaimed coastline of Te Whanganui-a-Tara and the modern city of Wellington, it draws on pre-colonial Māori traditions of the hākari stage and festivities, as well as contemporary exhibition and presentation formats. This ever-shifting, ever-collapsing event dis-assembles what Baz Kershaw has described as the 'social engine' of the conventional theatre machine, in order to reassemble its components in unlikely ways within a lively public environment. The event critiques the format of the art gallery or museum in equal measure, spaces where Kershaw's notions of disciplinary systems have just as much currency: where audiences learn trained behaviour, which 'is integral to the disciplines of late capitalist consumerism, paralleling the spread of shopping malls, heritage sites and other tourist venues' (Kershaw 1999: 32).

As a unique event within the global landscape of performance and live art presentation, The Performance Arcade resists the traditional economies of the class and knowledge controlled theatre, gallery, or arts festival to thrive within a space of disestablishment and precarity, as well as the cycles of its own construction and deconstruction each year.

> As a symbol of a globalised culture, the shipping container becomes a potent vessel for questions about contemporary publics and audiences. As a negotiation between the often polarised spaces of the theatrical 'black box' and the 'white cube' gallery, The Performance Arcade invites artists to seek new ways to engage

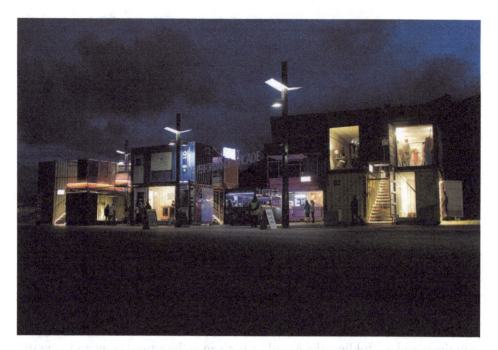

FIGURE 16.1: The Performance Archade 2017. Photo by Sam Trubridge.

FIGURE 16.2: *EurekaII*, by Amy Miller and Daniel Cruden. Photo by Sam Trubridge.

with a live and implicated audience. It provides a new space for this relationship to occur: one where there are fewer rules of engagement than one might find in the gallery or theatre. Here, in our city's public playground, it is possible to explore performance without fiction or narrative; where the act of doing something in a certain way can become invested with poetic, political, and emotional qualities. It does so in the space of a living, playful public – whose presence is critical to the completion of each work.

(Sam Trubridge, Curatorial statement for PA2011: n.pag.)

The Performance Arcade emerged from the Performance Design degree delivered by Massey University and Toi Whakaari NZ Drama School from 2004 to 2009. Briefs taught in this context became the first site of testing for concepts and processes central to the festival that The Performance Arcade became in 2011. Despite the degree's success, it was discontinued in 2009 after graduating four cohorts of students. At their end of year event, the last graduating class presented a self-published book entitled, *Disestablished*, to the staff of Toi Whakaari, with the following dedication:

New Zealand was one of the first countries in the world to have a degree called Performance Design, and now in 2009 it is the preferred title for theatre design around the world. This book and its pages hold some of the learning and work which we the Performance Design graduating class of 2009 have done over the past four years. This book is a manifesto, a guide and a documentation of the continual shifting nature of what it is to be a Designer of Performance. It signifies the end of an era, the closing of a book, in which we write the last chapter. It is seeded by those who have come before us, and is a standard for all those who are to follow. We gift this catalogue back to the school to be held in the library where it can be used for years to come. We would like to dedicate this book to those who paved the way for us and all those who design performance.

(Carpenter et al. 2009: 1)

Whilst The Performance Arcade was ideated through assignments run during this curriculum, the event only began to materialize after the disestablishment of the programme and closure of another performance initiative in 2010: The Print Factory Performance Laboratory, an informally run warehouse venue for experimental performance work at Massey University. These two examples of institutional withdrawal from performance often occur within the shift of tertiary institutions towards neoliberal models, where financial viability is often prioritized above academic excellence or other value systems, such as cultural innovation and industry development. On this topic, it is important to acknowledge the influential

Theatre Design department at Slade School of Fine Arts (University College of London), which was closed in 2002 – despite graduates comprising eleven of the twelve finalists at the previous Linbury Prize. It is a pattern of disestablishment that seems to pursue performance wherever it is found, where institutional regimes struggle to sustain the time-based, performative and ephemeral nature of the artform – or may even come to resist it. And yet, despite these challenges to performance practice, this space of disassembly often becomes a generative one – producing new platforms and solutions in the wake of such closures. While this may show how challenging or difficult the practice is for institutional routines, it also demonstrates how performance is at its most productive in this precarious environment of disassembly. The Performance Arcade is a good example of this phenomenon, finding its beginnings in that moment where the institution let performance go.

The Performance Arcade also draws on cultural sources within Aotearoa New Zealand. One significant precedent is the lost art-form of 'hakari' – temporary structures built by pre-colonial Māori to mark significant events and welcome visitors from across a region for extended periods of celebration, feasting, performance and discussion. The disappearance of this tradition within Te Ao Māori characterizes the shifts in spatial practices that occurred around the arrival of European settlement: from exterior events such as this to development of the 'whare runanga' as an interior space of meeting within the sacred open space of the Marae. The terraced structures of hakari sometimes towered high above the landscape, housing platforms where each 'hapū' would gather with their tribe to share their own regional delicacies, performance traditions, or contributions to the event. The Arcade celebrates and acknowledges these exterior, porous traditions for Pacific spatial practices, described by Samoan architect Albert Refiti (2005: 56–57) in relation to the concepts of 'wa/vā', as an in-between, inter-generational, relational space of connection.

The Performance Arcade brings this liquid, fluid architecture from the Pacific together with global architectural paradigms, in particular the 'arcade' itself – an environment of densely arranged or sequenced options, often given order by a spatial system or technological platform. In this way, the arcade is space where recreation and commerce interact – opening doors into exciting worlds of opportunity, novelty, distraction and attraction. The TV remote, shopping mall, games arcade (or 'spacies' in New Zealand), chocolate box, iphone and internet are all contemporary equivalents of this architectural form that took shape in the late nineteenth century European city centres. It was a form that inspired artists and writers and artists like Walter Benjamin, whose observation of the arcades of Paris and idle exploration of city environments produced his concept of 'the flaneur' – an audience of one, afoot in a city full of visual and sensory stimulation. Today's

flaneur browses layers of media for distraction and edification across arcades that fit into telephones.

A fourth influence was Vsevolod Meyerhold's (1911) *The Fairground Booth*, a text that denounced the vogue for naturalistic theatre and 'the well made play' by exulting in the medieval mystery, masks, puppets, the grotesque and 'cabotinage' (the work of 'the cabotin' – a strolling player, a jongleur, juggler and mime). Diverging from the theories of Stanislavski and the interest of other contemporaries in 'naturalistic' theatre, Meyerhold's views anticipated many of the experimental, visual and non-verbal forms of live performance known today. His words supported spectacle over drama, replacing the actor's 'mimicry' with performed action, addressing the complete sensorial body and celebrating the performance of non-human agencies like architecture and materials. Along with similar innovations in fine arts (moving away from conventional notions of painting and sculpture), this rejection of the expressive, dramatic crafts has since expanded theatre with an array of new signifiers: such as performance art, installation, live art, experimental theatre, dance theatre and social sculpture. Brought into an arcaded space, and responsive to the concepts of the flaneur and the dérive, The Performance Arcade coalesced as a space where all these forms could converge in exciting new ways. Exactly 100 years since Meyerhold published *The Fairground Booth*, *The Performance Arcade 2011* opened on Wellington Waterfront with eight container/booths for performance art.

The Performance Arcade was first produced in the year of the Prague Quadrennial's *Intersections* and Manchester International Festival's *11 Rooms* – two significant curatorial projects that both explored arcaded environments and the concept of 'maze dramaturgy' (Lotker and Černá 2011: 13) in relation to presenting performance art and performance design. Both demonstrate the contemporary significance of the arcade as a curatorial strategy, and emerged almost simultaneously as The Performance Arcade. However, there are critical differences. From its beginnings, The Arcade avoided the traditional 'paid admission' economy of arts presentation. This had the effect of opening artworks up to the volatile conditions of public space in a way that was unmediated by the disciplinary routines of the theatre and gallery, and unburdened by the transactional nature of entry fees. By contrast, the *Intersections* project slipped into patterns of territorialization by charging admission into its 'village' of works: thus creating a bordered condition, gate-keeping tasks and expectations amongst its paying audience. *11 Rooms* employed these same strategies within an interior gallery space. The Performance Arcade finds more pertinent equivalents closer to home, with the *One Day Sculpture* programme of works run by Litmus (Massey University) and led by Claire Doherty across New Zealand in 2008–09. Much like the Arcade, the *One Day Sculpture* experiment engaged with the public by

placing the work in the way of unexpecting locals throughout New Zealand's public terrains, cityscapes, imaginaries and cultural fabric. The radically transient nature of this programme allowed for artists to navigate diverse and intricate places like the small rural town of Hawera, a lot for relocated houses, a private jet between Sydney and Auckland, postcards, an old cinema, blockaded streets and weather forecasts – each becoming sites for performance, interventions and social sculpture.

The Performance Arcade is an event that addresses its public in a similar way to *One Day Sculpture*: by occupying an open, undisciplined environment like Wellington Waterfront, and in dialogue with the container port seen across the harbour. It is a space apart from the confines of the city street or building interiors. Instead the event occupies a place where codes of behaviour and traffic management are more relaxed: without road markings or signals, and without the invisible rules and routines of the gallery or theatre. There is a political resonance to its encounter with a passing public or 'accidental audience', where works are experienced within everyday contexts and where codes of behaviour are not so prescribed by familiarity. This has the effect of opening space up, liquefying it, destabilizing it and giving each action found there a potent political charge – as expressed in this extract from the Arcade's own *Manifesto for a Performance Community*, prepared by various regular artists and contributors to the event in 2014:

> Live Art is political – to work with an implicated audience, or to implicate your audience and make them a 'participant' is a political act. Thus live art is by its very nature is activism. To be a live artist is to be political.

The context that shaped The Performance Arcade in 2011 was also defined by the year of political unrest and reclamation of public spaces that spread across the world in 2010, with the Arab Spring, the global Occupy movement, and responses to the Greek debt crisis. Each mobilized public space and social media platforms with political activism. A second iteration of The Performance Arcade in 2011 for Auckland City was joined by the Occupy movement's Auckland contingent, who camped out opposite the shipping containers in Aotea Square. Together in this civic space, these contrasting initiatives created a potent forum for debate, politics and uncertainty within the broader context of New Zealand's hosting of the 2011 Rugby World Cup. This destabilization was also accompanied by a period of geological instability – manifested in the earthquakes of 22 February 2011 in Christchurch, New Zealand and 11 March 2011 in Tōhuku, Japan, which was followed by a devastating tsunami. Between these two events, and only two days after the Christchurch Earthquake – The Performance Arcade 2011 opened its

first programme of seven container works. This context of intense political and geological instability had profound effects on the institution of public space at the time, which was still coming to terms with the 9/11 terrorist attacks in New York City ten years earlier. By contrast with this earlier crisis, these new phenomena demonstrated the world-changing power that natural forces and public activism could have within the centres of civic and state authority: from Tahrir Square in Cairo to Cathedral Square in Christchurch.

Following the disaster of the Christchurch earthquake, the experimental theatre and performing arts scene in New Zealand entered a period of extended precarity and transience. The structural misperformance of buildings within this seismic event triggered numerous revisions of New Zealand building codes and insurance policies across earthquake-prone cities like Wellington, Napier, Hastings and Christchurch. As a result, property owners became increasingly risk averse to permitting public events in their premises. With their large auditorium spaces, many theatre and cinema venues were closed for restructuring. Various other 'at risk' buildings were demolished or closed indefinitely. In previous decades, the Wellington performing arts industry had been well-known for its innovative performance work in found spaces, and for its number of theatres; but after this event, it became a place with a very narrow choice of venues. Organizations like Urban Dream Brokerage worked hard to align artists with unleased retail spaces, but nonetheless there were very few of the ambitious warehouse performances that characterized the work of companies like Taki Rua, Jealous, Under Lili's Balcony, Seeyd Company, Red Mole and Trouble in the 1990s and 2000s. Meanwhile in Christchurch, Gap Filler worked at creating programmes within the devastated city centre's 'red zone' – where one in ten buildings were left standing. In this context, an extended state of 'disestablishment' characterized the personal, political, cultural and creative endeavours of many urban New Zealanders.

The Performance Arcade emerged from this instability to provide a platform and a transient architecture for artists to reflect upon their experiences and the experience of many across the country. The shipping container suddenly became a valued commodity, with new markets opening up from the 2011 Christchurch earthquake. Containers were used to protect pedestrian pathways from unsafe masonry, or to bolster up the sides of precarious walls like the frontage of Isaac Theatre Royal in Christchurch. In other circumstances, containers were refitted to provide temporary accommodation, storage solutions, pop-up businesses and new architectures in the ruins – such as Christchurch's Restart Mall, made entirely from shipping containers. In 2012, the freight-ship Rena ran aground on the Astrolabe Reef off Tauranga, and once again the container emerged as a symbol for disaster, with the images of their stacked towers toppling off the decks and spilling their

FIGURE 16.3: *Cargo*, by Kasia Pol and Mat Hunkin. Photo by Sam Trubridge.

contents into the ocean. Similar towers of containers stored in the port opposite The Performance Arcade collapsed like toy bricks in the 13 November 2016 Kaikoura Earthquake, remaining in disarray for several months before they were rearranged. Through all of this narrative of the country's geological and environmental frisson, the shipping container continued to perform as a vessel of meaning: carrying local anxieties about disaster, collapse and recovery whilst also exploring universal connotations with globalization, commerce and trade. These qualities were also explored by works within the event – such as Kalisolaite Uhila's *Stowaway* and Kasia Pol/Matt Hunkin's *Cargo* for PA2012 – where the globalized, capitalist artefact of the container is degentrified or decommercialized through their use in subversive performance processes and urban interventions. The Performance Arcade 2012 theme 'transgressive states' described this concept of the shipping container as a site of displacement: one that carries possessions, produce, contraband and refugees across oceans to new homelands. As a medium that connects us all, the sea was also considered as a recurrent element in selected works: complementing the boundaried, rigid form of the container with a state of transience. These two qualities have interacted throughout the history of the event in a series of performance spaces to create a portrait of a transgressive living, and a state of flux; celebrating oceanic fluidity and expressing anxieties about the structures of commerce that the shipping container is such an important part of today.

As The Performance Arcade emerged from its pilot presentations in 2011–13, it began to expand and experiment with the form that had taken shape. As it grew, the event emerged as an alternative model to institutional organizations already operating in town. In her *Illusions* review, Emma Willis critiques the 2012 NZ International Arts Festival where she asks 'rather than what festivals have become, how can both the public and artists be engaged with more dynamic processes that embrace the heady and unsteady model of carnival suggested by The Performance Arcade?' (Willis 2012: 43). Willis's titular question 'do new dramaturgies and new aesthetics need newspaces?' raised questions that were echoed by the writings of Chantal Mouffe on the significance of art practices to politics and democracy. Similarly, festival director Frie Leysen's keynote to the Australian Theatre Forum in 2015 challenged the ubiquitous model of the 'international arts festival' that has spread through city centres as symbols of civic pride and cultural affluence, entangling with attendant problems around consumerism, colonialism, internationalism and audience-pleasing curation. Mouffe's *Agonistics: Thinking The World Politically* (2013) explores similar issues to Leysen's speech: often promoting open public spaces over architectural enclosure, and an arts/culture strategy that is progressive, critical and agonistic. However, despite agreeing to these principles – arts organizations, presenters and even artists themselves habitually defer to the assumed primacy of architecture to categorize and legitimize creative practices and culture. Leysen's speech does this too. While she does present a bold challenge to the model of the city arts festival, her language remains focused on theatrical traditions of presentation within the theatre space, and to a seated, passive audience. Another example is evident in New Zealand artist Ronnie Van Hout's words about own his public sculpture *Quasi*, installed on the roof of Wellington's City Gallery in 2019: 'he [Quasi] never gets to go inside to hang with the real art' (City Gallery Wellington 2019: n.pag.).

It is not new or radical to make art outside of the disciplinary systems and city/state controlled architectures of the gallery and theatre. The Performance Arcade, however, seeks to develop this difference through three defining elements: free admission, the use of temporary architectural strategies and its harbour front location. As discussed earlier, ticketing/admission protocols create an economic boundary around creative works: controlling access and setting up a transactional relationship with its audience, thus making the perceived value of their experience a dynamic within their appraisal of the work. While other festivals and events often occur in public/outdoor environments; their economic devices, architectural frames and controlled access often has the effect of inhibiting any fluid or porous interaction between a work of art and public space. The question of value also has the effect of gentrifying or rarifying the art. The Performance Arcade's focus on an 'accidental audience' puts the public in place of Walter Benjamin's flaneur and

Guy Debord's dérive, with focus on an unscripted, undisciplined encounter with the work in the spaces of their everyday life. This audience usually happens across the work on their way to somewhere else, and can spend fifteen seconds or two hours there without obligation. Sometimes, they may return after an hour or two days to see that something has changed. It is often the spectacle that first attracts interest, or feelings of intrigue, repulsion, confusion and wonder. Whatever the case, these responses often produce a curiosity, a need to know more. This inquiry naturally leads to the beginnings of critical analysis. By working this strategy alongside other curatorial and pedagogical methods, The Performance Arcade has performed as an open institution characterized by its unique features and provisionality. As a bold intervention into the life of the city, The Performance Arcade intercepts its public in their daily routines through Wellington City. It positioned on the waterfront in the way that Māori populations placed *hinaki* ('eel traps') at narrow points on rivers and the estuarine spaces that preceded the wharves and city streets of this area. Thus, inhabitants of affluent suburbs of Mount Victoria, Roseneath and Oriental Bay find themselves travelling through the site to get to and from work in the business precincts of Lambton Quay and Thorndon.

However, the waterfront is not an elite space occupied exclusively by these affluent commuters – instead they intersect with other communities that gravitate to the waterfront for various leisure activities. Through two decades of urban development and landscaping of its nineteenth and twentieth century docklands, Wellington Waterfront has become a space to engage idle processes of spectatorship and performance, where people watching and showing-off go hand in hand, without the gentrification created in similar spaces by commercial developments and business precincts. In response to this culture, Wellington City Council initiatives have added various stages and plaftorms for this informal occupation – such as the nine metre diving platform where teenagers gather in summer to do bellyflops and divebombs for crowds of 150–300 people at a time. Within this dynamic social and cultural space, The Performance Arcade provides a more reflective, critical lens on the pervasive nature of performance in public and civic space, to a diverse audience of city dwellers and visitors. The public engages in a 'co-creative' fashion with many of the works, exploring their own civic agency and developing complicit dialogues between artist, artwork and audience. While the better-funded New Zealand Festival presents familiar theatrical encounters to its smaller, more exclusive audiences at higher ticket prices, audiences numbers surveyed for The Performance Arcade have continued to grow from 30,000 to 40,000 in its first five years, to as many as 90,000 in 2019. A figure that would fill Wembley stadium, or the entire population of the Seychelles, these metrics prove the viability of performance art taking place in the public spaces of cities and prove

the need for new paradigms beyond what reviewer Sophie Jerram calls 'the class and knowledge-restrained' spaces of the white cube and black box (2011). In this review of *The Performance Arcade 2011* for *Eye Contact*, she goes on to suggest that in this context,

> performance design has the potential to blend the performative integrity of theatre with the openness of visual art, and take on the risk of an unprepared audience who (not recognizing themselves as spectators) might become activists in a new community.
>
> (Jerram 2011: n.pag.)

The Performance Arcade does not hold one shape. Through ten years of presentation, the festival has avoided becoming its own institution or convention by continuing to find news ways to approach its annual process of assembly and disassembly on Wellington Waterfront. Each year, it is built from the ground up: installing the architecture, facilities, electricity, programmes and infrastructure in response to the artists' proposals and shifting local and global contexts. In this way, there is no space for monumentalism, fixity or routine within the event – instead it continues to evolve and adapt year by year, developing thematic frameworks in response to the selected works rather than imposing a theme on them at the proposal stage. The performance concepts generated by the artists also precede the architecture before any concept or ground plan is developed. From here, the works themselves define what is required from the arrangement of shipping containers, scaffolding and other structures. Thus, the event design is produced according to the specific requirements of each new selection of works. In the same spirit, the curatorial vision does not prescribe themes or limitations upon the artists while they are proposing the works, instead it waits to respond to concepts, concerns and common experiences that emerge through the selected works. This 'responsive curation' or 'curatorial reading' of the work allows for narratives to emerge from the zeitgeist of any year and resists the institutional mores of curatorial theme setting and prescriptive concept statements.

Through these techniques, the event also reverses traditional relationships between space and performance, 'disestablishing' presumed processes, and allowing art works and curatorial frameworks to determine the architectural schema for the event each year, rather than the other way around. This mobility avoids the institutional trap or routine that an event like this can fall into. Instead it echoes Romeo's Castellucci's descriptions of his sprawling *Tragedia Endogonidia* project (with Socíetas Raffaello Sanzio) as 'an organism on the run' where 'A+B shall not equal AB, A+B will equal C' (Astrié et al. 2004:2). In the spirit of Castellucci's quote, the event also accumulates and gathers knowledge and

layers within the event year after year: through an iterative, rolling, fluid process that doesn't discard each new annual solution, but instead absorbs them into the overall 'kaupapa' (purpose, principle or policy) of the event. Acknowledged within the thematic frame for The Performance Arcade 2015, this strategy of 'layering' allows for an intelligence to build within the event that avoids institutionalization and calcification:

> The theme of 'layers' celebrates the Arcade as a 'live' performance laboratory, where ideas have been tested and developed over its five years of presentation. As such it utilises recognisable elements from previous iterations, layered over with new innovations in 'containerism' to enhance certain elements. The concept of 'layering' also relates to the way that various contributions have each brought a quality to the event, and how a dense programme will be created for this year's presentation, woven through the existing programmes and the fabric of the city. Within the Arcade, architectural interventions will push through (and layer over) the familiar layout. In this way the Arcade will celebrate its five years of development, and the many creative energies and contributions that have shaped it to this day.
> (Sam Trubridge, Curatorial statement for The Performance Arcade 2015: n.pag.)

Texts like Frederic Jameson's (1983) *Postmodernism and Consumer Society*, or Gilles Deleuze and Felix Guattari's (1983) *Anti Oedipus*, both identify the 'schizophrenic' tendencies of capitalism, characterized by 'an experience of isolated, disconnected, discontinuous material signifiers which fail to link up into a coherent sequence' (Jameson 1988: 118). Rather than skipping around concepts, The Performance Arcade resists this trap by developing the event through each iteration: informed by the 2015 thematic of 'layers' that folds each subsequent theme, architecture and strategy into the organism of the event. Thus, in 2017, a collaboration with Massey University on the 'performing, writing' theme has imprinted a literary consciousness within the event – expressed by the annual 'Live Press' publication and subsequent contributions to the event by artists working between performance, literary arts and spoken word. In the same way, architectural strategies, performative marketing, programming solutions, conceptual devices and other features are constantly added to a growing toolbox that adds depth and versatility to an event proceeding in a constant state of disestablishment and restructure. In 2019, one such addition to The Performance Arcade was *Te Rarangi Māwhero* (*The Pink Line*), a 3.5-km long graphic design intervention that stretched from Wellington Railway Station on one side of the city along the waterfront to Carter Fountain in Oriental Bay. As this device weaved its way across the invisible boundaries of old foreshores, seawalls and Māori sites,

it was able to tell these stories of Wellington's history and the precolonial narratives of Te Upoku-o-te-Ika-a-Māui/Te Whanganui-ā-Tara (Wellington Harbour). Along this line, audiences were also directed to the locations of performance works, audio tours, installations and the sixteen-part project *Friction Atlas*, by Italian artists La Jetée. Leading to The Performance Arcade 2019 site, *Te Rarangi Māwhero* extended a state of performance along the entire waterfront by using a 50-cm wide textured vinyl strip that traversed Wellington's public spaces and activities. Joggers fell in line with its direction, children tightrope-walked it and along Oriental Bay Parade drifts of beach sand began to interrupt its clear path. Conceived as a marketing tool, a way finding device and an artistic work in its own right – *Te Rarangi Māwhero* informed the thematic framework for The Performance Arcade 2019 and lingered in various forms throughout the 2020 and 2021 presentations.

Te Rarangi Māwhero also foregrounded the relationship that The Performance Arcade has developed with the Wellington harbourfront environment since its inception. For over 3.5 km, the line traced a liminal boundary between the city and the sea that contained a range of poetic and conceptual references. Located on the margin between these two environments, The Performance Arcade has always addressed relationships between the ever-changing volatile nature of the sea and the structured regimes of the city. Many performances that have been presented embody characteristics of both these conditions, each balancing their own internal precarity with carefully planned and rehearsed systems in a space of high public exposure.

In this context, 'exposure' describes the intense relationship that works have shared with the elements (sun, wind, rain) as much as the state of extreme visibility and availability to the public. States of performance and performativity could even provide a fitting analogy for the play that occurs between city and sea: where structured human systems meet the contingent, dangerous or shape-shifting qualities of a natural world that remains evasive and unfathomable. With the sand, feathers and salt gathering along the pink line, we are reminded of other coastal boundaries and interstices between swell and shore, or audience and performer. The high tide line, that beach-comber's pathway, is a marker of the sea's highest reach and a margin where treasures are found and discoveries are made. Above this line of dried weed, driftwood, shells, plastic rubbish, ambergris and dried seahorses is a space where colonizers plant flags, where real-estate begins and relaxed bodies gather to sunbathe. Below this margin, the foreshore extends through the tides into a space of increasing fluidity and change – to reach far out into the pelagic spaces of the ocean, where coastlines and territories are forgotten. Arranged upon the blurred edges of these urban and oceanic environments, The Performance Arcade 2019 assumed qualities of both: exploring certainties

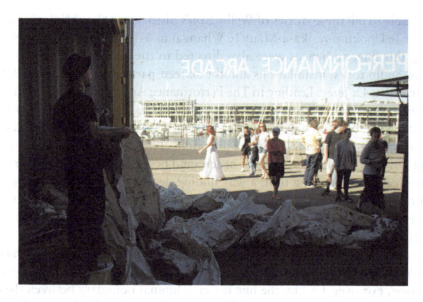

FIGURE 16.4: *A Machine*, by Meg Rollandi, Nick Zwart and Andrew Simpson. Photo by Sam Trubridge.

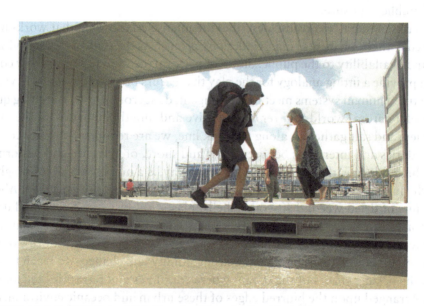

FIGURE 16.5: *Salt Walk*, by Mick Douglas. Photo by Sam Trubridge.

and uncertainties, entertaining possible worlds in a sequence of enclosed boxes, or travelling along a fragile line of vinyl. Those who undertook excursions into the city or out to sea from this space did so with an awareness that they were leaving this threshold environment to fully submerge themselves in either urban or maritime routines.

Celebrating its ten-year anniversary in 2021, The Performance Arcade embarked on a wider project funded by the Wellington City Council's Tipu Toa (City Recovery) Fund. As a response to the economic and social impact of COVID-19, this project re-imagined the event within a broader project titled – *'What if the city was a theatre?'* As a development of *Te Rarangi Māwhero* (*The Pink Line*), this initiative collaborated with numerous creative organizations to transform the urban landscape into a space for performance, imagining a city of live art. Wellington is the right place for this, with its compact centre and collaborative communities working across various sectors to make it a place of dense creative opportunity. There is a concentrated chemistry to a small capital city like this, where artists rub shoulders with politicians, business people, trade people, scientists, students and scholars. In 2011, The Performance Arcade was initiated because Wellington was the right home for this idea – and the community needed new approaches and new spaces for performance. Ten years later, the engagement and interest from artists and institutions around the world highlights the broader value of this project. *What if the city was a theatre?* was an initiative that celebrated this unique event with many of the artists and organizations who have made The Performance Arcade possible over the past ten years, exploring the whole city as a productive environment for performance – with a ballet on electric scooters, theatrical vignettes erupting at pedestrian crossings, musicians serenading the incoming and outgoing ferries, film festivals in carparks, dance performances on busses and cable cars, opera sung from building sites and balconies and projections of mythical creatures onto fountains in the harbour.

Wellington Waterfront inhabits a space where earthworks have 'reclaimed' land for the city, and where the sea bites back with coastal erosion, floods and the threat of immersion through sea-level rise. Cycles of construction and disassembly haunt this space, from the stumps of old wharf pilings, to the rumble of quarried stone being dumped at the edge of Centreport's expanding container yard into the harbour. In this unique environment, The Performance Arcade has been able to emerge as a ground-breaking presentation model, and as an institution balancing in that place where the waves meet the city. However, it is an institution in constant change that has responded to and continues to respond to the neo-capitalist methods of disestablishment and gentrification by resisting conventional architectural and curatorial models for presentation.

With The Performance Arcade, disciplinary structures familiar to public space, public movement and arts presentation are opened up for inquiry by a fluid, shifting framework that reconfigures itself year by year. Over numerous iterations of this 'institution in progress', evolution and revolution emerge as primary patterns, with concepts being tested and recycled in different forms, unbeholden to rigid mandates or architectural limitations. New, emerging and experienced art practitioners are all given a platform in this space – allowing for various pedagogical relationships and networks to form between artists. This retains some character of the university and performance design projects that originally produced this event, but within a wholly different environment informed by fluid, flexible and responsive processes. As a gestating, liquid project in constant reinvention, The Performance Arcade embodies contemporary interests in this mobility and transitional state of operation, drawing on its specific location, oceanic traditions and contemporary events to create affective and politically charged encounters for its public. In this way, The Performance Arcade represents an institution in a constant state of disestablishment, anticipating its imminent closure and reconstruction each year on the water's edge of the Te Moana Nui-a-Kiwa (The Pacific Ocean).

REFERENCES

Astrié, C., Castellucci, R., Kelleher, J. and Ridout, N. (2004), *Idioma Clima Crono*, booklet 1, Modena: Socíetas Raffaello Sanzio.

Benjamin, Walter (1927–40), *The Arcades Project*, Boston: Harvard University Press.

Carpenter, L., Dennison, R., Hammond, I., Kane, A., Kirkup, R., Larsen, R., Morrison, R., Ransley, E., Pierce, R. and Sanderson, J. (2009), *Disestablished*, Unpublished.

City Gallery Wellington (n.d.), 'The persecuted freak and the outraged torch weilding masses', https://citygallery.org.nz/blog/the-persecuted-freak-and-the-outraged-torch-wielding-masses/. Accessed 24 September 2019.

Deleuze, G. and Guattari, F. (1983), *Anti Oedipus*, Minneapolis: University of Minnesota Press.

Doherty, Claire and Cross, David (2009), *One Day Sculpture*, Berlin: Kerber Verlag.

Jameson, Fredric (1988), 'Postmodernism and consumer society', in A. Gray and J. McGuigan (eds), *Studies in Culture: An Introductory Reader*, London: Arnold, pp. 192–205.

Jerram, Sophie (2011), *Eye Contact: New Art Genre*, 8 April, https://eyecontactmagazine.com/2011/04/new-art-genre. Accessed 24 May 2022.

Kershaw, Baz (1999), *The Radical in Performance: Between Brecht and Baudrillard*, London and New York: Routledge.

Leysen, Frie (2015), *Australian Theatre Forum 2015: Embracing the Elusive, or the Necessity of the Superfluous*, 15 January, https://www.australiantheatreforum.com.au/atf-2015/documentation/transcripts/closing-keynote-frie-leysen/. Accessed 24 May 2022.

Lotker, Sodja and Černá, Martina (2011), *Intersections: Intimacy and Spectacle*, Prague: The Arts and Theatre Institute, p. 13.

Meyerhold, Vsevolod (1911), 'The fairground booth', in Edward Braun (ed.), *Meyerhold on Theatre*, London: Bloomsbury Methuen, pp. 145–70.

Mouffe, Chantal (2013), *Agonistics: Thinking The World Politically*, London: Verso Books.

The Performance Arcade (2014), *Manifesto for a Performance Community*, 1 June, http:// www.theperformancearcade.com. Accessed 23 March 2022.

Refiti, Albert (2005), 'Woven flesh', *Interstices: Journal of Architecture and Related Arts*, 1 September pp. 53–60.

Trubridge, Sam (2011), 'Curatorial statement', in The Performance Arcade 2011 programme, n.p.

Trubridge, Sam (2015), 'Curatorial statement', in The Performance Arcade 2015 programme, n.p.

Willis, Emma (2012), 'Enter here: Emergent dramaturgies & the civic role of an arts festival', *Illusions: A New Zealand Magazine of Film, Television and Theatre Criticism*, Spring, pp. 38–44.

17

Reclaiming Subjectivity through Urban Space Intervention: The People's Architecture Helsinki

Maiju Loukola

Urban environments are host to several institutional practices such as political, economic and legal exercises of power, control and security. It is a space that is inhabited by a wide range of actors, as well as rules, structures and practices that govern them. Urban space is not a predetermined order but a relative space–time that evolves and becomes re-structured and created in a polemical relationship between different actors, interests and goals. It is much defined according to what, where and when is legitimate and to whom. Urban space is according to Ari Hirvonen a 'normal space for normal' (Hirvonen 2011: 297) in which specific areas are allocated for consumerism, production, transportation, passage, work or free time. Thus, it is as much an institutionally defined hegemonic space, and as such it is never a neutral one. At the same time, urban space is also an open space of being and of temporary margins – a space of imagination, poetry, lingering and dreaming – a city of potentialities. Whether a city is through and through an administrative space managed by order and security principles, or a lively scene for activities and events for its citizens to claim their right for their city, is a political question (see Lefebvre [1966] 1996; Harvey 2012). By claiming public space for our own use, we challenge its conditions, definitions and uses and keep producing new ones.

Taking as a premise Henri Lefebvre's thematizations of the citizens' 'right to the city' and the 'revolutionary urban tactics' advocated in his writings (Lefebvre [1966] 1996), I look at the role of art's interventional tactics in challenging the so-called normative consumerist-administrative-utilitarian order in urban space. Lefebvre acknowledges urban space not only as a sphere saturated with governance,

industrial processes and capital accumulation, but argues that it is an 'oeuvre of its citizens – a work of art that is constantly being made anew' (Lefebvre [1966] 1996: 117; see also Butler 2007: 214). Linking Lefebvre's premise of the 'right to the city' with interventionist potentials of art and architecture, and Jacques Rancière's line of thought on emancipatory politics focusing especially on his politics of *subjectivation*[1] I ask: What kinds of emancipatory means may open up through scenographic activities, such as spatial interventions in urban space?

Through the lens of recent scenographic thinking where what scenography *does* is highlighted (in contrast to what scenography *is* or *represents*) (see, for example, Hann 2019), I look specifically at a case that I consider to hold emancipatory and inclusive potential by means of interventional spatial practices: a recent public art installation project called *People's Architecture Helsinki*, which took place in the heart of the city of Helsinki in autumn 2017. I see the project both as an intervention that liberated public space from its given purposes and, further, as an emancipatory process of the so called 'non-haves' – in this case a group of asylum seekers, paperless individuals, *sans-papiers* – who responded to the architect's open call and came to participate in the intervention. I consider the *People's Architecture Helsinki* installation as an example of an event and a performative act where the claiming of one's right to the city, staged by citizens and other volunteers, most of whom were a group of asylum seekers, becomes concretized.

People's Architecture was a design project initiated by the Taiwanese architect Hsieh Ying-Chun.[2] The shelter project was part of the Helsinki Design Week (HDW) city installations programme. Even though the project was commissioned by an institutional operator such as the HDW, I see it as an intriguing example of bringing together parties who operate in different fields – in this case, arts, architecture and social activism. A specific participatory potential is inherent to this project, in a way that leaves undefined who eventually may or is to participate in the process – thus it remains an open and democratic process.

Hsieh has conducted several post-disaster reconstructions in Taiwan, China and Southeast Asia in the past nearly twenty years. He facilitates projects for minorities and disadvantaged members of society, often times realized collectively with the local communities. Facing difficult social, geographic or climatic conditions of each project, Hsieh has initiated three key principles for commencing his work: collaboration, adoptability and affordability in terms of technology, and each project aims to remain an open system. It is said that 'more than an architect, he is an architectural activist who takes social, cultural and economic limitations and ecological concerns into account to create works that embody the ideals of "sustainable construction"' (Anonymous n.d.: n.pag.).

The Helsinki project involved installing a transitory dwelling in Helsinki city centre. Hsieh launched an open invitation for citizens to join and share the collective

responsibility of building a temporary shelter. Over 30 asylum seekers responded to the call. Over the course of ten days, the temporary shelter was installed on Three Blacksmiths Square, one of the most centrally located sites in the city. Adjacent to the square lie the classiest department stores in the city, surrounded by the most elegant book stores and fashion boutiques. The site is a perfect example of a socio-economically coherent, gentrified downtown location designed to be attractive for middle class tax payers and tourists. As such, it is also an exclusionary space to the marginalized urbanites such as the homeless, the paperless and the asylum seekers (Galanakis 2008: 243).

Societal backdrop

To outline the societal backdrop of the moment of Hsieh's project taking place in Helsinki, I briefly elaborate on the political tensions that had come to fill the public debate and media space in Finland around that particular time. In 2015, a record number of asylum seekers had arrived in Finland as a result of the 'refugee crisis'.[3] For a country used to receiving only about a thousand refugees yearly, it was an overwhelming number and it caused a sudden and aggressive rise of far-right nationalism. As the political climate in the country had suddenly turned into a scene reminiscent of the 1930s Europe, I cannot but help looking at the *People's Architecture Helsinki* also as a sensitively designed gesture of humanitarian activism. The project manifests a simultaneous empathy and empowerment, performed in a landscape contaminated by a at-that-time particularly harsh, hard-white xenophobic atmosphere.

Many of the asylum seekers, who responded to the architect's invitation, had at that point another ongoing project in their own name elsewhere in the city centre – namely, the *Right To Live* standing demonstration. This long-term event, led by the asylum seekers, stood for the call for more just legal refugee policies than were executed by the Finnish Immigration Services, which at that time was operating out of a right-wing government. What the asylum seekers urged for were nothing more than human rights policies that would far better respect the international agreements that Finland is (and was) committed to.[4] The *Right To Live* demonstration brought together a large community of supporting citizens, allies and open-border activists. This one-year-long human rights public space stage was run and operated by the asylum seekers themselves. Their actions and activism resonates, for me, with Rancière's ideas of equality at work. At the very core of Rancière's elaboration of the concept of equality lies the question concerning subjectivation, of becoming a collective subject of one's equality amongst all others and thus refusing any straight-forward categories or identifications as the 'excluded' or 'other'.[5]

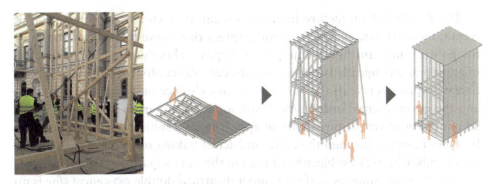

FIGURES 17.1 AND 17.2: *People's Architecture* Helsinki in-process. Courtesy of People's Architecture HDW 2017 / Architecture for People.

People's Architecture *as a scenographic intervention and an emancipatory project*

I look at the case of the *People's Architecture* from two perspectives: as a scenographic and artistic intervention taking place in a gentrified public scene Three Blacksmiths Square at the very centre of Helsinki, and as a process of what we may call, in the light of Rancière's emancipatory ideas, equality at work (see, for example, Rancière 2014: 3–5, 80–81).

Looking at the *People's Architecture* as an intervention from a specifically scenographic perspective, I ask: How can scenographic practice challenge the habitual use of urban space? Today's conceptions of the expanded scenographic practices stress scenography as an agency of active (and activating) spatial dramaturgy, which – in a parallel manner as in the discourse of arts in a more general sense – has activated the role of the spectator in a profound manner (see, for example, McKinney and Palmer 2017). Performance and performance space is ever more strongly understood as an eventful space and as a space of transformation, whereas the traditional conventions of scenography formulated scenography (and the task of the scenographer as a maker of) a visual, conceptual and spatial interpretation-tool of a dramaturgical text (see for example Hannah 2019; Loukola 2014). Contemporary scenographic practices have been articulated in terms of situation, transformative experience and action, and they are no longer aimed towards representative constellations of physical objects and metaphorical images. In her recent book, *Beyond Scenography*, Rachel Hann (2019) emphasizes the question of 'what scenography *does*' over the question of what it *is*. This, in its appearance small, yet quite significant change of perspective, describes clearly the shift in scenographic practices from interpretive and pictorial, to active and eventful.

The *People's Architecture* intervention can be seen as a manifestation of certain inclusive (vs. exclusive) scenographics that make the subjectivation of the political migrant figure emerge and appear. This does not mean that the migrant figure magically turns into a political subject alone. Rather the subjectivization process reveals the paradoxical co-existence of both the institutional and the governmental order (s/he *is* still a paperless person in the eyes of the administration) yet the possibility of appearing as a subject of one's own cause becomes manifest through the event and act of 'taking one's matter in to one's own hands' (the *act* of subjectification). On this emancipatory setting, the existence of the *sans-papier* is as if split into a theatrical double existence: s/he is no longer merely the excluded, passive figure with no say on the society, a *have-not*, but, through the act of participating in the intervention s/he at the same time actively plays a leading role through making visible the spatial, social and political transformation from migrant figure into a citizen of this city, in this particular place and event.

From the point of view of an urban intervention, the project poses a question about to whom the city belongs. Similarly, the *People's Architecture* challenged the prevailing conditions and social structures of the site of its erection, the Three Blacksmiths Square (Jensen et al. 2018: 127). In arts, interventions are site and time-specific actions that typically break the traditional expectations of presenting or performing art. An intervention may challenge the notion of spectatorship 'by injecting something new and surprising into the familiar and existing' (Jensen et al. 2018: 11–12).

Rooted within several moments in the history of arts, such as Dadaism, Surrealism and the Situationist movement, interventions question both the institutionalized and everyday life that shape our lived experience in a capitalist society. Place, as a concept and as a concrete physical space, has a central role in any intervention. Silvia Jestrovic calls this an *inter-performativity of place*, and notes that many public urban spaces can be associated with collective memory (Jestrovic 2013: 40; see also Jensen et al. 2018: 15). As such, interventions have a potential to challenge and alter these experiential expectations as well as to create a collective and participatory performance.

Furthermore, since public space interventions are not always realized inside (art) institutions, they are practices that can come to critique the institutional practices from yet another angle. In this sense, artistic interventions can be seen as part of the *post-studio* practices in arts such as socially engaged performances, and other collaborative and participatory practices. Claire Bishop calls these kinds of interventional tactics 'modes of action in which engagement is part of a politicised method' often with a focus on the creation of situations that have references to wider societal and political contexts (Bishop 2012: 1–2).

Second, following the Rancièrean line of thought, I argue that on both of the urban stages presented in this chapter – the *People's Architecture* intervention and the *Right to Live* demonstration – the production of hegemonic space is challenged as both projects are re-constituting these sites as stages for political acts and of subjectivization. As Rancière suggests, there is porousness in the line between 'us' and 'others' which can be dissolved through the creation of dissensual space – a shared space of disagreement where different 'normalcies' may come into encountering without the necessity of reaching a consensus (Rancière 2014: 2–5, 42, 71–72, 143–144; see also Mouffe 2013, 2005).

Further, for Rancière, the process of subjectivation is an enactment of (an already existing) equality by people who form a collective, a togetherness, to the extent that they are in an in-between position in society (Rancière 1992: 63; see also Rancière 1999: 15, 34–35). What is *not* at stake in this process, is the becoming of a (singular) *self* but rather, a moving from the position of an outsider to that of an in-between – of humanity and inhumanity, or of citizenship and its denial, of the status of a man of tools and the status of a speaking and thinking being.[6] In everyday language, this might be rephrased in terms of taking action into one's own hands and a refusal of straightforward categorizations such as 'them' (vs. 'us'), the 'excluded' or the 'other'. The *People's Architecture* intervention tackles the notion of citizenship – via the participation of the *sans-papiers* – and makes migration a public concern and visible as a political, humanitarian and cultural issue that cannot be excluded from the sight of the society.

Scenes of equality

Both the visible and manifest, but also the underlying yet powerful connotations and dimensions in the practices of space played a significant role in the process of entering the sphere of political subjectivation, in the process-of-becoming a political subject through the architectural intervention realized in the Three Blacksmiths Square. The process of subjectivation is by no means a straightforward one; it always denies any given identity as it is profoundly a heterological, plural – or as one could say, collective – process. 'It is the formation of a one that is not a self but is the *relation of a self to an other*' (Rancière 1992: 60).

How, then, did the *People's Architecture* enable or enhance an emancipatory process in the Three Blacksmiths Square? As a political performance and as an interventional process that temporarily rewrote the Three Blacksmiths Square anew, the intervention can be seen as one particular molecule of many in a larger

emancipatory process. The emancipatory potential of the *People's Architecture* project became manifest as a *political* event of subjectivization for all those who were involved in the intervention as participants, artists, pass-byers and spectators. It showed how an event of architectural activism can open up a scene for activating and demonstrating equality at work. The group of some thirty people, most of them asylum seekers, collectively framed a space of their own, by and for themselves but also for any one citizen who wished to enter that shared space. Through this particular event, the process of equality for all became in my analysis validated.

Urban space is saturated with various material means defining its formation and means of use through a number of administrative institutional practices and regulation, which also include a variety of 'soft' legal instruments and practices. Art, but also urban law manifests itself in material dimensions – in architecture, walls, squares and thoroughfares. In the case of *People's Architecture*, one comes to also acknowledge the materiality and embodiment that plays an important experiential role in urban place-making.[7] The temporary shelter was built of easily accessible, affordable wooden bars and plywood. The structure was simple and minimalistic and designed so that the shelter was open and accessible from all sides. Podestas and other seating places around the construction were designed to invite bypassers to get closer and get in contact and talk to the other people hanging around the shelter. For someone like me, who is not in need for a roof above your head or for a shelter reminiscent of a 'home', the experience served as a vehicle, as a way of making homelessness more concrete and embodied than when reading about it in the newspaper.

The *People's Architecture*, seen from the viewpoint of an interventional scenographic operation and as such a performative event, constructed as a polemical space by transforming a designated public square into a shared space of dissensus. As a temporary shelter, the spatial framing that resulted from the *People's Architecture* project was performed as an intervention with the normative institutional order of the city. Following Rancière's vocabulary: it reconfigured – or better yet: materialized – the existing *distribution of the sensible* in the urban space.[8] In this way, the scenographic event formulated a new gesture that is inherently political.

Claiming the institutional urban space for everybody

Cities have the capability of providing something for everybody, only because, and only when, they are created by everybody.

(Jacobs 1961: 238)

Without a more specified definition of *who* we are addressing as possessors of their right to the city – this *right* in itself is hardly more than an empty signifier, for it all depends on who is (the subject of) claiming this right. In light of the *People's Architecture* project, it becomes clear that is a different story for a regular city dweller than it is for a *sans-papier*. Furthermore, when one is concerned with marginalized neighbourhoods and those who have no part in the urban space, one must be careful not to repeat the inequalities of the urban space by treating those people as incapable to act in their own name and by themselves. The purpose of any 'emancipatory project' ought not to be to *donate* voice, rights, spaces, places or art to 'them' but to see those who do not have a voice in the society as capable to act and create by themselves in the name of the wrong done to them by the legal, social, political and economic order. An emancipatory project such as the *People's Architecture Helsinki* reached out to make the urgency of human rights visible, by designating free public space and guaranteeing public access for every citizen. By doing so, it opened up a potential scene of equality in the urban space. While in the city, an institutional order is established and inequalities are created, at the same time, opportunities for emancipation and democratization are opened up. As a network of subjects, places, events, emergences and imagination, urban space channels the needs, interests, desires and estuaries of all its users. But before everything else, the city is and needs to be created by *everybody*.

ACKNOWLEDGMENT
The chapter is dedicated to the memory of Ari Hirvonen (1960–2021).

NOTES
1. A note related to the varying translations of the term: Rancière himself uses in French the form *subjectivation*, but in the English translations the spectre varies. You can find at least these forms: *subjectivation* (which I use in this chapter, as it seems to refer to the process of *becoming-of-political-subject* in the least non-ambiguous way), *subjectivication*, *subjectifization* and *subjectivization*.
2. https://universes.art/en/venice-biennale/2009/tour/taiwan/04-hsieh-ying-chun/. Accessed 22 February 2022.
3. A total of 32,476 people according to the statistics from the Ministry of the Interior Finland Migration site: https://intermin.fi/en/areas-of-expertise/migration/refugees-and-asylum-seekers. Accessed 22 February 2022.
4. Finland is committed, by international agreements, to providing protection to those in need. The basis of this is the 1951 Geneva Refugee Convention and other international human

rights treaties and EU legislation. See the Ministry of the Interior Finland Migration site: https://intermin.fi/en/areas-of-expertise/migration/refugees-and-asylum-seekers. Accessed 22 February 2022.

5. Rancière writes:

> The logic of (political) subjectivization [...] is a heterology, a logic of the other [...] It is never the simple assertion of an identity; it is always, at the same time, the denial of an identity given by an other [...]. [...] it is a demonstration [...] and a staging of a common place that is not a place for a dialogue' for, according to Rancière 'there is no consensus, no settlement of a wrong.
>
> [...]
>
> The logic of political subjectivization, of emancipation, is a heterology, a logic of the other, for three main reasons. First, it is never the simple assertion of an identity; it is always, at the same time, the denial of an identity given by an other [...]. Second, it is a demonstration, and a demonstration always supposes an other, even if that other refuses evidence or argument. It is the staging of a common place that is not a place for dialogue or a search for a consensus [...]. There is no consensus, no undamaged communication, no settlement of the wrong. But there is a polemical commonplace for the handling of a wrong and the demonstration of equality. Third, the logic of subjectivization always entails an impossible identification.
>
> (Rancière 1992: 62)

6. The term 'place-making' has been actively used by urban planners and activists since the 1990s, yet the thinking behind *place-making* is influenced by trailblazers of urban planning development such as Jane Jacobs already from the 1960s on. Jacobs was one of the first ones to advocate the idea of cities for people, not for just cars and consumption.

7. Rancière defines 'police' as an organizational system that 'establishes the distribution of the sensible' as a law that separates communities and people into groups, social positions and functions; 'police' thus aims at maintaining a hierarchical order through an administrative power that categorizes communities and people into those who have, belong and are heard in the frame of the *police* order – and, vice versa, into those who have not, and are not heard. 'Politics' breaks or interrupts this normative order, yet it never aims into a consensus but rather into making way for a shared space where within any community it is more than welcome to disagree – and not fall into a consensus that evaporates all sensibilities and differences. Chantal Mouffe speaks, in terms of agonism, of the importance of maintaining a shared space where different parties can collaborate, in disagreement, non-consensually – as 'adversaries', not as 'enemies' (see Rancière 2014, 1999, 1992; Mouffe 2013, 2007, 2005).

REFERENCES

Anonymous (n.d.), 'Hsieh Ying-Chun', https://universes.art/en/venice-biennale/2009/tour/taiwan/04-hsieh-ying-chun/. Accessed 22 February 2022.

Bishop, Claie (2012), *Artificial Hells: Participatory Art and the Politics of Spectatorship*, London and New York: Verso.

Galanakis, Michail (2008), *Space Unjust: Socio-Spatial Discrimination in Urban Public Spaces: Cases from Helsinki and Athens*, University of Art and Design Helsinki A82 series, Helsinki: University of Art and Design [today Aalto University School of Arts, Design and Architecture].

Hann, Rachel (2019), *Beyond Scenography*, Oxon, Abingdon and New York: Routledge.

Hannah, Dorita (2019), *Event-Space: Theatre Architecture and the Historical Avant-Garde*, Abingdon/Oxon and New York: Routledge.

Harvey, David (2012), *Rebel Cities: From the Right to the City to the Urban Revolution*, London and New York: Verso Books.

Hirvonen, Ari (2011), 'Kiistojen kaupunki sääntöjen, hallinnon ja vastarinnan tilana' ('City of disagreement as a space of regulations, governance, and resistance'), *Oikeus (Justice) Journal*, 40:3, pp. 293–312.

Jacobs, Jane ([1961] 1992), *The Death and Life of Great American Cities*, New York: Random House.

Jensen, Anna, Rajanti, Taina and Ziegler, Denise (2018), *Intervention to Urban Space: Experimental Intervention as a Tool for Artistic Research and Education*, Helsinki: Aalto ARTS Books.

Lefebvre, Henri (1996), *The Right to the City, Writings on Cities*, Oxford: Blackwell [Original: *La droit à la ville*, 1966.].

Loukola, Maiju (2014), *Vähän Väliä. Näyttämön mediaalisuus ja kosketuksen arkkitehtuuri (Anywhere Near: Mediality of Stage and the Architecture of Touch)*, Helsinki: Aalto University Dissertation Series.

McKinney, Joslin and Palmer, Scott (eds) (2017), *Scenography Expanded: An Introduction to Contemporary Performance Design*, London and New York: Bloomsbury Methuen Drama.

Ministry of the Interior Finland (n.d.), 'Refugees flee persecution in their home countries', https://intermin.fi/en/areas-of-expertise/migration/refugees-and-asylum-seekers. Accessed 16 November 2019.

Rancière, Jacques (1992), 'Politics, identification, and subjectivization', *The Identity in Question*, 6, pp. 58–64.

Rancière, Jacques (1999), *Disagreement: Politics and Philosophy* (trans. Julie Rose), London and Minnesota: The University of Minnesota Press [Original: *La Mésentente. Politique et philosophie*, 1992.].

Rancière, Jacques (2014), *Dissensus – On Politics and Aesthetics* (trans. Steven Corcoran), London and New York: Bloomsbury Academic.

18

Public-Making as a Strategy for Spatial Justice

Kenneth Bailey and Lori Lobenstine,

Design Studio for Social Intervention

On 8 August 2019, in Times Square, motorcycles backfiring triggered a panic, with people running in all directions from what they apparently thought were gunshots. Later police confirmed that there was no active shooter involved. This scene was just two days after the back-to-back mass shootings in El Paso and Dayton.

The producing of terror is a production of atmosphere. It remains between us and inhabits space. Terror is meant to have social and spatial effects, to make social life feel a certain way, to affect society and space. The spaces we inhabit and the atmosphere we create are affected by its political atmosphere. Mass shootings are extreme examples of atmospheric politics, contestation and power. These contestations happen in smaller ways every day, when multiple forms of social life butt heads over things like who gets to be, thrive and express themselves in the public realm, who gets to perform the ownership of public space and public life, what sounds are condemned and what sounds are condoned, whose public presence is policed and whose is celebrated, whose is represented and whose is erased.

When we wrote our Spatial Justice paper in 2012, we broke down spatial justice into our rights to be, thrive, express and connect in and through space. Those rights are more vulnerable now than ever, whether it's the spiralling rise of white supremacist violence, the tearing apart and caging of immigrant and refugee families at our border, the increase in surveillance and spatial control tactics, the displacement caused by gentrification in our cities, or the fascist actions, policy and rhetoric coming from the White House. What's at stake is literally our rights to be, thrive, express and connect at every level.

What happens when most or all of what we experience is the experience of injustice? What happens if we succumb to the atmospheres of despair, anxiety, isolation and fear with no atmospheric balance or counterpart?

Current spaces and atmospheres

Most of the patterns of interaction available to us once we cross the threshold of the home into the broader public (particularly in the United States) are ones of one way exchange, using money to buy a thing, an experience, food or the like. And those experiences have social or cultural edges on them that discourage extended exchange across that pattern: the vertical exchange of money for things is structured, and the horizontal exchange between consumers or between consumers and vendors is to a large extent taboo. If you buy a meal, you might acknowledge the people next to you buying a meal as well, but it would be culturally transgressive to assume you and that other table are sharing what you buy, or that you'd invite a stranger into the said place to also partake of your food and other people's food. Our tacit interaction patterns don't allow for that. The outcome of these interactions is that being in public doesn't ease any sense of loneliness, fear or fracture; in fact, it's just as likely to increase it.

Relational aesthetics and spatial justice in the public realm

We leave too much of our social lives up to the market sectors – mainly the malls, restaurants, shops and movies that shape the qualities and contours of our daily exchanges. The logics of the market sector can't account for the robustness of our lives, nor will they be accountable to our demands to be, thrive, express and connect.

Even for those of us who are activists – spending much of our time fighting the status quo – it is hard to avoid the pervasive corporate aesthetic and capitalist opportunities that shape our social lives. We fall into them in many quotidian ways: looking in the windows of stores, wearing sports paraphernalia, going to the movies, etc. These are the social affordances and cues we *always already have* at our disposal. These kinds of affordances and spaces take up so much of our local landscapes that it's hard to imagine otherwise. And those opportunities for interaction simply aren't enough. Currently, even if we are looking to intentionally counter these kinds of interactions, it's up to us as individuals – perhaps with our family, friends and loved ones as a unit – to go out, to escape that set of commercial interactions for something out there, like the beach, hiking or the like. However, in

this set up, the same contours of interaction remain. There's a tacit private bubble around you and yours, them and theirs. The private bubble is further amplified with the addition of the device in the public realm. Whether it's all of our heads down while we walk about our neighbourhoods or the dance parties where everyone is dancing together to their own music, the device produces a space of many I's instead of an us or a we. We experience proximity without togetherness.

We believe the current overall production of public culture (and its correlated production of public loneliness, isolation and fracture) is something that we can and should take on. We believe that it is an urgent matter of spatial justice. We believe activists, artists and regular folk should feel themselves entitled to creating a more truly public social life, one in which people from all backgrounds and ways of life can interact, belong and express themselves. To us this means we need to imagine and test other arrangements and affordances of sociability, including more opportunities for interaction patterns that are free and that purposefully break the tacit cultural barrier between me and you, ours and theirs.

Public-making, sociability and spatial justice

We situate what we call public-making – the collective creation and activation of public spaces for interaction and belonging – as a way to organize and take on new forms of sociability. This is not to say that all public-making is radical or transformative. Indeed, the market sector engages in its own forms of public-making. They make places to drink and socialize, for example, like the current trend of outdoor beer gardens, complete with 'cornhole' games or adult swings. However, these spaces look public yet are extensions of business, corporation and their logics of market exchange.

How might we move beyond this kind of established, rehearsed relating in space to still less explored spatial and relational imaginaries? What would happen if people had places that connected public space and public discourse, outdoor play and collective healing, pop-up performances and shared food, movie nights and performance art? What if we used public space for the collective creation of opportunities for interaction, laughter, dialogue, learning and surprise? We imagine the possibilities for multi-textured and joyous counter-atmospheres that challenge this moment of increased isolation, tension and repression. We believe public-making – especially by those who regularly experience spatial injustice – is both radical and transformative. Our informal 'Public Making Manifesto' goes like this:

We are the public.
We belong in public space.

We can create our own public life.
Public-making can change the future.

Specific ways of exploring public-making

We'd like to propose some areas of investigation for those of us concerned with spatial justice, public culture, urban and placed experience and the aesthetics of social life.

1. *More public discourse in space*
How might we explore the production of public discourse in space? When and where can we talk about things and practice learning how to engage with people we haven't met? These kinds of practices are a major part of civic engagement, but those opportunities aren't often situated in the public in such a way that they are permeable. And when events that have a focus on discussion happen in public places like libraries, they are often only attended by those already on some list to find out about them. In that sense they are only permeable for a pretty limited public, one that is seeking that kind of space.

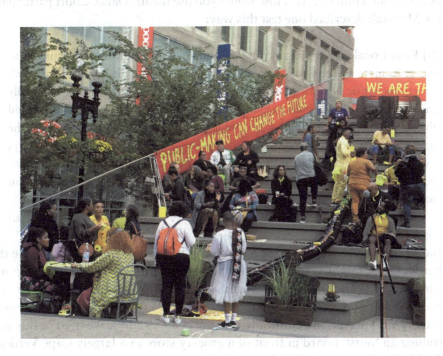

FIGURE 18.1: Participants at DS4SI's in PUBLIC Festival, 2019. Courtesy of Lori Lobenstine.

Perhaps public-making that lends itself to more low-threshold dialogue and conversation with strangers would be a draw for people that haven't identified themselves as such. If we built it, who would come? We want informal, public community conversation and sense-making; we imagine things like Claudio Prado's whimsical 'Rua Augusta' project in Sao Paolo, where he'd bring his living room furniture out to the street every Saturday night to make his community's own version of *Saturday Night Live* – complete with audience participation, star cameos, humour and information sharing.

2. *More opportunities to dance, sing and play together*
Most of the dancing we see in the streets in the US context tends to be street performers with routines they run in touristy areas for tips, along with the occasional one-off more produced event. The most inviting 'jump in and join us' experiences tend to be limited to annual celebrations like Carnival, Caribbean Festival and Gay Pride events. How might we explore and create different spaces and increased opportunities for collective participation in singing, dancing, acting and playing?

One intervention we created and tested was Dance Court, where we posed the question: 'What if Dance Courts were part of the ubiquitous landscape, like basketball and tennis courts? How would you use them?' Dance Court participant Terry Marshall described one test this way:

> DJ Keith Donaldson starting playing old soul and house music and feet began to move. As more Dance Court participants showed up and filled up the [basketball court], the music became more intense [...] that energy cast a net that eventually caught up some of the regulars around the park. Many of the folk who hang around the park in the daytime can be seen drinking their days away. They are usually the ones who society casts off as hopeless. But on this day they were *dancing* their days away. They brought some of the most intense dancing. Dance Court seemed to become this safe space in the park. The social aspect of the music and dancing seem to create a different environment.
>
> (DS4SI 2012: n.pag.)

Dancing is just one way to join each other in joy and movement. What are the other ways we might want to prototype opportunities for collective singing, drumming, playing and healing together? We don't mean the sanitized and 'upscale' adult playgrounds such as Boston's 'Lawn on D', but ones that might feel more site specific and culturally relevant. One example we tried of this was installing an 'ouril' board in front of a grocery store in a largely Cape Verdean neighbourhood.

PUBLIC-MAKING AS A STRATEGY FOR SPATIAL JUSTICE

FIGURE 18.2: Cape Verdean gypsy cab drivers playing ouril while awaiting customers. Courtesy of Max MacCarthy.

3. *More opportunities to make and learn*
What other play affordances might appeal to adults or to families? How can play mix up the delineations between mine and yours, ours and theirs? When do we get to make things together in public? And what would we make? There's fabulous float-making culture related to Carnival, but that is still fairly enclosed. There is sand-castle making culture at beaches, but that is also enclosed, usually by family. We explored using co-creation as a tool for both co-imagining a space and exploring collective authority over micro-spaces in a community that felt little authority to be, let alone to express themselves in public. With our 'Street Lab: Upham's' event, we invited residents to choose small public spaces and re-imagine

PERFORMING INSTITUTIONS

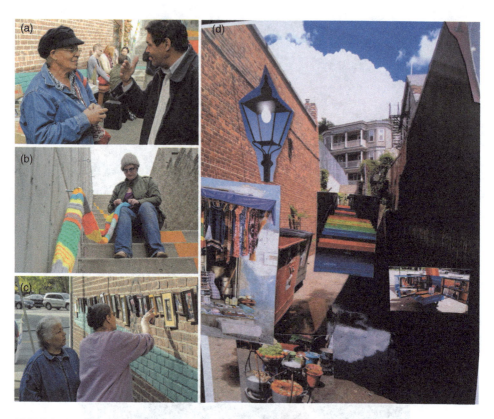

FIGURE 18.3: (a) Participants deep in conversation at DS4SI's Street Lab: Upham's event. Courtesy of Rafael Feliciano-Cumbas. (b) Street Lab: Upham's knitter working on the knit handrailing. Courtesy of Rafael Feliciano-Cumbas. (c) Residents check out Street Lab: Upham's temporary art gallery. Courtesy of Rafael Feliciano-Cumbas. (d) Magnet boards helped community members imagine what they'd like to see in the alley. Courtesy of Lori Lobenstine.

them together. Here's an alley that they turned into a temporary art gallery and a hand-knitted railing they made to show the city that a real railing was needed.

But making can look all kinds of ways – from collective cooking to learning how to do T-shirt printing, carpentry and construction, bike-fixing, button-making and more. Making events could build a collective form of expression, like a mosaic or barn-raising, or perhaps the shared nature of the event is more in the multi-directional flow of knowledge.

What about creating other porous opportunities to learn and share knowledge? The internet has largely turned into an echo chamber, so views and new information are narrowly shared amongst circles of users. Could we use physical opportunities in space and time to better democratize the kinds of insights that

one might come across? How could we democratize information, whether it's health insights like healing uses of honey, knowledge about products or practices that are earth friendly, or new ways to engage in our state's budgeting or policy-making? What new conversations and friendships might arise over a found passion for cooking with purple peas or debating the latest pop craze? How might more porous opportunities to find out about things you never thought about create or produce a public?

These are just a few examples of what public-making might include. There are many others already out there, and many still to be imagined. As we consider public-making as a strategy for spatial justice, it's important to not just have a diversity of content but a diversity of scale. To us, there's no such thing as 'too much' public-making. If our next Public Kitchen bumps up against someone else's collective reading event, which is down the street from a block party, that's across from a mobile pottery kiln next to the neighbourhood skate park, we are creating not just individual spaces of belonging and connection but a whole web of it. Similarly, if one event is a one-off, while one happens monthly and one happens every day or night, we have another type of web of duration and frequency. We believe that the more instances of public-making that folks bump into, the more they will also feel the authority and inspiration to create their own.

Public-making can change the future

What can the production of counter atmospheres through public-making do to public culture and spatial justice? We'd argue that public-making from a place of self-determination and spatial justice can create spaces of connection, belonging and joy for people who are made to feel fearful or alienated by spatial inequities and spatial domination. We'd argue that these kinds of enactments charge social space with another kind of world, one with compelling and attractive intensities and qualities of life. And when the switch from feeling alienated to feeling connected happens, it does many things to those experiencing it. One way to cut it is to say it can feel like collective healing. When the world seems set on being a certain way that leaves you out of it, it's easy to forget the possibility of another world. The brief experience of alterity reorients, it reassures and encourages those attracted to it to fight for it, to make it so. In this sense, public-making is where the political, aesthetic and social making of our future all meet. Done well, it can foreground the immediacy – and frankly the urgency – of what being in a sample of the desired world does for our ability and hope to create and sustain that world. It can create an embodied experience that helps us see (and feel, hear and sense) what is possible. Public-making can create temporary spaces of being, thriving,

expressing and connecting that mobilize our imaginations towards greater instantiations of spatial justice.

> We are the public.
> We belong in public space.
> We can create our own public life.
> Public-making can change the future.

REFERENCE

DS4SI (2012), 'From the archives - Terry Marshall on dance court', https://www.ds4si.org/blog/2012/11/28/from-the-archives-terry-marshall-on-dance-court.html. Accessed 7 September 2022.

Contributors

KENNETH BAILEY is the co-founder of the Design Studio for Social Intervention. His interests focus on the research and development of design tools for marginalized communities to address complex social issues. With over three decades of experience in community practice, Bailey brings a unique perspective on the ethics of design in relation to community engagement, the arts and cultural action. Projects he has produced at DS4SI include Action Lab (2012–14), Public Kitchen (2011–18), Social Emergency Response Center (SERC, 2017), People's Redevelopment Authority (2018) and in PUBLIC (2019). Bailey was recently a visiting scholar in collaboration with the University of Tasmania and also a founding member of Theatrum Mundi NYC with Richard Sennett. He is currently pursuing his MFA at Bennington College. His new book (co-authored with DS4SI) is entitled *Ideas—Arrangements—Effects: Systems Design and Social Justice* (Minor Compositions, 2020).

SYLVAN BAKER, FRSA, is a senior lecturer in Community Performance Applied Theatre at Royal Central School of Speech and Drama. He is a researcher and practitioner with over 30 years' experience working with creative arts practices. He has worked in Northern Ireland as an artistic director of the largest cross-community youth arts project in the province and has been working since 2006 with the internationally acclaimed favela-based social project Afroreggae. He is the former associate director of People's Palace Projects and an artistic research fellow in the Drama Department of QMUL. His current research interests apart from TVF include practice research analysis of academics of colour in Higher Education.

ANTON BELOV is the director of Garage Museum of Contemporary Art in Moscow, since 2010. He is a graduate of the Moscow Institute of Steel and Alloys, with

a degree in the physics and chemistry of processes and materials. Prior to his appointment at Garage, Anton ran the non-profit project Gallery White in Moscow, which he founded, working with young artists to develop new works. In 2009, Anton launched the bilingual magazine and online resource *Artguide*, which covers events in the field of contemporary art. It is now the leading magazine of its kind. He was a member of the Public Council of the Russian Ministry of Culture from 2012 to 2013. Since 2018, he has been the Head of Garage Museum of Contemporary Art's joint department at the Higher School of Economics in Moscow.

FRANZISKA BORK PETERSEN is formerly an assistant professor in Performance Design at the Department of Communication and Arts, Roskilde University. She holds a Ph.D. in Theatre Studies from Stockholm University and Freie Universität Berlin. Her work on fashion, performance, choreography and body modification has appeared in Performance Research and *Nordic Theatre Studies*. Franziska is currently completing a book about how notions of the body and utopianism relate.

FABRIZIO CRISAFULLI is a theatre director and visual artist. He runs the theatre company Il Pudore Bene in Vista based in Rome, which he established in 1991. Fabrizio's production work includes space and lighting design, and he also creates installations in addition to the company's activities. He works in Italy and various European and non-European countries. The defining aspects of his work are his use of light as an independent subject of poetic construction, and what he defines as the Theatre of Places (treating the place as 'text' and a matrix for performances), involving research along with stage production. He teaches at RomaTre University. In 2015, the Roskilde University (Denmark) conferred upon him the Doctorate Degree Honoris Causa in Performance Design. In 2016, in Italy, he received the Critics Award from the National Association of Theatre Critics. Among his publications translated into English: *Active light. Issues of Light in Contemporary Theatre* (Artdigiland, 2015).

SADHVI DAR is a reader in Interdisciplinary Management and Organization Studies at Queen Mary University of London. Her research focuses on processes of knowledge production and knowledge-making movements in institutional

organizations and spaces. Sadhvi was a co-investigator of the AHRC funded project, The Verbatim Formula (2017–20) which centred the experiences of care-experienced young people.

MICHAEL HALDRUP is a professor at Performance Design, Roskilde University. His work centres on performance, design and ontologies relating to the role of materiality and practice-based, embodied knowledge. In 2013, he was part of establishing FabLab RUC as an open facility for design and technology experiments and explorations and subsequently parts of his research has been about – and with – people and practitioners from the maker/fablab milieux. Current interests are speculative ontologies and utopian theory in relation to experimental and explorative approaches to research, design, teaching and activism. His recent publications include *Experimental Museology: Institutions, Representations, Users* (Routledge, 2021).

MARK HARVEY is a Pākehā/Māori Aotearoa/New Zealand artist working in visual arts-based performance art and video, with notions of productive idiocy, endurance, duration, social psychology, social justice, politics, climate change, ecology and social ecology. He has presented in a range of international contexts, such as the 55th Biennale for Visual Arts (2013), the NZ International Festival of the Arts/City Gallery (2012), New Performance Turku Festival (2014), Te Tuhi Gallery (Auckland, 2016), Trondheim Kunstmuseum (2012), Hitparaden (Live Art DK, Copenhagen, 2014) and Anna Leon Owens Gallery (Halifax, 2018). With a Ph.D. (AUT), he lectures at The University of Auckland.

LIISA IKONEN is a professor in Design for the Performing Arts at University of the Arts Helsinki, Theatre Academy. She has held the professorship previously at Aalto University Espoo, in School of Arts, Design and Architecture, Department of Film, TV and Scenographer (2014–21). She has served as a director of the Master Programme in Design for Theatre, Film and Television, a head of the Expanded Scenography Research Group and a principal investigator in the research project Floating Peripheries – Mediating the sense of Place at Aalto University. She holds a Doctor of Arts Degree from Aalto University Helsinki (2006) and her postdoctoral research has focused mainly on scenographer's alternative work processes

and applied forms of scenography. Liisa Ikonen has a 30-year background as a set and costume designer in both institutional and experimental fields of theatre and performing arts in Finland.

* * * * *

MAGGIE INCHLEY is a senior lecturer in Drama, Theatre and Performance at Queen Mary University of London with a background in teaching and directing. She is interested in political and cultural audibility and the intersectional aspects of vocal performance. Her publications include *Voice and New Writing 1997–2007* (Palgrave, 2015) and 'Touring testimonies: Rebalancing the public realm through human rights activism in *Asylum Monologues* and *Seven*', *Lateral: Journal of the Cultural Studies Association*, 5:2 (2016). Maggie is the principal investigator of the collaborative practice-based research project, The Verbatim Formula with care experienced young people.

* * * * *

KATYA INOZEMSTEVA is the chief curator at Garage Museum of Contemporary Art, Moscow. She holds a Candidate of Science degree in Philology from Moscow State University (2007). Prior to joining Garage in 2014, she was the chief curator at Multimedia Art Museum, Moscow (2011–14) and worked at Proun Gallery, Moscow (2006–11), Gary Tatintsian Gallery, Moscow (2004–05) and the National Center for Contemporary Arts, Moscow (2003–04). She has written extensively on Russian contemporary art and the Russian avant-garde.

* * * * *

KATHLEEN IRWIN, PROFESSOR EMERITA, is the past associate dean, Faculty of Media, Art and Performance, University of Regina, Canada. She holds a Doctor of Art degree, Aalto University, Helsinki (2007). Trained as a scenographer, theoretical notions of space, identity and representation inform Irwin's creative practice/research. Recent work investigates the intersection of food, power and performance. Former Canadian Education Commissioner OISTAT; Board Member: Canadian Association for Theatre Research; National Theatre School Alumni; Associated Designers of Canada; and co-founder of Knowhere Productions. Published in *Canadian Theatre Research*; *Theatre Research in Canada*; *Performance Design* (Museum Tuscalanum, 2008); *Public Art in Canada: Critical Perspectives* (University of Toronto, 2009); *Scenography Expanded* (Bloomsbury, 2017); *Artistic Approaches to Cultural Mapping: Activating Imaginaries and*

Means of Knowing (Routledge, 2018); co-editor *Sighting, Citing, Siting* (University of Regina, 2009); *Performing Turtle Island: Indigenous Performance on the World Stage* (University of Regina, 2018); and *Analysing Gender in Performance* (Palgrave, 2021).

SHAUNA JANSSEN, PH.D., is an interdisciplinary artist researcher, and associate professor of Performance Creation at Concordia University, Tiohtià:ke/ Montréal, Turtle Island/Canada, where she also holds a University Research Chair in Performative Urbanism. She directs PULSE, an interdisciplinary research and creation lab which focuses on designing performance methods for creative urban actions that engage with themes of spatial justice and the politics of urban change. She has staged, curated and designed a number of site-responsive works in Canada, Chile, Germany, Italy and New Zealand. Her writing on site-specific art, urban scenography, public space, performance pedagogy and performative practices have been published in numerous essays and monographs, including with the *Journal of Theatre & Performance Design*, and *PARtake: The Journal of Performance as Research*, and *FIELD: A Journal of Socially-Engage Art Criticism*.

CHRISTINA JUHLIN has a background in performance design and urban studies and is presently a Ph.D. fellow at the Copenhagen Business School where she is doing a fieldwork-based project about emotional and material responses to large-scale urban transformation. The project is a study of the social dynamics of sensing change, of affective attachments to spaces and of different forms of engagement in urban transformation, from emotional experiences of loss and nostalgia to more organized forms of political participation.

SEPIDEH KARAMI is an architect, writer and researcher with a Ph.D. in Architecture, Critical Studies (KTH) and currently a Lecturer in Architecture at the University of Edinburgh, School of Architecture & Landscape Architecture (ESALA). She completed her architecture education at Iran University of Science and Technology (MA, 2002), and at Chalmers University in Sweden (MSc, 2010). Since completing her first degree in architecture, she has been committed to teaching, research and practice in different international contexts. She works through artistic research, experimental methods and interdisciplinary approaches at the intersection of

architecture, performing arts, literature and geology, with the ethos of decolonization, minor politics and criticality from within. She has presented, performed and exhibited her work at international conferences and platforms, and is published in peer reviewed journals.

RAY LANGENBACH (LGB Society of Mind) creates conceptual artworks and performances, convenes gatherings, writes on cultural theory, performance and queer culture. He has presented his art works throughout Asia-Pacific, Europe and the United States and has curated exhibitions and performance events in Malaysia, Singapore, Palestine, USA and Germany. Langenbach's writings on Southeast Asian performance, propaganda and visual culture have appeared in numerous journals and books. *The Ray Langenbach Archive of Performance Art* focused on Southeast Asian performance, theatre and political events is housed at Asia Art Archive, Hong Kong, the International Institute for Social History, Amsterdam and various museums. Formerly professor of Live Art and Performance Studies, University of the Arts Helsinki, Langenbach currently is the Star Foundation Endowed Professor, Post Graduate Research, Faculty of Creative Arts, Universiti Tunku Abdul Rahman, Malaysia.

ANJA MØLLE LINDELOF is an associate professor at the Department of Communication and Arts, University of Roskilde. She has served as the head of Studies in Performance Design at Roskilde University, a teaching programme with project-based learning as well as practice-based research and teaching. In her teaching, she explores performative potentials of different teaching formats. Her research focuses on performance, liveness and audience experiences, with a special interest in processes of institutionalization and cultural policy. Recent publications include the edited volume *Experiencing Liveness in Contemporary Performance: interdisciplinary perspectives* (Routledge, 2017) and a special issue of a Danish Musicology Online (DMO) on the (lack of interest in) music institutions in Danish Music Studies.

LORI LOBENSTINE is a co-founder of the Design Studio for Social Intervention (DS4SI). Lori grew up in a family of community and union organizers and decided early on that working with youth was her passion and her route to creating change.

She was a youth worker for twenty years, in settings as diverse as classrooms, basketball courts, museums and foreign countries. Her consulting practice includes national facilitation work around diversity, equity and design, as well as evaluation and documentation work for the fledgling social justice practice field. Her recent writings include 'Social/Justice/Practice: Exploring the role of artists in creating a more just and social public', and 'Spatial justice: A frame for reclaiming our rights to be, thrive, express and connect'. Her new book (co-authored with DS4SI) is entitled *'Ideas—Arrangements–Effects: Systems Design and Social Justice'* (Minor Compositions, 2020).

ZIHAN LOO (LGB Society of Mind) is pursuing a Ph.D. in Performance Studies at the University of California, Berkeley. He received his MFA in Studio Practice (Filmmaking) from the School of the Art Institute of Chicago, and MA in Performance Studies at New York University. He is researching transnational resistance under illiberal regimes. Zihan is an educator and artist working in performance, dance, theatre and the visual arts. He has taught at various arts institutions including Nanyang Academy of Fine Arts and the School of the Arts, Singapore. He received the Young Artist Award by the National Arts Council in 2015 and he won 'Best Multimedia Design' at the 2017 M1 – The Straits Times Life! Theatre Awards for his work on The Necessary Stage and Drama Box's *Manifesto*.

GLENN LOUGHRAN is an artist, lecturer and researcher at the TU Dublin School of Creative Arts. Current research explores the future of the artschool, virtual teaching and the intersection between archipelagic thinking and art education. In 2020, he set up the archipelagic MA in Art and Environment delivered in the West Cork Archipelago. The MA Art and Environment supports the study of environmental art within the unique context of remote islands. In the Anthropocene, remote islands have become significant sites of exploration, reflection and study. Key texts include: *Evental Research: After the Future... of Work* (2018) and *Archipelagic Imaginaries: A World-Centred Education at the End of the World* (2019). Exhibiting Nationally and internationally, his work has developed hybrid forms of artistic research between pedagogical process, artistic intervention and evental philosophy. Key projects include: *The Hedgeschoolproject* (2006–12), *After the Future...of Work* (2016–20), *What is an island?* (2018–21).

MAIJU LOUKOLA is a university lecturer at the Doctoral Program in Fine Arts at the Academy of Fine Arts at the University of the Arts Helsinki, and an artist working with spatial, often site-related urban space interventions. Maiju is the head of 'The City as space of rules and dreaming' research project (2021–24) and one of the initiators of 'The Floating Peripheries – mediating the sense of place' (2017–21) project. She focuses on the politics of space and the spatial, temporal and narrative layers of urban space, defined and questioned e.g. in relation to democratization of space, peripherality and in-/exclusive practices. She is a member of the editorial committee of the RUUKKU Studies in Artistic Research journal. She curated the Prague Quadrennial of Performance Design & Space 2015 Finnish section (*Weather Station* sonic space exhibition) which won the first award in PQ15 Media in Performance and was nominated for the PQ 2015 main award.

JON MCKENZIE is a performance theorist, media maker and transdisciplinary researcher. He is dean's fellow for Media and Design and a visiting professor of English at Cornell University. The author of *Perform or Else: From Discipline to Performance* (Taylor and Francis, 2002) and founder and former director of DesignLab, a design consultancy for students and faculty at the University of Wisconsin-Madison. McKenzie produces experimental theory and gives workshops on transmedia knowledge. Mckenzie's work has been translated into a half-dozen languages. His current book project, *Transmedia Knowledge for Liberal Arts and Community Engagement: A StudioLab Manifesto*, outlines a critical design pedagogy for community engagement. Together with Aneta Stojnić, he is a founder of McKenzie Stojnic a NYC-based media performance group whose work operates at the intersections of art/life, theory/practice and episteme/doxa through talks, lecture performances, comics, videos, texts and workshops.

MITA PUJARA is a facilitator, artist and independent researcher with a background in movement and choreography who has worked in the socially engaged arts and cultural sector for twenty years. She has facilitated community arts projects for The Place, Museum of London, Akademi, National Theatre and, internationally for the British Council in Palestine, Kenya, Bangladesh, India and China. From 2000 to 2008, she was an associate director of Pan Intercultural Arts, founding two interdisciplinary arts interventions for refugee and asylum-seeking children and young adults. She currently evaluates a wide range of participatory arts, heritage

and cultural projects across the UK working with universities, councils, grassroots charities and policy change organizations.

JANE RENDELL, BSc, DipArch, MSc, Ph.D., is a professor of Critical Spatial Practice at the Bartlett School of Architecture, UCL, where she co-initiated the MA Situated Practice and supervises MA and Ph.D. projects. Her research, writing and pedagogic practice crosses architecture, art, feminism, history and psychoanalysis and she has introduced concepts of 'critical spatial practice' and 'site-writing' through her authored books: *The Architecture of Psychoanalysis* (2017), *Silver* (2016), *Site-Writing* (2010), *Art and Architecture* (2006) and *The Pursuit of Pleasure* (2002). Her co-edited collections include *Reactivating the Social Condenser* (2017), *Critical Architecture* (2007), *Spatial Imagination* (2005), *The Unknown City* (2001), *Intersections* (2000), *Gender, Space, Architecture* (1999) and *Strangely Familiar* (1995). Working with Dr David Roberts, she leads the Bartlett's Ethics Commission; and with Dr Yael Padan, 'The Ethics of Research Practice', for KNOW (an ESRC-funded project, *Knowledge in Action for Urban Equality*: PI Prof Caren Levy).

KRISTINE SAMSON, Ph.D., is an urbanist, environmentalist and associate professor at Performance Design, Roskilde University, Denmark. She has written articles on the performative city and situated design practices in urban space with an interest in how informal practices intervene in, and potentially transform the city. Currently working on a project on situated knowledges and material practices, she explores how we can work with situated yet collaborative approaches to inform environmental and social change. In her arts-based practice, Samson has published and co-created several articles, films and has curated exhibitions and performance lectures. She has co-edited *Situated Design Methods* (MIT Press, 2014), and she developed the Audio Paper Manifesto together with Sanne Krogh Groth in 2016.

PAULA SIQUEIRA, originally a social anthropologist, received her master's and Ph.D. from the National Museum in Brazil, where she studied Afro-Brazilian communities. She worked as a researcher for several years with various NGOs and charities in Brazil and the US such as FrameWorks Institute, Arapyau Institute

and FMCSV. After moving to London in 2015, Paula changed her career, became a professional portrait photographer and has since worked on several documentary and commercial projects. Paula's documentary photo series 'The Queers from the Beautiful Horizon' was shortlisted for the VIA Arts Prize and was part of a collective exhibition at the Brazilian Embassy in London. Paula has been photographing The Verbatim Formula since 2017.

HENK SLAGER is a professor of Artistic Research HKU University of the Arts Utrecht. Henk Slager has made significant contributions to the debate on the role of research in visual art. In 2006, he co-initiated the European Artistic Research Network (EARN), a network investigating the consequences of artistic research for current art education in symposia, expert meetings and presentations. Departing from a similar focus on artistic research, he has also (co-) produced various curatorial projects, a.o. *Translocalmotion* (7th Shanghai Biennale, 2008), *Nameless Science* (Apex Art, 2009), *Doing Research* (dOCUMENTA 13, 2012), *Offside Effect* (1st Tbilisi Triennial, 2012), The *Utopia of Access* (2nd Research Pavilion, Venice, 2017), *Freedom, What was that all about?* (7th Kuandu Biennale, 2018) and *Farewell to Research* (9th Bucharest Biennial, 2020). He recently published *The Pleasure of Research* (an overview of educational and curatorial research projects 2007–14) (Hatje Cantz, 2015).

ANETA STOJNIĆ, PH.D., is a theoretician, artist and psychoanalyst. Currently, she is an advanced candidate at the Institute for Psychoanalytic Training and Research – IPTAR in New York, where she is also on the Faculty of the Child and Adolescent Psychotherapy programme. Alongside psychoanalysis, her areas of research include artistic and theoretical practices at the intersections of art, culture and politics. She published two books and two co-edited volumes, as well as dozens of peer-reviewed articles on contemporary art, media and culture. She has authored numerous artistic and curatorial projects presented all over Europe. With Jon McKenzie, Aneta has realized several performance and media projects under the name McKenzie Stojnić. Aneta has taught performance, art and media theory at universities and art academies in Vienna, Belgrade and Ghent. She regularly presents her work and research at conferences and festivals worldwide.

RODRIGO TISI holds a Ph.D. in Performance Studies from New York University (2011) and a master's degree on Architecture from Pontificia Universidad Católica de Chile (1999). He is currently the director of Master on Design Sciences at the DesignLab of Adolfo Ibáñez University in Santiago. Tisi does work between hybrid spaces: performance, design, visual and scenic arts, architecture and the urban. His recent works shape forms to explore curatorial approaches to museography. He recently completed two projects for the Chilean museum of Pre-Columbian Art in Santiago and one for Centro Cultural Gabriela Mistral. In New York, he worked at the studio of Diller Scofidio + Renfro where he completed *The High Line* book and *EXIT*, an exhibition about human displacement. He was the creative director and special projects curator of the *XX Biennial of Architecture and Urbanism of Chile*.

SAM TRUBRIDGE has a Ph.D. in Creative Practice from Massey University. His thesis 'Pelagic states' (Massey University, 2019, Dean's List for Exceptional Theses) draws on his childhood living on a boat in the Pacific and Atlantic Oceans, relating this experience to a creative and scholarly practice moves fluidly across disciplines and methodologies. He is artistic director and founder The PlayGround NZ Ltd and The Performance Arcade: an annual festival of performance art on Wellington Waterfront. He has designed and directed *The Restaurant of Many Orders* (UK, Italy, NZ), *SLEEP/WAKE* in collaboration with sleep scientist Philippa Gander (NZ, USA) and most recently *Ecology in Fifths* (NZ). His work has been published and exhibited in Performance Research, Theatre Forum, PSi, The Prague Quadrennial and World Stage Design. He has lectured in Europe, Oceania, Asia and the Americas; and is currently Senior Design Tutor at Toi Whakaari O Aotearoa: NZ Drama School.

9781789389555